Public Art by the Book

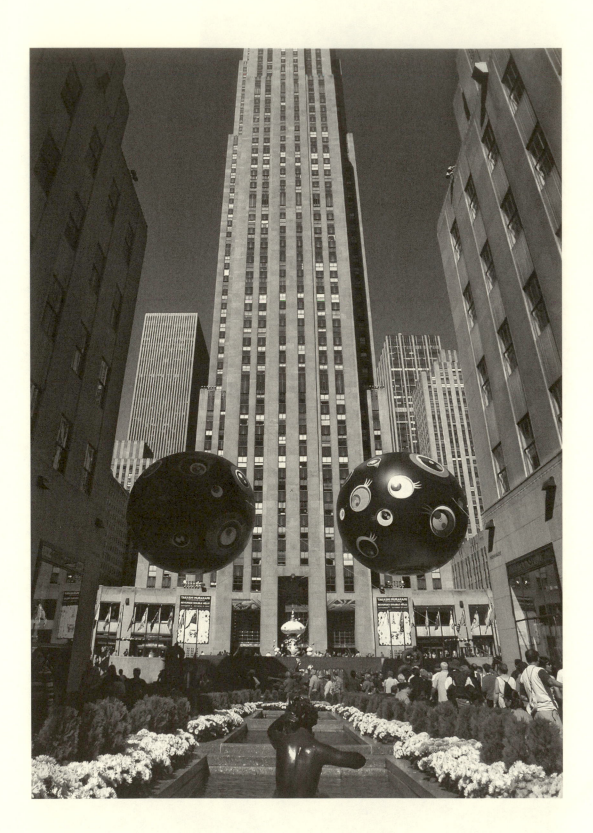

Public Art
by the Book

Edited by BARBARA GOLDSTEIN

Americans for the Arts
in association with
University of Washington Press
Seattle and London

© 2005 by the City of Seattle Mayor's Office of Arts & Cultural Affairs
Printed in Canada
Designed by Veronica Seyd
12 11 10 09 08 07 06 05 5 4 3 2 1

University of Washington Press
P.O. Box 50096, Seattle, WA 98145
www.washington.edu/uwpress

Library of Congress Cataloging-in-Publication Data
Public art by the book / edited by Barbara Goldstein.—1st ed.
 p. cm.
Includes bibliographical references.
ISBN 0-295-98521-6 (pbk. : alk. paper)
1. Public art—United States. I. Goldstein, Barbara. II. Title.
N8835.P83 2005
707'.9'73—dc22 2005001472

Frontispiece photo, p. ii: Takashi Murakami, *Reversed Double Helix*, courtesy of Public Art Fund, New York City.
Cover photos: McKendree Key, *Hallet's Cove*, Socrates Sculpture Park, New York; Takashi Murakami, *Reversed Double Helix,* Rockefeller Center, New York.

The paper used in this publication meets the minimum requirements of American National Standard for Information Sciences—Permanence of Paper for Printed Library Materials, ANSI Z39.48–1984.

Contents

Preface

The impulse to create art in public places is one of the things that make us human. From the earliest times, we have created art to record our history, mark our territory, build community, and inspire a sense of awe. During the Middle Ages and the Renaissance, monumental art and architectural embellishment were used to promote religion and assert the power of the church and the ruling classes. As one society colonized another, artworks pillaged and then reinstalled in the conquerors' homeland became a means of asserting the dominance of the conquering culture.

Early public art in the United States followed precedents established in Europe. The role of art was to embellish buildings and public places and to represent the power structure. The most common forms of public art were depictions of leaders or heroes and decorative artwork that was narrative or symbolic in form. Most government-funded public art programs were ad hoc in nature or dependent on the raising of public subscriptions for the creation of artwork and monuments intended to commemorate specific events.

By the middle of the twentieth century, the United States had begun to embrace the idea that using public funds for art was a legitimate government role. Comprehensive, federally sponsored art programs began in the Roosevelt presidency, when photographers and other visual artists as well as writers were commissioned by the Works Progress Administration (WPA) to document America and its people. The WPA also sponsored permanent artworks in federal buildings.

Thus the WPA program established the legitimacy of government-sponsored public art, and the earliest percent-for-art legislation, passed in Philadelphia in 1959, grew in part from this pioneering example. The Philadelphia legislation mandated that 1 percent of the city's public construction funds would be set aside for the commissioning of artworks for the aesthetic enhancement of buildings. The movement was successful, and other cities and private developers soon followed suit. Throughout the 1960s and 1970s, modern artworks were placed in public plazas, and they assumed the same symbolic function as the older style of civic monuments had fulfilled, but with the artwork rather than a statesman or a politician now playing the role of hero.

As government patronage grew, public art came to assume a broader role in public life. Governments began to see art as a means of building community, and artists turned their thinking toward actually creating the public realm rather than simply placing artworks in it. The concept of "art in public places," artworks transported from the studio to the public plaza, gave way to "public art," with art reinforcing a sense of place and occasion.

Public Art by the Book examines the philosophies and methods that have been adopted for placing art in the public realm. The book evolved from three conferences sponsored in 1998, 1999, and 2001 by the Seattle Arts Commission, an agency now known as the Mayor's Office of Arts & Cultural Affairs. The conferences, each of them titled "Public Art 101," provided an overview of public art programs and outlined the issues faced by arts professionals and volunteers who were trying to create public art in their communities. The conferences featured presentations by artists, arts administrators, attorneys, and community members in addition to workshops and tours of public art projects. Our agency sponsored the conferences because Seattle's efforts in the area of public art had developed a reputation as a model government-based program, and so the agency was continually approached for information on and assistance with structuring a public art program. This book includes many of the papers originally developed for the three conferences, and it expands on them with additional essays that explore the nuts and bolts of public art practice.

Since the last conference, held in October 2001, the public art resources available to artists and communities have vastly expanded. The organization known as Americans for the Arts has increased the information available through its Public Art Network, and public art programs offered in universities have grown and become more sophisticated in their offerings to artists and administrators. *Public Art Review*, a biannual publication that examines current public art practice, has grown in breadth and depth. This expansion of resources is reflected in the essays included in this volume, as it is in the Resources section at the back of the book.

Public Art by the Book offers a thoroughgoing discussion of the variables that can determine the practice of public art. The book starts with the big picture—the factors involved in developing a plan—and moves through funding mechanisms and governance structures to project types, practical issues, and resources. It explores public art that is created through public funding, public-private partnerships, and community process as well as projects that are initiated by artists themselves. It examines permanently sited art, temporary art, and art in the workplace. It looks at the legal issues governing relationships between artists, clients, and the public, and it provides a variety of tools that can be used for commissioning a single public artwork or creating a comprehensive public art program.

Today there are more than three hundred government-funded public art programs in the United States as well as scores of public-private partnerships and private agencies that are creating art in public places. Public art programs have grown beyond the public works model to embrace a wide variety of artistic media and forms. As this book goes to press, the definition of public art is continuing to change. During the 1970s and the early 1980s, the biggest debate in public art had to do with whether the public artwork should be a freestanding object or an element integrated into the physical environment. During the late 1980s and the 1990s, public art practice expanded to embrace the involvement of artists as community activists and the creation of ephemeral works in public. Today, at the beginning of the twenty-first century, artists continue working in all these modes but are also expanding their work to speak to the

public through the Internet and other interactive media, and each of these art forms remains valid and serves as a means of building community.

This book was made possible by the City of Seattle Mayor's Office of Arts & Cultural Affairs, particularly the agency's talented past and present staff, who contributed many of the ideas and essays. This book could not have been published without the enthusiasm, good ideas, and editorial assistance of Renee Piechocki, former Director of Public Art Network, Americans for the Arts. I would also like to thank the professional review committee who assisted me with the project: Jack Becker, Sandra Duncan, Gail Goldman, Jean Pasteur Greer, Jack Mackie, Debbie McNulty, Lee Modica, Norie Sato, and Jeffrey J. York. The National Endowment for the Arts, Americans for the Arts, and the University of Washington Press collaborated in the book's publication. I am honored to have had the opportunity to embark on this project and hope it will be helpful to those who use it.

BARBARA GOLDSTEIN
San Jose, California
November 2004

Acknowledgments

Portions of the discussion of Martin Puryear's *Pavilion in the Trees* were adapted from *Art: 21* (www.pbs.org/art21), produced by Susan Sollins for PBS (2001).

The discussion of Pepón Osorio's "*I have a story to tell you . . .*" is adapted from Penny Balkin Bach, ed., *New*Land*Marks: Public Art, Community, and the Meaning of Place* (Grayson Publishing, 2001).

An earlier version of "Revising Rosie the Riveter: From Public Art to National Park." by Donna Graves, appeared in *Places*, Spring 2002.

The analysis of potential alignments between the two master plans described in Laura Haddad's "The Art of Infrastructure" is indebted, the author acknowledges, to a methodology put forth by Elizabeth Meyer in "The Public Park as Avant-Garde (Landscape) Architecture: A Comparative Interpretation of Two Parisian Parks, Parc de la Villette (1983–1990) and Parc des Buttes–Chaumont (1864–1867)," *Landscape Journal*, Spring 1991, 16–26.

Call for Artists Resource Guide © 2003 by Americans for the Arts. Written by Renee Piechocki. Reviewed by Greg Esser and Marc Pally, members of the Services Committee of the Public Art Network, a program of Americans for the Arts.

The list of print and video resources in the Resources section was compiled by the Public Art Network, a program of Americans for the Arts. Listings for periodicals and serial volumes, for catalogs and annual directories, and for video resources were updated in March 2003; those for books and articles, in March 2004. To suggest additions or offer corrections, please send e-mail to pan@artsusa.org.

The interview with Mierle Laderman Ukeles is reprinted with permission from *Dialogues in Public Art*, Tom Finkelpearl, MIT Press, © 2000.

Public Art by the Book

Part I

Planning

Designing a Public Art Plan

How to Structure a Process and a Product to Meet Your Needs

The way you plan a public art program can guide the vision for what public art is ultimately able to accomplish in your area. Both the public art plan and the process of the plan's development offer ways to define a variety of the community's cultural needs in addition to the community's physical identity.

ELEMENTS OF THE PUBLIC ART PLAN: AN OVERVIEW

Public art plans come in many varieties. As a rule, however, they include key elements that define and address the following areas:

- Goals and community priorities
- Key locations and opportunities for public art
- Funding sources and projections
- Program structure and staffing requirements
- Implementation milestones
- Policies and procedures concerning such issues as community outreach, artist selection, collection management, and conservation

There are three primary reasons why you might want to undertake a planning process:

1. To establish the public art program itself
2. To provide a comprehensive means of implementing the program's mandate
3. To evaluate and refine an existing program

Most planning processes can be broken down into four basic phases:

1. Research
2. Development
3. Approval
4. Implementation

Once the research phase is complete, a preliminary set of recommendations can be

developed to address the key elements listed above. These recommendations can then be presented to an advisory committee for discussion and feedback. They can also be tested with one or more focus groups of civic leaders and other stakeholders, or at a public meeting.

The final plan, developed with the help of stakeholders' responses to the initial recommendations, usually takes the form of a printed document. More and more communities, however, are opting for the CD/ROM format and other electronic media, which allow the plan to be reproduced and distributed with far more cost-effectiveness.

Research and Development

Establishing the Context

Planning for a public art program is often a labor-intensive activity, particularly if broad public involvement is an objective. It is crucial to be realistic in assessing the funding, staff, and community support that can be called on for the planning process so that the plan's objectives are aligned with available time and resources.

As you embark on creating a public art plan—for a new facility, a neighborhood, or a city of several million people—remember that your plan, to be effective, must be tailored to your specific place and time. Therefore, start by establishing the context for your plan and program by making an inventory of existing circumstances and resources. Begin with these questions:

- What role do the arts currently play in your community?
- How has history shaped your city?
- What economic and demographic factors affect your region?
- How would a public art program have to be structured in order to reflect the unique characteristics of your area?
- What national trends in public art are relevant to your community and your plan?

Continue by posing the following question, at a minimum:

- Why do you want to establish a public art program?
- What are you hoping to accomplish?
- What issues need to be addressed?
- Who will work on the plan and the program?
- What funding is available?
- What are the structures that support art in your community?
- Are any *public* art activities already taking place in your community? If so, what kind? Who is participating in them?
- What will make your public art program successful?
- What will make your plan effective?
- How can you ensure that your plan will be implemented?

If your plan is for more than a single project, it will probably also require you to

analyze key locations or opportunities for public art and to review current and prospective community gathering places, civic spaces, and public facilities.

Additional research will usually focus on existing planning and budget documents, such as a general plan or a capital improvement projects plan. Ideally, your public art plan will build on and complement those existing plans and documents or be integrated into broader citywide planning documents.

Forming a Coalition

The successful process for planning a public art program needs a broad coalition of people to shape a cohesive vision, one that they are committed to seeing implemented. Most coalitions include, in some form, a citizen advisory group and a process for involving the public.

Citizen Advisory Group. Because the best way to build community support for an idea is to invite people to participate in shaping it, most plans involve some form of citizen advisory group or task force. In some cases, this set of participants may be limited to the members of an existing group, such as an art commission or a public art committee. It can be extremely beneficial, however, to involve a broader group of people as long as their participation is structured in a way that makes their contributions meaningful. For example, structuring an advisory group to include a smaller policy group or steering committee can facilitate effective communication.

The development and implementation of a public art plan will affect a number of interest groups. Therefore, in forming your advisory group, it is important to consider who shapes public opinion in your community as well as who will be crucial to your plan's implementation. Who are your key stakeholders? How can you best secure their involvement and commitment? The following constituencies are likely sources of your advisory group's members:

- Elected officials
- Community activists
- Planning commissions, the parks commission, the library commission, historic preservation commissions
- Key government agencies (such as the transit agency) or departments (such as departments of finance or public works)
- Neighborhood groups (such as homeowner or neighborhood improvement associations)
- The business and development communities
- The art and design communities

Before finalizing the composition of your advisory group, spend some time thinking about the roles that members will be required to play. Will they be asked for their comments or approval? How many meetings will they have to attend? Are there people on your list who may not be willing to commit themselves to an extended public process

but who would participate in a focus group or an interview? As one aspect of their advocacy efforts, could they give you access to other constituencies?

Public Involvement Process. Your planning process presents an excellent opportunity for educating the larger community about the many benefits of public art. For example, a good way to collect feedback on your priorities is to hold a series of public meetings or slide lectures where images of public art from other communities are presented. Focus groups, one-to-one interviews, and surveys are additional ways of obtaining comments and support, as are developing temporary public art projects and creating a Web site devoted to your planning process. A well-thought-out process for public involvement can supplement the efforts of your citizen advisory group and help foster the ownership that is essential to your plan's development and implementation.

Setting Objectives

An important first step for those involved in the planning process is to reach consensus on an initial list of objectives that reflect the priorities of the project's stakeholders. One such objective may be to gain extensive public participation in the planning process. Another may be to secure funding for a pilot project that can offer a firsthand demonstration of public art's benefits. Still another may be to establish a funding mechanism to ensure long-range support (for example, an ordinance allocating a certain percentage of tax revenues to public art).

With the planning process's objectives finalized and its key resources secured, work can begin on the plan itself. It is at this point that many communities turn to professional consultants for assistance in developing some or all of the plan's components.

Approval and Implementation

The process for getting a public art plan adopted depends primarily on the community. In general, a draft of the plan is presented for the citizen advisory committee's review and comments. It also goes to other key readers who were identified during the research phase. The draft is then revised, as necessary, on the basis of comments received. The final plan is presented to any official groups whose approval is required. The identity and nature of these groups will depend on the plan and the community, but they may include review boards, such as an art commission or a planning commission, and government bodies, such as a city council.

The approval process should be regarded as an opportunity for additional outreach and advocacy. This is the time to schedule meetings aimed at educating elected officials and other community leaders about the plan's key recommendations, and to assess the level of support for the proposed plan's approval. These meetings also provide excellent opportunities for reinforcing partnerships that will assist in the plan's implementation.

The successful plan, once implemented, is flexible and positioned to take advantage of opportunities that evolve over time, but even the best plan eventually needs to be updated or replaced. Every five to ten years, it is important to evaluate how well

the community has implemented the original recommendations. The evaluation period is also the time to identify new challenges and opportunities, amend existing policy guidelines to reflect changes in the field, and renew the community's enthusiasm and support for public art.

APPROACHES AND SOLUTIONS: SEVEN EXAMPLES

The objectives of a public art plan are often complex and multilayered, but the plan generally comes about because someone has decided that public art is the perfect vehicle for accomplishing something (commemorating an event, enhancing a transportation system, improving a neighborhood). The plans described in this section include the components already discussed, but they also have unique characteristics that make them appropriate to their particular communities. Most involve large cities with substantial budgets, but it is also possible to conduct public art planning on a smaller scale. Each of the following examples shows that a successful planning process is tailored to the specific objectives and resources of a community and reflects its individuality. (For additional details, see "Fact Sheet: Selected Public Art Plans," following this essay.)

Bellevue, Washington

The city of Bellevue, wanting to increase awareness of and participation in its existing public art program, undertook a community visioning process and leveraged a relatively modest budget through the careful design of focus groups. This process enabled broad community dialogue and helped the city identify key priorities for public art.

Broward County, Florida

Design Broward, the public art plan for Broward County, became a tool for rethinking an existing program. The rethinking process provided both an opportunity to address issues that the program had encountered over the years and a mechanism for building political support for expanding the program's funding. The planning team placed a great deal of emphasis on Broward County's urban fabric and on ways in which the public art program could be modified for greater impact on the area's unique physical characteristics. Planners worked with volunteers on a series of team projects focusing on conceptual design. The teams developed design solutions for a variety of locations, and these solutions were exhibited at a local museum. The process jumpstarted a new way of thinking about how artists could influence the look and feel of Broward County. At the same time, it revealed the depth of creative talent that was in the region and available to the program.

Charlotte, North Carolina

Public art plans are often created for municipalities, but a plan may also focus on a single facility (such as a library or an airport) or government agency (in particular, a

transportation agency). Although such a plan has much in common with the broader, municipally oriented plans, it generally revolves around ways in which art can support the programmatic goals of the individual facility or agency. As one example, the Charlotte Area Transit System (CATS), in keeping with Charlotte's existing percent-for-art mandate, was considering the development of a public art program and commissioned a public art plan. The plan, titled Art in Transit, established a funding mechanism for the program and framed the ways in which public art, through works revealing local culture, heritage, and aspirations, could support the transit agency's goals for its passengers and facilities.

Houston, Texas

Many of the same techniques employed in Charlotte, North Carolina, were used in developing the plan titled The Houston Framework. The members of the planning team looked at the entire Harris County region and took as their point of departure many of the urban design plans that had been developed for various parts of the Houston metropolitan area. Civic art and design became vehicles for thinking not only about the natural, physical, and social systems of a major urban center but also about articulating the role that the arts could play in shaping those systems. The Houston Framework also became a tool in the development of long-term funding for public art initiatives in both the public and the private sectors.

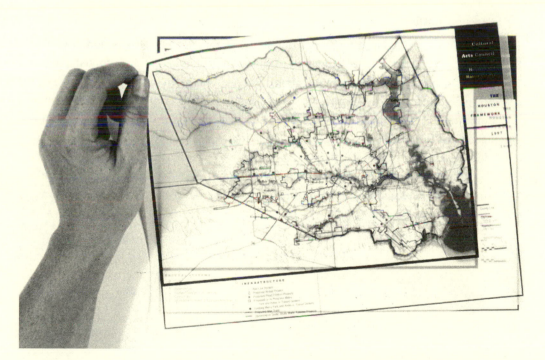

Houston Framework. Overlay maps. *Photo © 1997 by Core Design. Courtesy of Core Design.*

Phoenix, Arizona

In Phoenix, the need for a public art plan was precipitated by the adoption of percent-for-art legislation in a rapidly expanding city. The newly established public art program had to determine the best way of identifying and addressing community priorities. In what was a precedent-setting departure from earlier public art planning, the consulting team decided on an approach that tied the development of the city's cultural infrastructure directly to the city's physical infrastructure, inextricably linking the public art program's funding source with the resulting art product. The plan laid out a new way of leveraging public investment in concrete and asphalt by making them an investment in the artistic patrimony of the community.

San Diego, California

San Diego, in a unique approach to public art planning, established a series of neighborhood groups that were funded and empowered to develop their own public art projects. The projects transformed neighborhoods and changed the perception of the role that artists could play in shaping the city. This massive community outreach initiative resulted in an informed and supportive coalition that became the tool the local arts agency needed to craft citywide public art policy. (Note that in 2003–2004 the city undertook a new public art planning process, which may result in the adoption of a public art ordinance for projects in both the public and the private sector.)

Ventura, California

In Ventura, the public art plan was developed incrementally over a period of years, and with the help of several different planning consultants. The city adopted a public art ordinance in 1991 and implemented several projects. In 1996, in an initial phase of planning, community comment was solicited to shape comprehensive goals and objectives for the program. The next phase, in 1997, involved an assessment of the program and the development of policy recommendations to address issues that had been identified during the assessment process. The final phase included the development of a prioritized project list as well as revisions to the original ordinance. All these elements were then updated and compiled into a comprehensive public art plan that was adopted in early 2000.

This fact sheet compares a number of public art planning efforts undertaken in communities around the country. It is not intended as a comprehensive listing but rather as a representative selection of plans.

Bellevue, Washington

Title: Public Art: Creating Community Connections
Commissioning agency: Bellevue Arts Commission
Date: 1994
Planning team: Glenn Weiss, Kjristine Lund, Heather McCartney, Mary Pat Byrne
Advisory group? Yes
Budget: $12,000
Major funders: City of Bellevue, Washington State Arts Commission, King County Arts Commission
Existing art ordinance? Yes
Key points: This plan is in essence a visioning document that states the mission, goals, and key directions for the public art program. It focuses on public art that expresses community identity, and it stresses the importance of youth participation in creating a legacy for the children of the community.

Broward County, Florida

Title: Design Broward
Commissioning agency: Broward Cultural Affairs Division
Date: 1995
Planning team: Jerry Allen & Associates
Advisory group? Yes
Budget: $48,000
Major funders: National Endowment for the Arts, Broward County
Existing art ordinance? Yes (1976)
Key points: The plan provides an assessment of the existing public art program, a revised ordinance, policies and procedures with which to move forward, and recommended projects for the next five years. It focuses on providing an identity for Broward County through anticipated urban development.

Charlotte, North Carolina

Title: Art in Transit: Public Art Program Guidelines and Implementation Strategies
Commissioning agency: Charlotte Area Transit System (CATS)
Date: 2002
Planning team: Jack Mackie, artist; Jerry Allen & Associates

Advisory group? Yes

Budget: $28,000 (consultant fee only)

Major funder: Charlotte Area Transit System

Existing art ordinance? No

Key points: The plan establishes a public art program (1 percent for art) for CATS, based on meeting the city's existing standard. It articulates the art program's ability to support the transit agency's passenger and facility goals by creating artworks that reveal local culture, heritage, and aspirations.

Houston, Texas

Title: The Houston Framework

Commissioning agency: Cultural Arts Council of Houston & Harris County

Date: 1997

Planning team: John Kaliski, AIJK; Fletcher Mackey, artist; William Morrish & Catherine Brown, Institute for the American Urban Landscape; Kevin Shanley, SWA Group

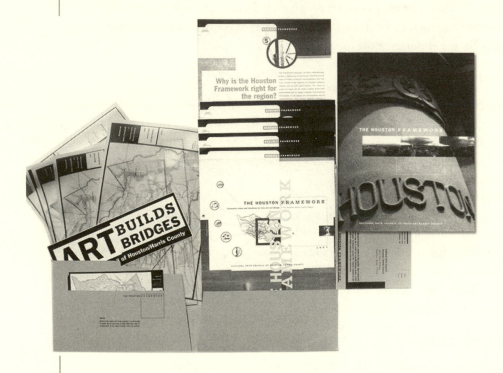

Houston Framework package. *Photo © 1997 by Core Design. Courtesy of Core Design.*

Advisory group? Yes
Budget: $120,000
Major funders: National Endowment for the Arts, Houston Endowment
Existing art ordinance? No
Key points: The plan focuses on the region's waterways as a key asset. It shows how the bayous function as the underpinning of a number of critical infrastructure systems, provide social and cultural linkages, and represent an underutilized resource. The plan ties public art directly to the bayous as well as to economic revitalization and community development in an attempt to generate a broad mandate for public art.

Phoenix, Arizona

Title: Public Art Plan for Phoenix: Ideas & Visions
Commissioning agency: Phoenix Arts Commission
Date: 1988
Planning team: William Morrish & Catherine Brown, Institute for the American Urban Landscape; Grover Mouton, artist
Advisory group? Yes
Budget: $20,000 (consultant fee only)
Major funders:
Existing art ordinance? Yes (1986)
Key points: The plan articulates and makes visible the link between the Phoenix infrastructure system, which is the public art program's funding source, and the city's cultural infrastructure. It provides a mechanism for evaluating and prioritizing projects in a large metropolitan area experiencing rapid growth.

San Diego, California

Title: Public Art Master Plan
Commissioning Agency: San Diego Commission for Arts & Culture
Date: 1990
Planning Team: Gail Goldman, public art program director
Advisory Group? Yes
Budget: $200,000 (including $120,000 for pilot projects)
Major Funders: City of San Diego, National Endowment for the Arts, California Arts Council
Existing Art Ordinance? No
Key Points: The plan's key aspect is the development of a series of community-based public art projects as a mechanism to generate support for the creation of a citywide public art policy. The projects establish a clear precedent for the role of the artist in the built environment.

Title: City of San Diego—Public Art Master Plan
Commissioning agency: City of San Diego Commission for Arts and Culture
Date: 2002–2004
Planning team: Jerry Allen & Associates and commission staff
Advisory group? Yes (Public Art Master Plan Steering Committee, 30 members; City of San Diego Commission for Arts and Culture, 15 members)
Budget: $130,000 (not including staff time and overhead costs)
Major funder: City of San Diego
Existing art ordinance? Yes (1992)
Key points: The plan establishes a 2 percent setaside for public art from selected eligible capital improvement projects and a 1 percent setaside for public art enhancement from private development, which can be satisfied by the financing of cultural and artistic facilities, on-site artwork, or an elected .5 percent contribution to the Public Art Fund account, to be used for the artistic enrichment of the city's public spaces. The focus of the public art plan is to enhance community participation in the public art process, provide support systems for local artists, promote community identity for San Diego's neighborhood "villages," celebrate San Diego's unique character and enhance its urban design objectives with public art, and use public art to promote economic and cultural tourism.

Ventura, California

Title: Public Art Program Long-Range Plan
Commissioning agency: City of Ventura
Date: 1996–2000
Planning team: Carol Goldstein and Marc Pally (phase 1); Jerry Allen & Associates (phase 2); Jessica Cusick, public art program director (phase 3)
Advisory group? Yes
Budget: N/A
Major funder: City of Ventura
Existing art ordinance? Yes (1991)
Key points: The plan provides an assessment of the existing program and a cohesive policy framework to remedy the community's articulated concerns about the program. Along with a capital improvement plan, it includes a new ordinance and lists a series of specific project opportunities that closely mirror the city's key visioning documents.

Part 2

Funding

Government-Based Funding Models

Public Support for Public Art

BARBARA GOLDSTEIN

The way a government designs its methods for funding public art can determine, in part, the quantity and character of the artworks a public art program is able to purchase. A funding method may be so restricted that it prescribes the kinds of artworks the program can commission as well as their related costs. It may be so broad that its purpose and uses can evolve with changing circumstances. This overview describes the funding methods of several public art programs in Washington, Oregon, and California. The documents that follow include a summary of each program's key elements and, as appropriate, a copy of the program's governance document.

One development worth noting here is that public-private partnerships constitute a new wave of government funding for public art. The public-private model is gaining acceptance throughout the United States. It is currently employed in the Portland area, as described here, as well as at the Cultural Arts Council of Houston and Harris County, at the Arts Council of Fort Worth and Tarrant County, Texas, and in King County, Washington, where the King County Cultural Resources Department has become a public development authority called 4Culture. This model, combining the administration of a government entity's percent-for-art program with a more entrepreneurial approach to developing art in other governments and institutions, has allowed a broader spectrum of public art across the range of project types.

SEATTLE

The Mayor's Office of Arts & Cultural Affairs, formerly the Seattle Arts Commission, is, as its name implies, an agency of the city government. Seattle's public art program, one of the nation's first, specifies that 1 percent of the city's capital improvement funds be set aside for the commission, purchase, and installation of artworks. Because Seattle owns its own water and electrical utilities, and because both utilities construct large amounts of in-city infrastructure, percent-for-art funds generated by the utilities' revenues have also been used to mitigate these construction projects' negative impacts on the cityscape. The utilities have funded many artworks that promoted a sense of community and neighborhood pride in areas where infrastructure was being built.

An artwork commissioned through Seattle's public art program can either be created as an integral part of an eligible construction project or located at any other city-owned site. Through various commissioning methods, the program acquires works in several categories:

• Major, permanently sited indoor and outdoor artworks to advance the integration of artworks into Seattle's urban fabric

• Products of team collaborations in which artists, architects, and design professionals are brought together to work on the overall design of a site or a major planning project

• Works for a portable collection (these are relatively small-scale artworks exhibited primarily in public buildings)

• Works produced through special projects in which artists are encouraged to explore the process of making art through residencies and through the creation of temporary artworks and media-based works

Seattle's public art program allows flexibility in the expenditure of funds, and many cities have tried to emulate its success. But Seattle's program is a little like the first desktop computer: it was a breakthrough when it was created, but newer models have surpassed its functionality. For example, Seattle's funding remains at the level of 1 percent of the city's capital improvement budget, and because the program does not restrict how the funds can be spent, the door is left open to questions about how much money will go to project management and how much to education costs and general overhead. This very openness has sometimes had the effect of restricting the funds available for artwork expenditures, especially during tight budget years. By contrast, many of the newer programs receive more than 1 percent for art from government-financed construction, and their funding often extends beyond public capital improvement budgets to funds allocated for redevelopment and/or private construction. A number of the latter programs spell out how much money can be spent for what purposes, such as allowable administrative expenses and expenses for maintenance of artworks.

Experience in Seattle has also demonstrated the fragility of even a well-established public art program. In response to a ratepayer-generated lawsuit, a court ruled recently that the program's percent-for-art funding from Seattle City Light and Seattle Public Utilities must be rescinded. At present the agency is building new relationships to develop artworks with a greater nexus to utilities construction and resource conservation.

PORTLAND

In Portland, a city-county agency split off to become a public-private partnership. Today the Regional Arts and Culture Council (RACC) administers public art programs for the city and for Clackamas, Washington, and Multnomah Counties as well as for such private nonprofit entities as the Doernbecher Children's Hospital. RACC is entrepreneurial and has developed a variety of projects, among them a remarkable public art program for Tri-Met, the regional transit system.

LOS ANGELES

Redevelopment agencies that use tax-increment financing have existed for some time, and many states have the ability to stimulate development through this financial mechanism. In 1992, however, the Los Angeles Community Redevelopment Agency (CRA)

initiated a unique program requiring developers to include arts and culture in their redevelopment projects and to fund the cultural enhancement of their communities.

The program, initially implemented only in connection with downtown development, now includes all of the city's redevelopment areas. CRA's program encompasses developer-initiated projects, agency-initiated projects, and special projects funded through the city's Cultural Trust Fund. Developer-initiated projects can include visual artworks, either freestanding or integrated into a building, as well as art facilities, cultural programming, and restoration of historical artwork elements. This public art program has brought about an impressive number of physical artworks and cultural programs in addition to the construction of cultural facilities throughout redevelopment areas in Los Angeles.

KENT, WASHINGTON

There are many smaller cities where a percent-for-art formula simply would not yield enough funds to create a reasonable public art program. The city of Kent, Washington, tackled this issue by designating an annual setaside of $2 per capital improvement project from the city's general fund, to be placed in the City Art Fund and used for commissioning and acquiring art for public display. By contrast with most other general funds, money in the City Art Fund can be carried over from year to year and pooled to support larger projects. As the city grows, the annual amount of funding grows, too. Because the funding is not tied to construction, the city's Arts Commission has the freedom to distribute these funds broadly and to plan carefully for projects that can have the highest impact. Commissions have included large-scale permanently sited works as well as small artworks that can be displayed in public places.

SAN DIEGO

In 1992, San Diego initiated its so-called negotiated public art program, which demanded an incredible act of faith: rather than designate a specific percent-for-art setaside, the city council backed its commitment to excellence in the city's built environment by creating a policy that mandated artists' involvement in the design of capital improvement projects. The program was embraced by the city's departments, which regularly included artists in their capital improvement activities, and it completed more than forty active projects of all varieties and scales. The negotiated model worked well for some projects, although in certain cases the lack of a predefined budget left artists stranded or created other funding challenges when projects reached the cost-cutting stage of their budgets.

After ten years of success with its negotiated program, San Diego decided to increase its support for public art. It commissioned a comprehensive public art master plan and introduced a farther-reaching funding program that includes a 2 percent capital construction setaside for art as well as a 2 percent private commercial construction setaside and a 1 percent setaside from multiple residential construction projects with

budgets over $5 million. San Diego also devotes Transient Occupancy Tax funds every year to special public art projects, including neighborhood-oriented projects. This arrangement allows money to flow to community- or neighborhood-initiated projects that are not specifically related to infrastructure.

ORDINANCE *City of Seattle*

Chapter 20.32 Art in Public Works Construction

SMC 20.32.010 *Purpose.*

The City accepts a responsibility for expanding public experience with visual art. Such art has enabled people in all societies better to understand their communities and individual lives. Artists capable of creating art for public places must be encouraged and Seattle's standing as a regional leader in public art enhanced. A policy is therefore established to direct the inclusion of works of art in public works of the City.

(Ord. 102210 Section 1, 1973.)

SMC 20.32.020 *Definitions.*

A. "Office" means the Office of Arts and Cultural Affairs.

B. "Commission" means the Seattle Arts Commission.

C. "Construction project" means any capital project paid for wholly or in part by the City to construct or remodel any building, structure, park, utility, street, sidewalk, or parking facility, or any portion thereof, within the limits of the City of Seattle.

D. "Eligible fund" means a source fund for construction projects from which art is not precluded as an object of expenditure.

E. "Municipal Arts Plan" means the plan required by Section 20.32.040 A.

F. "Administrative costs" means all costs incurred in connection with the selection, acquisition, installation and exhibition of, and publicity about, City-owned works of art.

(Ord. 121006 Section 11, 2002: Ord. 117403 Section 1, 1994: Ord. 105389 Section 1, 1976: Ord. 102210 Section 2, 1973.)

SMC 20.32.030 *Funds for works of art.*

All requests for appropriations for construction projects from eligible funds shall include an amount equal to one (1) percent of the estimated cost of such project for works of art and shall be accompanied by a request from the Office of Arts & Cultural Affairs for authorization to expend such funds after the same have been deposited in the Municipal Arts Fund. When the City Council approves any such request, including the one (1) percent for works of art, the appropriation for such construction project

shall be made and the same shall include an appropriation of funds for works of art, at the rate of one (1) percent of project cost to be deposited into the appropriate account of the Municipal Arts Fund. Money collected in the Municipal Arts Fund shall be expended by the Office of Arts & Cultural Affairs for projects as prescribed by the Municipal Arts Plan, and any unexpended funds shall be carried over automatically for a period of three (3) years, and upon request of the Office of Arts & Cultural Affairs, carried over for an additional two (2) years. Any funds carried over for three (3) years, or upon special request for five (5) years, and still unexpended at the expiration of such period shall be transferred to the General Fund for general art purposes only; provided, that funds derived from revenue or general obligation bond issues or from utility revenues or other special purpose or dedicated funds shall revert to the funds from which appropriated at the expiration of said three (3) or five (5) year period.

(Ord. 121006 Section 12, 2002: Ord. 105389 Section 2, 1976: Ord. 102210 Section 3, 1973.)

SMC 20.32.040 *Office of Arts & Cultural Affairs—*

Authority. To carry out its responsibilities under this chapter, the Office of Arts & Cultural Affairs shall:

A. Prepare, adopt and amend with the Mayor's approval a plan and guidelines to carry out the City's art program, which shall include, but not be limited to a method or methods for the selection of artists or works of art and for placement of works of art;

B. Authorize purchase of works of art or commission the design, execution and/or placement of works of art and provide payment therefor from the Municipal Arts Fund. The Office of Arts & Cultural Affairs shall advise the department responsible for a particular construction project of the Office's decision, in consultation with the Seattle Arts Commission, regarding the design, execution and/or placement of a work of art, funds for which were provided by the appropriation for such construction project;

C. Require that any proposed work of art requiring extraordinary operation or maintenance expenses shall receive prior approval of the department head responsible for such operation or maintenance;

D. Promulgate rules and regulations consistent with this chapter to facilitate the implementation of its responsibilities under this chapter.

(Ord. 121006 Section 13, 2002: Ord. 105389 Section 3, 1976: Ord. 102210 Section 4, 1973.)

SMC 20.32.050 *Municipal Arts Fund.*

There is established in the City Treasury a special fund designated "Municipal Arts Fund" into which shall be deposited funds appropriated as contemplated by Section 20.32.030 together with such other funds as the City Council shall appropriate for works

of art, and from which expenditures may be made for the acquisition and exhibition of works of art consistent with the plan specified in Section 20.32.040 A, and for Office of Arts & Cultural Affairs staff costs and administrative costs (as defined in SMC Section 20.32.020F) that are associated with developing and implementing the Municipal Arts Plan, but not the cost of maintaining City-owned art work, which maintenance cost may be paid from the Cumulative Reserve Subfund or such other source(s) as may be specified by ordinance. Separate accounts shall be established within the Municipal Arts Fund to segregate receipts by source or, when so directed by the City Council, for specific works of art. Disbursements from such fund shall be made in connection with projects approved by the Seattle Arts Commission on vouchers approved by the Director of the Office of Arts & Cultural Affairs.

(Ord. 121006 Section 14, 2002: Ord. 117403 Section 2, 1994: Ord. 116368 Section 242, 1992: Ord. 105389 Section 4, 1976: Ord. 102210 Section 5, 1973.)

FACT SHEET *City of Seattle*

How Financed

1 percent for art, which applies to the cost of all eligible construction projects

Legal Mechanism

Municipal Code Chapter 20.32

The role of the City is to assume the following obligations:

• Accept responsibility for expanding public experience with visual art
• Establish a policy for the inclusion of works of art in city public works
• Establish 1 percent for art on eligible construction projects
• Establish the creation of the Municipal Art Fund to receive 1 percent for art
• Assign the Office of Arts & Cultural Affairs responsibility for developing a plan and guidelines to carry out the city's art program, including methods for selecting artists, artworks, and the placement of art

Guidelines

• The Office of Arts & Cultural Affairs (the Office), in consultation with city departments and residents, creates the annual Municipal Art Plan (MAP), which allocates funds for artwork projects.

• The Office authorizes the purchase or commissioning of works of art in accordance with the MAP and pays for the implementation of this program from the Municipal Art Fund.

• The mission of the program is to integrate artworks and the ideas of artists into a variety of public settings, with the objective of contributing to a sense of the city's identity.

• The MAP seeks to provide opportunities for professional artists to place their works in the public realm and to participate with residents in the development of art in public places.

• The MAP must be reviewed and approved by the mayor and reviewed by the City Budget Office.

Governance

• The Seattle Arts Commission is composed of fifteen volunteer policymaking members, appointed by the mayor for two-year terms, who advise the Office of Arts & Cultural Affairs.

• The seven-member Public Art Advisory Committee, which includes members of the Seattle Arts Commission, design commissioners, and community members, meets at least monthly to review and make recommendations concerning sites for public artworks, the nature of public artworks, and allocations from the Municipal Art Fund.

Administration

All administrative and project-management costs are borne by the Municipal Art Fund.

Artist Selection Process

• At least 50 percent of the funds expended over a five-year period should be for commission and purchase of works by artists associated with the Pacific Northwest.

• Artwork is selected by a jury nominated by the Public Art Advisory Committee and Seattle Arts Commission staff. The committee can constitute itself as a jury.

• Juries consist of arts professionals assisted by technical and community advisors.

• Three methods of artist selection are available: (1) open entry; (2) limited entry/invitational competition; and (3) roster-based and direct artist selection.

• Eligibility requirements shall be recommended for each project by the Public Art Advisory Committee.

ORDINANCE 149425 *City of Portland*

An Ordinance amending Title 5, Revenue and Finance, of the Code of the City of Portland by adding a new chapter 5.74 to provide for the dedication of 1% of the construction cost of major city construction or alteration of certain city buildings for the acquisition and display of art, and declaring an emergency.

THE CITY OF PORTLAND ORDAINS:

SECTION 1. THE COUNCIL FINDS:

(1) That it is appropriate in the new construction or major alteration of certain city buildings that 1% of the construction costs of such major city construction be devoted to the acquisition and display of art to be displayed in, upon, adjacent to or in close proximity to such building;

(2) That the Code of the City of Portland, Title 5, Revenue and Finance, should be amended by

Adding a new Chapter 5.74, Acquisition of art;

NOW THEREFORE, THE COUNCIL DIRECTS:

(a) That the Code of the City of Portland be amended by adding thereto a new Chapter 5.74, Acquisition of art, to read as follows:

5.74.010 *Purpose.*

It is the purpose of this section and the policy of the city that each major city construction project which involves the construction or alteration of certain city buildings shall have an appropriate display of art integrated into the project.

5.74.020 *Definitions.*

As used in this chapter:

(1) "Construction Cost" means actual construction cost, excluding engineering and administrative costs, cost for fees and permits, and indirect costs, such as interest during construction, advertising and legal fees.

(2) "Construction or alteration" means construction, rehabilitation, renovation, remodeling or improvement.

(3) "City building" means all city buildings except service facilities not normally visited by the public.

(4) "Major city construction project" means a construction project which involves the construction or alteration of a city building with an estimated construction cost of $50,000 or more.

5.74.030 *Dedication.*

One percent of the construction cost of a major city construction project which involves the construction or alteration of a city building shall be set aside for the acquisition of art; which art shall be displayed in, upon, adjacent to or in close proximity to the city building which is the subject of the project; except that if it would be inappropriate to display art at that location, said one percent shall be used for the acquisition of art for display in, upon, adjacent to or in close proximity to other city buildings.

5.74.040 *Administration.*

The Metropolitan Arts Commission shall in its discretion administer the provisions of this ordinance relating to art acquisition and display.

5.74.050 *Guidelines.*

The Metropolitan Arts Commission shall adopt guidelines:

(1) to determine the cases in which it would be inappropriate to display art in a city building;

(2) to identify suitable art objects for city buildings;

(3) to encourage the preservation of ethnic cultural arts and crafts, including Pacific Northwest Indian Art;

(4) to facilitate the preservation of art objects and artifacts that may be displayed by a construction project;

(5) to prescribe a method or methods of competitive selection of art objects for display;

(6) to prescribe procedures for the selection, acquisition and display of art in city buildings; and

(7) to set forth any other matter appropriate to the administration of this chapter.

5.74.060 *Delegation.*

The Metropolitan Art Commission's decision as to the selection, acquisition, allocation and display of art objects shall be final.

5.74.070 *Ownership.*

All art objects acquired pursuant to this ordinance shall be acquired in the name of the City of Portland, Oregon, and title shall be vest in the City of Portland, Oregon.

SECTION 2. THE COUNCIL DECLARES:

That in order that appropriation of funds for art objects for city buildings may be authorized without unnecessary delay, an emergency exists and this ordinance shall be in force and effect from and after its passage by the council.

Passed by the Council April 10, 1980.

ORDINANCE 161537 *City of Portland*

% Expansion, January 4, 1989

Amend the Code regarding acquisition of art (Ordinance; Amend Code Chapter 5.74)

THE CITY OF PORTLAND ORDAINS:

SECTION 1. THE COUNCIL FINDS:

1. The City of Portland and Multnomah County have established the Metropolitan Arts Commission to create programs to promote the development of public art and to encourage public awareness of, and interest in public art;

2. Ordinance No. 149425 amended Title 5, Revenue and Finance of the Code of the City of Portland, by adding Chapter 5.74, to provide for the dedication of 1% of the cost of major construction or alteration of certain City buildings, for the acquisition and display of art;

3. Dedication of a percentage for art advances the goals of the City by:

 a. Adding to the high urban design standards of the City;

 b. Attracting national media attention to the City because of the City's leadership in the area of public art;

 c. Promoting City services and the purposes of participating bureaus through the use of public art; and

 d. Providing a mechanism to meaningfully involve citizens in the design of their environment.

4. Dedication of 1% for art by the City has resulted in private, state, federal and other local contributions for art and has encouraged other entities including the Metropolitan Service District, the Portland Public Schools and Portland Community College to develop similar programs.

5. The present 1% for art program is severely limited in that:

 a. Most of the existing public art is in the downtown area because placement of art is tied to construction of major city buildings;

 b. No new construction of major city buildings is planned in the near future; and,

 c. The present 1% for art program does not provide for many of the costs associated with public art;

6. There is a continued and ongoing need for public art including public art sited outside the downtown area;

7. It is appropriate to dedicate 1.33% of the total costs of City of Portland improvement projects for art.

NOW THEREFORE, THE COUNCIL DIRECTS:

 a. Chapter 5.74 of the Code of the City of Portland, Acquisition of Art shall be amended as follows:

Don Merkt, *Water, Please,* 1997. Aluminum and steel. Water Pollution Control Lab, St. Johns, Oregon. *Photo courtesy of Regional Arts and Culture Council.*

5.74.010. *Purpose.*

It is the purpose of this Chapter and the policy of the City of Portland to dedicate 1.33% of the Total Costs of all Improvement Projects to the selection, acquisition, siting, maintenance, administration, Deaccessioning, community education and registration of Public Art.

5.74.020. *Definitions.*

As used in this Chapter:

a.

1. Improvement Project means any project paid for wholly or in part by the Participating Bureau in which the Participating Bureau's contribution equals $100,000 or more, involving construction, rehabilitation, remodeling or improvement of any building, structure, park, public utility, street, sidewalk or parking facility or any portion thereof within the limits of the City of Portland.

2. Improvement Projects funded by the following revenue sources are exempt from the requirements of this Chapter: private development revenue, federal and state grants, Street Light Levy Fund and Local Improvement District revenue, Water Operating Fund, Water Construction Fund, Sewer Systems Construction Fund.

3. Improvement Projects which are developed privately and leased back to the City of Portland are not exempt from the requirements of this Chapter.

b. Total Costs means the Participating Bureau's contribution toward the price for completion of the Improvement Project. Total Costs does not include costs for: design and engineering, administration, fees and permits, building demolition, relocation of tenants, contingency funds, land acquisition, environmental testing or indirect costs, such as interest during construction, advertising and legal fees.

c. Public Art means original visual creations which are sited in a manner accessible to the public and/or public employees.

d. Public Art Trust Fund means the fund within the City of Portland Treasury into which all monetary contributions derived from Improvement Projects pursuant to this Chapter shall be deposited. Monetary contributions for Public Art originating from any other source shall also be deposited into the Public Art Trust Fund. The Public Art Trust Fund shall be divided into separate accounts if separate accounting is requested by the Participating Bureau.

e. Participating Bureau means a City of Portland Bureau or Commission that is subject to this Chapter by virtue of its sponsorship of an Improvement Project.

f. Selection Committee means the committee responsible for reviewing proposed Public Art, and, making recommendations to the Metropolitan Arts Commission on the selection of Public Art. The Selection Committee shall be composed of a representative of the Participating Bureau, the Improvement Project architect or engineer, artists, a citizen and a Metropolitan Arts Commissioner.

g. Deaccessioning means relinquishing title to a work of Public Art.

5.74.030. *Dedication.*

Any City of Portland official or employee acting on behalf of a participating Bureau who authorizes or appropriates expenditures for Improvement Projects of the Participating Bureau shall include in the capital improvement program of the City's capital budget a monetary contribution for Public Art equal to 1.33% of the Total Costs of the Improvement Project. If funding for a particular Improvement Project is subject to legal restrictions that preclude Public Art as an objective for expenditure, the portion of the Improvement Project that is funded with the restricted funds shall be exempt from the requirements of this Chapter.

5.74.040. *Public Art Trust Fund.*

There is created in the City of Portland Treasury a special fund called the Public Art Trust Fund into which monetary contributions for Public Art shall be deposited.

a. 1.33% of the Total Costs of Improvement Projects shall be dedicated to Public Art and shall be deposited into the Public Art Trust Fund by the City official or employee acting on behalf of the Participating Bureau.

1. 1% of the Total Costs of Improvement Projects shall be used by the Metropolitan Arts Commission for costs associated with Public Art including, but not limited to the acquisition, siting, maintenance and Deaccessioning of Public Art.

2. .33% of the Total Costs of Improvement Projects shall be used by the Metropolitan Arts Commission for costs associated with Public Art, including, but not limited to costs of selection, administration, community education and registration of Public Art.

b. Monetary contributions shall be deposited in separate accounts within the Public Art Trust Fund if separate accounting is requested by the Participating Bureau or required by law.

5.74.050 *Disbursements.*

Disbursements from the Public Art Trust Fund shall be made only after authorization by the Metropolitan Arts Commission.

a. Disbursements shall be made according to the terms of this Chapter and any guidelines adopted hereunder.

b. If an Improvement Project is funded by revenue sources whose expenditure is restricted by the City Charter or other law, the Metropolitan Arts Commission, prior to making a disbursement for Public Art from such a restricted account in the Public Art Trust Fund, shall adopt written findings demonstrating that the proposed disbursement complies with all applicable restrictions.

c. The Metropolitan Arts Commission will report annually to Participating Bureaus on the disbursement of money from the Public Art Trust Fund.

5.74.060 *Siting*.

Public Art selected pursuant to this Chapter may be sited in, on or about any Improvement Project or other property owned, leased, or rented by or to the City of Portland in accordance with any restrictions placed on siting by the Participating Bureau.

5.74.070 *Guidelines*.

The Metropolitan Arts Commission shall, after consulting with Participating Bureaus, adopt guidelines to:

a. Provide for annual meetings with Participating Bureaus;

b. Develop an annual plan for Public Art that takes into account the views of the Participating Bureau;

c. Provide a method for the appointment of representatives to Selection Committees;

d. Determine a method or methods of selecting and contracting with artists for the design, execution and siting of Public Art;

e. Determine the dedication and disbursement process for the Public Art Trust Fund;

f. Clarify the responsibilities for maintenance of Public Art, including any extraordinary operations or maintenance costs associated with Public Art, prior to selection;

g. Facilitate the preservation of art objects, ethnic and cultural arts and crafts, and artifacts;

h. Determine a process to Deaccession art;

i. Set forth any other matter appropriate to the administration of this Chapter.

5.74.080 *Ownership*.

All Public Art acquired pursuant to this Chapter shall be acquired in the name of the City of Portland, and title shall vest in the City of Portland.

5.74.090 *Decisions.*

Except as limited by other sections of this Chapter, the Metropolitan Arts Commission's decision as to the selection, acquisition, siting, maintenance, disbursement of the Public Art Trust Fund, Deaccessioning, administration, community education and registration of Public Art shall be final.

5.74.100 *Implementation.*

The Metropolitan Arts Commission, or its designee, shall implement the provisions of this Chapter.

THE COUNCIL FURTHER DIRECTS:

 b. The Metropolitan Arts Commission to work with representatives of the Bureaus of Water and Environmental Services to develop a procedure through which the Bureaus of Water and Environmental Services might become involved and participate in the 1.33% for Public Art Program.

SECTION 2.

The Council declares that an emergency exists because a delay in proceeding with the amendment may unnecessarily deprive the citizens of the City of Portland of the proposed public art; therefore, this ordinance shall be in force and effect from and after its passage by the Council.

Passed by the Council. Jan 4, 1989

ORDINANCE 811 *Multnomah County, Oregon*

Before the Board of County Commissioners for Multnomah County, Oregon

An ordinance amending MCC Chapters 5.50 (Transient Lodging Tax) and 11.90 (arts Commission) to substitute the Regional Arts and Culture Council for the Metropolitan Arts Commission as the recipient of certain funds and as administrator for the Percent for Art program.

MULTNOMAH COUNTY ORDAINS AS FOLLOWS:

Section 1. *Purpose.*

 1. Multnomah County decided in 1973 that a vital arts sector was a worthwhile investment and co-founded the Metropolitan Arts Commission (MAC) by Intergovernmental Agreement with the City of Portland to support the development of the arts and increase their availability to the public.

2. The Public Art Program was established in 1980. Ordinances are in place that provide for MAC management and collection of funds for the Percent for Public Art program for Multnomah County, the City of Portland, and Metro. MAC is responsible for selection, acquisition, siting, maintenance, administration, deaccessioning, community education, and registration of Public Art of the City/County public Art Collection.

3. Multnomah County was a primary sponsor, funder and participant of the citizen driven Arts Plan 2000+ and accepted its findings in February, 1992.

4. Multnomah County and the City of Portland recognized the increasingly regional scope of MAC duties and amended the Intergovernmental Agreement in 1993 to include Clackamas, Washington, and Clark counties allowing for regional representation and service delivery.

5. Multnomah County was an active participant in the Metro Regional Arts Funding Task Force, which recommended short and long term solutions to arts programs and facilities needs including the transition of MAC to a regional, nonprofit organization.

6. MAC has restructured into a nonprofit organization, The Regional Arts and Culture Council (RACC), in order to implement the Arts Plan 2000+ and Metro Regional Arts Funding Task Force recommendation to provide more cost effective, efficient and flexible services. This ordinance substitutes RACC for MAC as the manager of the Percent for Public Art programs.

7. Ordinance 790, adopted in June 1994, recognized the value of the Arts to the greater community and supported the allocation of $600,000 a year for 3 years to the Performing Arts Center and $100,000 a year for 3 years to the Metropolitan Arts Commission from the current hotel tax designated for the Oregon Convention Center, subject to certain conditions. This ordinance substitutes the Regional Arts and Culture Council for the Metropolitan Arts Commission as the recipient of the tax revenues dedicated to arts programs and program management.

Section 2. *Amendment.*

MCC 5.50 .050 (B) (5) is amended to read:

(5) After voters have approved issuance of general obligation bonds to finance or partially finance construction of the convention and trade show center or financing for construction has been obtained by some other means, funds deposited in the convention and trade show center special fund shall be used to assist Metro for the following purposes:

(a) First, to pay any expenses incurred or activities identified under MCC 5.50 .050 (B) (4);

(b) Second, if all expenses identified in subsection (a) above have been satisfied,

to pay any unfunded annual operating expenses that may have been incurred by the convention and trade show center;

(c) Third, if all expenses identified by subsection (a) above have been satisfied and if no otherwise unfunded annual operating expenses exist or if funds remain after the otherwise unfunded annual operating expenses have been paid, to provide for the promotion, solicitation, procurement, and service of convention business at the convention and trade show center to the extent necessary to fully implement the annual marketing program adopted by Metro;

(d) Fourth, if the needs identified in the foregoing subsections (a) through (c) have been fully satisfied, to pay ancillary costs associated with the development, construction and operation of the convention and trade show center, including but not limited to site acquisition and construction costs including financing of those costs;

(e) Notwithstanding the limitations on spending in subparagraphs (a) through (d), Metro may use an amount not to exceed $600,000 per year, for three years beginning with Metro's fiscal year 1994–1995, for operation of the Portland Center for the Performing Arts.

(f) Notwithstanding the limitations on spending in subparagraphs (a) through (e), Multnomah County may transfer an amount not to exceed $100,000 per year, for three years beginning with the fiscal year 1994–1995, as a special appropriation to the Regional Arts and Culture Council.

(g) The transfer of funds for operation of the Portland Center for the Performing Arts and for the Regional Arts and Culture Council pursuant to subparagraphs (f) and (g) shall not be made if, prior to June 1 of any year, the Metro Council declares that an emergency requires the funds to be used for the Oregon Convention Center. Any such declaration shall be in writing and shall be transmitted from Metro to the Chair of Multnomah County. The circumstances pertaining to the Oregon Convention Center warranting a declaration of an emergency shall include, but not be limited to:

(i) Current resources except beginning fund balance do not meet current expenditures less renewal and replacement fund transfer and unappropriated balance;

(ii) Revenues from the tax drop by more than 25% in any year when measured against the prior year;

(iii) A major structural failure at the center (not otherwise insured) such that total reserves are insufficient to repair the damage without the use of all or part of the 3–year $2,100,000 commitment.

(iv) Or any other situation that threatens the normal operation of the convention center.

Ilan Averbuch, *The Little Prince*, 1996. Rose Garden Arena Complex. *Photo courtesy of Regional Arts and Culture Council.*

Section 3. *Amendment.*

MCC 11. 90.030 is amended to read:

11. 90.030 *Funding.*

(A) One and thirty-three one-hundredths percent of the construction costs, capital improvement costs, budgets, development funds and purchase prices listed in MCC 11. 90.035 shall be set aside for the acquisition of art. The acquired art may be an integral part of the newly acquired building or property attached thereto or be capable of display in other public buildings or on other public property. Siting variances may be granted by the board.

(B) Thirty-three one-hundredths percent of the 1.33 percent in subsection (A) of this section shall be dedicated solely for use by the Regional Arts and Culture Council for the purpose of payment of administration, public education, or maintenance costs of the commission's Percent for Art program.

Section 4. *Amendment.*

Section 11. 90.035 is amended to read:

11. 90.035 *Funding Sources.*

The following shall be subject to the art acquisition policy referred to in MCC 11. 90.030:

(A) Construction cost of a major county construction project involving the construction or alteration of a county building;

(B) The capital improvement budget in the division facilities management for fiscal years beginning July 1, 1990;

(C) The purchase price of any building, including the appurtenant land, acquired on or after July 1, 1990 by the county for use in whole or part by the county.

Section 5. *Amendment.*

MCC 11. 90.040 is amended to read:

11. 90.040. Administration

The Regional Arts and Culture Council shall in its discretion administer the provisions of this chapter relating to art acquisition and display.

Section 6. *Amendment.*

MC 11. 90.050 is amended to read:

11 .90.050. *Adoption of guidelines.*

The Regional Arts and Culture Council shall have the authority:

(A) To determine the cases in which it would be inappropriate to display art in a county building;

(B) To identify suitable art objects for county buildings;

(C) To encourage the preservation of ethnic cultural arts and crafts, including Pacific Northwest Indian arts;

(D) To facilitate the preservation of art objects and artifacts that may be displaced by a construction project;

(E) To prescribe a method or methods of competitive selection of art objects for display;

(F) To prescribe procedures for the selection, acquisition and display of art in county buildings; and

(G) To set forth any other matter appropriate to the administration of this chapter.

Section 7. *Amendment.*

MCC 11. 90.060 is amended to read as follows:

11. 90.060. *Finality of commission's decision.*

The Council's decision as to the selection, acquisition, allocation and display of art objects shall be final.

Section 8. *Emergency Clause.*

This Ordinance, being necessary for the health, safety, and welfare of the people of Multnomah County, an emergency is declared, and the Ordinance shall take effect upon its execution by the County Chair, pursuant to Section 5.50 of the Charter of Multnomah County.

Adopted this 26th day of January, 1995, being the date of its First reading before the Board of County Commissioners of Multnomah County, Oregon.

FACT SHEET *Regional Arts & Culture Council*

How Financed

Projects for the City of Portland and Multnomah County are financed through a 1.33 percent for art program. All public art funds are deposited in and expended from the Public Art Trust Fund, which is managed exclusively by the Regional Arts & Culture Council (RACC).

• 1 percent of the total construction costs of major capital improvement projects goes to public art

- .33 percent of the total construction costs goes to administration and to the Public Art Trust Fund
 - .05 percent goes to maintenance
 - .95 percent goes to acquisition of public art

RACC also contracts with private and public agencies and consults nationally on public art programs. All proceeds from these contracts are deposited in the trust fund for public art uses.

The City of Portland also has a Floor Area Ration Bonus Program through which private developers may opt for a public art bonus in exchange for greater zoning density. They must deposit at least 25 percent of the public art budget into RACC's Public Art Trust Fund. The balance may be used to commission or purchase work that is approved by RACC and is accessible to the public, or the developer may contribute the entire bonus to RACC.

Legal Mechanism

The City of Portland and Multnomah County have public art ordinances, and RACC has intergovernmental agreements with the city, three counties, and Metro. The purpose of the public art program is to integrate a wide range of public art into the community and to reflect the diversity of people, artistic disciplines, and points of view.

Guidelines

RACC is responsible for all aspects of and final decisions about the public art program, without input from or approval from the City Council or the County Commission. RACC public art staff and the finance directors discuss upcoming improvement projects annually with each city or county bureau that contacts RACC when capital improvement projects are funded. RACC's public art staff then meets with a bureau representative and a project architect, who introduce the project to the Public Art Advisory Committee (PAAC). The PAAC reviews the project's public art budget, design, and construction schedule; suggests artists for the selection panel; and may suggest selection process options and general direction. The PAAC reviews the work of all selection panels and approves semifinalists. The panels report back to the PAAC when they have selected finalists.

Governance

The PAAC, the standing committee charged by RACC to oversee the public art program, meets once a month. The PAAC develops policies and goals for the selection, placement, and maintenance of works of art acquired through the percent-for-art program and other public/private programs. Membership includes no more than two

RACC board members, the RACC designee on the Design Commission, and six to eight arts professionals. Final appointments are approved by the RACC chair. Members are appointed to serve three-year terms, with one eighteen-month appointment reserved for an artist with public art experience.

Administration. The amount of 1.33 percent is applied to the participating bureau's capital construction costs for major improvement projects, excluding design and engineering, fees and permits, demolition, tenant relocation, contingency funds, land acquisition, and environmental testing as well as such indirect costs as interest during construction and advertising or legal fees. The amount of .33 percent goes to program administration, community education, and registration of public art.

Artist Selection Process

Selection methods are decided by the Selection Committee, with advice and approval from the PAAC. The selection committee continues to review public art projects throughout their development. Evaluation criteria include artistic quality, context, media, permanence, public safety, diversity, feasibility, and duplication.

FACT SHEET *Los Angeles Community Redevelopment Agency*

The public art policy of the Los Angeles Community Redevelopment Agency (CRA, or the Agency) mandates three different types of public art projects:

 1. Developer-initiated projects: public art or cultural facilities within private developments

 2. Cultural Trust Fund projects: public art projects funded through private developers' contributions

 3. CRA-initiated projects: public art projects incorporated into public projects managed by the Agency

How Financed

Developer-Initiated Projects. Development projects with CRA participation must obligate at least 1 percent of development cost to developing a project art plan. Very low, low, and moderate-income housing units, projects with development costs below $250,000, and historic rehabilitation projects that conform to the Secretary of the Interior's Standards are exempt. Up to 60 percent of the art obligation may be spent

for a public art component on the development site. Up to 100 percent may be allocated for a cultural facility.

Cultural Trust Fund Projects. At least 40 percent of the developer obligation must go into the corresponding redevelopment project area Cultural Trust Fund. The developer may also contribute the full obligation (100 percent of the 1 percent) to the corresponding redevelopment project area Cultural Trust Fund.

CRA-Initiated Projects. Public funds (tax increment, transportation grants, community development block grants, bond funds, and other public financing) are accessed. Grant applications include a line item for public art.

Legal Mechanism

This public art program is an integral part of the Agency's mission to eliminate blight and revitalize the city through redevelopment in designated residential, industrial, and commercial areas of Los Angeles. The Public Art Policy requirements apply to all redevelopment areas overseen by the Agency and are implemented through legal agreements with developers.

Guidelines

Developer-Initiated Projects. Responsibilities of the developer:

 • Implement an artist selection process that includes a diversity of artists as well as artists from the Los Angeles region, and seek Agency approval of the artist selection process and artists' qualifications

 • Identify an artist, concurrently with other design professionals, to be a member of the design team and contribute to the project's design development and to development of a project art plan concept; identify the artist prior to approval of concept design

 • At the concept design, design development, and final design stages, submit project art plans that are integral to and that coincide with submission of architectural and landscape designs; or, as an alternative, propose development of a cultural facility, either on site or off (including or in lieu of artist participation in the project), if a need for the facility is demonstrated and a cultural facility plan is accepted

Cultural Trust Fund Projects. These projects are developed and evaluated on the following criteria and dimensions:

 • The nature of the proposed project, its contribution to the community, and the issues it addresses

 • The project site, its contemporary and/or historical significance, and its proposed use and purpose

Michael Tansey, *Daffodil Metamorphosis*. The transformation of a Los Angeles civil defense siren into a work of art was funded through the Redevelopment Agency's Cultural Trust Fund. *Photo courtesy of Community Redevelopment Agency of the City of Los Angeles.*

Kunio Ohashi with Tierra, Sol y Mar. Ivar Theater marquee. *Photo courtesy of Community Redevelopment Agency of the City of Los Angeles.*

• A detailed budget of income and expenses

• The relationship of the proposed project to the goals of the public art program

• The artists and other design participants involved in the project, their professional and other experience relative to the proposed project, and the extent of collaboration among those employing different art forms

• The amount and type of community/neighborhood participation in the project definition

• A schedule for the project's completion, with major milestones

Cultural Trust Fund Projects are sometimes managed by arts organizations based in the corresponding redevelopment project area.

Agency-Initiated Projects. Responsibilities of the Agency:

• Whenever possible, select artists through a jury process, using open, invitational, or direct selection methods

• Form juries consisting of one or two community representatives and two or more visual artists or arts professionals

• Address the care and maintenance of artworks through maintenance plans that clarify ownership and maintenance responsibilities

Governance

The Agency is governed by a board of seven commissioners appointed by the mayor and confirmed by the City Council. An administrator is appointed by the board and directs the agency staff. Redevelopment areas with ongoing public art activity have public art advisory panels and public art and culture plans.

Administration

The public art program staff is funded through unrestricted Agency funds. Program staff members monitor and approve developer-initiated projects and manage most Agency-initiated and Cultural Trust Fund projects. Private art consultants often manage developer-initiated projects. Up to 10 percent of the art budget can be used for consultants and other administrative costs.

Artist Selection Process

Whenever possible, artists are selected through a jury process. Three selection processes are generally available to a jury: open competition, invitational competition, and direct selection. It is assumed that most if not all jury members will be from the region. Occasionally jurors from outside the region, with a national perspective on public art, should be included. For all projects, including developer-initiated projects managed by private art consultants, the Agency has adopted a variety of policies to ensure cultural and gender diversity and opportunities for emerging artists.

ORDINANCE 2552 *City of Kent, Washington*

An ordinance of the City of Kent, Washington, relating to public art; establishing a City Art Program, directing establishment of guidelines and procedures for administration of the City Art Program; establishing a City Art Fund; adding a new Chapter 2.35 Kent City Code in conjunction therewith; amending Chapter 2.34 KCC concerning the City of Kent Chapter 2.34 KCC concerning the City of Kent Arts Commission (Sections 1–6, Ordinance 1944); repealing KCC 3.14.368, the Arts Commission Fund (Section 7, Ordinance 1944).

WHEREAS, the aesthetic nature and charm of the City of Kent shall be enhanced, and the citizens of the City of Kent shall hold and enjoy works of art for the public environment and welfare; and

WHEREAS, the City intends to expand the opportunity for Kent residents to experience art in public places and to create a more visually pleasing and humane environment; and

WHEREAS, it is appropriate to establish a means whereby the City of Kent Arts Commission shall maintain an orderly acquisition of art by the City of Kent; and

WHEREAS, there shall be a City Art Program which shall consist of Guidelines, Procedures and an Art Plan; NOW THEREFORE,

THE CITY COUNCIL OF THE CITY OF KENT, WASHINGTON DOES HEREBY ORDAIN AS FOLLOWS:

Section 1.

A new Chapter 2.35 is added to the Kent City Code, as follows:

CITY ART PROGRAM

2.35.010. *Art Fund Created.*

There is hereby established a City Art Fund. Monies for the Fund shall be received from:

A. Annual Budget. Two (2) dollars per budget year for each City resident, based upon population data certified by the State of Washington Office of Financial Management. Budgeted but unspent funds shall be maintained in the Art Fund, and carried forward at the end of each budget year.

B. Gifts, Donations and Grants. Private or public gifts, endowments, donations, bequests or other grants.

C. Other. Such other sources as may be available.

D. Interest from the City Art Fund.

2.35.020. *Fund Use—Art Program—Collection.*

A. Inclusions—The City Art Fund may be used for all costs for works of art, administrative costs of the City Art Program, and all costs of installation and maintenance.

B. The City of Kent Arts Commission and Staff shall recommend the amount to be made available for the purchase of art, in consultation with City staff. The designation of projects and sites, selection, contracting, purchase, commissioning, review of design, execution and placement, acceptance, maintenance, sale, exchange, or disposition of work of art shall be recommended by the Kent Arts Commission and Staff, for approval by the City Council, in accordance with the City Art Program Guidelines.

C. All works of art purchased and commissioned under the City Art Program shall

become a part of a City Art Collection. The City Art Collection shall be developed, administered and operated by the Kent Arts Commission with cooperation and support of the Kent Parks Department Staff.

D. The works of art may be placed on public lands, integrated with or attached to a public building or structure, detached within or outside a public building or structure, or part of a portable collection or exhibit.

E. Nothing in this Chapter shall limit the amount of money the City of Kent may expend for art.

2.35.030. *General Procedures.*

A. Upon consultation with the City of Kent Arts Commission, Guidelines and Procedures shall be prepared by Staff for the implementation of the Arts Program. Such Guidelines and Procedures shall be reviewed by the City of Kent Arts Commission and Staff annually, and recommendations shall be made to the City Council for approval.

B. A City Art Plan including a schedule and budget for all City Art Program projects shall be prepared and updated annually by the City of Kent Arts Commission and Staff. The City Art Plan shall be reviewed and approved annually by the City Council.

Section 2.

Chapter 2.34 KCC (Ordinance 1944, Sections 1–7) is amended as follows:

KENT ARTS COMMISSION

2.34.010. *Arts Commission Created.*

There is hereby created ((an arts commission to be known as)) the Kent Arts Commission.

2.34.020. *Purpose.*

The City of Kent Arts Commission and Staff may, alone or in cooperation with any other private, civic or public body of any City, county or the State of Washington, initiate, sponsor or conduct programs calculated to further public awareness of and interest in the visual and performing arts.

2.34.030. *Membership—Term.*

The membership of the City of Kent Arts Commission shall be twelve members to be appointed by the Mayor with the approval of the City Council. Of the first twelve members appointed, six shall be appointed for two years and six shall be appointed for four years, with the respective terms of each initial appointee to be determined by lot. Subsequent appointments shall be for a period of four years or for the unexpired bal-

Carolyn Law, *A Community Portrait of the Green River*, 1995–1996. Stone and cast concrete, featuring images based on pinhole-camera photographs and cyanotypes by people from the community. The boat and a shaped granite boulder serve as a bench and a platform for viewing the river. *Photo by Carolyn Law.*

ance of the term for which appointed, whichever is the lesser period. In addition to the twelve appointed members, one member of the City Council shall be designated by the president of the Council to serve as an ex officio member of the City of Kent Arts Commission for a term of one year.

2.34.040. *Officers—Monthly Meetings.*

The City of Kent Arts Commission shall elect its officers, including a chairman, vice chairman, and such officers as it may deem necessary. Such persons shall occupy their respective offices to a period of one year. The City of Kent Arts Commission shall hold regular public meetings at least monthly.

2.34.050. *Rules—Public Record.*

The City of Kent Arts Commission shall adopt rules for transaction of business and shall keep written minutes of its proceedings which minutes shall be a public record.

2.34.060. *Budget.*

The City of Kent Arts Commission and Staff shall each year submit to the City Administrator and City Council for approval a proposed budget for the following year in the manner provided by law for preparation and submission of budgets by appointive officials.

Section 3.

KCC 3.14.368 (Ordinance 1944, Section 7) is hereby repealed.

Section 4. 1986 Budget—Funding.

The funding provided for in KCC 2.35.010A. shall first take effect and be in force for the 1986 City of Kent Budget.

Section 5. Effective Date.

This ordinance shall take effect and be in force five (5) days from and after its passage, approval and publication as provided by law.

FACT SHEET *City of Kent, Washington*

How Financed

 • Annual budget: permanent setaside of $2 per resident per year for acquisition of public art and management of the collection
 • Interest earned from the City Art Fund
 • Gifts, donations, grants, and other revenue

Legal Mechanism

Ordinance 2552, which has the following purposes:

 • To enhance the aesthetic nature and charm of the City of Kent for its citizens
 • To expand opportunities for citizens to experience art
 • To maintain orderly acquisition of art

• To establish the City Art Program, consisting of guidelines, procedures, and an art plan

• To establish procedures for allocation, project and artwork selection, and expenditure of funds from the City Art Fund

Guidelines

• The City Art Plan, prepared annually by staff, is reviewed and approved by the Arts Commission, which also approves expenditures from the City Art Fund.

• Each project in the City Art Program will be developed to respond to a specific site or building location, with the exception of artworks purchased to circulate among various sites or facilities. Each project will be evaluated by the Arts Commission, staff, and advisory panel within the context of the City of Kent and Arts Commission goals and objectives, and each will be written into the City Art Plan. The Arts Commission will identify priority projects and/or general locations for public artwork. The Arts Commission will seek to ensure that, over time, City Arts Program projects are spread among a wide number of types of sites and locations in Kent. Commissions will be awarded to a wide variety of nationally and regionally recognized artists and will reflect an overall diversity of scale, aesthetic vocabulary, community values, and forms of expression.

Governance

• With the approval of the City Council, twelve members are to be appointed to the Arts Commission by the mayor, of whom six will serve for two years and six for four years.

• Subsequent appointments will be for four years, or for the unexpired balance of an appointed term, whichever is the lesser.

• The chairman and the vice chairman will serve one-year appointments.

• The Arts Commission will hold public meetings at least monthly.

Administration

Costs are covered by the City Art Fund.

Artist Selection Process

• Eligibility requirements will be recommended for each project by the Arts Commission.

• Artists will be selected on the basis of their qualifications, as demonstrated by past works of art; professional references regarding past public art projects; appropriateness of their proposals to particular projects; and proposals' probability of successful completion, as determined by the selection jury.

• Specifically excluded are student works of art done under the supervision of art teachers or done to satisfy course requirements; work done by an artist who is a project architect, landscape architect, engineer, or other member of the project team; work done by an artist who is an employee of a firm involved in the project; and work done by an artist who is a member of the Arts Commission.

COUNCIL POLICY *City of San Diego*

Artist(s) Involvement in Selected Capital Improvement Projects
Policy Number 900–11
Effective Date 3/30/92

Background

The City of San Diego Commission for Arts and Culture is the primary advocate for arts and culture for the City. In fulfilling its mission, it recommends policies and programs to strengthen the involvement and input of artists and other professionals in cultural planning and community development, reflects the cultural diversity of the people it serves and fosters local, national and international cultural understanding.

The San Diego Commission for Arts and Culture received funds from the National Endowment for the Arts (Resolution Number R-275373, adopted on March 26, 1990) and the California Arts Council (Resolution Number R-272959, adopted on February 27, 1989) to develop the Public Art Master Plan (PAMP). A city-wide pilot program was established to involve communities and artists in the development and creation of site specific artwork. PAMP was established to better serve the residents of San Diego by providing an opportunity for community identity and a source of pride, to enhance the existing environment of San Diego's neighborhoods, and to provide an opportunity for artistic expression and cultural diversity (see San Diego Municipal Code 26.0701 and Purpose and Intent and 26.0707 Procedures, sections 7C and E).

To further enhance the goals of the Public Art Master Plan and to implement the duties of the Commission for Arts and Culture (see San Diego Municipal Code 26.0703), San Diego Municipal Code has been amended (SDMC 26.701 et seq. by ordinance 0–17757 adopted on April 20, 1992). In addition, the Council policy set forth below parallels the standard established by other municipal and state public art ordinances which mandate inclusion of artist(s) in the design process and/or the commissioning of site-specific artwork.

Purpose

The purposes are to establish a policy of the City Council to involve artist(s) in selected City Capital Improvement projects and to provide guidance to City staff and design consultants to implement this policy. This policy has been designed to address a commitment to excellence in the design of San Diego's built environment in the most efficient and cost effective way, with minimal impact on existing procedures, practices, and CIP budgets.

Implementation

It is the intent of this proposed policy to utilize existing procedures within each sponsoring City department to involve artist(s) in Capital Improvement Projects. Further, this proposed policy will be implemented and monitored without adding significant time or expense to the selection and contract procedures.

1. Arts and Culture Program staff shall annually consult with Directors or Deputy Directors of Engineering and Development, Park and Recreation, Waste Management, and Clean Water Program and any other department that has Capital Improvement Projects to identify potential capital improvement projects to include artist(s) in the design process, to commission artist(s) to create site-specific artwork, or to purchase existing artwork. Underground Utilities shall be exempted from this policy.

2. In accordance with the Managers administrative regulation governing Capital Improvements Programming, the department in whose program budget the project will appear shall involve artist(s) in the Capital Improvement Project Proposal in those selected Capital Improvement Projects identified through procedures established in Paragraph 1.

3. For Capital Improvement Projects that are selected, requests for proposals and requests for qualifications shall include a requirement for public art in language to be stated similar to: "The Vendor shall include a public art component in the project as an integral aspect of the overall site or building design."

4. Any committee formed to select consultants shall include one or more representatives who have expertise in the selection and siting of public art appointed by the City Manager.

5. In accordance with applicable administrative regulations governing selection of consultants, the Commission for Arts and Culture shall develop a consultant artist list to be made available to appropriate vendors responding to requests for proposals and requests for qualifications.

6. Before the contract is executed, the Manager shall ensure that the consultant proposed for selection complies with the Public Art Requirement set forth in this policy.

7. Arts and Culture Program staff shall monitor for compliance this Council Policy.

San Diego recently adopted a 2 percent for art program (see "Fact Sheet: Selected Public Art Plans," elsewhere in this book). This fact sheet describes San Diego's negotiated funding program as a unique nontraditional model.

How Financed

• Public art projects are financed as a negotiated part of the construction budget for new capital improvement projects.

• There is an annual Transient Occupancy Tax (TOT) allocation determined for special public art projects that are not part of the city's capital improvement program. These include projects eligible for a community-initiated matching-grant program called Public Art Sites.

Legal Mechanism

• City Council Policy 900–11 mandates inclusion of artist(s) in the design process and/or the commissioning of site-specific artwork.

• The purposes are to establish a policy of the City Council for involving artists in selected city capital improvement projects and to provide guidance to city staff and design consultants in implementing this policy. The policy is intended to address a commitment to excellence in the design of San Diego's built environment, in the most efficient and cost-effective way and with minimal impact on existing procedures, practices, and capital improvement budgets.

Guidelines

• For art integrated into capital improvement projects, the consultant interview panel includes representation from the San Diego Commission for Arts and Culture (the Commission).

• The artist is an equal member of the design team, including landscape, seating, fencing, and architectural details.

• The fee structure and scope of work for the artist shall be commensurate with that for other design team consultants.

• In consultation with the design team, the artist may also identify exterior and interior opportunities for site-specific artwork for the facility.

• Any artwork and design contributions identified by the design team for the facility may be incorporated into the construction bid documents as part of the responsibility of the construction contractor.

• Individual artworks may also be contracted directly between the city and the artist.

Robert Millar, bridge to viewing pavilion, Alvarado Water Treatment Plant. Questions branded into the bridge's wooden planks ask about water and its uses. *Photo © 1998 by P. S. Ritterman. Courtesy of City of San Diego Commission for Arts and Culture.*

Governance

The San Diego Commission for Arts and Culture is a fifteen-member commission appointed by the mayor and approved by the City Council. The Commission makes recommendations to the city manager, the mayor, and the City Council. The Commission is not responsible for approving public artists or artwork for capital improvement projects. However, it does have approval authority for public art projects funded through the TOT.

Administration

• The San Diego Commission for Arts and Culture includes the public art manager's salary in its base budget, paid for through the TOT.

• When there is a public art project, the public art staff's management and agency overhead is paid directly from the capital improvement project's setaside for city staff support. Public art staff time is billed directly to that department's capital improvement project.

• Art funds remain in the other department's project budget rather than coming into the Commission's budget. Contracts are usually between the artist and the prime consultant (for example, an architect or a landscape architect), even though artist selection takes place through a process that involves the Commission. Sometimes the prime consultant selects the artist.

Artist Selection Process

• Arts and cultural program staff shall annually consult with directors or deputy directors of the Departments of Engineering and Development, Parks and Recreation, and Waste Management, with the Clean Water Program, and with any other department that has capital improvement projects. The purposes of this consultation will be to identify potential capital improvement projects that can include artists in the design process, to commission artists to create site-specific artwork, and/or to purchase existing artwork.

• In selecting an artist for most capital improvement projects, a panel-based nominating process will be used. A project-specific panel is convened by the Commission at the request of the interested department. This panel, which consists entirely of arts professionals, nominates and selects finalists for the specific project. The finalists are then interviewed and selected by a panel that includes design team members, a project manager, a community representative, and at least two arts professionals. The selected artist then negotiates a contract as subconsultant to the prime consultant.

• The Commission maintains a regional directory of artists, which is made available to design consultants. A consultant has the option of selecting an artist from this directory, or the consultant can select an artist by other means and include the artist on his or her team in responding to a request for qualifications.

Private Funding Models

Private Support for Public Art

Three Model Organizations

PENNY BALKIN BACH

Public art programs sustained with private support enjoy a particular autonomy that tends to permit and encourage experimentation and innovation. The material that follows presents an overview of three private, not-for-profit public art programs, including a description of each program and its commissioning process and governance along with profiles of specific projects.

All three organizations—Creative Time, in New York; the Fairmount Park Art Association, in Philadelphia; and the Public Art Fund, also in New York—consider the public realm as a laboratory for artistic experimentation. They offer varied opportunities for creative research, permanent works, temporary installations, performance-based projects, and special events. In addition to funding, they provide technical expertise and a support structure for artists to realize their creative goals. The results have ranged widely, from projects that provoke and challenge prevailing thought and technology to works that retreat from the everyday and provide for contemplation or reverie.

ARTISTIC LEADERSHIP

Each of these public art programs has strong curatorial leadership supported by an influential board of trustees composed of individuals in cultural and leadership positions, whose varied resources can be extremely beneficial. Artists are selected through invitation or competition by experienced arts professionals, who are generally from within the organization. This approach in turn builds a curatorial vision with a sense of innovation and programmatic continuity. Each of the organizations is committed to working with emerging and established artists and includes artists with local, national, and international connections. Each also has a membership base or a specific group of supporters, with members and supporters forming the basis of an expanded audience and advocacy group for public art practice.

FUNDING STRATEGIES

Because none of these organizations has a single dedicated funding stream, each constantly seeks financial support from diverse sources. As a result, they all garner a broad base of support in the wider community. Funding sources typically include various agencies of local, state, and federal government; foundations; corporations; and indi-

viduals. For example, the Public Art Fund has received support from Target Corporation, Bloomberg, and Con Edison. Panasonic has sponsored Creative Time's Astrovision project, and Häagen-Dazs has supported a major Creative Time event in Central Park. The Fairmount Park Art Association, chartered in 1972 as the first private nonprofit organization in the United States dedicated to public art and urban planning, is somewhat unusual in having an endowment that provides for basic operations. The Art Association also seeks funding for commissions and special projects, and it enhances its opportunities for financial support through timely coordination with a variety of private and government-sponsored capital improvements in Philadelphia.

COLLABORATION

A defining characteristic of private support for public art is a broad latitude that allows for work in all sorts of spaces and places. Therefore, the three groups discussed here typically do not work with mandated or dedicated sites, as percent-for-art programs generally do. Instead they develop partnerships and seek collaborators as part of a strategy for significant public engagement. For example, the Fairmount Park Art Association works closely with local agencies, such as Philadelphia's Fairmount Park Commission, the Department of Streets, and the Penn's Landing Corporation, as well as with community organizations throughout Philadelphia. Its recent collaboration with the Greater Philadelphia Tourism and Marketing Corporation builds on the idea that public art is a defining aspect of Philadelphia's environment and contributes to the city's attractiveness as a tourist destination. The Public Art Fund has successfully collaborated with major New York City museums and cultural organizations, among them the Whitney Museum of American Art in connection with its Biennial in Central Park, the Museum of Modern Art, the Museum of Jewish Heritage—A Living Memorial to the Holocaust, and the Brooklyn Academy of Music. Creative Time has worked with the Central Park Conservancy and the Battery Park City Authority, among other organizations, and its artists' projects have been coordinated with exhibitions at the Asia Society and Museum and the Whitney Museum of American Art.

ART IN THE PUBLIC REALM

Creative Time has a reputation for commissioning and presenting exciting art—everything from milk cartons to billboards to skywriting to fireworks—to enhance the public realm, from the Brooklyn Bridge Anchorage to Grand Central Terminal and Times Square to Greater New York City. Lower Manhattan was the site of some of the organization's earliest projects at the U.S. Custom House and the Battery Park Landfill (*Art on the Beach*). More recently, at the site of the destroyed World Trade Center, Creative Time sponsored *Tribute in Light,* the temporary memorial to the victims of the attacks of September 11, 2001. Creative Time also presents site-specific, temporary, and multidisciplinary artworks on the plaza of the Ritz-Carlton New York and video art in Times Square, one of the richest centers of media culture in the world.

The Public Art Fund has sponsored a series of dazzling and innovative projects in New York City's Rockefeller Center in addition to experimental projects throughout the diverse neighborhoods of New York.

Since its inception more than a century ago, the Fairmount Park Art Association has explored the synergistic association of art and urban planning. A program initiated in 1996, named New*Land*Marks: Public Art, Community, and the Meaning of Place, continues this tradition by bringing artists and community organizations together to plan and create new permanent works of public art for Philadelphia. These efforts celebrate community identity, commemorate "untold" histories, respond to the local environment, and offer visionary yet reasonable ways to invigorate public space. Because of its significant history of commissioning masterworks of American sculpture, it is only logical that the organization has become involved with sculpture conservation and, more recently, with the dramatic lighting of outdoor sculpture along Philadelphia's major thoroughfares.

ARTIST-DRIVEN CONCEPTS

Individual projects, because they generally are not connected to new construction, are usually based on artist-driven concepts and responses to contemporary civic life. The Public Art Fund has consistently encouraged artists to think boldly, and the resulting tour de force projects have included huge digital inkjet installations, work featuring thousands of multihued flowering plants, and an authentic transmission tower with lasers and neon lights. Creative Time has invited multidisciplinary projects encompassing sound works, digital and Web-based art, video pieces, performance-based work, skywriting, and, yes, sculpture. For visual artists seeking new solutions to technical problems, the Fairmount Park Art Association has provided access to building and landscape architects, engineers, conservators, lighting designers, and other design professionals. All three organizations have been forceful advocates in support of opportunities for artists to expand their vision and contribute to our cultural milieu.

EDUCATION AND ADVOCACY

Creative Time, the Fairmount Park Art Association, and the Public Art Fund are more than commissioning agencies. They all emphasize public engagement and education by means of publications, exhibitions, workshops, lectures, and events—all designed to make contemporary art accessible and to promote public interest in public art.

The Public Art Fund, for example, offers Tuesday Night Talks—an ongoing series of presentations and discussions with artists, critics, and curators—as well as a publication program and *InProcess,* a newsletter that provides an overview of the organization's activities.

The Fairmount Park Art Association works to make public art accessible through educational and interpretative programs, including tours, publications, conferences, workshops, and lectures. The organization has held two major exhibitions of public

art proposals at the Pennsylvania Academy of the Fine Arts, and through its New*Land*Marks program a unique series of community exhibitions has traveled to participating neighborhoods, offering the opportunity to preview proposals for public art in the community contexts from which the work had emerged. For its publications, the Art Association has also engaged scholars to consider public art from many perspectives, among them an anthropological viewpoint and the public art discipline's social, political, and communal imperatives.

CELEBRATION

Everyone likes a good party, whether in Central Park, Fairmount Park, or a small neighborhood elsewhere in Philadelphia or in Brooklyn. By attending festive events, openings, and dedications, the public comes to participate in the history of the city's public art. Private nonprofit organizations in particular recognize this benefit. Creative Time, the Fairmount Park Art Association, and the Public Art Fund have different origins and mandates, but they share an enduring commitment both to civic celebration and to meaningful creative inquiry and engagement.

FACT SHEET *Creative Time*

Description

Creative Time, a New York–based nonprofit organization, has commissioned and presented adventurous public art projects in all disciplines for thirty years. Creative Time terms itself an "arts presenter" whose main goal is to foster artistic experimentation in the public realm. The organization commissions and presents art that challenges notions of what art is and can be. The work is site-responsive and temporary, and artists are encouraged to try something new.

Process Overview

Creative Time considers the public in its realizations, and it works with a diversity of sites, supporting artists in their approach to the public realm as a laboratory for experimentation. Two of the more specific programs that Creative Time offers are Art on the Plaza and The 59th Minute: Video Art on the Times Square Astrovision.

Art on the Plaza. Working with The Ritz-Carlton New York, in cooperation with the Battery Park City Authority, Creative Time presents Art on the Plaza, a long-term program of site-specific, temporary, multidisciplinary artworks displayed on the plaza of The Ritz-Carlton New York, Battery Park. Lower Manhattan was one of Creative Time's first venues, and Art on the Plaza builds on Creative Time's thirty-year history

of enriching New York's public spaces with adventurous public artworks in all disciplines by innovative artists. Art on the Plaza also complements the Battery Park City Authority's renowned commitment to commissioning permanent public sculpture by internationally acclaimed artists.

The 59th Minute. Creative Time partners with Panasonic to sponsor videos airing the last minute of every hour throughout the Astrovision programming day, from 6 A.M. to 1 A.M. The Astrovision screen is three stories high and four stories wide. It contains a million and a half light-emitting diodes (LEDs) and is capable of displaying more than a billion shades of color. The goal of The 59th Minute is to offer a new opportunity to present artists' work and bring innovative art to Times Square. The program explores a contemporary reality: that our culture is stimulated by the spectacle of moving images. This rare opportunity gives artists a chance to show inventive video art to the public in one of the most exciting centers of media culture in the world.

Governance

Creative Time has staff in the areas of project development, administration, and communications. There are curatorial, financial, and coordination staff as well, in addition to a board of directors.

Artist Selection Process

The organization's selection process looks for exciting art in all mediums—sound works, digital and Web-based art, video pieces, performance, and sculpture. Creative Time wants to foster art that challenges everyone.

PROJECT PROFILE *Art on the Plaza*

Breath, by Shirazeh Houshiary and Pip Horne

Shirazeh Houshiary and Pip Horne's *Breath* imbues the cool formality of minimalist sculpture with spirituality and human presence. The twenty-foot-tall tower of white enameled brick is shaped like a double helix and conceals a sound system that emits a low sequence of four spiritual vocal tracks from dawn until dusk each day. Anchored by a humming bass, the continuous eighteen-minute loop of interwoven invocations includes the Azan, the Islamic call to prayer; a Jewish tribute to the invisible god; tonal breathing exercises of Buddhist monks; and "O Jerusalem," a historical Christian

Shirazeh Houshiary and Pip Horne, *Breath*. The twenty-foot-tall tower of white enameled brick, shaped like a double helix and concealing a sound system, emits a low sequence of four spiritual vocal tracks. *Photo courtesy of Creative Time, Inc.*

work by the twelfth-century composer Hildegard von Bingen. The sound, seeming to expand and contract in intensity, conveys a sense of inhalation and exhalation. *Breath's* slow spiral further underscores the sense of perpetual motion, defying the potential stasis of sculpture. Finally, the column recalls downtown skyscrapers, twisted baroque pillars, Islamic decorative tile, and, with its multitude of voices, the Tower of Babel.

Houshiary and Horne use the collective melodic range and diverse languages in the songs of prayer, to gesture toward basic similarities in humanity. Prayers spanning far-flung cultures, geographies, and ideologies are placed in close proximity within the looped religious track. With *Breath,* Houshiary and Horne use the form of the physical code for life and a rhythmic, meditative sound component to unite diverse religious traditions—a pointed statement in a time of misguided religious zeal and fractured globalism.

About the Artists

Shirazeh Houshiary was born in Iran in 1955. She moved to London in the early 1970s and graduated from the Chelsea School of Art in 1979, emerging with a group of artists that included Anish Kapoor and Richard Deacon. In Europe she is well known for her sculptures, which seek to investigate spiritual principles and abstract forms. Her labor-intensive paintings unite the word and the canvas into a meditative visual experience. Houshiary has had solo exhibitions at the Musée Rath in Geneva; the Museum of Modern Art, Oxford; the Camden Arts Centre, London; the University of Massachusetts, Amherst; the Museum Villa Stuck, Munich; and the Bonnefanten Museum, Maastricht, among other venues. In 1994 she was nominated for the Turner Prize. Houshiary is married to the architect Pip Horne, her collaborator. She currently lives and works in London and is represented by Lehmann Maupin, New York.

Project History

This installation opened in May 2004 and was scheduled to run through January 2005.

PROJECT PROFILE *The 59th Minute*

Shadow Procession, by William Kentridge

William Kentridge's video project *Shadow Procession* depicts a procession of black puppetlike figures made of cardboard cutouts. They move from left to right— crippled,

William Kentridge, *The 59th Minute*, 2001. *Photo courtesy of Creative Time, Inc.*

hunched, hauling their belongings. Donkeys, carts, sacks, chairs, even entire towns are carried on their backs, as though the puppets are engaged in a mass departure. This work by Kentridge was influenced by the brutality of apartheid and its effect on his native land. The burdened, anonymous figures on their collective journey resemble the figures in a classical frieze. Against the cacophony of Times Square, this simple video project humbled viewers with its rendering of the displacement of a people, effectively conveying the difficulty of living in the midst of long-drawn-out violence.

About the Artist

William Kentridge is an artist from Johannesburg, South Africa. He is known for his handcrafted animated films, theatrical productions, and drawings. His films, projected from laser disks, originate from the medium of drawings made with charcoal, and they form the basis of his films. He adjusts his drawings by adding new marks or erasing old ones. This technique ensures that the drawings retain traces of every mark made on the "scene."

Project History

From May 21 through September 10, 2001, *Shadow Procession* was shown as part of Creative Time's program titled The 59th Minute. It had a summer retrospective showing during the same period at the New Museum.

FACT SHEET *Fairmount Park Art Association*

Description

The Fairmount Park Art Association (FPAA) was the nation's first private, nonprofit organization dedicated to integrating urban planning and public art. FPAA focuses on three areas: commissioning, interpreting, and preserving public art in Philadelphia. The organization also promotes the appreciation of public art through programs and advocacy efforts.

Founded in 1872 by a group of concerned citizens who believed that art could play a beneficial role in a growing city, the organization initially focused on enhancing Philadelphia's Fairmount Park with sculpture, but its concerns soon expanded beyond the park to the city as a whole. FPAA also advocated the adoption of the city's Art Jury (an approval agency that was the predecessor of the current Art Commission) and the

adoption, in 1959, of the country's first percent-for-art ordinance, under which a percentage of construction costs for city projects must be set aside for fine arts.

Today, through publications, special events, conservation, and cooperative ventures with other organizations, FPAA continues to promote the role that public art plays in the creation and enhancement of city spaces.

Process Overview

Form and Function. FPAA initiated its Form and Function program in 1980. Artists were invited to propose public art projects for the city that would be site-specific, utilitarian, and integral to community life. This pioneering program looked for works that would be integrated into the public context through use and placement. The artists were asked to give meaning or identity to a place. Ideally, they were to probe for the genius loci, or the "spirit of the place." The intention was to respond to the needs of the changing city while accommodating the individual expression of the artists. The resulting proposals, which ranged from bridges to plans for city parks, expanded the definition of public art in the 1980s.

Light Up Philadelphia. FPAA started this program in 1985 to study the potential for creative urban lighting. The history and future of creative lighting in Philadelphia was investigated. The program wanted to integrate artists' works into urban planning initiatives. The study also examined how lighting and new technology could improve a city's livability. New visions were suggested for the use of public art to enhance and create public space. Creative means to increase residents' and tourists' security, mobility, and enjoyment of the city's resources after dark were suggested in the artists' proposals, as were ways to emphasize architectural and sculptural treasures and increase local pride in neighborhoods and commercial districts.

*New*Land*Marks.* New*Land*Marks: Public Art, Community, and the Meaning of Place is a program that explores an important question: How can public art promote community engagement and still create a supportive environment for the most artistic outcome? The program offers an opportunity for communities to take an active role in defining the unique qualities of their neighborhoods while offering artists the opportunity to work directly with the public from the start of the creative process. In 2002, New*Land*Marks received an EDRA/*Places* Award for Place Planning from the Environmental Design Research Association and the journal *Places: A Forum of Environmental Design.*

Governance

A small staff oversees project development, administration, and communications; consultants provide conservation, architectural services, and day services. FPAA has a board of twenty-one top Philadelphia leaders, including museum professionals, architects, design professionals, lawyers, business leaders, and collectors, whose diverse resources are helpful to the organization. Board members serve rotating three-year renewable terms. FPAA's smaller Artists Advisory Committee is made up of artists who have completed commissions with the organization. FPAA works closely with the city but is not a city agency, a branch of the Fairmount Park Commission, or a component of the Art Commission.

Artist Selection Process

For the New*Land*Marks program, the Fairmount Park Art Association sent out a call to local, national, and international artists. At the same time, FPAA asked communities to participate on a voluntary basis. To introduce the program, presentations that highlighted public art projects from around the world, along with community meetings, were held throughout the city. Communities were asked to think about what they wanted to leave for future generations.

FPAA then invited eighteen communities and twenty-five artists to work with the program. The artist selection process focused on how the artists' ongoing work addressed the stated interests of the community groups. Community representatives and artists engaged in a dialogue and design development process for almost a year. The design phase featured a series of public art workshops that addressed essential issues related to the creation of public art. The series culminated in a New*Land*Marks symposium at the Philadelphia Museum of Art in May 1999, where artists and community participants presented their proposals in a public forum.

The participating communities endorsed sixteen proposals, and FPAA commissioned five of them. Other proposals moved into a research-and-development phase. During 2000, a community exhibition traveled to locations in participating neighborhoods, offering the opportunity to view proposal materials in the community contexts from which the work had emerged. A major exhibition about the program was on view at the Pennsylvania Academy of Fine Arts from February to April 2001, and an illustrated catalog of the proposals was published.

For the Form and Function program, Martin Puryear was invited to participate.

Pavilion in the Trees, by Martin Puryear

Inspired by the widely shared childhood longing for a tree house, Martin Puryear built *Pavilion in the Trees* from Western red cedar, heart white oak, and heart redwood because of their natural durability. The open structure consists of a sixty-foot walkway that leads across a natural basin to an observational platform. A latticed canopy covers the square deck. *Pavilion in the Trees* rises twenty-four feet above the ground and is situated high among the treetops. The work has become a beloved place to relax and contemplate nature. Puryear worked with consulting architect Samuel Harris to realize the project.

About the Artist

Martin Puryear was born in Washington, D.C., in 1941. After earning his B.A. degree from Catholic University, Puryear joined the Peace Corps in Sierra Leone. He later attended the Swedish Royal Academy of Art. He received his M.F.A. degree in sculpture from Yale University in 1971.

Puryear's work with wood, stone, tar, wire, and various metals combines minimalist logic with traditional crafts. Martin Puryear represented the United States at the São Paolo Biennial in 1989, where his exhibition won the Grand Prize. In 1992–93 he was artist-in-residence at Atelier Calder, Saché, France, and during 1997–98 he was artist-in-residence at the American Academy in Rome. In 2003, BALTIC: The Centre for Contemporary Art, Gateshead, England, held the first U.K. solo exhibition of Puryear's work, including *Brunhilde* (1998–2000), an elegant latticed structure with bent, cone-shaped corners that resembles a giant sack or bag made of laminated strips of red cedar that flow from an oval base and converge at the top corners, and *Confessional* (1996–2000), a huge bulging form crafted from wire mesh, tar, and wood. Puryear lives and works in the Hudson Valley region of New York.

Project History

Pavilion in the Trees was installed in 1993 and is a permanent installation. The original model included a steep set of stairs, but the artist decided to substitute a sloping ramp for aesthetic and safety reasons. *Pavilion in the Trees* is near the Horticulture Center in West Fairmount Park, Philadelphia.

"I have a story to tell you . . . ," by Pepón Osorio

To respond to the changing needs of Philadelphia's Latino community, the Congreso de Latinos Unidos relocated to a larger facility, a former industrial building in North Philadelphia. Representatives from the Congreso worked with Pepón Osorio to plan an art project that has transformed the new headquarters into a community landmark.

Osorio met with members of the city's Latino community and discussed the issues that the project should address. A common refrain was dissatisfaction with the media's portrayal of the community.

Alba Martínez, former executive director of the Congreso, explains that community participants "envisioned a landmark that would pay homage to our community's

Pepón Osorio, *"I have a story to tell you. . . ,"* 2003. Exterior view of Casita at night.
Photo © 2004 by James B. Abbott. Courtesy of Fairmount Park Art Association.

sacrifices and struggles and that would combat feelings of invisibility and 'outsiderness.' People wanted to see their history, values, strengths, and hopes for the future conveyed."

To give the community an opportunity to represent itself, Osorio collected photographs from community members. He sought images that were reflective of shared experience and that would depict local events whose impact had been felt on community life.

"My principal concern," says Osorio, "is to return art to the community. My creative process is one of listening to stories, uncovering histories, channeling collective experiences, and transforming these into artworks that can serve as reflections of the group."

Working with Joel Katz Design Associates, Osorio enlarged the photographs, which were then transferred onto glass panels by Derix, in Taunusstein, Germany. To create a sense of three-dimensionality, Derix developed a brand-new process through which the mirror image of a photograph was screen-printed with enamels onto two glass panels. These panels were then sandwiched together to create a single image, which has greater depth and body and is also extremely durable. The panels were used to construct a *casita* or "little house" in the courtyard adjacent to the Congreso building.

The *casita* serves as a community gathering space, and the images are visible from both the interior and the exterior. At night, internal lighting makes the *casita* look like a glowing "community photograph album." Working with the renovation project architects Agoos/Lovera, Osorio also integrated photographs into selected windows of the main building. During the day, visitors inside the building can see these images from the community superimposed on the sky or on the local landscape. Illuminated from within at night, the artwork animates the Congreso building and makes it a distinctive landmark.

About the Artist

Pepón Osorio, an internationally renowned artist, was born in Puerto Rico and now resides in Philadelphia. His work has appeared in the Whitney Biennial and has been exhibited worldwide. He creates installations that incorporate artifacts and images from daily life in Puerto Rico and in Latino communities on the mainland. The process of cultural transmission and the construction of social and cultural identity are themes explored in his work. He is seeking to "bridge boundaries . . . that separate the art world and community life." Osorio has used contemporary art to engage underserved communities around the country. His installations develop from an exchange of ideas among community members, social service providers, and commissioning institutions. He is currently the first artist-in-residence for the Department of Human Services in Philadelphia. "*I have a story to tell you . . .* " is Osorio's first permanent public art commission.

About the Congreso de Latinos Unidos

The Congreso de Latinos Unidos is a multicultural community agency and the leading provider of social, economic, health, and educational services to the Latino community of Philadelphia. The Congreso's broad range of programs offers a holistic approach to community development and social services intended to build "human capital." The facility at American and Somerset Streets, in an industrial building donated by the City of Philadelphia, has placed the organization in the heart of Latino Philadelphia.

Project History

"I have a story to tell you . . . " was installed in 2003 and is a permanent installation.

Pepón Osorio, interior detail of the Casita roof. *Photo © 2004 by James B. Abbott. Courtesy of Fairmount Park Art Association.*

FACT SHEET *Public Art Fund*

Description

The Public Art Fund (PAF) presents artists' projects, new commissions, and exhibitions in public spaces. For more than twenty-five years, PAF has been committed to working with emerging and established artists to produce innovative exhibitions of contemporary art throughout New York City. PAF takes artworks outside the traditional context of the museum or gallery, thereby increasing public access to the art of our time. The organization attempts to dismantle barriers to the accessibility of contemporary art while providing artists with a unique opportunity to expand their artistic practice.

Process Overview

PAF's programs encompass three major categories: Major Initiatives with Established Artists; *In the Public Realm,* a program that realizes projects created by emerging New York artists; and additional outreach projects that include the Tuesday Night Talks, the PAF newsletter *InProcess,* and a publication series.

Major Initiatives with Established Artists. For this program, the Public Art Fund commissions new projects and curates exhibitions of existing artworks previously not seen in New York City. The organization also collaborates with New York museums, to help them expand the reach of their exhibitions beyond the gallery space.

In the Public Realm. In the Public Realm is designed to encourage innovative and experimental projects by emerging artists living and/or working in New York City and New York State. This program offers artists the opportunity to undertake the challenge of creating temporary works in public space. The artists who are selected are encouraged to investigate the physical, social, and psychological nature of the urban environment throughout the city's diverse neighborhoods. Previous experience working in public space is not required for selection. The artists who are chosen to participate offer proposals, develop their work in relation to urban conditions, and present their work in the complex arena of public life in New York City.

Additional Outreach Efforts

Tuesday Night Talks. PAF's Tuesday Night Talks offer an ongoing series of presentations and discussions with artists, critics and curators. Participants have the opportunity to discuss past, present, and future projects while exploring ideas about the state of contemporary art and culture. The talks take place in Manhattan at the New School. Recent participants have included the artists Matthew Ritchie, Rineke Dijkstra, and Paul McCarthy.

Mark Handforth, *Lamppost*. Aluminum with enamel paint and red lights. This artwork was placed at the southeast corner of Central Park as part of Public Art Fund's *In the Public Realm* program. *Photo courtesy of Public Art Fund.*

Newsletter: InProcess. This newsletter, a benefit of membership, gives artists, supporters, and the general public an overview of the Public Art Fund's activities. *InProcess* documents the contemporary art projects commissioned by PAF for sites throughout New York City, and it serves as a reference for academics, students, and the press.

Publication Series. The Public Art Fund published its first artist book in 1999, *Looking Up: Rachel Whiteread's Water Tower,* to document the artistic process of Whiteread's first public art project in New York City. PAF has since expanded its publication program to include artist catalogs featuring selected works commissioned by the Public Art Fund. All PAF publications are available at Printed Matter, New York.

Governance

The Public Art Fund consists of a project development and coordination staff, administration and communications staff, and a nineteen-member board of directors.

Artist Selection Process

For PAF's *In the Public Realm* program, in February an advisory committee of artists, critics, curators, and experts in the field of public art selects up to seven artists to develop formal proposals for public art projects. The artists are chosen on the basis of the materials they submit.

Each artist who is selected receives a fee of $1,000 to create a formal proposal. After investigating communities and potential sites in New York City for his or her proposed project, the artist develops drawings, prepares a maquette of the proposed project, and presents an accurate budget.

After the selected artists present their proposals, sometime in the summer, PAF chooses up to three projects for realization. Each of the artists selected receives $7,500 toward fabrication and installation, based on the finalized project budget, and a fee of $2,500. Selected projects are exhibited the following year, opening in the spring and the fall. Projects may be exhibited for up to one year.

PROJECT PROFILE *Major Initiatives with Established Artists*

Reversed Double Helix, by Takashi Murakami

This solo show by the Japanese artist Takashi Murakami, featuring all new work, transformed the famous Rockefeller Center plaza into a "fantastical pop cityscape." The title, *Reversed Double Helix,* refers to twisted spirals of DNA and to Murakami's cast of mutant cartoon characters.

At the center of the installation, flanked by four smaller figures, was the artist's largest sculpture ever: a thirty-foot-tall figure, with multiple arms and a pointed head, known in Murakami's universe of characters as "Tongari-kun" ("Mr. Pointy"). A mushroom, another familiar motif in Murakami's artwork, surrounded the central sculpture and served as seating for visitors. Two "eyeball" balloons thirty feet in diameter floated sixty feet above the plaza and surveyed the scene. Murakami also designed the flags for the plaza.

About the Artist

Takashi Murakami—artist, entrepreneur, curator, and student of contemporary Japanese society—was born in Tokyo and received his B.F.A., M.F.A., and Ph.D. degrees from the Tokyo National University of Fine Arts and Music. Murakami's work is inspired by the traditional as well as the contemporary. His current approach to art production reflects the influence of anime (*otaku* animated films), manga (comics) and the fashion and music inspired by Japanese youth culture. His bright acrylic pat-

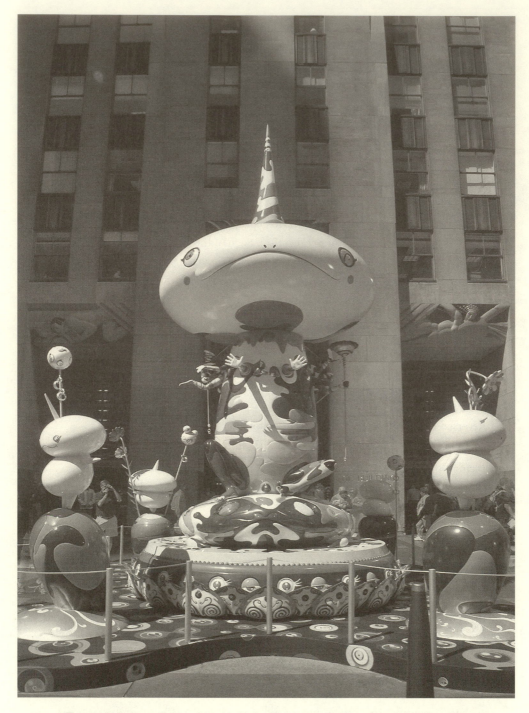

Takashi Murakami, *Reversed Double Helix*. Sculpture using fiberglass, balloons, and flags at Rockefeller Center. *Courtesy of Public Art Fund.*

terns and smooth surfaces reference nineteenth-century Japanese *Nihon-ga* paintings as well as Walt Disney animation and such pop culture influences as Andy Warhol's Factory. Murakami's work appeals to the public on an exciting visual level while alluding with formal sophistication to art history, religion, and cultural differences.

In 2000, he curated the exhibition *Superflat,* which acknowledged the influence that mass-produced entertainment has had on contemporary aesthetics. He is also known internationally for collaborating with the fashion designer Marc Jacobs to design handbags and other products for the Louis Vuitton fashion house.

Project History

Reversed Double Helix was organized by the Public Art Fund on behalf of Tishman Speyer Properties and was presented by Target Stores. It ran from September 9 through October 12, 2003.

PROJECT PROFILE *In the Public Realm*

TOURGUIDE? by Christine Hill

Christine Hill's improvisational walking tours were centered at Deitch Projects, 76 Grand Street, throughout the summer of 1999. The artist and the participants in this effort infiltrated the city of New York and engaged in an entertaining alternative to the popular commercial tours of the Big Apple. The sites selected by the artist provided an experience that most guidebooks do not direct tourists to experience. Hill's two-hour-long tours guided groups through downtown locations and offered excursions to other parts of New York City. The tours included anecdotes and group discussions along with guest guides, theme events, treasure hunts, and other special excursions. The entire experience provided tourists with a countercultural look at New York City.

About the Artist

Christine Hill is an artist, musician, and certified New York tour guide. She has studied improvisation with the Upright Citizens Brigade of New York City. Her work has been exhibited extensively in museums and galleries internationally.

Project History

Tourguide? was organized by the Public Art Fund and supported with funds from the New York State Council on the Arts, the City of New York City Department of Cultural Affairs, and other funding support. The project ran from June to September 1999.

Part 3

Exhibiting Public Art

I t can be scary for an artist to go public, and scarier still for public art administrators and curators to manage a project by an untested public artist. But if there is room at all for such a risk, it is in a university environment, where education and dialogue are the core mission, and where process is often considered more important than product.

The University of Minnesota, for example, took a big risk in 2003 by commissioning Eduardo Kac to create a work of public art for its new Cargill Center for Microbial and Plant Genomics. For all his accomplishments and acclaim as a telecommunications and "bio" artist, and through two decades of cutting-edge, controversial work, Kac had never created a single piece of public art before this commission.

The committee that selected Kac had no idea what he would make, largely because Kac himself had no idea. Kac was commissioned in part because he was not averse to the challenge, because faculty and staff on the selection committee were enthusiastic about an artist who had studied genomics, and because his work was connected to their academic program and not simply to their building's architecture. A year after winning the commission, Kac presented a proposal for an abstract metal sculpture: a giant replica of a protein to be taken from a plant. The plant itself would be created through the combination of two genes: a plant gene, and the synthetic reproduction of a human gene to be drawn from Kac's own blood. The protein extracted from this new plant would serve as the model for the sculpture. Kac hoped that by combining human and plant genetics he would inspire people to reflect on the "genetic continuum" among all living creatures. For Kac, the proposed sculpture presented itself as a bridge between two worlds: the general public, which would recognize the work's shape as that of an abstract sculpture, and the scientific community, which would recognize its shape as belonging to a protein. Through time and dialogue, Kac believed, both responses would merge. The technologies to be used in creating the protein, being standard in laboratories, were easy to come by, but Kac still needed the support of the university's scientific community to create an effective project. Toward that end, he is involving faculty and students in a rich, collaborative experience. While pushing his work forward, he encourages continuous communication about the broad cultural impacts of biotechnology.

The college campus is a natural home for this kind of experimentation—and for the failures that may be a natural consequence. The campus offers an avenue of interaction between professional artists and students, and it provides a safe place for criticism. Although the university's mission of education and dialogue stands in contrast to the goals of governmental and even private nonprofit public art organizations, most university public art programs use the same funding mechanisms, selection processes, policies, and master plans as those used by the other types of public art organizations, and they all face the same challenges of conservation and maintenance.

In 1979, legislation for art in state buildings created a funding base at the University

Janet Zweig, *The Medium*, 2002. School
of Journalism and Mass Communication,
University of Minnesota. *Photo courtesy
of University of Minnesota.*

of Iowa for forty-two new works of public art. In 1981, the University of California–San
Diego established a foundation to fund public art on campus and has since amassed
an acclaimed collection of site-specific public artworks. Michigan State University's
public art collection includes more than nine hundred works by nearly three hundred
fifty artists, represented in eighty-five departments and sixty buildings and outdoor
locations throughout the campus. Pennsylvania State University is nearing the com-
pletion of an effort to develop a public art policy and a master plan for all twenty-four
of its campuses.

Although only a few universities offer degrees in public art—the University of
Southern California has a well-established degree program in public art administra-
tion, California State University at Monterey Bay offers a graduate degree in public
art, the University of Liverpool has a new M.A. course titled "Visual Art in the City"
that is based on the study of architecture in relation to urban life and public art, and
California College of the Arts will soon offer an undergraduate degree in community
arts—courses in the field are multiplying across the country. These courses, specific
yet diverse, and offered across disciplines, all investigate fundamental questions:

- What is public art, and what is its history?
- What do we mean when we say "the public"?
- How is public art different from studio arts and design?
- What is the role of the artist in the community?
- What is the function of public art?
- What are the differing functions of permanent and temporary public artwork?

Some courses in public art use case studies to examine definitions and prevalent themes.
Others work in tandem with the development of public art on campus. Still others
teach the history of public art, focus on theoretical issues (such as those related to com-

munity involvement, urban space, and understanding the audience for public art), help students identify and negotiate barriers in civic systems and structures, teach the skills needed to be a successful public art administrator and curator, or use public art to present possibilities for cross-disciplinary education:

• At the University of Michigan's School of Art and Design, Mark Pomilio presents "real life" situations to students, who then compete for commissions, seek the necessary approvals from the university, and design and install permanent artworks on campus.

• John T. Young, at the University of Washington, teaches interdisciplinary public art courses where students design and build permanent and temporary public artworks for community sites.

• At the University of California–Berkeley, Anne Healy has designed a semester-long class for students who must seek their own funding, receive approvals, and make temporary public artworks.

• In the spring of 2004, students from multiple colleges and departments at the University of Minnesota jockeyed for seats in the world-renowned artist Alfredo Jaar's course, "The Wounded City." Jaar's three-week class, which included a week-long trip to New York, considered visual and cultural practices as integral elements in a network of social and cultural relationships. The course taught students—only a quarter of them art students—to think about societal issues and communicate their conclusions to an audience through a series of short films, each one directed by one of the students. The technical expertise needed to make a film was less important than learning about the directorial, managerial, and administrative skills involved in filmmaking and in practicing the skills associated with visual interpretation of an idea.

• Also at the University of Minnesota, the College of Architecture and Landscape Architecture invited San Francisco Bay Area artist John Roloff and Minneapolis landscape architect Rebecca Krinke to design four outdoor courtyards and multiple interventions throughout a new building addition designed by Steven Holl. Their concept combined stone, water, vegetation, and geological information about the site with complete records of the design process (in the form of a book to be accessioned into the college library) and text intended to provoke thought and reflection and to reveal information about the site. The project was designed both as a teaching tool for faculty and as a model for collaboration between artists and designers. Says Tom Fisher, dean of the College of Architecture and Landscape Architecture, "Since you can literally see right through the building, the landscape is an integral component of the building and of the site. The project also allowed us to rethink the campus landscape in a more sustainable way, and it celebrates Minnesota—the geological basis on which the building and the landscape exists."

As public art programs and curricula proliferate at colleges throughout America, they are teaching the practical and theoretical intricacies of the field. They are also allowing for experimentation, research, and criticism, thereby ensuring the continued exploration and movement of public art.

Art in the Workplace

Management of the Seattle Portable Works Collection SEAN ELWOOD

Because there is no well-established tradition in the United States for municipal collections of portable artworks, it is somewhat easier to define what the Seattle Portable Works Collection is not than to define what it is. We are not a museum, although we do sometimes use the methods of museums. We are not an art center, although we do have a collection (if no "gallery"), nor are we a private collection or a commercial gallery. What we most resemble is a corporate collection that shows art in work spaces, although our responsibilities and processes are very different from those of such a collection.

The Seattle Portable Works Collection, like other "art in the workplace" collections, developed from a simple, long-held, occasionally maligned assumption: that there is benefit to having artworks in the office, and that art improves the quality of the environment by enlightening and soothing those who work in proximity to it.

ART IN THE WORKPLACE

A workplace collection is meant to benefit employees and members of the public who do business in a particular place. It is not intended for an interested public that has sought out the experience of looking at art. Unlike a collection housed in a museum or in a private home, a collection like ours has to exist in the rough-and-tumble environment where people work. The works in our collection don't have the luxury of being displayed in special conditions governing the levels of light, temperature, humidity, or security. In a workplace collection, one constantly walks the line between maintaining artistic quality, diversity of expression, and the good condition of the artworks, on the one hand, and, on the other, cultivating the acceptance and interest of a large, disparate, opinionated, and often apathetic audience.

Collections that exist in these conditions are necessarily subject to special requirements and policies regarding the acquisition, exhibition, maintenance, and disposal of artworks. Such conditions require the evolution of very pragmatic collection-management practices, with less rigorous attention to certain aspects of administration than might be expected among museum professionals and others whose primary concern is the preservation of cultural artifacts.

That said, consistent policies and procedures do evolve. For us, the development of those policies and procedures, along with the experience of administering this collection, has reaffirmed our conviction that art does indeed improve the quality of the environment, and that those who work in its presence are enlightened and soothed by it—sometimes in spite of themselves, given the peculiarities of our collection, which are a significant aspect of why it has become so valuable. The constant rubbing together

of the artworks and the "real world" produces problems, challenges, and intense reactions. But this interaction makes the art, and the place where it is displayed, both stronger and more interesting.

A BRIEF HISTORY OF THE COLLECTION

The Seattle Portable Works collection came into existence in 1973, shortly after the establishment of the Seattle Arts Commission (now the Seattle Office of Arts & Cultural Affairs). Almost from the beginning, the commission had as part of its stated mission "the acquisition of works of art which will enrich the urban environment and increase awareness of the visual arts. To this end the [Office of Arts & Cultural Affairs] seeks to acquire works of art of the highest quality which are representative of the diversity of artistic expression." The Public Art Program was established by municipal ordinance in 1973, and it specified that 1 percent of the city's capital improvement funds were to be set aside for the commissioning, purchase, and installation of artworks. Henceforth, a portion of the city's percent-for-art funds was allocated to the purchase and maintenance of relatively small-scale artworks that would be exhibited primarily in public buildings. In this way, Seattle became one of the first cities in the United States to actively pursue a policy proclaiming the value of owning a large, diverse, growing collection of artworks to be made available for exhibition in the city's public municipal spaces. Every two years, each of the works in the collection is rotated from one public space to another.

The first portable artworks entered the collection in 1973, and in the years since then they have been followed by more than two thousand prints, paintings, drawings, and sculptural works in almost every imaginable style and material. Despite occasional grumbling from some city employees, the program has become so successful that it has also become a victim of its success, struggling to procure and distribute art fast enough to keep pace with the demand of the burgeoning city government. Given the scope, variety, and sheer number of objects in the collection, changes have been needed in how the city acquires, manages, and occasionally disposes of works of art within it. But the original vision—that of a dynamic municipal collection intended to enrich the environment, increase awareness of the visual arts, and represent diversity in artistic expression—remains unchanged.

WHERE WORKS COME FROM

An artwork enters the collection in one of three ways: as a direct purchase, as a commission, or as a gift. Every work proposed for the collection must be evaluated on the basis of the following criteria:

- The work's aesthetic quality
- The work's relationship to the collection as a whole

• The presence and number of works by the same artist that are already in the collection and sufficiently on display in the city's public spaces
• Community or departmental process and approval, as appropriate
• The available budget

In addition to these criteria, issues of the work's fabrication, technical feasibility, durability, probable life span, potential to be vandalized, safety, maintenance, and preservation must be considered.

The purchase of a portable work begins with the design of a purchase program that takes account of the criteria just listed and of the general goals outlined by the Seattle Office of Arts & Cultural Affairs, the Municipal Art Plan, the funding department, and considerations involving the collection itself. A call for artists is issued, and application materials are received and prepared for a panel's review. The typical panel is made up of three to five arts professionals appointed by the Office of Arts & Cultural Affairs. The panel reviews each proposed purchase in light of the relevant criteria and then makes a purchase recommendation that is forwarded for final approval to the Public Art Program Committee and the Office of Arts & Cultural Affairs.

A commissioned work will be one of two types: a portable work completed by an artist as the outcome of an accepted proposal, or a portable work generated as part of a commission for a permanently sited work or a temporary installation. The acquisition of a work in the first category is determined by a selection process identical to the process described for purchases. Production of works in the second category is a standard requirement for artists who have been commissioned to complete permanent or temporary installations, and the acquisition of these works is determined and administered by the staff of the Office of Arts & Cultural Affairs.

A work that enters the collection as a gift is evaluated according to the same criteria used for purchases and commissions. The evaluation is conducted by the De-accession & Gifts Panel, which the Office of Arts & Cultural Affairs appoints every two years. The panel's recommendations are forwarded for final approval to the Public Art Program Committee and the Office of Arts & Cultural Affairs.

CARE AND DISPLAY OF THE COLLECTION

Once an artwork has been accepted into the collection, it is documented, made available for exhibition, exhibited, rotated from place to place, occasionally stored, and maintained until it leaves the collection (if it ever does leave).

Collection-management issues can be broken into three categories:

1. Documentation, or methods for keeping track of the collection
2. Exhibition, or the question of where the collection meets the audience
3. Maintenance, or activities involved in caring for the collection

Documentation

Good documentation is essential to managing an art collection of any size. For the purposes of the present discussion, it will not be useful to discuss documentation in great detail, since the documentation conventions we use for our collection are not unique. We apply the standard forms of accessioning and recordkeeping used by almost every substantial public, corporate, or private collection (see Patricia Favero, "Recordkeeping and Public Art," elsewhere in this volume).

Exhibition

Exhibiting a public collection like ours presents a series of unique challenges. A public collection is more vulnerable to its audience, both physically and philosophically, than a museum collection is, for the public collection's audience is not restricted merely to people who are already interested in art. It is a particularly diverse, opinionated, verbal group of people who may greet the entry of artworks into the workplace with interest and pleasure, or who may react with suspicion and hostility. It is important to do everything possible to place the work in a way that is respectful both to the people who will live with it and to the artist who created it.

We have found that it is important to involve workers in the selection of artworks. We encourage the use of themes in the selection process. In this way, the artworks tend to relate to one another and to give people in the artworks' environment the sense of hosting an art exhibition instead of a hodgepodge of unrelated objects.

It has also proved helpful to conduct continuous educational conversations with those who work in an office where art is being installed. We create label copy that supplies interpretive information about the work, to prevent misinterpretation of the artist's intent, and we supply a checklist of the "exhibition," making it possible to take a self-guided tour of the works on display. When asked to do so, we have offered presentations about the art, conducted either by the Office of Arts & Cultural Affairs collections manager or by someone else who is familiar with the artworks or with the themes represented. These efforts at education have increased the sense of stewardship among citizens and departmental staffs.

Sometimes, however, there is nothing to be done about the negative response to a particular piece of art in the workplace. On rare occasions we have removed art because of strong objections from the workers who were asked to live with it. For an artwork to be removed, complaints about it must be in writing, and the objections must be specific. We do not remove artworks on aesthetic grounds alone.

Maintenance

The risk to artworks in a collection like ours is considerably higher than the risk to works housed in a secured and insulated collecting institution. Unfortunately, we occasionally have to face the fact that someone has bounced a basketball off the surface of one of our paintings, an event that is less likely to occur in, say, an art museum.

To avoid these kinds of problems, we follow the standard precautions used in the preparation of artworks for exhibition. We take care to keep works out of harm's way

by carefully considering how and where they are installed, and we make every effort to educate the audience about how to protect them. We also allocate sufficient funds for the professional help that will be needed to take care of artworks, which, even in the best of circumstances, inevitably need care and attention as they age.

WHERE WORKS CAN BE EXHIBITED

Artworks in the Seattle Portable Works Collection are exhibited only in the public areas of city offices. A public area is any space that is open to or can be seen by members of the public who visit a particular municipal office. Public areas include reception areas, training rooms, meeting rooms or auditoriums where public meetings take place, and hallways or private offices that are visible through clear glass windows or partitions. Artworks from the collection cannot be displayed in a private office unless the office is used on a regular basis to conduct public meetings.

Artworks from the collection may occasionally be shown in nonmunicipal public spaces or in special exhibitions. Proposals to show artworks that belong to the city must be made in writing, and the staff of the Office of Arts & Cultural Affairs considers such requests on a case-by-case basis.

WHY AND HOW WORKS LEAVE THE COLLECTION

When the collection-management staff becomes aware that an artwork is not being displayed because of its content or its condition, the work is referred to the De-accession & Gifts Panel for review. The panel may recommend one of several actions: do nothing, trade or return the artwork to the artist, donate the work to another public art institution, sell the artwork in a public process, or destroy it. This recommendation is forwarded to the Seattle Arts Commission for approval. Once approved, the recommendation is followed, and the artwork exits the collection.

WHY HAVE A PORTABLE WORKS COLLECTION?

Maintaining and managing a collection of portable works is challenging enough to raise the question of why to have one at all. The reason is simple: everyone benefits. Employees and citizens benefit from an improved work environment. The region's artists benefit from the program's financial support and from the less tangible reward of perceiving that they and their work are valued. The city accumulates not just an amenity but an appreciating asset, and it gains the civic reputation of being an enlightened supporter of the arts. A portable works collection also has a positive "ripple effect" on the professional art-supporting community of curators, art administrators, and art handlers.

Establishing and maintaining a public collection of portable works is not easy, but a dynamic collection benefits everyone who creates, maintains, or simply views it. Quite simply, it is a win-win endeavor.

GUIDELINES FOR THE EXHIBITION OF ART
OWNED BY THE CITY OF SEATTLE

Background

The Public Art Program of the Seattle Arts Commission, now the Mayor's Office of Arts & Cultural Affairs, was established by municipal ordinance in 1973 and specifies that 1 percent of city capital improvement project funds be set aside for the commission, purchase, and installation of artworks. Artwork commissioned by Seattle's Public Art Program may be created either as an integral part of an eligible construction project or at another city-owned site.

A portion of the city's percent-for-art funds is allocated to the purchase and maintenance of relatively small-scale artworks, which are to be exhibited primarily in public buildings. These works are rotated from one public space to another every two years or so. The Office of Arts & Cultural Affairs is responsible for displaying works of art collected by the City of Seattle.

The purpose of the Portable Works Collection is to increase public awareness of and support for the arts by displaying works of art in public buildings. These artworks enhance the working environment for employees of the City of Seattle and for members of the public who do business in those offices.

Where Can Artworks Be Exhibited?

Artworks in the Seattle Portable Works Collection will be exhibited only in the "public" areas of city offices. A public area is any space that is open to or can be seen by members of the public who visit a particular municipal office. Public areas include reception areas, training rooms, meeting rooms or auditoriums where public meetings take place, hallways, or private offices that are visible through clear glass windows or partitions. Artworks from the collection cannot be displayed in a private office unless the office is used on a regular basis to conduct public meetings.

Pieces from the Portable Works Collection occasionally can be shown in nonmunicipal public spaces or in special exhibitions. Proposals to show artworks that belong to the City of Seattle must be made in writing. Office of Arts & Cultural Affairs staff will consider such requests on a case-by-case basis.

Responsibilities and Conditions

The Office of Arts & Cultural Affairs is primarily responsible for the care and maintenance of the Portable Works Collection. However, the host office is responsible for supervising the condition of works in the collection while they are on display. Any damage or deterioration should be reported to the Arts & Cultural Affairs collections manager immediately. The collections manager, or contract workers hired by the Office

of Arts & Cultural Affairs, will be responsible for any repairs, restoration, or moving of artworks.

Nonmunicipal spaces that wish to exhibit art from the city collection are responsible for the costs of transporting, installing, and removing works and for maintaining the condition of the works while under their care.

Works of art that are difficult to display because of their size, delicacy, or complexity may require semipermanent installation and will not be rotated.

Procedures for the Selection of Artworks for Exhibition in City Offices

In every office there should be a designated "art contact person." All issues having to do with the public artworks on display will be relayed through that representative.

The art contact person from any City of Seattle municipal space may request an exhibition of public artworks in his or her offices. The request should be made to the Office of Arts and Cultural Affairs collections manager. After the initial request, the collections manager will prepare a slide presentation to be given to the small art committee from the office that has made the request. A follow-up slide presentation can also be scheduled (two slide presentations are normally needed). Once the exhibition has been chosen, the collections manager will make arrangements to deliver and install the selected works.

If the art contact person should change, the collections manager should be notified so that Office of Arts & Cultural Affairs files can be kept current.

Term

Under normal circumstances, a work is exhibited for an average of two years before being rotated out to another location. The Office of Arts & Cultural Affairs reserves the right to remove works if the art is needed for exhibition elsewhere, or if it is felt that a work has been damaged or is in jeopardy of being damaged. The Office of Arts & Cultural Affairs will make every reasonable effort to replace a work that has been removed with another from the collection.

Interpretation and Education

In an effort to emphasize education, in order to empower citizens and department staff in taking a greater stewardship role in the collection, the Office of Arts & Cultural Affairs will provide interpretive materials about artworks being displayed in a host office. These materials will include labels, with text regarding the artwork, as well as a checklist of the "exhibition" (including the same text as that on the labels) so that it is possible to take a self-guided tour of the works on display. In addition, upon request from the host office, the Office of Arts & Cultural Affairs will make every effort to provide a presentation about the art, to be given either by the collections manager or another speaker.

Project Types

Artist-Initiated Projects

The Glory and the Dream of Public Art HELEN LESSICK

In every discipline, there are fire starters and fire tenders. This is especially true in public art. It may seem self-important to claim the entire field as an artist-initiated enterprise, but Seattle's public art programming, like others around the nation, arose directly from the efforts of visionary artists. These artists believed that art displayed in public venues should have access to public funding. Producers and presenters, they worked with the city and for the city: de facto art administrators creating policy and procedures, legislation, and politics to achieve illuminating percent-for-art ordinances.

But today the flaming hearth of public art is in danger of being channeled into central heating. The residue of fire tending includes ordinances and policies delimiting a public art status quo. Public art is a career choice, distinct from art in our public places. Lacking aesthetic ignition, art programs and projects respond to architectural design or social problems. Artists' invention and initiatives are given minimal attention and even less public funding. But artists make art, developing public projects because the metaphoric and actual canvas is there.

Experience shows that artists' initiatives will lead to unpredictable, controversial, and occasionally beautiful places. Speaking as an artist, I would say that our overarching goal is to create in context, in community, in public. Artists initiate projects on the sidewalk and in the concert hall, in the community theater and the bus shelter, in the city park and the industrial brown field.

Entire professional careers have been created and nourished by artist-initiated projects. Seattle's own record is a fine example. In 1981, a young artist named Jim Pridgeon was awarded a commission to create *Inserts* as a public art program. Both an artist and administrator, he meted out grant monies to eleven other artists, each charged with creating a project in a public, nongovernmental site. Innovative works by (then) public art tyros Norie Sato and Alan Lande were generated, as video art appeared on Sears's display TVs and original prints were served on bar napkins at local watering holes. In *Salmon in the City,* Seattle's multifaceted, multisite temporary art program of 2001, fifteen artists explored the listing of Chinook salmon as a regionally threatened species. Each artist selected a medium, a viewpoint, a site, a duration, and a budget to create a work accessible to the public. Sculpture, prints, poems, parades, and an animated film were commissioned. In the twenty years between these two examples, the expectations and experience of public artists have changed. So has public art and, with it, the public art program of Seattle.

Outside governmental structures, artists initiate the means of production and exhibition of their works in diverse venues. Seminal exhibition and performance spaces, including Seattle's and/or (1975–1986) and ConWorks (2000–) and, in Oregon, Port-

land's Center for the Visual Arts (1974–84) and the Portland Institute for Contemporary Art (PICA, 1987–), are training grounds for artists and curators alike. Some artist-run organizations, including P.S.1 Contemporary Arts Center and Franklin Furnace in New York, merged with or morphed into a museum context. Others, including Creative Time and Socrates Sculpture Park, remain independent experimental laboratories for generative artists. Publicly and privately funded, artist-initiated projects draw their expansive worldview from the strength of purpose and the problem-solving ability of artists as staff.

Every artist is an activist, an artist-initiator working to fulfill the glory and the dream of art in public places. At the inaugural session of Public Art 101, the fire starters in attendance included Jack Becker, founder of the *Public Art Review,* and Matthew Lennon, founder and artistic director of the HorseHead Project. These cultural instigators embrace the primacy of the generative artist. Both have helped artists make some great work—and some mediocre pieces. Both have given the audience a new experience: space for consideration of personally made, publicly presented, art.

Consider how far we have come from the early percent-for-art efforts. The art of public art is in danger of being extinguished through strategized solutions and commodified aesthetics. The public knows what public art looks like through complacent and complicit administrators and artists.

But artists start fires, not knowing where they will spread. And public art programs can ignite creative fires through policy, supporting artists' initiatives, artists' residencies, experimental and new-media projects, and nonvisual art works as elements in the panoply of public art. As artists redefine and reinvigorate the publicly subsidized, site-related presentation of contemporary art, administrators reinvigorate programs and neighborhoods. This is the lesson of artist-initiated models: Don't follow artists. Join us as leaders carrying the torch.

Case Study

The HorseHead Project

MATTHEW LENNON

The HorseHead Project was started because it was necessary. In the 1980s I had been noticing a lessening of attention to and support for sculpture. I had friends whose models of ideas were covered with dust, warehoused in their studios, for the simple reason that there was nowhere for them to show their work.

In 1987 my family and I purchased thirteen acres in Bucoda, Washington, a recession-weary area of cattle farms and loggers. The site was quite diverse. It had a three-acre wooded hillside leading to two seasonal ponds, rolling meadows, and acres of rough land. I decided to offer the site to artists as a laboratory for the visual arts, even though I was told that no one would participate so far away from the institutions, the marketplace, of Seattle.

Eleven artists made the pilgrimage for the first exhibition in 1988. They worked weekends throughout the summer, making the ninety-minute trek from Seattle, predominantly creating their pieces on site. They put forth the effort because they wanted what all artists want: to do what is natural to them, to *make art*. Artists and their audiences want someone or something to facilitate the artmaking experience with as little pretense or predictability as possible, and without commercial or institutional interference.

Much of the work that followed remained experimental, and the Bucoda project itself rested on the premise that it is better to move artists than to move art. Thus, for three years, the project moved urban-based artists into a rural environment, encouraging their exploration not just of ideas but also of place, and hoping to decrease their dependence on the insular environment of the studio.

By 1990 there were twenty-eight original works at the site. Many of the pieces from the first exhibition, held in 1988, were still present, displaying various degrees of weathering and environmental wear. Bill Moore's oversize mummylike figurines looked tattered, with fading of their primary red and blue. Jonathan Stevens's swirling, sixteen-foot-tall circle of blackened alders, the trees themselves between sixteen and twenty feet high, had become entwined at one point with what appeared to be thousands of spider webs; in winter it glistened with ice, and by the spring of 1989 the circle of trees had rotted at the base. The piece crumpled in on itself, forming the materials for an evening bonfire. Robert Yoder made a minimalist arc of discarded library books buried in a hillside for the 1990 exhibition. The books had been selected from the throwaway bins of bookstores and libraries. Their multicolored bindings whispered against neglect and expedient devaluation.

In 1991 the HorseHead Project, as it was now known, became more mobile. For the next six years, we developed exhibitions on a nine-acre site in suburban Duvall, Washington. The woods there were filled with alder, a result of the devastating practice of clear-cutting Douglas fir and cedar woodlands; there was a natural bowl-shaped meadow, with many elevated vantages.

The Duvall artists, like those at Bucoda who had been involved in all the other HorseHead shows, were encouraged to work from site, to define place in terms as broad as possible, and to integrate their practices in a manner sympathetic to the environment. There were no themes or curatorial dictates; the artists were always invited to do something they really wanted to do and to explore as many diverse materials as possible.

During this six-year period, Michael McCafferty began his intense exploration of entropic works designed with primal form and constructed from bales of hay. Kay Kirkpatrick shrink-wrapped an eighty-foot arcing alder. There were armies of creatures made from found objects, and a ritualistic installation scene featuring a fiberglass figure. From 1992 through 1994, Malcolm McLaren made figurative pieces of various sizes combining a range of materials (salt, bread, adobe, wildflower seeds). Bob Teeple installed a computerized sculpture in 1992. In 1995 Paul Martinez created a ceramic installation made of low-fired terra-cotta bowls and a central altarpiece; the installation was meant to crack and deteriorate, forming a place of ruin. The Trinidadian

costume designer Fitzgerald DeFreitas made an installation of insects in 1996. Kurt Geisel's video installation was created in 1997.

The artists' instinctive investigation of materials fulfilled HorseHead's mandate to be a site-integrated laboratory. HorseHead also became a model for the cultivation of alternative outdoor presentations of "sculpture" and for pursuits of the temporal and the temporary in public arts programming.

The audience for HorseHead grew, and the openings had a celebratory feel. The first opening, in 1988, welcomed about three hundred attendees; more than three thousand turned out for the 1999 opening, which marked concurrent HorseHead shows held at Seattle's Sand Point Magnuson Park, a former naval base, and in Belfast, Northern Ireland.

Matthew Kangas, in an article titled "HorseHead Sculpture Project '98: Sand Point Naval Station," which appeared in the December 1998 issue of *Sculpture,* reported that HorseHead had gone "all out" for the tenth-anniversary show. Kangas cited the "hands-off approach" that "let the artists choose their own sites—the only proviso being that minimal alteration of the environment occur," and he observed the result: thirty-four pieces that "took many manifestations, from installation art and discrete object sculpture to earth art and environmental sitings."

In all, more than two hundred U.S. and international artists have participated in the HorseHead Project, coming from the West Indies and Canada but also from as far away as Japan, Ireland, France, and Italy. They have installed computerized art, sound works, and video works; they have produced elaborate performance pieces. The press has been enthusiastic, and the HorseHead Project has been a success. But why?

I think the project's success is due to its uniqueness, and that HorseHead is unique for a variety of reasons:

- HorseHead's intent, dating from the project's inception, to create a history, not an institution
- The belief that it is better to move artists than to move art
- An understanding that artists and audiences want the same thing: something and someplace away from the institutional environment
- HorseHead's intrinsic trust in artists to produce good work without curatorial interference
- Extension of that trust to the audience, in the fundamental belief that audiences will be active witnesses, not submissive viewers
- HorseHead's material experimentation
- The project's commitment to view notions of place in the broadest possible context

Ultimately, the success of any program lies in its artists' desire and willingness to do good work. The question facing most programs and institutions is this: Why are we making that so difficult?

Socrates Sculpture Park is an artist-initiated project of unusual scope and scale. Through luck, timing, and predilection, I was among the group of artists and neighbors who saw past the landfill and rotten piers and envisioned a public showcase for the construction and exhibition of outdoor sculpture.

It's no coincidence that Socrates Sculpture Park was founded in Long Island City, a working-class neighborhood in the borough of Queens, New York. The land was ideally positioned on the fringe of Manhattan, between the New York studios of the internationally renowned sculptors Mark di Suvero and Isamu Noguchi. Many artists were drawn to the empty industrial spaces with stupendous views nestled within this working-class community.

We embrace the notion of open public space and urban river access, but it took the protean instigator Mark di Suvero to unite these concepts with the production of contemporary art. His vision informed both the structure and the spirit of a park for sculpture. Di Suvero established Socrates in 1985, under the aegis of his Athena Foundation. In his irreverently titled "Flounder's Statement," the artist wrote:

> The Foundation is dedicated to the arts for the people. The Athena Foundation will try to help artists realize their visions which their creative imagination proposes, so that the society shall become healthier, more cooperative, happier, and more unified. To this end, the Foundation shall search out artists (thru the recommendation of other artists on the basis that artists know art best). The Foundation shall try for flexibility and innovative vision in their programs. The Foundation in its larger format shall help communities to realize a work of art or construct a public sculpture space.

In early 1985, the future site of Socrates Sculpture Park was a riverfront dump with garbage and autos, guns and crack pipes. The East River inlet of Hallets Cove captured Bronx flotsam and the occasional buoyant corpse and deposited it in park waters. This was a public space neglected by its owner, the New York City Department of Ports and Terminals. But artists saw the pearl in this encrusted oyster. Di Suvero, with the support of Noguchi, worked both the politics and the government, interested disaffected neighbors, and harnessed the energy of a motley group. We refurbished the land, ignited community pride, and put up a public sculpture space.

It took a year of cleaning, hauling garbage, and planting trees. In October 1986 we invited the public behind the chain-link fencing. Socrates' first exhibition mixed works of well-recognized and unknown sculptors with painted rocks, printed T-shirts, and local musicians. We worked, and we evolved, drawing success from transition. Over time, Socrates was incorporated as a 501(c)(3) not-for-profit organization, with

leveled ground, cobblestone paths, potable water, and permitted electricity. It has an executive director, with educational and fundraising staffs.

Dennis Hevesi, writing on May 26, 1994, in the *New York Times* ("Sculpture Garden Rises in a New Patch of Green"), quoted di Suvero and Henry Stern, then commissioner of the Department of Parks and Recreation:

> "This is where they used to do illegal garbage dumping," Mr. di Suvero said. "There was no fence. There were huge puddles: broken steel, old cars. It took us about a year to clean up this place." According to Parks and Recreation Commissioner Henry J. Stern, "The Park means that there will be a place for monumental sculpture to be exhibited year round on the east bank of the East River. And they did it," Mr. Stern said of the community. "That's the great part. The city cooperated but the people did it."

Staff worked and evolved, too. I was first involved as an exhibiting artist; then as a seasonal project facilitator, literally staging biannual shows; then as a board advisor. Volunteers became paid staff and then left to establish other projects in other cities. But everyone did everything, from picking up trash and pulling weeds to sitting on selection committees and working the concession stand. Turnover was embraced as a chance for other voices and views. It was a heady, hands-on training ground for artist-initiated projects on a grand scale.

New York City transferred management of the Socrates site from Ports and Terminals to the Department of Parks and Recreation and granted the sculpture park permanent leased status in 1998. Under these conditions, the land is protected from development, and the sculpture park continues to help artists realize their visions. "Socrates has come far from its improbable start as a modest sculpture garden whose artworks were painted with help from neighborhood children," observed Douglas Martin in the *New York Times* on December 6, 1998 ("After 14 Years, City Embraces a Sculpture Park"). "Twice a year it stages an international show of 15 or more pieces of immense sculpture, startling contortions blossoming on a modest knoll directly facing the Manhattan skyline."

Socrates Sculpture Park is still open, free to the public, from 10 A.M. to dusk, 365 days a year. October 2004 marked the eighteenth-anniversary exhibition of this artist-initiated, temporary-sculpture project. One cannot predict where artists will lead.

FORECAST Public Artworks is a Twin Cities–based nonprofit organization that works to strengthen and advance the field of public art locally, regionally, and nationally. The organization's Public Art Affairs program, established in 1989 and funded by the Jerome Foundation, seeks to lay the foundation for a vibrant public art scene in Minnesota by supporting individual emerging artists in the development of their public art careers. Because Public Art Affairs also seeks to help artists work with communities in a more direct way than they may have done before, the program educates audiences and works to expand the audience for public art throughout Minnesota.

Public Art Affairs is open to artists working in all disciplines, and this openness ensures a mix of experiences as well as a mix of approaches to the often complex realities of public art. FORECAST developed this annual regranting program with two distinct categories of funding: Public Project grants of up to $4,000 for the implementation of new projects, and Research & Development (R&D) stipends of $1,000 for pursuing public art ideas of any scale that require financial and technical support to get off the ground. Since 2000, FORECAST has also partnered with select organizations that want public art projects at their sites or for their events. Partner Public Project grants, with budgets from $8,000 to $10,000, allow artists to work with a larger budget and to develop projects in conjunction with organizations. Four Public Project grants, four R&D grants, and one Partner Public Project grant are awarded each year.

Every year FORECAST distributes approximately five thousand postcard announcements, beginning in August and setting a deadline of November 15. In September and October, free informational workshops are offered at sites around the state. Between forty-five and sixty-five proposals are received during each round, and between one-third and one-half of applicants request R&D support. An independent review panel is assembled, consisting of an artist, a design professional, and an administrator or curator. Critics, historians, and others have also served, with at least one panelist from outside Minnesota and one from Greater Minnesota (that is, from the state of Minnesota, but outside the Twin Cities area). An effort is made to diversify the panel's membership in terms of race, gender, age, and geographic origin, and familiarity with public art is a must.

By contrast with traditional commission opportunities, Public Art Affairs challenges artists to seek out sites and respond to issues of interest to them in ways that they may not have previously considered. FORECAST provides up to four hours of facilitation or technical assistance, including help with public relations, documentation, material acquisition, fundraising, and resource identification. Recipients of funds for R&D projects may return the year after receiving a grant to request project support; Public Project recipients must wait a year before reapplying.

Every year almost half the applicants have never applied to the program before, and several have never before written a grant proposal. There are many more projects of merit than can be funded, and so some of the rejected applicants continue to pursue their efforts, since some of the groundwork has been done (for example, meeting with site owners, sketching mural designs, or attending neighborhood gatherings). FORECAST offers modest assistance to these and other unfunded applicants by suggesting alternative resources, in-kind services, or contacts in the field.

FORECAST produces a year-end document that records the work of each participant, and the artists as well as FORECAST use this document as a tool for education and marketing. Postcards, catalogs, videotapes, and, more recently, CD-ROMS have also been produced and distributed nationally, in an effort to encourage other communities to consider adopting their own versions of the Public Art Affairs program.

Public Art Affairs has proved useful in building a community of artists who are willing and able to explore the public realm from a variety of perspectives and to bring their energies and talents to the larger audiences outside traditional venues. Since its inception, the program has spawned dozens of independent projects, including murals, performance events, projections, sculptures, environmental installations, collaborations, and community-based efforts. The following projects are examples of those funded in the past few years:

• Erin Gleeson's residency with, and public exhibition of photographs of and by, Cambodian elders and youth in Saint Paul

• Coral Lambert's *Discover Sculpture, Explore Lanesboro* Partner Public Project, a series of cast iron medallions depicting important themes in the life of the small town of Lanesboro

• Shá Cage's storytelling/spoken word/performance series presented during Women's History Month at Seven Bridges World Market

• Lucas Alm's R&D project focused on a mobile sound canopy for possible use at Mall of America to transform mall noise into soothing sounds

• Dung Tri Mai's woven grasshopper installation in Red Wing, Minnesota, conceived as a meditation on the transience of nature

• A series of percussion pieces, using found objects, presented by Mary Ellen Childs and the performance group CRASH at festivals and events in the greater metropolitan area

Previously funded projects have included those listed here:

• A series of murals by José Curbelo and Creative Energy
• The creation of Philip Blackburn's prototype instruments for a sonic playground
• Concrete Farm Dance Collective's *Flatbed,* a roving dance performance
• Wing Young Huie's *Lake Street,* a five-mile-long storefront exhibition of his photographs depicting economically and culturally diverse communities along the exhibition route

• Artist/engineer Katrin Scholz-Barth's "green roof" architecture R&D project

• Amy Ballestad's and Shelley Chinander's all-female *Chicks on Sticks* performances involving teenagers walking on stilts

• David Hall's *The Fates,* a mythological pyrotechnic performance presented in Fair Oaks Park, Minneapolis, with a theme of destiny

• Majorie Pitz's fantasy miniature dwellings at the Minnesota Landscape Arboretum

• Dean Lucker's interactive sign-pole boxes on sidewalks around the Twin Cities

Contact information for FORECAST and Public Art Affairs can be found in the Resources at the back of this book.

Dean Lucker, interactive sign-pole boxes on sidewalks around the Twin Cities. *Photo courtesy of FORECAST Public Artworks.*

Ephemeral Public Art PATRICIA C. PHILLIPS

The domain of the temporary in public art has been a particularly fruitful area for artists to develop politically based, independent projects in public spaces, with and without official sanction. Jenny Holzer, for example, in *Truisms* (1970–73), clandestinely pasted onto buildings, doorways, and streetlights in New York hundreds of her posters containing long lists of aphorisms, which were concurrently wise and puzzling and frequently disturbing. In the 1980s, Kate Ericson and Melvin Ziegler initiated and developed a number of projects, placing advertisements in regional newspapers and often seeking homeowners to collaborate on short-lived projects in and about the public spaces of the domestic environment. In *Half Slave Half Free,* they proposed a performative project with a Hawley, Pennsylvania, homeowner who agreed to cut precisely half of his lawn while leaving the other half to grow unattended throughout a summer.

The independent interventions of artists' collectives have also effectively deployed ephemerality as a resource for examining and disclosing sites of social injustice. REPOhistory, organized in 1989, included artists, writers, performers, and activists who initiated a series of public projects to examine race, class, and the history of overlooked or suppressed stories. The group's *Lower Manhattan Sign Project* (1992), initiated during the controversial Columbus Quincentennial, involved the installation on lampposts below Canal Street of thirty-nine signs with "alternative" narratives about citizens, communities, and events that are generally ignored in official histories. The signs embraced more open approaches to history and public memory, encouraging different ways of witnessing the city's past and often dealing with issues of race and colonialism. In one case, across the street from a historical marker for the original New York Stock Exchange, artists Tess Timothy and Mark O'Brien installed a descriptive sign at the site of New York's slave market, established in 1746 and eventually the new nation's second largest. The signs also become an incentive and apparatus for supporting other activities and events, including artist-led walking tours and public dialogues.

Coalitions like Group Material, Critical Art Ensemble, and other progressive artists' groups have also pursued a fusion of artist-initiated temporary projects, engaging issues of representation and social justice and continuing to offer an urgent and energetic formula.

Clearly, ephemeral or temporary public art is not a new development; there is a robust tradition of strategically evanescent activity. But attention to ephemeral public art has increased in the past fifteen years, for practical as well as theoretical reasons.

NEW PERSPECTIVES AND DISCOURSES

In 2001, the Cambridge Arts Council, in Massachusetts, organized an ambitious international forum on the conservation and maintenance of contemporary public art (see

Hafthor Yngvason, ed., *Conservation and Maintenance of Contemporary Public Art*). For those of us who pondered the "attractiveness," if not the gravity, of the subject, the conference proceedings produced, surprisingly, a fascinating stew of practical case studies and philosophical questions about permanence, ephemerality, change, durability, and stability. Clearly, however, questions of conservation are not just conceptual and ethical; they are technical, too, and the fact remains that objects, structures, and materials do erode, deteriorate, and change over time. In spite of engaging philosophical queries concerning contemporary conservation practices, one unassailable fact endures: the conservation of art, which includes public art, must be undertaken responsibly, and it requires considerable resources over time. Although the Cambridge Arts Council forum was not designed to discourage the development of more enduring works in public spaces, it was a sobering reminder of the commitment needed to maintain a legacy of permanent works.

But even the staunchest defenders and producers of temporary projects, interventions, and performances recognize that most cities and communities generally seek a balance between lasting aesthetic forms (buildings, spaces, sculptures, established landscapes, and other artifacts) and short-lived, if not spontaneous, aesthetic initiatives. This dual pattern invariably represents the temporal lineaments of contemporary life. To take one example, the orchestration of steadfastly enduring and stunningly spontaneous aesthetic forms has been poignantly revealed in the area of public memory and commemoration, where the quiet fortitude of Maya Lin's Vietnam Veterans Memorial is recursively articulated by the objects placed temporarily at the memorial site. Perhaps communities need the lasting, the permanent, in order to fully appreciate the timeliness of more urgent aesthetic practices. Permanent work may demonstrate a particular kind of commitment to civic space, to a concept of place, whereas temporary projects represent a less confirmed conviction. The point, at any rate, is not to place the permanent and the temporary in opposition but to accept contemporary public art as a discursive process.

Ephemeral public art has never been a precise or single-minded endeavor. Its growing number of practitioners, and many of the organizations that support this type of work, demonstrate a conceptual and strategic diversity. As the line between the ephemeral and the enduring becomes increasingly imprecise, however, it is crucial for artists and arts organizations to develop and articulate theoretical positions and conceptual clarity with respect to the forms, dispersal, and duration of the work.

In ephemeral public art, there is an important distinction (others could be made) between concentration and decentralization. Without privileging one mode over the other, it is important to distinguish temporary practices that generally are place-bound from those that are centrifugal.

DECENTRALIZED PRACTICE

A growing number of public artists pursue more dispersive ephemeral practices. These artists, less interested in single events or concentrated forms, often appropriate the

forms (cards, schedules, posters, coasters, table tents, and so on) and distribution processes of public institutions and commercial spaces.

Temporary Services

In 2002, the Chicago-based collective Temporary Services, its name unmistakably announcing the temporal scope of its work, presented *Strategies: Nine Posters* as part of the *Shadow Cabinets in a Bright Country* exhibition that was held at apexart, New York (see Ted Purves, *Shadow Cabinets in a Bright Country*). The simple, colorful posters—elements in a glossary of ephemeral objects and interventions that the collective (then consisting of Brett Bloom, Marc Fischer, and Salem Collo-Julin) has developed in connection with its activist practice—offered tactical instructions for "reinforming" public spaces. Available at no cost in the gallery and elsewhere in the Tribeca area, the posters proposed ways to "add books to public libraries" and "use fences to distribute messages," and they promoted seven other strategies for disseminating critical information and creating interventions by ordinary citizens. In addition to the production of ephemerata—that is, posters and other short-lived materials— most Temporary Services projects are artist-initiated and deploy a direct system of distribution to an undetermined, nonart audience. The group's service-based practice illuminates just one of many traditions and trajectories of contemporary temporary public art.

Peggy Diggs

A recent Temporary Services poster encouraged members of the public to "modify dollar bills," and Peggy Diggs, a long-term practitioner of temporary public art, did just that in *Make Do* (2002–03) (see Ron Platt, *Borne of Necessity*). Renowned for her deliberately consumable and disposable *Domestic Violence Milk Carton Project* (1991–92, sponsored by the New York–based organization Creative Time), in *Make Do* Diggs examined individuals who are consigned to or choose poverty. For that project, she formed questions about people's relationship to money or experiences with poverty and then sought to initiate a conversation by creating stamps that imprinted these questions on the edges of dollar bills: "What is satisfied in you by buying things?" "What if you only had what you needed?" "What do you think is gained in poverty and lost through wealth?" *Make Do* had other components, but all used expendables and existing systems of exchange to disseminate public art. For Diggs, the subject in question determines the aesthetic strategies.

Helen Lessick

Helen Lessick engages the vast potential of temporality in a range of contexts, and she does so with agility. As a dedicated Situationist, she finds that particular opportunities influence, if not determine, the character of her work. For more than fifteen years she has been creating a series of one-room houses to explore dynamics of oppressive conventions as well as metaphorical liberties of the private and the public, of nature and culture. Lessick has a capacity to invent and insert her work within the patterns

or conventions of systems and institutions, when she is not actively poaching from an existing condition. She works with the prototypical, embracing both its prosaic and profound qualities, and has used books, brochures, pamphlets, installations, performances, and combinations of these forms.

Lessick's appropriative resourcefulness and active curiosity have shaped a number of her recent public projects and collaborations, and she encourages people to be attentive to one another while engaging in activities that may have become dull and repetitive. In 1993, for example, with support from the arts program of Metro, a division of the King County, Washington, Department of Transportation, Lessick and Julie Johnson used the format of a conventional bus schedule to create *Metro Hair Survey*. The reconstituted "schedule" identified a taxonomical system of hairstyles and hairstyle elements (Beatle cut, cornrows, bangs, Afro, wedge, and so on) and included a hair survey and a "hairy hall of fame" featuring little-known facts about hair. The survey, distributed in the transit system's ordinary information racks, promoted a certain amount of activity, participation, and consciousness regarding a range of culturally informed practices and conventions that have to do with the body and its adornment.

Lessick has also created projects for more specific events and occasions. In *Collect 'Ems* (1999), she made packets of fifteen baseball cards for the opening season of Seattle's new ballpark, Safeco Field. Lessick is a legendary researcher, and the *Collect 'Ems* cards, distributed by performers throughout the facility, included information about the physical artifacts (bats, balls, chest protectors, and so on) as well as the rules and lore (concerning fair or foul balls, signals, statistics, and the like) that hold sway over the great American pastime. In 2003, in advance of the 2004 opening of the Seattle Public Library's new Rem Koolhaas–designed Central Library, Lessick designed ten different bookmarks that created attention and momentum for the much-anticipated twenty-first-century library. Based on the Dewey Decimal Classification, each of the bookmarks constituted a clever critique of the changing systems and inflexible orthodoxies used to organize and perpetuate knowledge. The project, with sponsorship from the Seattle Office of Arts & Cultural Affairs and the Seattle Public Library, distributed 3,500 free bookmarks to library patrons during the first week of ten successive months in 2003.

CONCENTRATIVE PRACTICE

Krzysztof Wodiczko

Krzysztof Wodiczko's still and video projections in public spaces are time- and place-based, even though his often far-flung research and reconnaissance follow and reflect the stories of many different, often disenfranchised, citizens. Wodiczko's projections occur for a limited number of pre-established evenings at carefully chosen sites that are densely layered with historical and symbolic content. Arduous development and preparation come together in concentrated events whose resonance is particularly vivid because of their uncompromising ephemerality. Wodiczko's methodology is informed and shaped by democracy's unsettled and uneven character, and his work's brilliant

impermanence intensifies the festival-like ambience where democracy historically has been performed and challenged. (For more about the artist, see Patricia C. Phillips, "Creating Democracy: A Dialogue with Krzysztof Wodiczko.")

EPHEMERAL ART AND THE ETHOS OF THE GIFT

The ephemeral artist's intention, and our acceptance of ephemeral work, is inseparable from the work's ordinary perishability. Nevertheless, some objects do overcome their impermanence; for example, many of Helen Lessick's public art projects are ephemeral in the sense of having no appreciable lasting value, but their distribution and exchange recount the enduring tradition of the gift. Gifts can be short-lived or lasting. Some are ignored or "used up," whereas others are passed on for generations. Some are remembered long after material evidence of the giving has deteriorated and decayed; thus Krzysztof Wodiczko suggests that his short-lived art really "appears" only after the projectors are turned off.

Ephemeral public art may appear to reach an end, but its potential for creating continual social exchange and public dialogue remains encouragingly imminent. This is the promising paradox and conceptual challenge of the temporary in public art.

Gifts and Memorials

Developing a Policy for Gifts and Memorials BARBARA GOLDSTEIN

For those who collect art and have confidence in their own taste, offering a community the gift of an artwork is an opportunity to make a special civic contribution. For those who create art, offering gifts of their own work may be a way to elevate their reputations. For those who support a cause, a memorial artwork can help a community remember an individual or a group's history. All such artworks have the potential to be important civic landmarks.

It is also true that the offer of a gift presents a community with challenges as well as rewards. The offer is likely to be rewarding if the artwork or memorial is welcome, and if there is somewhere to put it. But without a policy for evaluating or planning for such an offer, the gift of an artwork can bring controversy, hurt feelings, and continual problems with maintenance.

Often, before a community has begun to think about purchasing art, it is offered gifts of artwork. If the offers are considered carefully and fairly, gifts can be a major means of creating a civic collection, and a community can even develop a policy for actively building an art collection in just this way.

In that sense, developing a policy for accepting gifts and memorials may be more important than creating a mechanism for purchasing or commissioning art. Several factors should be considered in developing this kind of policy:

• *Location.* Where are the community's meaningful open spaces, and how should they be occupied? A location high above the city may seem ideal for a sculpture or a memorial, but people may wish to keep it free for flying kites or daydreaming. It may be possible for the community to create a site inventory and seek specific donations of artwork to be placed at designated sites.

• *Audience.* Whom will the artwork serve? Is this a work that the whole community will appreciate, or is it more in the nature of a monument to the artist or collector who is offering it? A community or an interest group will often rally around the idea of donating an artwork or creating a memorial, and if there is civic support for this activity, then the artwork can be a tremendous asset to the community. With sufficient advance consideration of such a project, a community can actually raise funds for a memorial and then seek proposals from which to choose. That is how the Vietnam Veterans Memorial in Washington, D.C., was created.

• *Maintenance.* Who is going to care for the artwork? A beautiful bronze or painted metal sculpture may look wonderful when first installed, but it will deteriorate over time if it is not maintained. Establishing a maintenance endowment or a community-

Michael McCafferty, *Hive*, 1995. Installation created from straw bales at HorseHead, Duval, Washington. *Photo by Arthur Aubrey.*

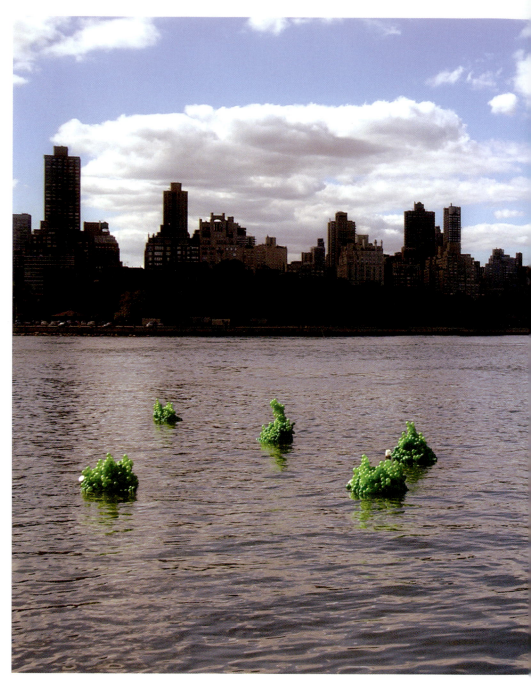

McKendree Key, *Halletts Cove*. Sculptural installation made of ten thousand green balls that form sixteen structures floating in the cove to the west of the park. *Photo courtesy of Socrates Sculpture Park.*

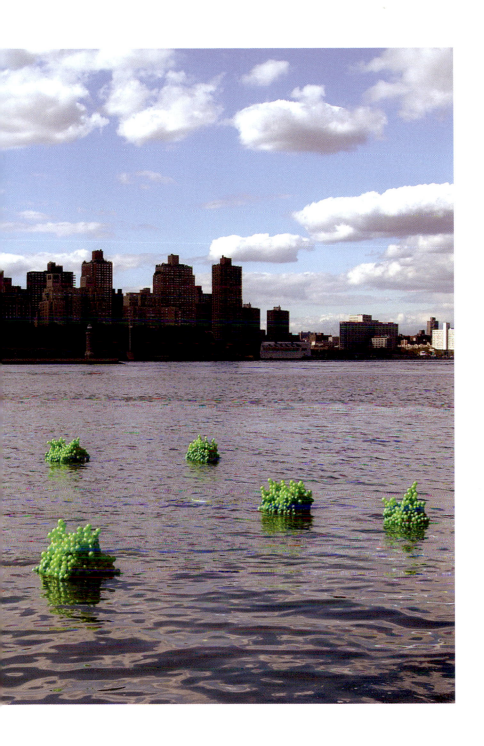

Krzysztof Wodiczko, C-print of public projection at Hirshhorn Museum, Washington, D.C., October 1988. *Photo: © Krzysztof Wodiczko. Courtesy of Galerie Lelong, New York.*

Helen Lessick, *Collect 'Ems,* 1999. Book of fifteen baseball cards for Safeco Field, Seattle. *Photo by Helen Lessick.*

Aki Sogabe, *Song of the Earth*, 1999. Pike Place Market, Seattle.

Nina Karavasiles, *Recipe for Friendship*. Amici Park, San Diego. The piece features a bronze table with recipes printed on the plates. *Photo: Nina Karavasiles and Dana Springs. Courtesy of City of San Diego Commission for Arts and Culture.*

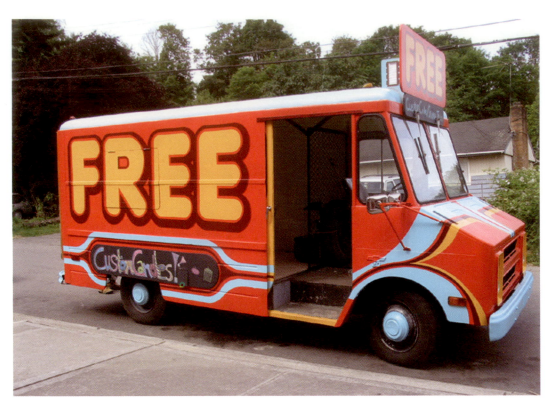

Ben Rubin, *FreeMobile*, 2003. ARTS UP project. *Photo by Ben Rubin. Courtesy of Mayor's Office of Arts & Cultural Affairs, City of Seattle.*

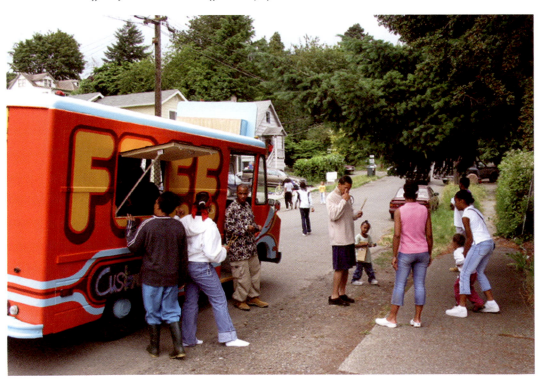

Artist design team Andrew Keating, Sherry Markovitz, and Buster Simpson helped design Viewlands Hoffman substation in Seattle, a pioneering public art collaboration. As part of the project, the team purchased windmills from folk artists Emil and Veva Gehrke to create a "whirligig garden" at the substation— a tribute to wind-generated energy.

Lorna Jordan, Adams Street Bridge, 2001. Longfellow Creek Habitat Improvement Project. *Photo by Lorna Jordan. Courtesy of Mayor's Office of Arts & Cultural Affairs, City of Seattle.*

Linda Beaumont, *Traveling Light*, 2004. Sea-Tac International Airport. Artist was selected from design team roster. *Photo by Spike Mafford. Courtesy of 4Culture.*

Dan Corson, *Skagit Streaming*, 2000. "Fish cam." *Photo by Dan Corson. Courtesy of Mayor's Office of Arts & Cultural Affairs, City of Seattle.*

based maintenance plan around a gift or memorial will ensure that it remains a civic asset.

Seattle and Portland are two cities that have developed policies for reviewing and accepting gifts of artwork and memorials. These policies evolved from attempts to tackle the issues just described. By providing clear rules and procedures for reviewing gifts and memorials as they are offered and for applying consistent criteria in accepting or declining offers of gifts, the policies have helped each city build its collection.

GIFT REVIEW POLICY *Mayor's Office of Arts & Cultural Affairs, Seattle*

Background

Works of art are occasionally offered as donations to the City of Seattle through the Mayor's Office, the City Council, the Office of Arts & Cultural Affairs, and other city departments. Gifts to the city are an important part of the city's growing visual artwork collection, presently at more than 2,500 works. In order to ensure the quality of the collection, the Office of Arts & Cultural Affairs has established this Gifts Review Policy. The Office of Arts & Cultural Affairs has limited funds to protect, maintain, preserve, and conserve the artworks in the city's collection. There is also a dwindling number of suitable artwork sites on city-owned property. Therefore, a careful review process has been established to evaluate proposed gifts to the city.

Until 1978, with the passage of the Gifts Ordinance, there existed no standard method of reviewing proposed gifts. The 1978 Gifts Ordinance (Municipal Code Section 20.36) charges the Office of Arts & Cultural Affairs with responsibility for evaluating the suitability of proposed artwork gifts and making recommendations to the mayor. If accepted, the Office of Arts & Cultural Affairs maintains records of the artwork and oversees its maintenance of artwork gifts.

The Seattle Arts Commission is responsible for review of all proposed gifts of art to the city, including donations by individuals, neighborhood and community groups, and international organizations. Artworks created by any of these groups may be placed temporarily on city property, without being offered to the city as gifts, provided that donors obtain the appropriate revocable permits for placement of the works and agree to maintain them throughout the life of the works. In these cases, gift review is not required.

Review of artwork gifts is conducted by a panel of three to five arts professionals appointed by the Office of Arts & Cultural Affairs, by the Seattle Arts Commission, or by its Public Art Committee. The appointed gift review panel meets as necessary, typically once every six months, to review proposed gifts of art to the city.

Maintenance

The Office of Arts & Cultural Affairs maintains records of artwork gifts and oversees their maintenance. However, funds to maintain artworks in the city's collection are limited. Therefore, in accepting a gift, the Office of Arts & Cultural Affairs may require that the donor sign a maintenance agreement or establish a maintenance endowment to ensure an adequate quality of care for the artwork.

Community-Generated Projects

Artworks generated through community process may remain the property of that community or may formally be accessioned into Seattle's City Art Collection. Artworks may be offered to the City Art Collection as a component of community-generated development projects, either through Seattle Department of Neighborhoods matching-funds grants or through other fund sources. If the resulting artwork is located on city property, the Office of Arts & Cultural Affairs may require a signed maintenance agreement or establishment of an endowment for maintenance, preservation, and conservation in perpetuity from the community group responsible. If the community group plans to retain ownership of the artwork, no gift review is required. However, the Office of Arts & Cultural Affairs strongly encourages community groups to raise funds and/or make specific plans for the maintenance of such works.

Panel Review Guidelines

The De-accession & Gifts Panel reviews each proposed gift of art on the basis of the criteria established below. Community groups or individual donors proposing gifts will be provided with the gifts policy in advance in order to ensure that all these criteria are addressed. The panel will require evidence that these issues have been satisfactorily resolved before making a recommendation regarding a proposed gift.

1. Aesthetic Quality. Is the proposed gift an artwork with strong aesthetic merit? Criteria for aesthetic quality include:

- Durability and craftsmanship in fabrication
- Relationship of artwork to other works in the City Art Collection as a whole
- Appropriateness of artwork scale to the proposed site
- Appropriateness of artwork to other aspects of its surroundings
- Artist's credentials and recognition

2. Site. What type of site is proposed for the artwork? Siting criteria include:

- Written evidence that location of artwork on the proposed site has been approved by the city department that occupies the site

• Neighborhood plan designation of artwork on the proposed site

• If an artwork is designated in the neighborhood plan, evidence that the artwork gift proposed is consistent with the plan recommendations

• If an artwork is not designated on this site in the neighborhood plan, evidence that the site is appropriately located and scaled for the placement of this artwork

• If the artwork is proposed for a site of regional significance (e.g., a regional park, an arterial route, a major civic building), evidence that its scale and aesthetic quality merit a prominent location

3. *Relationship to the Collection as a Whole.* How is the proposed gift compatible or incompatible with the City of Seattle's public art collection? Criteria for compatibility include:

• Does the artwork contribute to the diversity and breadth of the city art collection?

• Is the artist's work already adequately represented in the city art collection? (Artwork gifts by artists whose work is located at more than six city sites will not be considered.)

4. *Community Process.* Artwork gifts require public involvement and review. The following requirements should have been met:

• The donor must present evidence of public involvement and comment about the proposed gift. This could include a record of community meetings, notices, and opportunities for community comment.

• For community-based projects, artist selection must have been based on an open competition or a process that demonstrates substantial community involvement (e.g., review and discussion by immediately surrounding community).

• If the artwork gift is a result of direct selection by the donor, it must contribute to the diversity of the city's collection.

5. *Technical Specifications and Feasibility.* Artworks proposed for installation on city property must be durable and meet city safety concerns. The De-accession & Gifts Panel will review detailed construction/fabrication drawings consisting of site plan, elevation, and section view of artwork, describing:

• Adjacent/surrounding site conditions, if applicable
• Dimensions
• Materials
• Colors
• Power, plumbing, or other utility requirements
• Construction/installation method.

• Fabricator's qualifications to install the work, and evidence that the fabricator carries adequate insurance to meet city standards

The panel may require additional support materials, such as text verbally describing artwork and specifications, structural and engineering drawings, models, or presentation drawings.

6. Budget and Contractual Information. Prior to acceptance of a proposed artwork, the De-accession & Gifts Panel will review the adequacy of its proposed budget and funding source. Criteria include:

• Artist's fee must be equal to at least 20 percent for the artwork cost or must have been waived by the artist/artist's estate in writing.
• Projected costs must be accurate and realistic as demonstrated by artist/fabricator and/or installer estimates.
• Cost estimates must be guaranteed by the provider through the installation of the project.
• Payment for artwork and its installation must be guaranteed by the provider through a valid, signed contract with the artist.

7. Durability and Routine Maintenance. Proposed artwork gifts must be accompanied by a maintenance plan prepared by and/or reviewed by an artwork conservator. It is expected that proposed permanently sited artwork gifts will last a minimum of thirty years. Criteria include:

• Explanation of expected life span of artwork in public, nonarchival exhibition settings
• Description of durability of similar artworks in the same material(s) attained
• Explanation of environmental conditions and suitability of artwork materials to the conditions of its proposed display
• Demonstration of seismic safety considerations (i.e., engineering review for seismic safety)
• If the site presents special obstacles (e.g., poor drainage, steep slope), evidence that these obstacles been adequately addressed

8. Vandalism and Safety. Proposed artwork gifts must entail consideration of potential vandalism and public safety issues. Proposed gifts must demonstrate consideration of the following criteria:

• Description of potential safety hazards and how they have been addressed
• Description of elements of the artwork that might be prone to vandalism and how this potential for vandalism has been addressed
• Description of how the specific issue of graffiti has been addressed

9. Long-Term Maintenance. The Office of Arts & Cultural Affairs is responsible for overseeing the maintenance of artworks in the city art collection either directly or through oversight of the organization accepting maintenance responsibility. A maintenance plan for artwork gifts must be provided as part of the donation proposal. This plan must be filled out by the artist or a qualified conservator and submitted on a form provided by the Office of Arts & Cultural Affairs. The De-accession & Gifts Panel will review this form for adequacy. Maintenance criteria that must be met include:

• Estimated accounting of ongoing maintenance requirements and cost

• Provision of maintenance funds or agreement (the panel may, at its discretion, require the donor to sign a maintenance agreement and/or allocate funds for ongoing maintenance and preservation of the artwork)

• Description of artwork installation and removal requirements

• For gifts of "portable" artworks, handling and installation requirements (e.g., instructions for personnel and equipment required for moving the work)

• Written permission from the artist/artist's estate for work by a qualified conservator (reasonable efforts will be made by the Office of Arts & Cultural Affairs to contact living artists in the event of the need for major restoration; general maintenance work will be conducted as necessary, without such formal notification)

• Written permission granted by the artist for removal of the work because of possible changes in future use of the site

10. Timeline. If a proposed gift is not completed within the timeline originally established, or if significant changes (both conceptual and financial) to the proposed work occur, it must be reviewed again by the panel. The Office of Arts & Cultural Affairs is authorized to request that a proposal be resubmitted and to review the costs incurred by a delay in the timeline.

Recommendations on Acceptance and Rejection of Gifts

The panel makes a recommendation to the appropriate committee of the Seattle Arts Commission on a course of action regarding each proposed gift or project. Upon approval by the committee, the recommended acceptance will be forwarded to the mayor and the Office of Arts & Cultural Affairs itself. Based on the recommendation of the panel, the committee may also recommend that a community group retain ownership of the work.

The committee's recommendation will be presented to the Office of Arts & Cultural Affairs, and staff will notify the donor and the recipient department of its recommendation to the mayor.

If the gift is accepted, the recipient department will supervise and assist in the installation of the artwork.

De-accession Review

Gift artworks will be reviewed on a regular basis and de-accessioned, as necessary, through steps provided in the Office of Arts & Cultural Affairs de-accession policy and in accordance with national standards for de-accessioning works of art.

Worksheet for Prospective Donors Offering Gifts of Portable Artworks to the City of Seattle (Addendum/Appendix to City's Gifts Policy)

It is an honor for an artist's work to be included in the City of Seattle's collection of public art. Many gifts of art are offered to the city, but only a few can be accepted. The Office of Arts & Cultural Affairs Gifts Panel is charged with the responsibility of reviewing all artworks offered as gifts to the city. After reviewing an artwork, the Gifts Panel makes a recommendation to the Office of Arts & Cultural Affairs to accept the gift, decline the gift, or table the offer until further information is available. To make sure your offer is reviewed the first time through, please submit the following to the Gifts Panel:

• The actual work(s) of art, if feasible. Talk to the public art project manager before you decide. If possible, submit several works offered for the panel's choice.

• A cover letter explaining that you are offering this artwork to the city as a gift; a copy of the artist's résumé or biography; context for the artist's work; a description of other examples of the artist's work, plus exhibitions and collections, if any; and further background, if available, on the artist's significance.

• 35mm color slides of a range of the artist's work (for context). Indicate if more than one work is available for selection or is being offered.

• A current appraisal of the artwork's value.

• Information on this particular work's context, provenance, history (where it comes from, where it's been, where it's been displayed, if at all).

• A letter of authentication from the artist, stating that it is his or her own work. If you are a donor submitting an artwork that you did not make, this letter should be from the artist.

Artwork submitted for consideration should be in good condition. If conservation work is required, this may be a reason for discussion with the donor. (Work may not be accepted if the panel judges that the work may require immediate and/or expensive conservation.)

PORTLAND MEMORIALS POLICY *Placing Memorials in Public Parks*

Adopted by City Council on April 12, 1989

The primary purpose of a park or open space is to be usable by the public. Donors of new memorials should be asked to broaden their search for an appropriate location. Also to be considered are temporary or portable memorials and the naming of existing parks. Memorial proposals should represent community values and be mindful of future generations. The quality of timelessness should be considered in the significance of the person or event being memorialized. Maintenance concerns should be a primary consideration, including durable materials and future maintenance. A location may reach a saturation point, and limitations will be considered on future installations at that location. Improvements made in public space become the property of the public. The memorial donor is to pay for the design, installation, manufacture, and maintenance of the memorial.

Seven Basic Types of Memorials

• *Simple plaques:* The installation of simple plaques will not change the character or use of a park setting. Depending on their placement, however, they may impact park maintenance operations.

• *Adorned plaques:* The installation of adorned plaques has more of an impact on the use and maintenance of existing parks. Incorrectly placed, they can interfere with use areas or circulation patterns.

• *Sculpture and other permanent artwork:* The arts community will be consulted through the Metropolitan Arts Commission and the Design Review Commission. As these proposals are more complex and can be more expensive, the donor is required to go through the entire process twice: once at a conceptual level, and again when the design is developed.

• *Fountains:* Fountains are in a category by themselves because of the added complexity of utilities necessary for installation. As these proposals are more complex, the donor is required to go through the entire design process twice: once at the conceptual level, and again when the design is developed.

• *Memorial gardens and plazas:* These types of installations can be truly monumental in scale and can change the character of a park. Other impacts can include maintenance, traffic, and circulation. For these reasons, the review procedure must be more extensive and careful. These proposals also go through the process twice, once at a conceptual level, and again when the design is developed.

• *Other memorials:* Any memorial that does not fit any of the categories previously described will be reviewed according to the process outlined under "Memorial gardens and plazas." This will ensure that the process is careful, public discussion.

• *Basic park accessories:* Basic park amenities (such as benches, picnic tables, trees, and shrubs) that meet park standards do not require an extensive review process. These may be handled administratively by the Park Bureau to ensure that the location is appropriate within the park. The Park Bureau reserves the right to adjust the location.

Approval Criteria

• The person or event being memorialized is deemed significant enough to merit such an honor. The person so honored shall have been deceased for a minimum of two years.

• The memorial represents broad community values.

• The memorial has timeless qualities and makes a statement of significance to future generations.

• The location under consideration is an appropriate setting for the memorial; in general, there should be some specific geographic justification for the memorial being located in that spot.

• The location of the memorial will not interfere with existing and proposed circulation and use patterns of the park.

• The memorial is compatible with the park's current or historic master plan, if existing. (If there is no master plan, the Park Bureau shall prepare a "statement of character.")

• The location and design of the memorial is consistent with the character and design intentions of the park.

• The quality, scale, and character of the memorial are at a level commensurate with the particular park setting.

• The memorial contributes to the park setting from a functional or design standpoint.

Maintenance

In general, any proposed memorial should be backed by insurance, a bond or endowment fund, or a maintenance schedule by the memorial donor adequate to ensure its care so that the gift will remain in a condition satisfactory to the donor and the city. The posted insurance or bond should also cover costs of installation and/or removal. If an adequate level of maintenance is not continued, the city reserves the right to remove or modify the memorial or a portion of the memorial. When the city commits to maintain a particular memorial, and the city is not able to maintain the memorial at a level satisfactory to the donor, the donor shall have the opportunity to supplement maintenance as required.

Appeals

If the donor's proposal is not acceptable, the donor has the right, after the review process is complete, to appeal to the commissioner in charge of the Bureau of Parks and Recreation and to City Council for a reconsideration of the proposal. Conversely, if a memorial is approved and a citizen opposes the project, that citizen also has the right to appeal to the commissioner in charge and to the City Council for a reconsideration of the proposal.

Revising Rosie the Riveter

From Public Art to National Park

DONNA GRAVES

M onuments and memorials, by their very nature, are only fragmentary constructions of the past. At times, however, and under the right conditions, they can serve as catalysts for more vital connections between contemporary residents, the history of the places where they live, and their own place in history. One such monument is the Rosie the Riveter Memorial in Richmond, California. Created to honor American women's labor during World War II, the monument project illustrates the fertile intersections among public art practice, public history, and community development.

HISTORICAL BACKGROUND

Richmond initiated the Rosie the Riveter project in 1996, as a means to reclaim an important aspect of the city's history. At the beginning of World War II, Richmond's population had been 23,000; by 1943, the city was a twenty-four-hour boomtown with more than 100,000 residents. The Kaiser Shipyards, the nation's largest and most productive wartime shipbuilding facility, played a central role in this transformation, bringing people from all backgrounds and all areas of the country to work in the San Francisco Bay area.

Few American towns or cities can claim a World War II home-front story as dramatic as Richmond's, and yet the decades after the war found Richmond residents alienated from their community's distinguished history. The city's regional reputation as a center of heavy industry, poverty, and crime was solidified in the postwar years. Without the intense development that took place in many other Bay Area communities, large parts of Richmond retained their wartime-built environment, yet most physical reminders of the war years along the waterfront had been demolished.

Beginning in the 1970s, the Richmond Redevelopment Agency, which controlled development on the former shipyard site, transformed much of the area into a collection of light industrial facilities, gated residential communities, and public open spaces along the bay. In the early 1980s, the first of a series of waterfront city parks was designed and built on the former site of Kaiser Shipyard No. 2.

By the 1990s, as the city's economic prospects brightened and its former shipyard workers reached old age, the time became ripe for public recognition of Richmond's wartime contributions, especially those of local women. In fact, just such a project had become something of a crusade for Donna Powers, a city councilwoman who promoted the importance of commemorating Richmond's "Rosies," as she called them. By 1996, others in the city's power structure had joined the crusade.

As a first step, city staff and community representatives formed a memorial committee that entertained a variety of strategies for recognizing women's wartime roles. Suggestions included a waterfront "walk of fame" where individual names would be inscribed, and the renaming of a city park. Meanwhile, the Richmond Arts and Culture Commission was working to pass a public art ordinance, which influenced the memorial committee to settle on an interpretive artwork as the most desirable option. The city council then directed the Richmond Redevelopment Agency, which administered one of the city's largest budgets, to fund and oversee an interpretive art project to be built in one of the parks located in the area that had been Kaiser Shipyard No. 2.

In 1997, the Redevelopment Agency hired me as the memorial's project director, and I immediately began to look for other commemorations of women's efforts on the World War II home front. Not surprisingly, I found none: there are few landmarks dedicated to women's history anywhere in America's urban environments. Given this scarcity of recognition, the memorial committee agreed to broaden the project's commemorative scope. Our revised goal was to develop the first *national* tribute to American women on the home front.

THE MEMORIAL'S DESIGN

In 1997, the Rosie the Riveter project launched a regional design competition. We asked for interpretive visions of Richmond's local history and of the crucial contributions that eighteen million U.S. women had made to the World War II labor force. From a field of more than seventy-five individual artists and interdisciplinary teams, we commissioned five finalists to develop designs.

The design submitted by Susan Schwartzenberg, a visual artist, and Cheryl Barton, an environmental sculptor and landscape architect, was chosen for its skill in responding to a complex interpretive demand with a design accessible to a broad audience. Their proposal, "Constructing Memory: Commemorating Rosie the Riveter," took the form of a ship under construction, both to recall the actual work performed at the monument site and to evoke the "constructed" nature of social memory. History as a shifting collection of multiple narratives—an idea shaped by decades of work by social historians that informs an increasing number of public artworks—would be represented by the inclusion of a rich variety of texts and images, providing catalysts for individual memories and lively conversations.

The memorial design in its finished form also integrates sculptural and landscape elements that enliven an underused area of the park along the San Francisco Bay Trail. A regional effort to link communities around the entire Bay Area, the trail's intersection with the monument means frequent casual encounters with the Rosie the Riveter Memorial by those walking, running, or cycling along its path.

In addition to Schwartzenberg and Barton's site-specific artwork, other components were developed to create richer connections between the memorial project's sub-

Susan Schwartzenberg and Cheryl Barton, landscape architect, *Rosie the Riveter Memorial* viewed from crane, looking west. *Photo: Lewis Watts, courtesy of Susan Schwartzenberg.*

ject matter, the local community, and the wider public. These included a newsletter; a Web site; a questionnaire that yielded a trove of memories and a list of more than two hundred women who had worked in the Richmond shipyards; an oral history program; a short video documentary; a high school education project developed with a local nonprofit organization; and a campaign, "Tradeswomen: Pioneers Then & Now," developed in collaboration with labor organizations and geared to contemporary young women interested in employment in the trades.

RECEPTION OF THE MEMORIAL

Before the memorial was built, few people living near the project site expressed reservations beyond worrying that the artwork might block their bay views. But plans for the memorial did feed into existing tensions over how Richmond's waterfront parks were used, and about who was using them. For example, residents of nearby middle-class housing developments had been vocal in their displeasure with weekend parties and soccer games in the park, and with the exuberant children who flocked there from other Richmond neighborhoods; the memorial's proposed displacement of an out-

dated playground cheered some who hoped that installation of the monument prom-
ised a new commitment on the part of the city to more passive uses of the park. (Plans
for relocating a totlot elsewhere in the park were the subject of lively debate and are
now stalled because of budgetary constraints.)

Since the memorial's completion, its local reception has been overwhelmingly pos-
itive. A steady stream of visitors traverses the monument, absorbing its words and
images; moving through the site, students and families engage in dialogue and infor-
mal history lessons. Public events and forums organized as part of the memorial project
have dramatically raised awareness of and pride in this chapter of Richmond's his-
tory. Media coverage, too, has been favorable. Numerous articles about the monu-
ment have appeared in the regional press, and such national outlets as CNN, the *Weekly
Reader,* and the *New York Times,* in addition to magazines devoted to art and design,
have run features. Richmond, a community most accustomed to media coverage of
its homicide rate and toxic industrial accidents, has reveled in the positive spotlight
and been inspired to incorporate its history into further plans for community and eco-
nomic development.

A NEW NATIONAL PARK

The most dramatic outcome of the Rosie the Riveter Memorial project was the devel-
opment of a new national park in Richmond. From the earliest phases of planning for
the memorial, it was clear that a story even larger than that of the local "Rosies" was
embedded in Richmond's streets, structures, civic organizations, and personal mem-
ories. Support from Congressman George Miller led to a visit from the National Park
Service in 1998, when city representatives and I laid out the complex story that
Richmond had to tell of migration, housing, child care, health care, labor unions, civil
rights struggles, and integrated workforces on the home front. By October 2000, the
U.S. Congress had passed legislation to authorize creation of the new national park,
and congratulatory letters from President Bill Clinton and Vice President Al Gore were
read aloud to the throng of several thousand people assembled for the Rosie the Riveter
Memorial's dedication.

Inspired by and expanding upon the city's memorial project, the Rosie the
Riveter/World War II Home Front National Historical Park incorporates a range of
sites: war-era daycare centers that still serve local families, the original Kaiser Field
Hospital, complexes of war workers' housing, a Victory ship, and more. With its new-
found recognition of Richmond's historical resources, and with encouragement from
the National Park Service, the city of Richmond passed a historic-preservation ordi-
nance to protect those sites and others that would be identified as planning for the
park moved forward.

Now in its early phases, Rosie the Riveter National Historical Park presents dra-
matic challenges to the National Park Service, the city, and additional collaborative
partners upon whose efforts its development will depend. The park's historic sites are
owned by both public and private entities and are woven into a changing and, in places,

quite challenging urban fabric. The social history that the park interprets is complex and, in several instances, contentious: a current project combining art and interpretation has inspired debate about how the World War II experiences of Richmond's Japanese American community should be described.

Forged through partnerships among a variety of stakeholders, the Rosie the Riveter/World War II Home Front National Historical Park will inevitably face tensions over historical interpretation, aesthetics, politics, and the requirements of commerce and tourism. Yet the effort is also a remarkable opportunity to incorporate contemporary art, historic preservation, and community development and to develop innovative strategies for animating a neglected aspect of Richmond's and America's social and urban history.

Case Study

Designing the Rosie the Riveter Memorial SUSAN SCHWARTZENBERG

Cheryl Barton's and my joint expertise combines history, memory, biography, history of place, and the cultural landscape. We came together in part because of our interest in narrative and places, but also because we both identified with the struggle of women to realize professional lives. We wanted to give homage to a generation of women who had opened opportunities for us.

Before our first visit to the site, we gathered some historic images of the Kaiser Shipyards and docks that had been copied from the collection of the Richmond Museum of History. We were both struck by the lack of indicators of the scale of the industry that had existed less than sixty years before. There had been twelve shipways, where more than seven hundred Victory and Liberty ships had been mass-produced, as well as several assembly yards and huge metal-fabricating shops.

The Museum of History also housed materials, collected by the Rosie the Riveter Memorial project, that proved to be triggers for the design. The memorial team had gathered several binders of letters and forms that women had filled out to describe their work and lives in the shipyards. (The Kaiser Company had left no workforce records.) The letters and descriptions built a picture—of labor, life during the war, marriages, opinions, memories of Richmond, and friends—but they also cataloged the strange process of memory. Often women apologized for not remembering the exact years they had worked in the shipyards or the last names of their foremen or how many different jobs they had held. And yet, although they had forgotten facts and figures, they remembered special friends as well as numerous amusing and scary experiences on the job. Often a woman would begin her letter with a list of everything she had forgotten, but then her narrative would gain momentum as memories seemed to

flow from her pen. It also seemed that some women had spent little time recalling those years, and that this opportunity to remember offered a retrieval of their forgotten past.

A photograph of one expansive shipyard, where ship sections were in the process of being constructed, proved particularly evocative. The individual sections would be assembled in the shipways, but the shapes in the yard already resembled a ship, although one had to use one's imagination to construct it. In this link between remembering—or the reconstructive process of human memory—and the assembly process required to build the ships, a concept suggested itself. We based the sculptural elements of the memorial on these prefabricated pieces.

The memorial, integrated into this waterfront landscape, was also intended as an experience—a walk through both time and space—where people could travel its length looking at imagery and reading quotes and historical references. Personal quotes from the letters were selected to suggest experiences that might trigger the memories of the World War II generation, memories that could be shared with family members and friends. From these component fragments—sculpture and landscape, images, words, and recollections—each visitor might build a picture of the past. We also chose an underutilized location at the water's edge, to bring the park visitors to a view toward the Pacific Ocean: the embarkation route for each ship and crew.

Close collaboration with Donna Graves and the City of Richmond resulted in several programs to involve the local community and inform the design. Graves organized a panel to explore the theme of monuments and memorials as public history. The panel included a historian, a cultural historian, the design team, and a landscape architect. A lively debate wrestled with issues of labor and women's history and what to include in a home-front story.

A memory workshop was also coordinated. We invited the "Rosies" and their families to bring photo albums and artifacts from the war years to share, and to let us photograph for inclusion in the memorial and in the Rosie the Riveter Archive. After people looked at one another's memorabilia, the discussion was spirited, demonstrating how shared recollections can boost individual memory. The discussion was recorded, and transcribed excerpts were integrated into the memorial design.

During development of the memorial's design, people living in Marina Bay Park became nervous that the memorial might block their views of the waterfront and have a negative effect on property values. They also feared that it might bring too many people to the park. In response to these concerns, we invited community residents to an afternoon walk-through event, guiding them along the path of the proposed memorial, showing them where the sidewalk would be, and letting them look at drawings so they could discover for themselves how "see-through" all the memorial's components would be. We also told them about park renovations that were planned. This extra effort proved worthwhile, and most of the neighbors were happy and very supportive. In fact, some of them today have taken on a stewardship role, coming out to sweep and clean around the memorial.

Community-Generated Projects

Community-Based Public Art Programs BARBARA GOLDSTEIN

Much of the public art throughout the United States is created through grassroots efforts. Neighborhoods or communities that decide to commemorate events or develop local amenities often choose the approach of public art, raising money and commissioning artists to create landmarks. Such community-generated projects include murals, neighborhood gateways, commemorative sculptures, and many other forms of public art. They enrich our neighborhoods and make our cities more interesting places.

Community-based public art programs often receive public support, but not always from arts agencies. Their funding is more often derived from social service agencies, neighborhood service agencies, community-development block grants, and the like. Most government-based public art programs use a percent-for-art funding formula, whereby a certain percentage of the government's capital construction budget is set aside for public art commissions. As a result, most governments are restricted to spending their funds on specific public works projects. Those arts agencies that are able to fund community-based projects often provide support in the form of grants, or they fund projects that match activist artists with community groups.

NEIGHBORHOOD MATCHING-FUND GRANT PROJECTS

Many cities have departments that support neighborhood development, and often such departments offer programs of grants to support community-generated projects (see the Resources section at the end of this book). One example of such a program, and a notable model of public support for community-based art, is Seattle's program of neighborhood matching-fund grants. This granting program makes funds available to geographically based communities that propose projects likely to strengthen the city's neighborhoods. The program funds projects that address a wide range of community issues, from the environment to education and public art.

One example of these projects is Aki Sogabe's *Song of the Earth*, which commemorates the history of a community that has virtually disappeared from Seattle's Pike Place Market: the Japanese and Japanese-American farmers who made up two-thirds of this open-air market's growers and sellers until February 1942, when President Franklin D. Roosevelt issued Executive Order 9066 and confined 120,000 Japanese and Japanese-American U.S. residents in internment camps. Sogabe, a Japanese national who had previously worked primarily in the traditional Chinese form of papercut, translated their story into a colorful mural and transposed it photographically to porcelain enamel steel panels. According to Janice Yee, a community organizer who spoke about

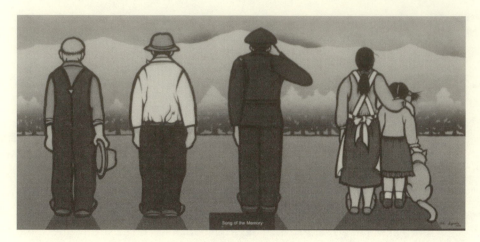

Aki Sogabe, *Song of the Earth*, 1999. Pike Place Market, Seattle.

Song of the Earth to the *Pike Place Market News*, these farmers "cleared the land, grew and harvested their produce and traveled from all over the Puget Sound area to sell their produce directly to the public in the Market. They did this despite extreme race prejudice exemplified by the alien land laws which prevented them from owning the land they worked." The mural's creation was initiated by the Japanese American Citizens League and financed by individuals, community societies, foundations, and a neighborhood matching-funds grant. It was installed directly above the primary public entrance to Pike Place Market, where it stands as a reminder of the enormous contribution that these farmers made to Seattle.

PROJECT GRANTS

Some arts agencies designate specific funds for community arts grants; in San Diego, for example, such funds are derived from a hotel-motel tax. A recent project funded through this program is *Recipe for Friendship,* by Nina Karavasiles. The work, four tables topped with red-and-white glass mosaic tablecloths and bronze sculptures of food, is sited in Amici Park, in the city's Little Italy neighborhood. The tables reflect the nature of immigrant life and the relationships created over meals, and they include recipes inscribed on bronze napkins, which encourage viewers to interact with the work by taking rubbings. Plaques adjacent to each table include additional inscriptions that pertain to Italian and Mexican culture.

NEW-GENRE PUBLIC ART: NEW*LAND*MARKS AND ARTS UP

Another model of community-generated public art has grown out of the work of such "new genre" artists as Suzanne Lacy and curators like Mary Jane Jacob, whose Culture in Action program engaged artists with Chicago communities to create temporary pub-

lic artworks during a period of several months. New-genre public art, encompassing a variety of media, has been extensively discussed and debated in such books as *The Citizen Artist,* an anthology edited by Linda Frye Burnham and Steven Durland, as well as in Cynthia Freeland's *But Is it Art?* and Suzanne Lacy's *Mapping the Terrain* (see the bibliography, in the Resources section).

New*Land*Marks

Extending the idea of artist activism, the Fairmount Park Art Association initiated New*Land*Marks: Public Art, Community, and the Meaning of Place in 1996. (For a fuller description of this association and its history, see Penny Balkin Bach, "Private Support for Public Art," elsewhere in this book). The Fairmount Park Art Association has actively sought out communities to engage with artists and then selected artists to work with those communities. To date, the organization has successfully paired artists with sixteen communities throughout Greater Philadelphia. In the course of the project, not only has the Fairmount Park Art Association matched artists with communities, it has also strengthened the bond between them by providing extensive training in public art practice to artists and community members alike.

ARTS UP

In 2000, inspired by New*Land*Marks and artist-activated projects, Seattle initiated a similar program, titled ARTS UP (the program's name is an acronym for "Artist Residencies Transforming Seattle's Urban Places"). This program also built a pool of artist-activists and paired them with communities that wanted to explore their identities through art. The program differs from New*Land*Marks in that it has expanded beyond visual art and encouraged communities to select their own artists from a prequalified pool.

ARTS UP has been effective in helping communities share their stories with a broader public. The partnership between the Hillman City neighborhood and Oakland artist Jon Rubin provides an illustration.

"Hillman City is one of Seattle's earliest communities," explains Lisa Richmond, project manager. "However, unlike surrounding neighborhoods that have successfully built on their historical roots, Hillman City struggles to find its own identity. The residents of the area are mostly lower-income and include a large immigrant population, first-time homeowners, and renters. There is little sense of community identity or cohesion. Hillman City applied to ARTS UP in the belief that working with an artist could help them build community."

Hillman City residents selected Rubin precisely for his ability to create vibrant, offbeat projects that draw people together. In the summer of 2003, Rubin produced *FreeMobile,* a series of weekend performance works in which different community members drove a decorated ice-cream truck around the neighborhood and distributed free goods and services, including candles, hair braiding, and dance lessons. The project drew neighborhood residents out of their houses to meet each other and learn more about their community.

Design Team Projects

The Artist and the Design Team BARBARA GOLDSTEIN

There are several ways to integrate the work and thinking of artists into environmental or architectural design. One way is to include artists as members of the design team. Another is to create a plan for incorporating art into specific architectural elements. Yet another is to include artists in the earliest planning aspects of infrastructure projects (see the section titled "Artist-in-Residence Projects," elsewhere in this volume).

Traditionally, the lead designers of buildings and environmental projects have been architects, engineers, or landscape architects. Their role has been to set the direction and model the aesthetics for other members of the design team. Traditional arrangements like these have ensured consistency of aesthetic vision, but they may also have limited the opportunities for surprise, whimsy, and creative synergy.

An alternative approach, one that can lead to broader artistic vision and creative cross-fertilization, is to place an artist on the design team at the beginning of the project. In a successful partnership of this kind, the artist can reinforce the design program by introducing an additional creative voice and providing a sort of "underpainting" that illuminates the purpose of the project. Collaborations of this type add value to projects, encouraging artists and architects to work together and to use standard construction elements in creating extraordinary things.

A design team will work best when all its creative participants—architects, landscape architects, engineers, artists, and others—are selected at the same time, at the outset, and can undertake their work as a collaborative effort. Team members must be willing to view their projects conceptually at first, looking at how the environment and their own design programs might be transformed through their collaborative efforts. In fact, the creative transformations that are the hallmark of a successful design team can occur only when the participants are genuinely interested in collaboration and are able to work cooperatively in a nonterritorial way.

Sometimes it is not possible to include an artist at the outset of a construction project. When an artist can't be selected early in the design process, it may be advisable to take a more traditional approach of incorporating art into architecture. In this scenario, when a project reaches the late schematic stage or the phase of design development, the lead designer identifies construction elements that might be enhanced by the work of one or more artists. Examples of such elements could include terrazzo floors and artist-designed railings, metalwork, glass, or lighting elements. Additional funds for art are generally required in this type of project, and the designer will also specify the budgetary allowance for these elements so that the artists know the base budget. Once the elements and their budgetary allocations have been decided, artists

are selected to create designs that can be incorporated into the project's construction documents.

Both scenarios will result in an enhanced project. In design team projects, the artist is often able to influence the direction of the design to create elements that help reveal the function of a building or that lead people on a journey through a landscape. A wall can become a historical exhibition, just as a reception area or a garden can become an environmental installation. In "art in architecture" projects, the artist can reinforce the architectural details by adding decorative elements and burnishing the building's aesthetics.

Design Teams

A Brief History

NORIE SATO

The design team, as pioneered by the Seattle Arts Commission (now the Mayor's Office of Arts & Cultural Affairs), originated in 1976 during a conversation between the Arts Commission and Seattle City Light, the city's public electrical utility. City Light, in connection with expenditures for burying power lines, had generated money for public art through Seattle's percent-for-art ordinance and was now about to build the new Hoffman Substation in the Viewlands neighborhood of Seattle.

I was serving on what was at the time the Seattle Arts Commission, and was participating in discussions on how to proceed, when City Light's engineer Bob Bishop suggested a project in which artists and architects might collaborate on incorporating art into the new substation. Though the Arts Commission staff was somewhat skeptical that any artists would be interested, I was rather enthusiastic about the idea. I was also the only visual artist on the Arts Commission. As it happened, the other commissioners were willing to listen to the artist in their midst, and we decided to move forward.

After a call for artists and a selection process, which for the first time involved conducting interviews as well as looking at artworks, the Arts Commission selected Buster Simpson, Andrew Keating, and Sherry Markovitz to work together on the project. I was on the approval panel—a necessary advocate from the administrative side.

This was not perhaps the smoothest of projects, but the process nevertheless worked, and its success engendered many others. Much credit must go to the initial team members, including the architects and the Arts Commission support staff, for exploring the new territory. What the team did was change the process by which such projects had been developed and designed. Team members looked at the community in a way that was different from City Light's customary perspective, and they engaged

the community in a way that was new. They considered not just architecture and place but also the systems and functions of the substation, and they tried to make sense of them for the public. They looked at what art could be—at what kinds of art could both enhance the substation and inspire the public. Not only did the artists contribute substantially through specific elements at the substation, they also recommended the purchase of a series of colorful and charming wind-activated kinetic artworks by Emil and Viva Gehrke, folk artists from Coulee City, Washington.

The Arts Commission was fortunate to have a succession of visionary, smart staff people who developed the design team idea more fully with other artists, and in subsequent projects. Commissioners, too, were active, supportive, and willing to get behind projects that pushed the envelope. They were willing for artists to see where their thinking might take them, if not always to production of a recognizable "artwork."

Since then, other design team projects from around the country have added immeasurably to our knowledge and experience base. Now, nearly thirty years later, and with much more experience, my own as well as that of many fellow artists, we still owe a lot to the early projects and to the thinking and methodology they pioneered. Yet each design team is in some sense a reinvention of the system. Each one is highly individualistic, dependent as it is on the personalities, the context, the place, the agencies, and the administrators involved. We are better and more skilled at working on design teams now, and each new experience builds on our accumulated knowledge and skills. Nevertheless, there is so much that is different, new, and quirky about each project and team that the process has not become any less challenging or less interesting.

PROCESS

The design team is less a structure than a process for conceiving, designing, and developing the entire site or project as well as the artwork itself. It is a way to integrate "art" thinking (or an artist's thinking process) with that of other design disciplines, an opportunity to make an artistic vision or idea the basis of the entire project. If the team approach is more or less standard practice among building and landscape architects, among artists it remains something of an anomaly. Artists—trained to pursue our own ideas, to develop individuality, to work individually, and to make the solo statement—are often at a disadvantage when thrust into a design team context. The design team process is one that many of us had to learn through discussion and trial and error. And still there are no set "standards"—it is a process I continue to learn, and to learn from.

The design team brings art values and "art" thinking into the mix, and art brings meaning and metaphor to a place. An artist's early involvement with the design team helps introduce meaning and metaphor at the outset, so that not art alone but all the other disciplines contributing to the endeavor can together design a project that supports that meaning and metaphor. Thus they create a site marked by overall conceptual cohesion, not just material or stylistic cohesion.

Inherent in the idea of the design team is the idea of collaboration—perhaps the most difficult part of the process. In 1998, Elizabeth Conner, Jerry Mayer, and I, in a document for the Sound Transit (Seattle) Art Program, defined collaboration as

> the willingness of different types of people to share their perspectives to identify and solve art and design challenges. This process involves free interaction among artists and design professionals, administrators and the public. In a successful collaboration, all participants remain open to each other, listen carefully and challenge with sensitivity.

By the time we were able to develop this seemingly simple definition, which took us a while and required more than a little careful crafting, the Viewlands Hoffman Substation project was more than twenty-five years in the past. The three of us had already worked on several design teams (though not together). One reason why collaboration is difficult is that ideas—and their proponents—are exposed and vulnerable. Another is that in artmaking and design one is taught to own an idea, but in the best collaboration it is the group, not the individual, that owns the idea. This means that the initial seed of an idea will pass through many different brains and iterations. In a context where there may be competition and the potential for clashes of egos, personalities, and chemistry, this is a tough process. But the best design teams and collaborations are those in which all participants are equally able to suggest and debunk, to transform on a grand scale and attend to minute detail.

Contrary to the popular notion that ego should be suppressed in a collaboration, the truth is that ego—or, perhaps better, confidence—is important to the process. One needs enough ego, or confidence, to promote an idea and be comfortable responding to others' ideas, but not so much that one can't recognize others' good ideas or stop promoting an idea shown to be of no interest to others on the team. The process isn't a series of compromises, as some people claim, but one of making ideas better, making them work in the context. One's initial idea changes and transforms. It may even lose one critical aspect and develop another. The transformed idea is not necessarily less valuable or valid; it may be much better. The worst design teams, in my experience, have been those where a member held on to an idea and didn't let anyone else in or wouldn't let the idea go when it was shown to be inappropriate. On those teams, the process became a competition of ideas, mine versus yours; there was nothing but stalemate and friction between members. On the best teams in which I've been involved, everyone was comfortable putting out ideas, not necessarily formed or "good" ones. Even when an idea was good, I have seen it completely transformed into something truly wonderful, which could not have been imagined at first. I have seen a "bad" idea, or one that was not right for the context, spark another idea that was brilliant.

To collaborate well, team members need to communicate well, and that means they have to learn each other's language. Architects have a certain language that artists need to learn, just as the architects need to learn the artists' language. Good commu-

nication involves not just language but also images and architectural plans and the ability to draw and sketch both. Time is the important element in this process. For example, I had to spend a lot of time learning to read architectural plans and make architectural types of drawings, working within that system to express ideas or visions that often were difficult to explain, let alone draw. Making art is usually more direct than making architecture, and often we artists aren't sure of the end result as we proceed, whereas in architecture one often needs a vision of the final product before it even becomes possible to put an idea forward for others' consideration. These differences can sometimes make the collaborative process difficult. It takes time, trust, and plain hard work.

PRODUCT

Integration is an inherent quality of the product that results from the design team's process. For me, this means that "art" thinking and the elements of art find seamless placement within the structure or facility. To cite again the document I coauthored with Elizabeth Conner and Jerry Mayer, integration can be of three different kinds, which may manifest singly or in combination:

- Conceptual: integrated art intellectually and emotionally supports the artistic vision of a site.
- Functional: integrated art fuses utility with the artistic vision of a site.
- Material: the materials support the artistic concept while the vital role of their durability and maintenance is also recognized.

These definitions of integration support the notion of "artistic vision," but they also include the whole team's vision for the site or facility.

The end result often comes as a surprise. There is much that is intangible in the outcome of a design team process. The entire site is better, more responsive to the human experience of place. Details have been thoughtfully incorporated. There may be unusual use of materials, bravado of technique—or softer benches. There may be stand-alone art, recognizable as art—or there may be a quality of light that is beautiful but not recognized as art. Does it matter that one can tell whether it is art, or is the entire project artful?

The design team process does not lead to a single type of outcome. Each context should produce the appropriate solution instead of adhering to some perceived standard. It can be somewhat difficult to tell whether a solution is good, appropriate, good enough, or superior. It may not be possible to say categorically that a particular final outcome for a site is the best one, because we cannot compare the design team product to the same site as it would have been without the artist's involvement. But I believe that many minds trained on the problem, and the inclusion of "art" thinking and testing, actually do make the final outcome better.

Willow Creek and 185th Avenue Station. Westside Light Rail design team, Portland, Oregon. Artist team included Norie Sato, Tad Savinar, Richard Turner, Mierle Ukeles, and Bill Will. *Photo by Norie Sato.*

Sunset Transit Center. Westside Light Rail design team, Portland, Oregon. Artist team included Norie Sato, Tad Savinar, Richard Turner, Mierle Ukeles, and Bill Will. *Photo by Norie Sato.*

Design Team Projects

A design team depends first and foremost on willing participants. It also depends on supportive agencies and "clients" who are committed to staying with the process through its difficulties as well as its successes. An art program administrator sometimes needs to step in and support the artists or mediate a stalemate. It takes the work, care, and vigilance of many people to make a design team successful. The design team process is often exhilarating to participate in or even just to observe, but it calls for a long-term commitment. All the groups involved in the process should understand its goals as well as the length and amount of commitment that will actually be required for the process and the project to reach completion. Patience is a virtue here, as is dogged attention to detail.

Whereas architects, engineers, and landscape architects often work in firms, artists mostly work alone. This fact can create an unfair power dynamic, just by the numbers, which may tend to trivialize the ideas and work of the artist. Agencies' and clients' support of the process helps to make sure that artists' voices are heard and respected. In addition, because the architects, engineers, and landscape architects often draw the detailed plans for construction, artists need to be able to review those documents to make sure that ideas have been properly translated. Review of the plans often falls to artists because the process of engineering and developing the work for constructability can drastically change how the work looks or will be perceived. But this level of attention to technical detail can be difficult for some artists, and additional technical support may be necessary.

Budgets and money are also an issue. Design team processes take a lot of time, and artists (as well as the other design team members) need to be compensated fairly for the amount of time they spend working with design teams: they are not serving on design teams "for fun," nor is the design team process a normal commission process. I believe that artists, to have credibility and legitimacy, need to be paid, just as other professionals on the team are paid. By the same token, in order to be compensated at a fair rate, an artist needs to account responsibly for time spent doing the design team's work.

CONCLUSION

The design team process is just one option among many by which artworks can be produced for public contexts. Design team projects are not for every artist. These projects require patience as well as the ability to put out ideas and think on one's feet. They also require time, improvisation, meetings, and work in group situations, all of which the budget must support. The design team process often isn't easy for an artist, who would just like to make art. Although I remain committed to the design team process as an instrument for developing public art, I also find myself moving away from the notion of the integrated artwork as the major product of a design team process.

In some of my own and other artists' previous projects, the art became too subsumed into site architecture, landscape architecture, and other types of design. It got lost.

Design teams have allowed artists to work in a realm of interdisciplinary thinking. They have also allowed architects, landscape architects, and even people from outside the design fields to participate. Everyone has learned something from everyone else. I am now seeing situations where what was originally the realm of artists is being taken over by designers. Architects and landscape architects are now applying and being selected for public art projects and placed on public art rosters.

As artists, we should be proud of our infiltration, of our influence, and of results that have been better than they would have been without us. Increasingly, though, I would like people (the public) to know they are looking at art, to be able to experience art *as* art in the public sphere. Using the design team process to shape a place does not preclude making art that can sit separately, or even at a counterpoint. Conceptual integration is still essential, of course, and the design team process provides it. But perhaps functional and material integration is no longer essential as the only measure of a successful design team outcome—and this may be the maturation of the design team process.

Artist-in-Residence Projects

Models for Residency Programs in Public Art BARBARA GOLDSTEIN

There are many ways to involve artists in public projects. One way, discussed in the previous section, is to include artists in design teams. Another approach is to place artists "in residence"—that is, in organizations or businesses where they can contribute new perspectives or propose innovative ways in which art can enhance an organization's work. In the United States there are several models for this kind of artist involvement.

THE PRIVATE SECTOR

Since 1974, the Kohler Company of Kohler, Wisconsin, has been inviting artists for eight-week-long arts/industry residencies at the company's corporate headquarters. The participating artists observe Kohler's manufacturing techniques, enjoy access to the company's facilities (including pottery, iron, and brass foundries and enamel shops), and create works that are displayed in the company's gallery. As a requirement of their tenure, the artists also present their works in community settings.

THE PUBLIC SECTOR

Two of the earliest artist residencies in the public sector emerged in New York City and in Saint Paul, Minnesota. These two residencies, and the example of the Kohler Company, combined to inspire an artist-in-residence program in Seattle and helped revitalize the rest of Seattle's public art program. In Boston, one foundation is using an artist-in-residence program to sponsor site-specific projects on the East Coast and at other locations around the country.

New York: The Department of Sanitation

In 1977, Mierle Laderman Ukeles initiated her own residency in New York City's Department of Sanitation. Her efforts grew out of her art practice, which explored the role of maintenance work and maintenance workers in our society and the value we place on them.

At a sanitation commissioner's invitation, she placed herself in the department and embarked on a project that was to last more than twenty years, investigating the department's work and bringing it to public attention. She met the people who worked there, learned at first hand the value of the work they did, and discovered for herself the value placed on them. She was able to give voice to workers' stories and to raise public awareness about maintenance work. The outcomes of her project included per-

formance-based works, such as a choreographed "ballet" of sanitation trucks; a gallery installation at P.S.1 Contemporary Arts Center titled *Re:Entry*; *Flow City,* a site-specific installation in a marine transfer station; and a major landscaping effort at Staten Island's Fresh Kills Landfill.

Saint Paul: Artist Design Fellowships

In 1989, Jack Becker assumed management of the City of Saint Paul's $15,000 Artist Design Fellowship program, funded by the National Endowment for the Arts (NEA). Becker conducted a national call for artists and placed three artists "in residence" in city departments. The funds invested by the NEA were matched by funds contributed by each department, and the artists—Richard Posner, Michael Mercil, and Deborah Frasier—were placed, respectively, in the Departments of Planning and Economic Development, Public Works, and Community Services.

Each artist was given a desk and a phone in the department and was assigned to be a team member exploring issues in design and planning. Each worked twenty hours per week for three months. The first month was an introductory period: the artists shared their artwork and ideas with their departments and learned about the work their departments performed. In the second month, the artists conducted an intensive analysis of infrastructure projects that were in development in their departments, to learn how an artist could influence these projects. During the third month, the artists developed recommendations, ideas, and suggestions for integrating art with the work of their departments. The artists then presented their recommendations to their departments, and some of their ideas took root.

Seattle: An Artist-in-Residence Program

In the 1990s, representatives of some Seattle city departments, having "contributed" to the city's municipal art fund for more than twenty years, began to complain that there was little connection between the money their departments had been providing for art and the art that had been commissioned for their departments. Artists, for their part, had worked on design teams but felt that their creativity was being underemployed, and that they were being brought in late in the design process and asked merely to dress up uninspired architecture. To address these concerns, the Office of Arts & Cultural Affairs initiated an artist-in-residence program to build a stronger relationship between artists and city departments. The program has injected new energy into Seattle's public art.

For the first artist residency, in 1996, the Office of Arts & Cultural Affairs commissioned the photographer Peter deLory to spend about six months in the Water Department. He would be visiting facilities, meeting people, and seeing how the department operated. The goal of the residency was for deLory to create a portrait of the department and its work.

DeLory was assigned a workspace, and a longtime Water Department employee was assigned to be his "guide." He was introduced to Water Department employees through "meet the artist" events and the department's Web site. As he observed the

department's work and visited its facilities, he took photos and posted them outside his workspace, encouraging employees to keep any that they liked. This invitation stimulated conversations and provided deLory with new ideas for places to photograph. At the end of his residency, deLory created a suite of photographic diptychs and triptychs showing the Water Department at work, night and day, on projects ranging from laying pipe to tasting water. The photographs are displayed prominently throughout the department. They have been used in annual reports, and as the department merged with other city utilities to become Seattle Public Utilities, deLory was engaged once again, this time to expand his photographic survey.

DeLory's 1996 residency completely redefined the relationship between Seattle Public Utilities and the Office of Arts & Cultural Affairs. After that experience, the Office of Arts & Cultural Affairs proposed placing more artists in residence, with a far more open-ended goal: to assess opportunities for developing both art and artists' thinking in the context of departmental planning.

Since 1997, there have been two artists in residence in Seattle Public Utilities, Lorna Jordan and Buster Simpson (for a description of their projects, see Laura Haddad, "The Art of Infrastructure," later in this section). The residency concept has spread to other city departments, too. From 1999 to 2002, Dan Corson was artist in residence at Seattle City Light, developing a series of conceptual projects and sculptures that explored issues of sustainability and environment. One landmark project, *Skagit Streaming,* monitored the salmon downstream from a hydroelectric installation by recording and playing back their activities on a Web-based camera. In 2002, Lyn McCracken joined Seattle City Light as photographer in residence, documenting the utility's activities and installations. Daniel Mihalyo became artist in residence in the Seattle Department of Transportation in 2003. He has developed a handbook for integrating the work of artists into streets, bridges, bike trails, and the department's shops.

All these artists worked in different ways to influence the thinking of the departments they were working in, and each artist's explorations overlapped into the territory of the others. The outcomes of these efforts are encouraging and will have a long-lasting impact. Seattle has benefited from the infusion of different voices and new thinking into how the city does business. City agencies that once viewed artists primarily as decorators and fabricators of objects now want to include artists in fundamental work. The bonds between the Office of Arts & Cultural Affairs and other city departments have also been strengthened as artists have come to play a more significant role in Seattle's civic life.

A PUBLIC-PRIVATE PARTNERSHIP: NEW ENGLAND FOUNDATION FOR THE ARTS AND THE NATIONAL PARKS SERVICE

On a national scale, a program of the New England Foundation for the Arts, titled Art and Community Landscape, addresses local and regional environmental concerns through site-specific art projects. Initiated in 2002, the program is administered by the foundation in partnership with the National Parks Service and the National

Endowment for the Arts. The program employs artist residencies to encourage new ways of connecting art with community landscapes. Its goal is to support site-based temporary and ephemeral art as a way of increasing environmental awareness and community action. Artists selected for the program work as team members with community partners, local citizens, and representatives from the National Parks Service. Projects have been completed in Vermont, the Pacific Northwest, and Southern California, with others in development in North Carolina and Massachusetts.

In Southern California, the sculptor/installation artists Kathryn Miller and Andreas Hessing worked in collaboration with local residents and the cities of Whittier, Pasadena, and Puente Hills to develop site-specific installations addressing the restoration of native habitats. They developed sculptures and installations in connection with Pasadena's Arroyo Seco Watershed, the Puente Hills Landfill Native Habitat Preservation Authority, and the Whittier Greenway rail-to-trail conversion. The installations used native plantings and interpretive educational sculpture to bring public attention to environmental issues and increase public involvement in the sites.

The Art of Infrastructure LAURA HADDAD

In a world of expanding networks, the scope of Seattle's public art has followed suit. The customary procedure of public art is for an arts commission to identify projects for artists to work on and then to select artists for those specific jobs. At Seattle's Office of Arts & Cultural Affairs, however, recent calls for artists have included projects that significantly stepped up the artist's role in creating work for the public environment.

In 1997, for example, two innovative artists, Lorna Jordan and Buster Simpson, were commissioned to act as artists in residence for Seattle Public Utilities (SPU), a new department that had been formed from existing elements of other city utilities (water, engineering, solid waste, and wastewater/drainage in addition to the customer services and construction group of the city's electrical utility). These commissions were opportunities for the artists to work directly with SPU in the creation of art programs that would more effectively and systematically integrate public art into the infrastructure of the city. Jordan was to look at water supply, Simpson was to examine wastewater/drainage, and each artist was to write an SPU arts master plan, which would identify future art projects, develop a philosophical structure to unite those projects, and create a framework by which the utility could implement the art projects. In themselves, the master plans constituted a new form of conceptual public art.

This new province of art on a regional scale is, I believe, a consequence of the

general "supersizing" of the world, coinciding with the culmination of a four-decade shift in consciousness about what art is. Jack Burnham's catalytic notion, set out more than thirty-five years ago—that art was moving away from object orientation and toward a "systems esthetic"—has been so vehemently proved true that we now barely even consider it; it just is. In "Systems Esthetics," published in *Artforum* in September 1968, Burnham argued that a new aesthetic was rising out of a complex set of relations involving social factors, science, and information:

> A systems viewpoint is focused on the creation of stable, on-going relationships between organic and nonorganic systems, be these neighborhoods, industrial complexes, farms, transportation systems, information centers, recreation centers, or any of the other matrices of human activity. . . . In an advanced technological culture the most important artist best succeeds by liquidating his position as artist vis-à-vis society. . . . The significant artist strives to reduce the technical and psychical distance between his artistic output and the productive means of society. . . . This strategy transforms artistic and technological decision-making into a single activity. . . . Progressively the need to make ultrasensitive judgments as to the uses of technology and scientific information becomes "art" in the most literal sense. . . . For systems, information, in whatever form conveyed, becomes a viable esthetic consideration. . . . There is no end product that is primarily visual, nor does such an esthetic rely on a "visual" syntax. It resists functioning as an applied esthetic, but is revealed in the principles underlying the progressive reorganization of the natural environment.

Lorna Jordan and Buster Simpson are among the progeny of this revolutionary philosophy. They both create work imbued with a systems aesthetic. Jordan is best known for *Waterworks Gardens,* a public art project in Renton, Washington, which puts the biofiltration of storm runoff at its center. One of Simpson's public art projects, *Host Analog,* consists of an old-growth Douglas fir windfall installed outside the convention center in Portland, Oregon, where its decay is demonstrated simultaneously with its service as a host for new seedlings. In both pieces, the aesthetic message is inseparable from the systems that are revealed. This methodology is exactly what affords these artists the vision to integrate art into a regional infrastructure. To take this methodology a step further, it can be construed that having artists design public art master plans is a logical step in the progression of an art movement steeped in a systems aesthetic. With their SPU arts master plans, Jordan and Simpson were challenged to take the systems aesthetic to another level of conceptuality. The challenge was, essentially, to make the infrastructure itself a work of art.

As the logic of a systems aesthetic would once again have it, Jordan and Simpson both used their residencies to explore SPU as an integrated utility, examining all its functions rather than staying within the respective boundaries of water supply and wastewater/drainage. When it came to writing their master plans, though, their approaches diverged.

Lorna Jordan, Adams Street Bridge, 2001. Longfellow Creek Habitat Improvement Project. *Photo by Lorna Jordan. Courtesy of Mayor's Office of Arts & Cultural Affairs, City of Seattle.*

Jordan is looking at a very large picture. She is interested in redefining the public's somewhat impaired relationship with nature. She wants to use infrastructure—specifically, water—to reconnect people with the spirit of place and, in so doing, to reframe how natural systems are perceived. The art of such an endeavor is to make that construction almost magical so that people feel it through their souls as opposed to simply understanding it rationally. It is about restoring to water its mysterious essence so that it is perceived as more than just a chemical substance circulating through the city.

The projects outlined in Jordan's master plan are designed to achieve this goal by various means of "revealing," "recreating," and "enhancing" SPU's infrastructure of water. She identifies seven specific public art opportunities, whose sites range from North Seattle to Tacoma and from the Tolt Basin to Elliott Bay. Six of the opportunities propose that artists work as design team members in the development of SPU capital improvement projects. These projects include the Tacoma Intertie, linking the Green River and Cedar River watersheds; the Lake Washington Ship Canal Smolt Passage restoration, at the Hiram M. Chittenden Locks; the Landsburg Master Plan/Fish Hatchery; the Highline Well Field, adjacent to SeaTac park; and a park at Lincoln Reservoir. This layout creates an infrastructure of public art along the lines of Boston's Emerald Necklace, the series of parks designed by Frederick Law Olmsted. Although

the partiality of these projects, as outlined in the master plan, is toward the restoration of natural systems, the plan is never specific in terms of design. As a result, other artists have room to interpret Jordan's philosophical framework as they may. Each project is given the space to develop its own character while maintaining an overall coherence that identifies the SPU infrastructure.

The most comprehensive project identified in Jordan's master plan is called *Watershed Illuminations.* This project introduces a new model for integrating art into SPU's programs in that Jordan is proposing that she, as the public artist, lead a core consulting team in developing its design. *Watershed Illuminations* comprises a series of sites, with three watersheds at its core: a water supply (the Tolt River), a degraded urban creek (Puget Creek), and an in-city neighborhood lake (the south end of Lake Union). The project could also include wetlands, storm-runoff detention ponds, and reservoirs. Jordan believes that the power of *Watershed Illuminations* lies in its unfolding of a consistent vision over time. According to her plan, it provides a systemwide approach to "revealing, reclaiming, and recreating" an infrastructure of watersheds, and it develops "connective tissue" through which to consider the physical and conceptual relationships among them. The "garden," considered by Jordan to be a philosophical balancing point between wild nature and human control, provides the structure around which the projects will be developed. What I find most intriguing about *Watershed Illuminations* is Jordan's idea of inverting the paradigm of park construction: if an infrastructure of healthy watersheds is established, parks can be built around them.

Simpson's approach is entirely different. His is a truly holistic master plan for integrating art into SPU's infrastructure, bringing about what he calls a "poetic utility." The plan identifies a bounty of opportunities for SPU to synthesize art with future SPU infrastructure projects (transfer stations, watershed projects, and water-quality studies), existing SPU infrastructure activities (trash pickups and water pipeline rights-of-way), and existing non-SPU infrastructure activities and entities (Seattle's Torchlight Parade, the city's annual Home Show, and the city's neighborhoods). In their scale, Simpson's proposed projects run the gamut. Some of his suggestions entail sweeping through the regional system as a whole (and ignoring even SPU boundaries). For instance, Simpson calls for a reconsideration of land use and zoning policies, and he suggests that Seattle's Parks Department join the SPU Strategic Plan in looking at open space and waterways. The principles behind these sweeping ideas are also applied to small-scale "agitprop" projects, interventions that include billboards, toilet paper, bottled water, and television messages.

The predominant concept behind Simpson's ideas for art concerning wastewater/drainage is one of water "replenishment," skirting the edge between water supply and drainage. According to his master plan, Simpson wants art to play a role in "reducing our needs for water from the Tolt and Cedar Watersheds," and he proclaims it "time to re-invent the cistern." He proposes various ideas to promote water conservation, which he says should start on the home front. One suggestion is for artists to live in home laboratories of exemplary resource consumption and to display doc-

Buster Simpson, *Beckoning Cistern*, 2003. Growing Vine Street project. *Photo by Buster Simpson. Courtesy of Mayor's Office of Arts & Cultural Affairs, City of Seattle.*

umentation of their lives on Web sites and at home shows. Another is that artists be commissioned to produce, in their own neighborhoods, incremental social artworks like roadside wetland ditches and innovative landscaping. Simpson's master plan also identifies opportunities for artists' involvement in larger SPU wastewater/drainage projects, which might include artists acting as design team consultants on watershed projects. Some of the watershed projects Simpson lists coincide with those named in Jordan's master plan. Of these opportunities, the one described in most detail is called *Growing Vine Street/Green Street*. This "urban stormwater 'laboratory,'" currently in design (with Simpson a member of the design team), includes "an open watercourse fed by stormwater runoff from the adjacent street and buildings' roof watersheds." The ultimate goal of the project is to provide biotreatment to the runoff, thus creating a prototype for educational outreach.

Simpson's proposal also includes a system of public art "events" as well as projects to be sited in contexts other than the landscapes and buildings typical of public art (for example, Web sites, exhibition stands, operas, and even real life as art, to name a few). Such alternatives provide avenues of engagement for artists who may be interested either in unconventional media or in art involving slightly more insurgent

interventions—artists who might not otherwise participate in creating public art. It is this allowance of a multiplicity of artistic voices that makes Simpson's plan a structure for creating art that speaks to everyone.

Simpson's master plan recommends a process by which artists can acquire the experience and technical competence they need to work effectively on large public projects. It would begin with a "navigational boot camp" in which practitioners and administrators would use case studies and hypothetical drills to teach artists. After that would come a "reality" charette where SPU managers, engineers, and design consultants would present SPU projects in early stages of design, and then artists would collaborate in a brainstorming session. Next the performances of the artists at boot camp and in the charette would be evaluated (the crit). A number of artists would then be put on retainer with the Office of Arts & Cultural Affairs, and they would remain available for SPU projects with short timelines. These "artists on retainer" could also serve as a peer review panel for SPU public art works in progress.

Although Jordan's and Simpson's master plans are quite different in approach, they complement each other well. These plans are not two isolated objects. Instead, both are organized around a systems aesthetic whose boundaries are permeable. As such, they can be layered together so that the points, lines, and surfaces of their various systems of art align, enhancing each other. Moreover, unpredictable intersections of disagreement could occur, leading to rebellious nodes of critical art that would keep the system in check and, in a word, public. An overlay of these two master plans would give the infrastructure of SPU an identity rich in texture and impact.

Seattle Public Utilities and the Office of Arts & Cultural Affairs undertook a brave initiative in extending the art master planning process to artists, and they were successful in selecting two artists whose unique visions can be integrated. The artists have done their part by putting forth provocative proposals. Now the initiative is back in the hands of SPU and the Office of Arts & Cultural Affairs, where the ideas must be combined and implemented as a system, not as pieces picked and chosen at random. The two organizations are hereby challenged to follow the lead of these two artists in transforming Seattle's public art from an object-oriented process to an infrastructure built around a systems aesthetic.

Mierle Laderman Ukeles at New York's Department of Sanitation

TOM FINKELPEARL

Mierle Laderman Ukeles has been active as an artist since the late 1960s. Her work has generally centered on issues of the environment, the city "as a living entity," and service labor, although she has undertaken a number of projects outside the realm of public art, including installations in museums and galleries. For example, in 1997, she created an enormous installation at the museum of Contemporary Art in Los Angeles, *Unburning Freedom Hall,* examining the meaning of fire in the city. However, in this context, I will focus on Ukeles's long-standing collaboration with New York City's Department of Sanitation (DOS), where she has been the official artist in residence since 1977. Since her role at DOS has never been funded by the agency or clearly defined, she has had the opportunity to chart her own course, to claim the *whole* city as her site (through a system that keeps it running), and to define her "community" as *all* New Yorkers. Ukeles has been able to work her way through the various divisions of DOS to create sanitation-based artworks that have included performance, video, temporary installations, and (to be completed) permanent artworks.

After an education in international relations and art, Ukeles had a child. The transformation that this brought to her life changed her art as well. . . . The essential elements of this transformation were clearly stated in Ukeles's *Manifesto! Maintenance Art* of 1969 in which she declared that survival work—maintenance—and art, including her domestic work and her art, were one. . . . With the manifesto as a backdrop, she created seventeen different performance works, including *Maintenance Art Performance Series* (1973–1974) and *I Make Maintenance Art 1 Hour Every Day* (1976).

Ukeles's first year and a half at DOS (1977–1978) was spent getting to know the agency—from the workers to the history of waste management in New York to the structure of the bureaucracy. The commissioner assigned Gloria Johnson, an assistant for special projects, to help Ukeles through the department. In turn, Johnson introduced her to a series of foremen and workers. Ukeles began going to DOS every day, either to do research in the city archive, to talk to employees, or simply to go out on shifts with the workers. As Ukeles became a fixture at Sanitation, Gloria Johnson realized that Ukeles would need a desk of her own. She offered Ukeles an office in Waste Disposal Planning, which she occupied for sixteen years (1977–1993) before moving to her current, larger office in Sanitation's downtown headquarters for Solid Waste Management and Engineering Waste Prevention, Refuse, and Recycling.

Ukeles's first official work with DOS was *Touch Sanitation Performance* (1978–1980). This performance had two parts: *Handshake Ritual,* which consisted of visiting all of New York City's fifty-nine community districts and facing 8,500 sanitation workers,

Mierle Laderman Ukeles, *Touch Sanitation*, 1978–80. *Photo by Marcia Bricker. Courtesy of Ronald Feldman Fine Arts, New York.*

shaking hands, and saying to each, "Thank you for keeping New York City alive," and *Follow in Your Footsteps,* which involved replicating the sanitation workers' actions as they collected trash. As in many of her collaborative projects, Ukeles wrote a letter to the sanitation workers to explain what she was up to:

> I'm creating a huge artwork called TOUCH SANITATION about and with you, the men of the Department. All of you. Not just a few sanmen or officers, or one district, or one incinerator, or one landfill. That's not the story here. New York City Sanitation is the major leagues and I want to "picture" the entire operation.

Over the next five years, Ukeles intensified her collaboration with the Department of Sanitation, culminating in the Touch Sanitation Show in the fall of 1984 (cosponsored by Creative Time). This vast undertaking involved a huge exhibition on the Hudson River, an environmental exhibition at Ronald Feldman gallery, and *Cleansing the Bad Names,* a performance on Mercer Street with 190 participants.

In 1984, she wrote *Sanitation Manifesto!,* this time speaking as the artist in residence at DOS. She saw the public system of sanitation as a bond that ties us all together; the subtitle of the manifesto was *Why Sanitation Can Be Used as a Model for Public Art.* As opposed to other documents she had written, this text was clearly aimed at the art world, not sanitation workers. She speaks to every citizen's public interdependency and interconnectedness:

> We are, all of us, whether we desire it or not, in relation to Sanitation, implicated, dependent—if we want the City, and ourselves, to last more than a few days. I am—along with every other citizen who lives, works, visits, or passes through this space—a co-producer of Sanitation's work-product, as well as a consumer of Sanitation's work. In addition, because this is a thoroughly public system, I—we—are all co-owners—we have a right to a say in all this. We are, each and all, bound to Sanitation, to restrictiveness.

While her primary focus had shifted to work in a public agency, she continued to work in traditional art world venues, often with the cooperation and collaboration of DOS.

For an exhibition of community-interactive projects at Projects Studios One (P.S.1) organized by Glenn Weiss and myself, Ukeles created a multifaceted collaboration that required cutting through three gallery walls. It included a 90–foot-long, 18–foot-wide, 13–foot-high work with twenty tons of recyclables forming the walls, ceiling, and floor, and a sound work created with the sounds of recycling. The work, *Re:Entry,* was fabricated from all of the materials that were being recycled by DOS at the time.

While *Re:Entry* was an ambitious project for P.S.1, it was only a maquette or a prototype for a part of Ukeles's permanent work called *Flow City,* which will be the public portion of a marine transfer station at 59th Street and the Hudson River. Ukeles's contribution will be made up of three basic components: a 248–foot ramp (much like the P.S.1 model), a "glass bridge" for viewing the mixed waste and recycling operation, and a 24–monitor multimedia wall, including live camera images from sites such as the Fresh Kills Landfill.

This is an unusual public art project in that Ukeles intends to change the meaning and use of the site. Without *Flow City,* the facility would never be open to the public. Instead of allowing the building to remain separated from the city, she wants to draw the people into the transfer station's inner workings, or, more accurately, to help them understand viscerally that they are already implicated in the plant's inner workings.

At the present time, Mierle Ukeles is beginning to participate on a design team that will address the 2002 closing of Staten Island's Fresh Kills Landfill and its eventual opening to the public as a park. Her participation on the team will be funded by New York City's Percent for Art Program. Fresh Kills, the city's only operating landfill, covers 3,000 acres, and its enormity is mind-boggling. The *New York Times* described the landfill thus:

> It grows cell by cell, each 20 feet high and 1,000–2,000 feet in length, advancing 75 feet a day as giant trucks dump more and more, and 35–ton vehicles with giant metal rollers compact the earth. . . . Nearly 600 people work [at Fresh Kills Landfill] unloading the barges that arrive 24 hours a day, six days a week. . . . The fill rate, at 14,000 tons per day, 306 days a year, equals 5 million cubic yards per year.

While certainly not our greatest achievement, the landfill *is* the world's largest man-made structure. Though Ukeles has spent many years observing the landfill and has been working on related issues for the last thirty years, her budget for work on this design team calls for hundreds of hours of additional research. She plans to know the landfill "inside out" before beginning to contemplate what design might begin to address the needs of the site. She will undoubtedly consult with a wide range of people within and outside the Department of Sanitation, a range that would be impossible if she were not already *in* the agency.

Ukeles's presence at Sanitation is a complex fusion of outsider (independent artist) and insider (long-term fixture in the department). In working on Percent for Art

projects, I met many Sanitation administrators, *all* of whom knew Ukeles personally. A typical response to Ukeles and her work came from a contract officer who had been at Sanitation for over thirty years. (Ukeles's two and a half decades at DOS, by the way, is not a particularly long tenure by department standards. Many workers go to Sanitation for job security and spend their entire adult lives there.) When Ukeles's name came up, the officer chuckled and said that she was a "pain in the ass" who had put him through a lot of extra work. "But seriously," he said, "she's really a dynamic lady. Do you know she took the time to meet every sanitation worker when she came on board?" His attitude was one of amused bewilderment mixed with appreciation for what she had done for the agency and its workers.

In a 1994 *New York Times* article, Emily Lloyd, then the new commissioner of sanitation, discussed how she had overcome initial doubts about the department's artist in residence. She said of Ukeles:

> Her philosophy is my own. . . . She's saying, We have to understand that waste is an extension of ourselves and how we inhabit the planet, that sanitation workers are not untouchables that we don't want to see. She advocates having our facilities be transparent and be visited as a way for people to be accountable for the waste they generate.

This is a remarkably succinct summary of Ukeles's goals, and it demonstrated the commissioner's commitment to environmental consciousness rather than simple waste removal. What is left out is the means that Ukeles employs. After all, she is an artist, feminist, environmentalist, and social activist, probably in that order.

Part 5

Practice

Artist Selection Methods

Public Art Network's *Call for Artists Resource Guide*

RENEE PIECHOCKI

Whether your public art program has been writing calls for artists for years or your organization is just getting started with commissioning public art, the *Call for Artists Resource Guide* contains information that will help you announce opportunities to artists that clearly describe your projects and give them the information they need to submit applications.

The *Call for Artists Resource Guide* was developed by the Public Art Network (PAN), a program of Americans for the Arts. PAN is designed to provide services to the diverse field of public art and to develop strategies and tools to improve communities through public art. Its key constituents are public art professionals, visual artists, design professionals, as well as communities and organizations planning public art projects and programs.

Copies of this resource guide may be downloaded free of charge from the Public Art Network section of the Americans for the Arts Web site, www.AmericansForThe Arts.org/PAN.

For more information about PAN or Americans for the Arts, e-mail pan@ artsusa.org, or visit www.AmericansForTheArts.org/PAN.

What Is a Call for Artists?

Public art programs and organizations commissioning public art projects enlist artists to be considered for their projects in a variety of ways, including calls for artists, juried slide registries, and direct invitations.

A Call for Artists is an opportunity notice that gives artists the information they need to know in order to apply to be considered for the project. Issuing a Call for Artists is a standard practice of the public art field.

There are currently over 347 public art programs in the United States. They can be rural or urban; government agencies based in municipalities, counties, or statewide; they can be private nonprofit organizations run independently or as part of a local arts agency.

Types of Calls. There are two types of Calls for Artists: Requests for Qualifications (RFQ) and Requests for Proposals (RFP).

An RFQ asks artists to send in their qualifications to be reviewed by the selection panel but does not ask for a specific proposal to be submitted. Organizations use RFQs

when they choose to work with a smaller pool of artists, or a single artist, based on their qualifications, to develop a detailed proposal for the site at a later stage.

An RFP asks artists to submit their qualifications as well as a proposal for a specific site. Organizations use RFPs when they want to solicit proposals from a larger pool of artists or need to solicit proposals from a larger pool based on funding or government regulations.

There has been a discussion within the field of public art about the appropriateness of RFPs and RFQs. PAN's issue paper *Methods of Artist Selection* discussed this topic online at www.AmericansForTheArts.org/PAN.

Call Elements: Definitions and Descriptions

Below is a list of content typically found in a Call for Artists, with advice on how to clearly convey your information.

1. *Call Summary: A brief project summary.* The Call Summary helps artists quickly decide whether they are interested or eligible for the call, and lets organizations posting your call decide how it should be advertised. Include the project name, commissioning organization, application deadline, project timeline, budget, geographic eligibility requirements, and whether it is an RFP or RFQ.

2. *Project Description: An overview of the artist's scope of services.* Discuss whether it is a design-team project, a commission of new work, an artist residency, a purchase of existing work, or another type of opportunity. Include a description of the organizations involved with the project.

3. *Artwork Goals: A list of any predetermined goals for the artwork established by the commissioning organization, funder, or community.* The specificity of the artwork goals will range by commissioning organization and project. They can be broad—e.g., create a sense of place within the community—or specific—e.g., design streetscape elements that reflect the industrial history of the neighborhood.

4. *Artwork Location Description: A description of where the artwork will be placed within the commission site.* Sometimes, the location for an artwork is predetermined by the funder, commissioning organization, or community before a Call for Artists is distributed. If this applies to your project, give a highly detailed description of where the artwork will be located within the site, especially for an RFP. The description should include, but not limited to: engineering or architectural information about the location's structure, materials used at the location, visibility within the site, and lighting.

If the artwork location is not predetermined, state whether or not the artist will be able to participate in selecting the artwork location(s).

5. *Site or Artwork Location Plans: Plans, photographs, or other visual information of the site or artwork location.* If available, or applicable, include plans or photographs for the artwork location and project site. If it is not feasible, post the information online and include a link in the Call for Artists.

6. *Site History or Description: Information about the site where the artwork will be located.* Describe the site's function, including what activities will happen there and who uses it. Be sure to include whether or not the site is open to the public, or if the public can see the facility but not enter the site. Also include a description or history of the site and community where the artwork will be placed and list additional resources for the artist to research.

7. *Budget: The amount of funding allocated for the project.* Clearly state the budget and what aspects of the project it must cover, as not all projects have the same project costs allocated within the budget. For example, in a design-team project, the budget may include only the costs of the artist's fee and travel. In the commissioning of a permanent artwork, project costs may include the artist's fee, travel, and the fabrication, installation, and documentation of the art, in addition to costs such as signage, liability insurance, fine arts insurance, postage, and telephone calls.

If the project budget has not been set, clearly state the amount that has been secured and to what range the project may be raised.

8. *Artist Eligibility: The qualifications that an artist must meet in order to be eligible for a project.* Questions to consider include: Must the artist live in a certain geographic area or is the call open to artists nationally? Is the call open to professional artists or are students eligible? Are artist teams eligible for the project? Must the artist have completed a project with a similar budget, scale, or scope?

If you are seeking to reach out to certain types of artists, include a sentence encouraging artists that meet those goals to apply. For example, if the commissioning organization is seeking to reach out to emerging artists, include a statement such as "professional artists who are new to the field of public art are encouraged to apply." Or if the project is one that will involve a high level of interaction in a high-school setting, include a statement such as: "artists who have experience working with young adults are encouraged to apply."

This is also the place to include an equal opportunity statement that may be required by the commissioning organization, local municipality, or funder.

9. *Application Requirements: The list of materials artists should send with their applications.* Be very specific about the information artists should include with their application materials since it will determine how they are presented to the panel reviewing applications.

Typical application requirements include:

- Number and type of visual support materials
- Annotated support materials list
- Résumé
- References
- Letter of interest
- A self-addressed stamped envelope (SASE)
- Project proposal *(for RFPs only)*

Visual support materials can include slides, videos, CDs, or prints. If requesting slides, list the number of slides artists may submit and how they should be labeled. If your panel is reviewing videos or CDs, list the length of time the submission must be and the formats you are capable of viewing. If you are reviewing prints, list the number of prints the artist should include.

The *annotated support materials list* allows artists to describe the visual support materials and can include: description, materials, budget, location, client or commissioning organization, and any other relevant project information.

The *letter of interest* allows artists to introduce themselves and describe why they are interested in the project, their approach to creating public art, and any past relevant experience. If there is a specific question you would like the artist to address in their letter, be sure to include it in the Call for Artists.

If you are issuing an RFP, clearly list the types of materials you would like the artists to submit to best present their work to the review panel. Typical proposal submission materials include: project description, drawings, renderings, budget, photographs, materials list, and timeline. Questions to consider include: Should all of the work submitted be the same format and/or size? Do you want a detailed visual proposal or just a written description of an idea?

If artist teams may apply, clearly state if you require additional visual support materials, résumé, and references for each team member.

10. Deadline: The date by which an application must be either postmarked or received. List the date by which an application must be postmarked or the date and time by which it must be received at the mailing address. Be sure to state if overnight or express delivery is NOT permitted.

11. Submission Address: The address to which the application is mailed. Include the mailing address. If overnight or express shipping is allowed, be sure that the address is not a post office box or supply an alternate address for this type of delivery.

12. *Selection Process:* A description of how the applications will be reviewed and an artist selected. Include the types of people who are on the selection panel, e.g., community representatives, art professionals, agency representatives, and funders. Include the number, or range, of finalists that will be selected and what will be required of the finalists, including proposals, dates for presentations, and travel. State the fee that finalists will be paid, to what that fee can be allocated, and if a separate travel budget is available.

13. *Selection Criteria:* A list of the criteria established by the commissioning agency or artist selection panel that will guide them as they evaluate the applications. Listing the selection criteria establishes the priorities of the artist selection panel. They also assist artists when considering whether or not they should apply for a project. For example, if the criteria for an RFQ includes artistic excellence, evidence of working in the field of public art for more than 5 years, and experience working in community settings,

artists new to public art with limited experience with communities will be informed that their qualifications are not a good fit for the project.

14. *Project Timeline: The timeline the project will follow from artist selection to project completion.* The timeline includes dates for the following milestones, as they apply: submission deadline, panel review, finalist notification, and estimated completion and installation of artwork.

15. *Sources for Additional Information: A list of resources the artist may consult for additional information on the project site, commissioning organization, community, etc.* Providing artists a list of resources they can consult about different aspects of the project can help them decide if they want to apply and if their work is a good fit. In the case of an RFP, the list can be a launching point for research. Include Web site addresses, publications, contact information for organizations, and other information that would be helpful and relevant to artists as they research the project.

16. *Resources for Questions: The contact information for the person or organization to be called if the artist has a question or needs additional information.* Be clear about whether telephone calls are accepted or if questions may only be submitted by fax or e-mail. Also state whether or not there is a deadline by which questions must be submitted.

Getting the Word Out: Where to Advertise Your Call for Artists

The Public Art Network suggests the following resources for posting artist opportunities:

• *Public Art Network Listserv.* Available to all Americans for the Arts members, this networking tool connects colleagues and acts as a research engine, newsletter, and stage for critical dialogue. Artist opportunities are frequently posted on the listserv as well as in the *PAN Weekly* e-mail broadcast. To join Americans for the Arts, and learn more about the listserv, visit www.AmericansForTheArts.org/PAN or e-mail membership@artsusa.org. E-mail pan@artsusa.org to submit opportunities.

• *Public Art Review.* Published by FORECAST Public Artworks, this is the only national journal dedicated to public art. It includes articles, reviews, book reviews, artist opportunities, job listings, and other information of value to the field. Opportunities and some articles are posted online. Visit www.forecastart.org or www.publicartreview.org.

• *Milestones.* This monthly online public art newsletter, produced by the Phoenix Arts Commission, lists artist opportunities, information about projects in Arizona, public art job listings, and general information of interest to the field. Visit the public art program link at www.Phoenix.gov/Arts.

• *NYFA Source/NYFA Current.* The New York Foundation for the Arts' NYFA Source is an extensive national database of awards, services, and publications for artists of all disciplines. Artists, arts organizations, and the general public can access information on over 2,900 arts organizations, 2,800 award programs, 2,400 service programs, and 900 publications for individual artists nationwide. In addition, the *NYFA Current* is a free, weekly, national e-newsletter. Visit www.nyfa.org.

• *ArtistsRegister.com.* This online slide registry and resource center is a service of WESTAF (Western States Artist Federation). Services include postings of artist opportunities, a monthly listserv bulletin, community discussion bulletin boards, and the sale of artist mailing lists. Visit www.artistsregister.com.

• *ArtsOpportunities.org.* This free online classifieds bank offers information about artist, employment, and internship opportunities and connects arts-related organizations with artists, interns, volunteers, and potential employees. It is an initiative of the Southern Arts Federation and the Center for Arts Management and Technology at Carnegie Mellon University. Visit www.artsopportunities.org.

SAMPLE REQUEST FOR QUALIFICATIONS

Prospectus for Commissioning Artwork(s) for the Hargraves Community Center in Chapel Hill, North Carolina

I. Project Intent. The Chapel Hill Public Arts Commission (CHPAC) seeks to commission an artwork or artworks for the Hargraves Community Center in Chapel Hill, North Carolina, under the town's Percent for Art Program. The artwork(s) will be sited in a prominent location or locations throughout the building complex.

This artwork(s) should:

• Create excitement and interest for the community
• Honor and commemorate the rich history of the Center
• Celebrate the impact the Center has had on the community
• Inspire the young people to remember the past, highlight their activities at the Center, and inspire them to see a legacy that belongs to them and to future generations.

The artists' willingness to learn in-depth about the community and have a dialogue with interested community members from which to apply the concepts is integral toward developing the artwork(s).

The artwork(s) must be durable, low maintenance, and appropriate to the location. The artist should take into consideration the high amount of pedestrian traffic within the center, light (both natural and electric), and temperature control when designing the artwork.

Works in a variety of media and forms will be considered. Examples of media include, but are not limited to: textiles, paint, wood, metal, and photography. A wide variety of forms for the artwork will also be considered, including functional elements such as seating or display cases; artwork integrated into the existing architecture of the building; murals; freestanding sculpture; and photography, among others. Although the CHPAC does not endorse any restrictions on any particular artistic content, in making decisions the project's Artist Selection Panel will consider the fact that users of the building will see this artwork(s).

II. Budget. The town's Percent for Art budget for this project is $17,000. The CHPAC is currently seeking grants and donations for this project with the expectation that the budget will be raised to $20,000–$25,000. The budget includes all costs associated with the project including, but not limited to: artist's design fee, travel, materials, fabrication costs, documentation, and transportation and installation of the work.

III. Eligibility. The project is open to all artists, age 18 and over, regardless of race, color, religion, national origin, gender, age, military status, sexual orientation, marital status, or physical or mental disability. Artist teams are eligible to apply, including teams of artists from multiple disciplines.

IV. Time Line.

March 10, 2003: Postmark deadline for application materials
March 2003: Artist Selection Panel meets to review materials and choose finalists
April 3, 2003: Finalists interviewed
April 2003: Finalists exhibit proposals at the Hargraves Center
May 2003: Project awarded
March 2004: Installation of artwork at the Hargraves Center

The Commission reserves the right to change the project time line.

V. How to Apply: Artists interested in this project must prepare and submit the following:

1. A Letter of Interest, no more than one page in length, which explains the artist's interest in the project.

2. A current résumé. If submitting as a team, a résumé should be submitted for each team member.

3. Fifteen slides of the artist's work. Slides must be in a clear plastic sheet. Each slide must be numbered, the top of the image indicated, and the artist's name included on the slide. Artists applying as a team may submit 15 slides of each artist's work.

4. An annotated slide list must include the artist's name and a brief description of each slide stating its title, date, medium, size, location and, if a commissioned project, the commission budget.

5. A list of at least three professional references who have an intimate knowledge of their work and working methods. The list must include complete addresses and telephone numbers.

6. A self-addressed stamped envelope must be included for the return of application materials.

7. Optional: The artist may include up to three selections of support materials such as reviews, news articles, and other related information.

Artists interested in being considered should submit the following materials by March 10, 2003 at 5:00 P.M. to:

Chapel Hill Public Arts Commission
306 North Columbia Street
Chapel Hill, NC 27516
919.968.2888 ext. 377

VI. Selection Process. An artist selection panel consisting of at least two community members, two representatives from the CHPAC, a Council member from the Town of Chapel Hill, the Town Manager of Chapel Hill or a designee, a representative of the Hargraves Center, and two art professionals will review all artist submissions and select artists to be interviewed for the commission. The finalists will be invited for a site visit and to have a dialogue with the community. The finalists will then be asked to develop a conceptual approach for artwork at the site and to make a presentation of their proposal, including concept, materials, size, weight, hanging requirements, details of maintenance guidelines, and budget. The finalists' proposals will be exhibited at the Hargraves Center for approximately four weeks. The three finalists will be compensated ($300 each) for their participation in this stage of the selection process.

The Artist Selection Panel will meet again to award the project in May 2003.

VII. History of the Hargraves Community Center. The William M. Hargraves Community Center, originally known as the Negro Community Center, followed by the Robeson Street Center, was renamed in 1973 for William M. Hargraves, a former Parks and Recreation Commission member who died in an automobile accident.

The idea for the construction of a community center for Negroes originated in the 1930s because of the concerns of the Negro Civic Club. The founders of the club noted that Negroes did not have a place to socialize and participate in organized recreational activities. A request to the Town Council to provide recreational facilities for Negroes had been turned down. The white community was able to use the recreational facilities at the University and at the white schools. Lincoln, the school for Negroes, was built without any gyms or other recreational facilities. A Negro Community Center Association was formed for the purpose of securing a site and raising funds for construction and operation of the Center. Louis Graves, editor and owner of the *Chapel Hill Weekly*, organized the committees that made up the Association. He was instrumental in getting the influential citizens of the community to raise money to purchase the land.

The land for the Center was purchased by the Negro Community Center Association on September 8, 1938. The land and was deeded to the Town of Chapel Hill on July 29, 1940 with the stipulation that it be used as a site for a community cen-

ter and other recreational activities for Negroes. Most of the funding for construction of the Center was provided through the New Deal, Works Progress Administration. Mr. Charlie Craige drew the architectural plans, and rock for the building was hauled from his farm. Negro craftsmen were the primary construction workers. Their wives joined in the effort and cooked the meals for the workers.

Construction began on January 9, 1941, only to be halted in May by the onset of World War II. In 1942, a Navy Preflight School was located on the University's campus. Because of segregation, the Negro navy band could not be housed on campus. The Town Council and other influential citizens successfully negotiated with the Secretary of the Navy to finish the construction of the Center. Once construction was completed, the Negro navy band was housed in the Center. After the war the Navy turned the Center over to the Town.

In 1948, Frank Robinson and Edwin Caldwell, Jr. met with the University's president, Frank Graham and asked that Negro children be allowed to use the University's pool at least one day a month. After this meeting, all children were banned from using the University's pool. Professors from the University objected to this ruling because it affected their children. At this time, an anonymous donor gave money to construct a pool at the Community Center.

The first paid director of the Negro Community Center, Lucille Caldwell, was hired in February 1951. Ms. Caldwell served for 12 years and was the first Negro professional recreation administrator in North Carolina.

Since 1959 many additions and improvements of the facility have been made. The Hargraves Community Center is comprised of a main building which houses the administrative offices, meeting rooms, and a day care center. Three tennis courts, a gymnasium, an outdoor basketball court, playing fields, pool, and pool house are within close walking distance to the main building. In January 2002, the Town authorized a more than $1,000,000 renovation project for the Center.

Additional Information. If you have any questions or need any additional information, please call Karen Slotta at 919.968.2888 ext. 377 or e-mail kslotta@townofchapelhill.org.

SAMPLE REQUEST FOR PROPOSALS

Scottsdale Public Art Program
Public Art for the City of Scottsdale Adult/Senior Center
Request for Proposals
Deadline February 14, 2003

1. Eligibility

Open to professional artists (or teams of related disciplines) residing in the USA

2. Budget

$82,000 all inclusive

3. Art Opportunity

Overview. The Scottsdale Public Art Program seeks an artist/artist team to develop and facilitate community workshops that engage the community and result in the permanent installation of public art for the planned Adult/Senior Center for the City of Scottsdale, Arizona. The workshops should be complete by October 30, 2003. The permanent art should be ready for installation October 1, 2004. Schedule is contingent upon the City's project schedule and may be changed at any time.

The goal is for the workshops to create a meaningful process that engages Center patrons (and/or community members) either through hands-on involvement in the making of the permanent art or contribution to the ideas that shaped it. Artists have the option to develop workshops that provide one of two options, or a combination of both:

1) that involve Center patrons (and/or potentially community members) in informing the creative process, theme, content

AND/OR

2) that allow the public to participate with the artist in some way, such as creating actual aspects of the permanent art.

The art, to be installed permanently in the Center, should include two-dimensional art and/or include an audio component (oral history, sound art, storytelling or other related genre) in a recorded format, also permanently installed. The visual and aural aspects of the workshops and permanent art should be developed and designed in concert with one another.

Art "Theme." The theme for the art has not been pre-selected. The artists' proposal will include a "theme" that will be illuminated or articulated through the workshops and subsequent art. The goal of the public art project is to contribute meaningful

content to patrons' personal connections and experience with the facility, which for many is their "second home." Potential directions for theme include, but are not limited to: vitality, aging, heritage, cultural expression, history, life stories, cross-generational communication, humor, food, dance, gardening, handiwork, and other areas of interest to adult/senior populations.

Installation. The City's Architect/Engineer will make design provisions for the public art installation including structural, electrical, architectural details and specifications. This is not a design team commission. Coordination and meetings with the project design team will be limited. Preliminary designs for the permanent art must be approved by the Public Art and Collections Committee. The artist will be required to make two presentations about the preliminary designs/plans.

The artist will be asked to submit anticipated installation needs and siting requirements for the permanent art prior to commencing workshops. The project architect and engineers will interpret the artist's specifications for art installation in their design process from Spring-Fall 2003. Depending on the installation needs, there may be some coordination during this time with the public art project manager, architect and/or engineer.

Scope. As of the writing of this document, project scope and budget are being refined. The Scottsdale Public Art Program reserves the right to cancel or amend any or all of the scopes or budgets referenced in this document.

4. Background

Design for the Adult/Senior Center is to commence spring 2003. Completion of construction is scheduled tentatively for early 2005.

The Adult/Senior Center will be located at the northwest corner of McDowell Road and Granite Reef Road. The new Adult/Senior Center will serve as a community, recreational and Human Service facility for the City of Scottsdale (current annual citizen contacts exceeds 250,000) and will include services such as recreation, social services, health/wellness services and socialization opportunities. It will also concentrate primarily in serving the needs of active adults and seniors in the southern and midsection area of the City of Scottsdale. Patrons will range in age anywhere above 40 years old. The new facility will serve the dual ends of the age spectrum: the cerebral/aerobic and the frail/sedentary. The facility may also house offices for brokered agencies, a police substation and space for support groups.

For many of its loyal patrons, the Adult/Senior Center will become their "second home." Vital services, everything to promote physical, mental, emotional, and social health, will be found at the new center: foreign language, art and computer classes; aerobics classes; assessment and counseling services; leisure specialty classes such as "note card making" and "writing your life story" classes; social events such as coffee and

bagel hour, billiards tournament; lunch and home delivered meals; health fairs, flu shots.

This project may replace the services currently provided at the Civic Center Adult/Senior Center. Currently the City of Scottsdale offers Adult/Senior Services programs at the Civic Center Adult/Senior Center located at 7375 E. 2nd Street, and the Via Linda Senior Center located at 10440 E. Via Linda. For more information about Scottsdale's existing senior centers visit the City of Scottsdale's Web site at http://www.ScottsdaleAZ.Gov/seniors.

5. Scottsdale, Arizona

Scottsdale is the major resort center of the Phoenix metropolitan area. Although not all of the local major resorts are located in the city, Scottsdale contains the core of specialty shopping, art galleries, recreational facilities and many of the cultural and sporting events that attract and sustain the local tourism industry. Because of the lack of services in most areas adjacent to the city, Scottsdale's retail centers, parks, employment centers, and libraries are heavily used by residents outside of the city. The high quality of the visual environment in the city is an important component of maintaining the tourism industry and civic framework.

In his 2000 study entitled "Scottsdale City Image" (a report to the City of Scottsdale's Urban Design Studio), Todd Bressi reports that "Scottsdale is a city whose visual character is especially important to its residents, and where the sense of landscape and openness in the city are valued." He suggests four specific values that would contribute to a strengthened identity of Scottsdale's civic framework and primary spaces of public experience: recognize the importance of the pedestrian scale of Scottsdale's civic framework; celebrate the places that make Scottsdale great; strengthen the design of the arterial grid; reconnect with the Sonoran landscape. The efforts of the Scottsdale Public Art Program represent movement toward addressing the values suggested by Bressi's report.

6. Scottsdale Public Art Program

In 1985, the Scottsdale Public Art Program was created with the goal to enhance the quality of life afforded area residents and visitors. Since that time more than 30 permanent public art installations have been completed throughout the community. Public art has taken many forms in Scottsdale ranging from such traditional sculpture in the public square as Ed Mell's "Jack Knife" to a transit center designed by artist Vito Acconci, architect Doug Sydnor, and landscape architect Angela Dye. The program's collection also features public buildings, streetscapes, noise abatement walls, and public art master plans by regionally and nationally acclaimed artists, including Kevin Berry, Carolyn Braaskma, James Carpenter, Mags Harries, Larry Kirkland, Laurie Lundquist, Jack Mackie, and James Turrell.

The Scottsdale Public Art Program seeks to instigate a renewed commitment to the public domain by way of such projects that may invigorate social, cultural, historical, or environmental issues. Projects may possess a direct social relevance that is community referential or they may push the "placemaking" envelope and involve the viewer in the complexities of urban experience. Public art in Scottsdale is meant to transfuse a spirited perspective of traditional or new iconographies and reinvigorate the vitality of public life. For more information, http://www.scottsdalearts.org/publicart.

7. Selection Process

A selection panel will evaluate artists' submissions and either select an artist based on preliminary submission materials, interview short-listed applicants, or seek more detailed proposals. Selection criteria include: the applicant's professional qualifications; proven ability to undertake projects of a similar scope; artistic merit as evidenced by the submitted materials; and demonstrated ability to work with government agencies, engineers, and/or focus groups in the creation of an art project.

Based on proposal and review of slides/support materials, the artist will be recommended by a selection panel and approved by the Public Art and Collections Committee (PACC). PACC approves art concepts, project scope and budget thereby allowing the artist creative license within the established project plan. Contract and project plan are to be negotiated with the Associate Curator of Public Art. PACC reserves the right to reject any and all applications.

8. Timeline (contingent upon the City's project schedule and may be changed at any time)

February 14, 2003: Deadline for response to RFP (by 5:00 P.M.)

February 28, 2003: Short-listed artists notified by this date

March 3, 2003: During this week, interviews with short-listed artists

March 12, 2003: Selected artist notified by this date

March 20, 2003: Anticipated execution of contract by this date

March 30, 2003: By this date, submit anticipated installation needs and siting requirements for the permanent art. Project architect and engineers will integrate the art installation specifications into their design during Spring-Fall 2003. Depending on the installation needs, there may be some coordination during this time with the public art project manager, architect and/or engineer

October 30, 2003: Tentative date for completion of workshops

January 2005: Anticipated completion of building construction and installation of art. Depending on the nature of the installation needs, there may be some coordination during this time with public art project manager, the architect and/or contractor

9. Application Delivery

Qualifications due by 5:00 P.M., MST, 14 February 2003 at:

> Scottsdale Public Art Program Request for Proposal
> 7380 East Second Street
> Scottsdale, AZ 85251

The application should be packaged in such a manner that the sealed envelope clearly reflects the project name(s) and the Applicant's name and address. All materials submitted become the property of the Scottsdale Public Art Program and will not be returned unless a self-addressed and stamped envelope, with sufficient postage, is provided. The Scottsdale Public Art Program will make every effort to protect submitted materials; however, it will not be responsible for any loss or damage.

10. Application Presentation

Please do not staple any materials together. All pages of your application should clearly indicate your name, date and project submitting for. Present your materials in the following order.

11. Application Content.

11.1. *Annotated slide list* (typed, 2 page maximum): The slide list must be provided with the artist's name, title or location of work, medium, date of work, dimensions, the corresponding slide number and short description of slides. Indicate budget where applicable.

11.2. *Professional résumé* (2 pages maximum for each team member): teams must submit a résumé for each member.

11.3
• *Proposal* (typed, 4 page maximum)
• *Theme & Workshops:* Describe your overall "theme" and style of art to be produced. Explain your proposed schedule, process, medium and method by which you will involve adult and senior users (and/or other community members) in concept development and/or design development. Explain your experience in developing and facilitating workshops.
• *Fabrication & Installation:* Describe the anticipated fabrication and installation needs for the permanent art. Be sure to include information that will help facilitate the artistic integrity of your work:

a) How much space will the art need?

b) Describe how you envision the installation: will it need wall space, floor space, hang from the ceiling, be protruding from the wall?

c) Describe the electrical requirements (describe to the extent that you are knowledgeable. The artist will not be required to determine exact specifications, but must be clear on the desired effect. The exact specifications will be refined at a later date by the architect)

d) Describe special equipment or other needs

11.4. Preliminary budget (typed, one page maximum): Include a cost estimate for all facets, including but not limited to artist fees, insurance, travel expenses, workshop costs, materials costs, anticipated fabrication and installation costs. Artist is not responsible for actual installation, but installation needs should be noted in your proposal and reflected in your preliminary budget.

11.5. Optional illustrations (2 page maximum, 8 1/2 x 11" maximum size): Additional visual support material and/or illustrations to show your proposal.

11.6. Three references: include client name, contact name and phone number.

11.7

• *Visual support materials:* Pages or slides must be annotated, including title or location of work, medium, date of work, and dimensions, the corresponding slide number and include short description of slides. Indicate budget where applicable.

• *Photographic slides:* Up to 20 slides (35mm) of recent work. Slides must be in a clear plastic slide sheet; each slide must be labeled with the artist's name, the top clearly marked with an arrow, and a number to correspond to an annotated slide list; OR

• *Computer presentation (optional):* Up to 20 HTML pages or Powerpoint slides.

11.8. Optional relevant experience and qualifications support information: May use selected printed materials such as articles, catalogues, etc. (1 copy).

11.9. S.A.S.E. To have your application materials returned following the competition, include self-addressed stamped envelope, with accurate postage.

12. Inquiries. All questions regarding this Request for Proposals are to be directed to Margaret Bruning, Associate Curator of Public Art, Scottsdale Public Art Program 480.874.4634.

Roster-Based Selection

CATH BRUNNER

Just as selecting the right artist for the job is at the core of a successful public art project, the foundation of any successful public art program is a thoughtful, inclusive selection process that maximizes resources and involves community members and professional peers. Among many other ways to select artists, a public art agency can establish a preapproved pool of qualified artists, called a "roster" or "registry," to facilitate the selection process.

Roster-based selection offers at least three clear advantages:

1. It maximizes resources for artists as well as for the agency. Particularly for an agency that manages many projects, an open competition (that is, a call for artists) requires the use of considerable resources for conducting outreach, processing applications, and facilitating the work of the selection committee. Artists also spend time and money preparing their applications. When a roster is established, however, the initial setup costs are amortized by use of the roster materials to select artists for multiple opportunities over the course of a year or more. Rosters established by larger agencies can also be shared with small arts councils or neighborhood groups that have limited resources and experience.

2. It saves time. Every art agency managing a project hopes to hire an artist in the early planning stage, but the reality is that often the project design is well along or proceeding on an accelerated schedule before the process of soliciting an artist begins. A roster-based selection process can bring a qualified artist into the project within a week.

3. Roster-based selection can ensure the artistic success of the project as well as more ownership of and involvement in the selection process by the people who will ultimately live or work with the art. A selection committee or panel may be composed of neighborhood representatives, members of a design team, artists, and/or employees who will work in the facility to be constructed. Because the artists whose names appear on a roster have been prescreened by professional peers for artistic excellence, experience, and specific skills or interests, a selection committee composed entirely of nonartists can choose an artist from a roster with assurance that the artist's level of artistic quality and professionalism is high.

HOW A SPECIFIC ROSTER WORKS: THE ARTIST-MADE BUILDING PARTS PROJECT

4Culture is chartered by the government of King County, Washington, to advance community through a unique integration of arts, heritage, preservation, and public art. The agency has a thirty-year record of producing and managing public art projects for King County and, on a consulting basis, for other public entities and for private ones as well. 4Culture maintains two specialized rosters, one in connection with its

Design Team Artists Registry and the other for the agency's Artist-Made Building Parts (AMBP) Project.

The AMBP Project, established in 1992, grew out of focus groups conducted to discover how artists, architects, and potential clients might use a roster. Since its inception, the AMBP Project has parlayed an average annual investment of $20,000, together with outreach advocating the benefits of working with artists, into more than $5 million in public artworks commissioned through its roster by public and private developers and organizations. (This investment in public art is in addition to the established percent-for-art programs in 4Culture's region.)

The AMBP Project is essentially an advocacy program, and a substantial focus of its activities is the reinforcement of professional standards and best practices for commissioning artists and helping individuals and organizations interested in producing public art. With the idea that any construction project can incorporate public art in the form of decorative or functional building parts made by contemporary artists, the AMBP Project aims to increase creative employment opportunities for local artists and encourage the integration of art and architecture in public and private construction. AMBP resource materials are made available even to projects that are not being managed by 4Culture (the agency is still involved in such projects, but at a different level).

Selecting Artists for the Roster

The success of the AMBP Project is directly related to the quality of the artists it features. 4Culture works hard to get the word out to the arts community. Its call for artists is widely circulated in both print and electronic media, and the agency's staff offers workshops to help artists who are first-time applicants put together strong proposals. Staff members are also active in recruiting applications, both from established artists and from talented emerging artists who need the marketing support and artistic "seal of approval" that inclusion in a respected roster can bring.

The AMBP Project roster is open to new applications every three years; maintaining the project's full-color print catalog and Web site is too expensive and time-consuming to allow for more frequent addition of new artists. Moreover, previously included artists must reapply every time the roster reopens, since their work may have changed over the three-year period. Every jury is different, too, and two different juries may not select the same artists.

4Culture uses peer review to select artists for open competitions and for its AMBP roster. The seven-member selection committee consists of an architect, a landscape architect, an engineer, two visual artists, an art fabricator, and a construction project manager. The committee evaluates applications against several criteria: artistic quality, as represented in visual documentation of an artist's past work; applicability of the artist's work to the focus of the AMBP Project (with slide documentation showing examples of building parts created by the artist); the artist's relevant experience; and the artist's technical excellence and abilities.

Because the AMBP Project roster is used by different clients for many projects,

Linda Beaumont, *Traveling Light*, 2004. Sea-Tac International Airport. Artist was selected from design team roster. *Photo by Spike Mafford. Courtesy of 4Culture.*

diversity of aesthetic styles and media is important. Therefore, the experience of the selected artists includes small-scale modest-budget projects as well as extremely large-scale expensive work. The selection committee is instructed to choose the very best artists who meet the criteria for the roster; there is no set minimum or maximum number of artists. To ensure that King County and other government agencies can use the roster to hire artists directly, the AMBP Project conducts outreach and artist solicitation in conformity with the competitive procurement requirements of public works contracts.

Maintaining Roster Resources

The AMBP Project's roster materials include a slide registry in addition to the color catalog and the Web site. All the roster materials are designed to be useful to governmental construction agencies, private developers, and design professionals.

Every artist who applies for the roster is required to submit twenty slides. Once an artist has been included in the roster, there is no limit to the number of slides that

he or she may keep in the slide bank as long as the projects fit the focus on artist-made building parts. In fact, artists selected for the roster are encouraged to continually update their slides with images of their new projects.

4Culture's catalog, in the form of a binder, features each artist on a "cut sheet" page with color images, the artist's contact information, and a description of the artist's work. (The binder is modeled on the Sweets Catalog, a resource familiar to designers that is used in locating building materials and components.) To launch each new volume of the catalog, 4Culture staff members present slide shows to architectural firms, featuring the roster artists' products. Three hundred copies of the catalog are distributed free of charge to design and construction professionals in King County. Both the AMBP Project roster and the Design Team Artists Registry are also posted at www.4Culture.org. The electronic format widens the use of both resources beyond King County and supports more color images than the print catalog can.

Selecting Artists from the Roster

Despite the advantages of roster-based selection, not every project is well served by use of a specialized roster. Many public art projects are still advertised through open calls for artists, and other approaches are used as well. Where King County's public art program is concerned, 4Culture's Public Art Advisory Committee reviews project scopes and schedules and then designates, on a case-by-case basis, those projects for which artists will be selected from the AMBP Project roster and those for which artists will be selected by another method. If building components are to be funded through the county's construction budget, county construction managers frequently use the roster to locate artists and establish contracts directly with them.

When the AMBP Project roster is to be used for a project managed by 4Culture, the agency's staff culls a short list or "pool" of artists from the roster and submits it for a selection committee's consideration. To decide which artists to include in the pool, the staff considers the project's scope, its schedule, appropriate media, and the budget. Slides kept on file for each eligible artist are then shown to the selection committee.

The 4Culture staff also offers technical assistance to organizations and individuals interested in commissioning an artist through the roster. Users of the resource materials are responsible for contacting artists and their references and for negotiating all project specifics (such as budget, schedule, and deliverables) directly with the artists. 4Culture does not recommend individual artists or act as any artist's agent.

Case Study

A Public-Private Partnership CATH BRUNNER

King Street Center, in Seattle's historic Pioneer Square district, is an eight-story government office building developed through a partnership between King County and Wright Runstad & Company, a building developer. The neighborhood's other, older buildings reflect a time when artisans and architects worked together to create memorable handmade elements and decorative finishes. Incorporating the work of contemporary artists into a new building was a continuation of that tradition.

An art committee— composed of the construction project manager, design team members, and representatives from the tenant group—first developed a plan for the building's artwork. The committee decided to locate designated "art zones" in the most public areas of the building: the main entrance, the first-floor lobby, and the plaza at the southwest corner of the building. Representatives from the art committee then served as the artist selection panel. They used the AMBP Project roster to choose the artists who created metal entry gates and glass lighting fixtures for the lobby, and they used the Design Team Artists Registry to select the artist who developed a design for the plaza.

For the main entrance, Jean Whitesavage and Nick Lyle forged hundreds of pieces of ironwork, depicting plants and animals of the Pacific Northwest, into the remarkable *Rain Forest Gates*. Brackets linking this theme to the curtain wall structure reach up to a decorative steel band of deer fern and end at the building cornice, which is inset with forged alder leaves. During the creation of the gates, the artists opened their studio to the art committee, to construction workers, and to the building's tenants. These visitors to the studio were invited to give forging a try, thereby gaining a much greater appreciation of the artists' craft.

In the lobby, Maya Radoczy used three artwork components, sited sequentially, to render wind, water, and earth in luminous cast glass. The first component, in the entry vestibule, is a chandelier that captures the essence of wind. At the midpoint of this arrangement is a metal track suspending backlit glass panels, sculptural abstractions of rushing water. Finally, crystalline formations clad the wall where the lobby ends, at the elevators.

Jack Mackie's plaza design uses landscape, hardscape, railings, and formliner treatments to recall the early shoreline bluffs that once marked the building's location. The plaza was designed in close collaboration with the architectural firm NBBJ and with Hewitt Architects. Mackie contracted with a local art fabricator to provide the beachgrass railing elements, but all other aspects of the plaza design were executed by the general contractor.

Recreational Equipment Incorporated, or REI, is a well-known and much loved Seattle-based retailer. When the company decided to build a new flagship store, it wanted to create an environment that would transcend the mere experience of shopping. The new store, designed by Mithun Partners, saw the first high-profile use of the AMBP Project roster for a privately developed project. The lead designer and the interior designer used 4Culture's resource materials and technical support information to hire seven artists for the project.

The artists told the "REI story," reflecting the company's origins as a cooperative and purveyor of ice axes and mountaineering gear and its later development into one of the region's largest suppliers of specialty outdoor equipment. In the entry doors, cast glass panels fabricated by Maya Rodoczy interpret the form and feeling of glacial ice. The footprints of twenty-two different wild birds and animals—bronze tracks created by Judith Caldwell—are embedded in the concrete floor, near the products related to each animal's customary environment. Mountain goats, hikers, kayakers, king salmon, towering fir trees, and graceful herons have been depicted in concrete elevator surrounds by Glenn Herlihy and Peter Geoetzinger. The heart of the store is dominated by a large fireplace wall of natural granite boulders, where Phillip Baldwin's elegant fireplace surround of forged steel has the look and feel of weathered wood. At the checkout counters, Peter Reiquam's sleek sculptural light standards incorporate climbing gear and ropes. Mark Fessler created a lectern from mixed-media recycled materials for the conference room.

The REI project was a success on more than one level. The flagship store became the focus of media attention, garnering several architectural awards and propelling the AMBP Project roster into the consciousness of the design community. The artists, the architects, and the project manager also found their collaboration rewarding and have gone on to complete other stores together. Perhaps most important, the project proved the feasibility of funding integrated artwork by looking to the base construction budget and hiring local artists to make building parts that reflect the character of the community.

Contracts

Basic Considerations RURI YAMPOLSKY

Contracts with artists come in many forms, but all contracts serve the general purpose of outlining the rights, responsibilities, and obligations of the signatories with respect to the services and products being purchased from the artist. The contract is the vehicle by which all the parties maximize any agreements pertaining to the artwork and minimize any potential misunderstandings.

A contract with an artist specifies what one is purchasing (whether services or an artwork), establishes a time frame for the completion of the work, and states what the artist's compensation will be.

Whether a contract is needed depends on the jurisdiction. Some jurisdictions require a contract only when a particular dollar threshold is reached (for example, $5,000). Nevertheless, because a contract specifies expectations regarding products or services, it may be useful to issue a contract in every case, regardless of the compensation amount.

Adhering to boilerplate text may be convenient, but it is also helpful to be flexible in drafting a contract with an artist, and to accept that writing a contract is an evolving process. Sometimes conditions require that a standard contract be amended, and sometimes artists ask to negotiate aspects of their contracts. In Seattle, the Office of Arts & Cultural Affairs uses the City of Seattle's standard boilerplate for consultants and contractors when it contracts with artists but adapts the boilerplate text to reflect the business of art. In any event, it is highly advisable and often mandatory for an arts agency to seek legal counsel when a contract's boilerplate text is being established.

Typical Elements of an Artist Contract RURI YAMPOLSKY

This is an outline of the various sections typically included in contracts established between artists and the Seattle Office of Arts & Cultural Affairs. Those sections described as "boilerplate" are not discussed in any detail; each jurisdiction may or may not have its own version of them. Sections 14–18 pertain to considerations outlined in the Visual Artists Rights Act (VARA); at the Seattle Office of Arts & Cultural Affairs, we extend these rights in a limited fashion to artworks that are not necessarily covered by the VARA legislation. The section headings are followed by descriptions of what they typically cover. This outline is followed by two sample contracts, which supply more specific text for the sections described here.

(HEADER)

This section, which is typically unnumbered and bears no specific label, provides basic information used for administrative purposes, such as the project name and number, the contract number, the funding source, and the expiration date of the contract.

(TITLE)

This section, which is typically unnumbered and bears no specific label, may state the type of contract (for example, "Sited Artwork Commission Agreement," "Agreement for Design Services," and so on).

1. CONTENTS OF AGREEMENT

This section names the various parts of the contract: "Scope of Work," "Compensation Terms," "Standard Terms" (boilerplate), and "Attachments."

2. TERM OF AGREEMENT

This section states or repeats the expiration date of the contract, which typically will not coincide with the completion date of the artist's work. (Time should be allowed after completion of the scope of work, and before the contract's close-out date, for any other deliverables to be submitted and for other administrative details to be handled.)

3. SCOPE OF WORK

This section spells out the artist's obligations and the agency's expectations for the artist's work. It has to be as complete as possible. It is not simply a description of the artwork and/or services that the agency is purchasing; rather, it is an outline for the work that the artist is performing. It gives the *who, what, where, when, why,* and *how* of the work that the artist will perform and that the agency is purchasing.

In the *design services contract,* the agency specifies with whom the artist will be working (for example, with other departments, with designers, with community members), what the artist will be producing, where the artist will perform the work (for example, whether the artist will travel to the agency's jurisdiction, or whether the work will be performed in connection with a residency), the purpose for which the work will be performed (for example, to develop an art plan, to design artwork, and so on), and the schedule that the artist will follow. The agency will want to specify the deliverables for the design phase: drawings, written proposals, budgets, specifications, and the like. The agency will also want to specify the dates when major milestones will be completed and when presentations will be expected. The agency may want the artist to develop a more detailed schedule, which can then become an attachment.

The *commission contract* is often a fabrication contract; sometimes it includes design development and fabrication. The agency should specify whether the commissioned artwork will be sited, site-integrated, portable, or of another type, and, if sited or site-integrated, what aspect(s) of the site will be part of the artwork. Defining the type of artwork will help define the extent to which the Visual Artists Rights Act applies to this artwork, should it or its site need to be modified. Anything unusual and/or restrictive can be included in what is specified as the scope of work. The more that can be anticipated and included, the better off both parties to the contract will be. The commission contract typically includes the following clauses:

• Time of Completion
• Acknowledgment (this clause may specify that the artist must acknowledge the agency and/or funding sources in any public presentation or publication of the artwork)

A. Description of Artwork

This is primarily a physical description of the artwork, and the description should be detailed. It should include what is known about materials, dimensions, colors, locations, quantities, and so on. If it is desirable to include very specific aspects of how the work will be performed, and concerning what the final product will be, the agency might consider requiring specifications, which can then become an attachment.

The contract should also specify any other work that the artist is to perform. Will the artist be expected to give a lecture, attend dedications, and so on? Will the artist be expected both to fabricate and install the work? Will someone else install it? Will the artist be expected to coordinate with someone else?

B. Consultation with Conservator

In order to complete the work, the artist may need to consult with conservators. The agency may want to make such consultation a contractual requirement, to ensure the durability of the artwork and the soundness of the materials or of the installation decisions.

C. Consultation with Others

In order to complete the work, the artist may need to meet with other consultants (for example, design consultants, engineers, lighting consultants, and so on). The agency may want to require this sort of consultation contractually.

D. Travel

If the agency has hired an artist from outside its jurisdiction, it may be desirable to stipulate the number of times the artist will be required to travel to the agency's jurisdiction in order to complete the scope of work.

E. Residency

Although the scope of work described here may be more relevant to a design services

contract, performance of the work may depend on the artist's spending time "in residence" with a particular group or entity.

F. Artwork Documentation and Maintenance Instructions

In addition to having the artist create the artwork, the agency will want him or her to provide any documentation about the artwork (descriptions, statements, photographs or slides, and so on) that will be important for recordkeeping. The agency will also want detailed maintenance instructions for its files.

4. PUBLIC INFORMATION

This section says that the agency will be solely responsible for coordinating public information materials and activities related to the dedication of the artwork. It is intended to prevent the provision of conflicting information from different sources.

5. COMPENSATION REIMBURSEMENT

This section spells out the total compensation that the artist will receive for completion of all the tasks outlined in the scope of work. Total compensation will include reimbursement for travel or taxes, if such provisions are applicable.

6. SCHEDULE FOR PARTIAL PAYMENT OF COMPENSATION

This section specifies division of the artist's compensation into several payments, for which the artist invoices the agency. Receipt of payment is contingent on the artist's having provided various deliverables and met specific milestones, which are spelled out for each payment increment. Examples of deliverables are fabrication drawings, specifications, budgets, schedules, proof of insurance, and actual parts of the artwork. The expectation is that the artist, before submitting the invoice, will have performed the work, purchased the materials, or become obligated to pay for orders so that the agency making the payment is not extending credit to the artist.

7. PROCESS FOR REIMBURSEMENT OF EXPENSES

In general, the artist is responsible for all expenses. Occasionally funds are set aside for travel if there is a design services contract.

8. PROCESS FOR PAYMENT OF COMPENSATION

This section essentially says that the artist, in order to receive payment, needs to submit an invoice documenting the work performed.

9. PROCESS FOR PAYMENT OF TAXES

This section affirms that the artist is responsible for paying and submitting all taxes.

10. ARTIST IS INDEPENDENT CONTRACTOR

This boilerplate section states that the artist is a contractor responsible for providing all labor and materials to complete work.

11. NO CLAIM ALLOWED BY ARTIST'S EMPLOYEES, CONTRACTORS, OR OTHER PARTIES

This boilerplate section states that no one who is an employee or subcontractor of the artist is considered to be an employee of the agency or jurisdiction.

12. NO ASSIGNMENT OF WORK WITHOUT AUTHORIZATION

This boilerplate section states that the artist cannot, without permission, assign to anyone else work for which the artist is contracted, but this section does not preclude the artist from hiring other people to perform the work.

13. AGENCY AUTHORIZED TO REVIEW WORK IN PROGRESS

This boilerplate section states that the agency is allowed to inspect work performed to date.

14. COPYRIGHT, AND AGENCY'S RIGHT TO REPRODUCE IMAGES

This section typically states that the artist retains copyright, whereas the agency keeps the right to reproduce images for educational or (as defined by the particular agency) municipal purposes. This arrangement allows the agency to publish the artwork proposal or images of the artwork in a newsletter or distribute such material to the press.

15. AGENCY RECORDS REGARDING ARTWORK

This section states that the agency will keep records regarding the artwork and its creator on file. It is the artist's responsibility to keep the agency informed of his or her whereabouts in case there is a need to contact the artist about changes to the artwork.

16. ARTIST'S IDENTIFICATION LABEL

This section states that the artist can request removal of his or her identification label (or plaque) if changes to the artwork occur and if the artist feels that the artwork has

been compromised to such an extent that the artist's reputation will be damaged by his or her further association with the work. This provision thus allows the artist to no longer be identified as the creator of the (now damaged) artwork.

17. ARTWORK CHANGES

This section outlines a process for handling changes to the artwork or removing the artwork altogether. Here, issues concerning the artist's rights are dealt with contractually. If there is a need to clarify the artist's rights as accorded by the language of the VARA legislation, or if the VARA language must be modified to suit a jurisdiction's needs, this is where such clarification or modification might occur.

A. Material Changes prior to Acceptance

This subsection outlines the process to be followed if modifications must be made to the artwork before it can be accepted by the agency in performance of the agreement.

B. Material Changes after Acceptance

This subsection outlines the process to be followed if the artwork must be removed or modified. It provides for notification in the event that changes are made, or need to be made, to the artwork and offers options should modifications occur. A statement is made that the jurisdiction or agency retains the right to maintain its properties and that, in doing so, may have an impact on the artwork. If the artwork is to be installed in a building, a special clause is added, asking the artist to acknowledge that the artwork may also need to be removed.

18. REPAIRS AND MAINTENANCE

This section designates who will be responsible for maintaining the artwork. The Seattle Office of Arts & Cultural Affairs currently includes this section only in contracts for portable works.

19. RISK OF LOSS

This boilerplate section states that the artist is fully responsible for ensuring that the artwork is delivered. Any loss that occurs before transfer of ownership is the responsibility of the artist. Therefore, it behooves the artist to have property insurance and premises insurance to cover the possibility of loss.

20. INDEMNIFICATION

This boilerplate section states that the artist must hold the agency harmless from any action, suits, or claims arising from the artist's negligence or omission.

21. INSURANCE

This boilerplate section states that the agency requires the contracted artist and his or her contractors to have general liability insurance and commercial automobile insurance. The limits vary according to the artwork and the complexity and location of its installation. The coverage typically required by the contract is commercial general liability insurance for the following areas:

- Premises/operations liability
- Products/completed operations
- Personal/advertising injury
- Contractual liability

The policy typically provides the following minimum coverage:

- Bodily injury and property damage at $1,000,000 per occurrence, with $1,000,000 annual aggregate
- Professional liability (errors and omissions), generally required only for consultants and not usually for artists (but because the artist usually delivers the product to the installation site, personal automobile liability is required, including coverage for owned, nonowned, leased, and hired vehicles and providing $300,000 minimum coverage per accident)

22. ARTIST'S WARRANTIES

This boilerplate section requires the artist to provide a one-year guarantee on workmanship and materials. Any failure of the artwork within the year, other than a failure due to vandalism or accident, is the responsibility of the artist to repair. The Seattle Office of Arts & Cultural Affairs also includes a statement of the expectation that the artwork will last at least thirty years, the length of a typical bond.

23. ADDRESSES FOR NOTICES AND OTHER DELIVERABLES; WAIVER OF ARTIST'S RIGHTS UPON FAILURE TO PROVIDE CURRENT ADDRESS TO AGENCY

This boilerplate section emphasizes the need for the artist to keep the agency informed of his or her whereabouts, to maximize the artist's ability to keep his or her VARA rights intact.

24. COLLECTION MANAGEMENT

This boilerplate section again gives the artist notice of the contract's handling of his or her VARA rights. Here, the Seattle Office of Arts & Cultural Affairs specifies the agency's right to maintain and manage its collection and its properties and forewarns the artist of the potential for the artwork's modification or removal.

25. CREDIT

This boilerplate section states that in any and all publicity materials generated on behalf of the artwork, the artist is required to give appropriate credit to the administering agency and to the appropriate funding sources, using language determined by the agency.

26. DEFINITION OF "AGENCY" AND "DIRECTOR"

This boilerplate section defines the agency and its successors, and it defines the director as meaning the director of the agency or anyone else acting on his or her behalf.

27. AUDIT

This boilerplate section states that for a period of six years the agency, or any entity involved in funding the artwork, can request a financial audit of the artist's (or subconsultants') books pertaining to any work performed under the agreement.

28. COMPLIANCE WITH LAWS AND REGULATIONS

This boilerplate section spells out the artist's obligations with respect to laws, licenses, taxes, and other requirements.

A. General Requirement

The artist must comply with all laws of the agency's country, state, and jurisdiction, including laws that pertain to health and safety standards.

B. Licenses and Similar Authorizations

The artist must obtain any and all licenses and permits needed for the artwork's fabrication and installation.

C. Taxes

The artist must pay, as required, all taxes applicable to the agreement except where the agreement indicates otherwise.

D. Use of Recycled-Content Paper

The artist will attempt to use recycled paper whenever such use is possible.

E. Americans with Disabilities Act (ADA)

The artist must comply with the requirements of the ADA, particularly if he or she is providing services as part of the agreement (that is to say, all services must be accessible by people with disabilities). In addition, if it is possible for someone to walk on or enter the artwork, the artwork will be expected to meet ADA code.

29. WOMEN AND MINORITY BUSINESS ENTERPRISE (WMBE) REQUIREMENTS

This boilerplate section states that the artist will comply with all applicable WMBE requirements. If no such requirements exist, adherence to WMBE requirements is nevertheless encouraged.

30. NONDISCRIMINATION AND AFFIRMATIVE ACTION

This boilerplate section states that the artist may not discriminate against any individual during the performance of the agreement. If it were to be determined that the artist had engaged in such discrimination, the agreement would be terminated.

31. CONTRACTUAL RELATIONSHIP

This boilerplate section states that the artist is not an agent of the agency or jurisdiction and does not represent the agency or jurisdiction.

32. INVOLVEMENT OF FORMER AGENCY EMPLOYEES

This boilerplate section outlines the limitations to be observed in subcontracting with former employees of the jurisdiction.

33. NO CONFLICT OF INTEREST

This boilerplate section states that the artist may not be related to any employee of the agency or jurisdiction who may be administering the agreement, negotiating the agreement, or evaluating the performance to be carried out under the agreement.

34. EXECUTORY AGREEMENT

This boilerplate section states that the agreement is valid only when signed by both parties (that is, the agency and the artist).

35. BINDING EFFECT

This boilerplate section states that the agreement binds the parties, their legal heirs, their representatives, their successors, and their assigns.

36. APPLICABLE LAW; VENUE

This boilerplate section defines the legal jurisdiction that governs the agreement.

37. REMEDIES CUMULATIVE

This boilerplate section states that if the artist does not exercise a right granted under the agreement, his or her exercising that right at another time is not precluded. The use of one remedy shall not be taken to exclude or waive the right to use another.

38. CAPTIONS

This boilerplate section states that the titles of the sections in the agreement are just titles and do not define or limit the contents of the sections.

39. INVALIDITY OF PARTICULAR PROVISIONS

This boilerplate section states that if a legal ruling throws out a term, condition, section, or portion of the agreement, the other terms, conditions, sections, or portions of the agreement will remain in effect.

40. NO WAIVER

This boilerplate section states that a waiver of one aspect of the agreement does not serve as a waiver of subsequent default or breach of other terms of the agreement. Receipt of compensation does not suggest that defective performance has been accepted.

41. EXTRA WORK

This boilerplate section allows for the possibility of amending the agreement for extra work, but no compensation shall be made unless an amendment has been fully executed.

42. KEY PERSONS

This boilerplate section is used only when the artist has incorporated or is in a legal business partnership (not a partnership between sole proprietors). This section indicates that those designated by the artist to be working on the project shall do so, and that replacements can be made only with approval of the agency.

43. DISPUTES

This boilerplate section states that if there is a dispute, and if the artist and the assigned project manager from the agency cannot come to a resolution, the artist will be allowed to designate someone to deal with the director of the agency. If the dispute cannot be resolved in this manner, a legal remedy may be sought.

44. TERMINATION

This boilerplate section outlines reasons for which the agreement may be terminated.

A. For Cause

The agreement may be terminated if either party fails to perform and if the failure is not corrected in a timely manner (termination in this case requires written notice of breach).

B. For Reasons beyond Control of Parties

Either party may terminate the agreement, without recourse by the other, because of reasons beyond anyone's control, such as acts of nature; war or warlike operations; civil commotion; riot; labor dispute, including strike, walkout, or lockout; sabotage; and superior governmental regulation or control.

C. For Public Convenience

The agency may terminate the agreement in whole or in part whenever the agency determines that such termination is in the best interests of the public, or for lack of continuing appropriations.

D. Notice

This subsection defines how much notice is required in the event of termination.

E. Default

If the artist defaults on the agreement, he or she is required to refund to the agency the amount of any interim payment he or she has received.

45. MODIFICATION OR AMENDMENT

This boilerplate section states that any modification or amendment to the agreement must be in writing and must be signed. The parties reserve the right to modify the agreement from time to time by mutual consent.

46. ENTIRE AGREEMENT

This boilerplate section states that the agreement, including any exhibits and addenda attached to it and forming a part of it, is all of the covenants, promises, agreements, and conditions between the parties. Before the execution of this agreement, no verbal agreements or conversations between any officer, agent, associate, or employee of the agency or its jurisdiction and any officer, agent, employee, or associate of the artist shall affect or modify any of the terms or obligations contained in this agreement. Any such verbal agreements shall be considered unofficial information and in no way binding on either party.

(SIGNATURE)

This section, which is typically unnumbered and bears no specific label, is where the artist/contractor and the designated signatory for the agency sign and date the contract. In addition to signature and date, the artist is asked to supply his or her address, phone number, and tax number (social security number or federal tax ID number). The artist signs first and returns all copies for the signature of an officer of the agency. A fully executed copy is then returned to the artist.

ENGINEER AND ARTIST AGREEMENT

San Diego Commission for Arts and Culture

AGREEMENT
between

and

This Agreement, made this _____ day of _____, 1996 by and between _____ (Engineer) and _____ (Artist)

Whereas, the Engineer desires to employ the Artist to render certain artist services for the _____ Project; and

Whereas, the Artist has the expertise and has a thorough knowledge of public art and is qualified to render such services; and

Whereas, the Artist is willing to provide these services for the consideration and upon the terms hereinafter stated;

Now, Therefore, in consideration of these premises and of the mutual covenants herein set forth, the parties hereto agree as follows:

Section 1. Basic Services of the Artist

1.1 The scope and details of the services are more fully described in the Scope of Services, attached hereto and made a part hereof.

1.2 The Engineer and the Artist agree that the agreement between Nasland Engineering and the City of San Diego ("Owner"), is a part of this Agreement to the extent that its terms affect the services to be provided by the Artist under this Agreement. In the event of conflict between the terms of this Agreement and the Contract, this Agreement shall be controlling.

Section 2. Additional Services by Artist

2.1 Additional services may be required in carrying out the work. Because it is not possible to determine in advance the need for such services, they are excluded from the basic services described in the attached Scope of Services. Additional services will be undertaken only upon written authorization by the Engineer.

Section 3. Services by Engineer

3.1 It is agreed that certain services shall be performed or furnished by the Engineer. These services include:

3.1.1 Assisting and cooperating with the Artist in completing the work in a timely and effective manner:

3.1.2 Designating a representative who shall have authority to transmit instructions, receive information and enunciate Engineer's policies and decisions; the Engineer's representative shall be _____;

3.1.3 Arranging for and holding promptly any required meetings;

3.1.4 Making available to the Artist existing available information which may in any way be pertinent to the work herein described;

3.1.5 Responding within a reasonable time to the Artist's requests for written decisions or determinations, pertaining to the work, so as not to delay the services of the Artist;

3.1.6 Giving prompt written notice to the Artist whenever the Engineer becomes aware of an event, occurrence, condition and circumstance which may substantially affect the Artist's performance of services under this Agreement;

3.1.7 Preparing construction documents that incorporate the Artist's ideas.

Section 4. Time Schedule

4.1 Unless otherwise directed the Engineer, the Artist shall commence the performance of the Basic Services upon execution of this Agreement by both parties and after receiving a written "Notice to Proceed" from the Engineer.

4.2 The Artist recognizes that the services under this Agreement are to be performed as expeditiously as is practical. Every reasonable effort will be made to substantially complete the Basic Services based on the schedule including in the attached Scope of Services.

4.3 Performance of any Additional Services not described in the attached Scope of Services will commence upon separate written authorization by the Engineer and shall be complete in accordance with a schedule set forth in the authorization.

Section 5. Amount and Method of Payment

Note: All invoices must prominently show the Project Number _____. Failure to do so may delay the processing of the Artist's invoices.

5.1 For the services provided under the attached Scope of Services, payment shall be in accordance with this section and the Payment Schedule in Paragraph 5 of the attached Scope of Services. Invoices shall be billed "not to exceed" based on hourly charge rates and reimbursable expenses as listed in said Paragraph 5.

5.2 It is expressly understood and agreed by both parties that the Engineer will be paid by the Owner for the services performed by the Artist and that the Artist will not be paid until the Engineer has received payment from the Owner. The Engineer agrees to process the Artist's invoices promptly (monthly) and to take every reasonable measure to expedite payment by the Owner.

Section 6. Changes

6.1 The Engineer may, at ant time, by written order, make changes in the services or work to be performed within the general scope of this Agreement.

6.2 If such changes cause an increase or decrease in the Artist's cost of, or time required for, performance of any services under this Agreement, an equitable adjustment shall be made and this Agreement shall be modied in writing accordingly.

Section 7. Disputes

7.1 Except as this Agreement otherwise provides, all claims, counter-claims, disputes, and other matters in question between the Engineer and the Artist arising out of or relating to this Agreement or the breach of it will be decided by mediation if the parties hereto mutually agree, or in a court of competent jurisdiction within the City of San Diego, State of California in which the Engineer is located.

7.2 Should suit be led to enforce or for the breach of terms of this Agreement, the prevailing party shall be entitled to the award of reasonable attorney's fees.

Section 8. Suspension of Work

8.1 The Engineer may order the Artist to suspend, delay, or interrupt all or any part of the Artist's services for such period of time as the Engineer may determine to be appropriate for the convenience of the Engineer.

8.2 If the performance of all or any part of the Artist's services is, for an unreasonable period of time, suspended, delayed, or interrupted by an act of the Engineer, or by her failure to act within the time specied in this Agreement (or if no time is specied, within a reasonable time), an appropriate extension of time may be made if mutually agreed for any such delay in the performance of this Agreement necessarily caused by such unreasonable suspension, delay, or interruption and the Agreement modied in writing accordingly.

Section 9. Termination of Agreement

9.1 Engineer may terminate upon written notice if the Artist breaches her obligations under this Agreement or for any other cause, including but not limited to, cancellation of the Engineer's contract for the project. Engineer shall compensate the Artist for performance of services through the period of notice. All work shall become the property of the Engineer, in the event of termination.

Section 10. Insurance

10.1 Artist agrees and shall submit evidence to the Engineer before beginning work on this project that Artist has procured and will maintain as a minimum the following insurances: (a) Workers Compensation in compliance with the applicable State and Federal laws; (b) Commercial General Liability Insurance with limits of not less than $500,000 each occurrence, and combined single limit bodily injury and property damage (Artist shall name Engineer as additional insured to her Commercial General Liability policy); (c) Commercial Automobile Liability Insurance, including owned, hired and non-owned automobiles, bodily injury and property damage in amounts not less than California statutory requirements.

Section 11. General Provisions

11.1 Artist agrees that she shall act as an independent contractor, and shall perform the services provided for in this Agreement in accordance with the generally accepted standard of care of the Artist's profession.

11.2 In addition to, and not in limitation of the insurance requirements contained in Section 10 of this Agreement, to the fullest extent permitted by law, the Artist hereby agrees to indemnify and hold _____ and the City of San Diego, harmless from and against any and all losses, damages, settlements, costs, charges, or other expenses or liabilities of every kind and character arising out of or relating to any and all claims, liens, demands, obligations, actions, proceedings, or causes of action of every kind and character arising from the negligence of the Artist, their employees, agents or others for whose acts the Artist is responsible under this Agreement, provided, however that Artist's duty to indemnify and hold harmless shall not include any claims of liability arising from the negligence or willful misconduct of _____ or the City, its agents, ofcers or employees.

11.3 This Agreement shall inure to the benet of and be binding upon the legal representative and successors of the parties, respectively.

11.4 Interpretation and enforcement of this Agreement shall be in accordance with the laws of the State of California.

SCOPE OF SERVICES

Artist Name: _____

Project Location: _____

Project Description: Artist Services for the _____Project

1. Artist's Rights and Responsibilities

1.1 The Artist shall provide professional services including but not necessarily limited to, artist ideas and input, presentations before authorized groups, meetings with the Engineer, and all other services necessary to complete this attached Scope of Services.

1.2 The Artist shall not assign the creative or artistic portions of the work to another party without the written consent of the Engineer.

1.3 The Artist shall be responsible for providing services described herein including, but not limited to, the quality and timely completion of the services. If the involvement of the Artist results in a tangible object or objects of art, the Artist shall, in collaboration with the Engineer, design and create the artwork, so that it can be constructed without exceeding the construction cost budget allocated for the Project. The Artist shall, without additional compensation, correct or revise any negligent errors, omissions, or other deficiencies in her performance. The Engineer shall not pay the Artist for work incidental to changes required by the Artist's negligent errors or omissions. The Artist shall be responsible for additional costs incurred as a result of her own negligent errors or omissions.

1.4 If the involvement of the Artist results in a tangible object or objects of art, the Artist warrants that (a) the design or work being commissioned is the original product of his/her own creative efforts; (b) the work is original, that it is an edition of one (1), and; (c) the Artist shall not sell or reproduce the work or allow others to do so without the prior written consent of the Engineer.

1.5 The Artist, in collaboration with the Engineer, shall make presentations to authorized groups and to the City of San Diego, the Engineer, and citizen and community groups to provide them with information about the proposed artwork, and to any governing or regulatory body or agency for other approvals as may be required.

1.6 The Artist shall consult with the Engineer to ascertain requirements for the Project, including community reviews, schedule, and construction budget.

1.7 If the involvement of the Artist results in a tangible object or objects of art, the Artist shall submit conceptual and final designs of artwork to the Engineer for review prior to presentation to the City of San Diego, and citizen and community review groups. The Artist shall proceed with the work only after receipt of written authorization from the Engineer.

1.8 The Artist and the Engineer agree that any proposal to alter, modify, damage or otherwise change the work of the Artist shall be first discussed with the Artist. Written approval shall be obtained from the Artist prior to proceeding with the proposed alteration, modification or change; such approval shall not be unreasonably withheld by the Artist.

1.9 The Artist agrees that the Engineer will be granted royalty-free the authority

to incorporate the Project artwork in construction documents for the purposes of constructing and completing the Project.

1.10 The Artist shall have the right to photograph, or contract to have the Project photographed, during and upon completion of construction and to provide these photographs for publication.

1.11 The Artist shall register the Project and place a copyright notice on or near the Project in the form and manner required to protect copyrights of the Project under United States copyright law. If the copyright is registered with the US Copyright Office, the Artist shall provide the Engineer with a copy of the application for registration, the registration number and the effective date of registration. Except as provided in this Agreement, the Artist retains all copyrights in the Project including its preliminary design and incidental works created for the Project.

1.12 The Artist hereby grants the Engineer and the Owner, a permanent, assignable, non-exclusive royalty-free license to make, or cause to be made, photographs and other two dimensional reproductions and models of the Project for educational, project awards, public relations, tourism, arts promotional purposes without payment of a royalty to the Artist. For purposes of this Agreement, the following are among those deemed to be permissible reproductions for the above cited purposes: brochures and pamphlets pertaining to the Engineer and Owner; reproduction in exhibition catalogues, project awards, books, slides, photographs, postcards, posters, and calendars; in art magazines, art books and art and news sections of newspapers; in general books and magazines not primarily devoted to art; slides and film strips; and television. On any and all such reproductions a copyright of the Project under the United States Copyright Law and credit the Artist. The Artist agrees that all written references to and reproductions to the Project shall include the following credit line:

"This project was performed in collaboration with _____ and sponsored by the City of San Diego."

1.13 Upon completion of the Artist's work, the Artist agrees that she will have no other rights in the Project and/or any artwork created as a result of this Agreement other than the rights specified in Paragraphs 1.10 and 1.11 above, with all other rights thereafter belonging to Engineer and Owner, including but not limited to all other rights created and/or protected by the federal trademark, patent, and copyright laws, and California Civil Code Sections 980-989.

1.14 Artist understands and agrees that the creative design and artwork called for in this Agreement constitute matters of taste and judgment in which Artist must satisfy Engineer and Owner. Engineer commits to Artist that Engineer's approval of the creative design and artwork will not be unreasonably withheld, but subject to many

constraints and political pressures in matters of taste and judgment. Artist acknowledges and accepts these conditions.

 1.15 Engineer agrees to credit Artist on the _____ for collaborating efforts in the planning portion of the Project. The Engineer agrees that the cover sheet to the _____ shall include the following credit line:

 "…in collaboration with _____, Artist…"

2. Scope of Basic Services to be Provided

The services furnished by the Artist shall be artist planning services for the _____ Project as described below. The Artist will be included as a member of the design team to collaborate with the prime and other subconsultants to impact the overall design development of the project. The Artist, with the team, may identify opportunities within the project for the commissioning of site specific artwork. The Artist will participate in community and schematic design development meetings. The Artist's scope of services as a minimum will include:

Task 1: Participation in Conceptual Master Plan Design

The Artist shall participate as an active Design Team member in the development of a Schematic Master Plan design.

Task 2: Presentations

The Artist will attend and participate in up to four (4) Community Group meetings.

Task 3: Sites for Public Art

The Artist will collaborate with the design team in identification of potential sites for site specific artwork.

Task 4: Research and Written Narratives

The Artist will perform research necessary for the development of an art component or integral art aspects which may include historical information, environmental information and neighborhood information as needed.

Task 5: Sketches

The Artist will provide sketches in support of design team concepts and public art elements. (Construction drawings will not be included as part of this phase).

Task 6: Public Art Concepts

The Artist will provide preliminary public art concepts for the development of the Conceptual Master Plan and for presentation at meetings.

Task 7: Reimbursables

All reimbursables such as airline tickets, hotel, materials, reproducibles, etc., shall be billed as a direct cost (no markup).

3. Additional Services

No Additional Services are identified at this time. If additional services are required in the future, additional fees will be negotiated in writing.

4. Period of Performance

The period of performance for the Artist shall commence after a written "Notice to Proceed" is issued to the Artist and shall continue through the completion of the above Scope of Services.

5. Fee and Method of Payment

5.1 Fee

For the Basic Services outline in Paragraph 2, the Artist will be paid a fee based on hourly charges rates and reimbursable expenses "not to exceed" the amount of $_____.

The "not to exceed" fee includes all costs, including labor, subcontracts, all supplies and materials, equipment, printing, photography, travel insurance, licenses and any other expense incurred by Artist to properly complete the services required under this Agreement. Invoices to the Engineer shall be billed as per Hourly Charge Rates listed in Paragraph 6 below.

6. Hourly Charge Rates

By:_____ By:_____
 (Signature) (Signature)

Title:_____ Title:_____

Date:_____ Date:_____

TERMS AND CONDITIONS FOR THE PURCHASE OF ARTIST-MADE BUILDING PARTS

King County, Washington

THIS AGREEMENT is entered into by KING COUNTY (the "County") acting through the Metro Transit Department/Division and JANE DOE (the "Artist") whose address is:

_____ Telephone: _____

The County desires to purchase Artist-Made Building Parts, "Parts," described in this agreement for the No Name Transit Hub Project (the "Project"). The Parts will be incorporated into: four custom bus shelters located at California Ave. SW and SW Alaska St. The Artist has been selected by the County from the Artist-Made Building Parts Project in accordance with established policies and procedures based upon his/her creative skill and abilities.

NOW, THEREFORE, the parties do mutually agree as follows:

1. Scope of Work

A. The Artist will use his/her best efforts to perform the services required under this Agreement in a satisfactory and competent manner.

B. The County agrees to purchase the following building parts, "Parts," from the Artist:

[INSERT A SHORT DESCRIPTION OF THE PARTS AND ARTIST'S RESPONSIBILITY FOR DELIVERY AND INSTALLATION]

2. Schedule

A. The Artist shall be responsible for completion of fabrication, delivery and installation of the artwork in accordance with the agreed upon schedule. The Artist will seek out regular updates from the County regarding schedule for completion and installation of the artwork.

B. The estimated completion date is [INSERT DATE]. This date may be amended by mutual Agreement of the Artist and the County.

3. Ownership of the Building Parts

Ownership of the Parts under this Agreement shall transfer to the County upon completion of payment to the Artist.

4. Additional Services of the Artist

The County may request that the Artist provide extra services or changes to the scope

of work beyond those required in this Agreement. These changes, if performed due to circumstances causing the Artist extra work and expense, shall be paid for by the County in addition to the agreed upon fee. Any changes required of the Artist after the signing of the Term and Conditions shall require a written change order and the increased cost of such change order in Artist's labor and materials shall be added to the Agreement amount.

5. Responsibility of the Artist

A. The Artist shall be responsible for providing the services described in this Agreement.

B. The Artist agrees to comply with all applicable County, local, state and federal laws, regulations and ordinances regarding performance of the work.

C. The Artist shall notify the County of changes in his/ her address, and failure to do so shall be deemed a waiver of the County's responsibilities described in SECTIONS 6 and 12.

D. The Artist shall give credit in the following form for any public showings of reproductions of the work: "Commissioned through the King County Artist-Made Building Parts Project, King County, Washington."

6. Responsibility of the County

A. The County shall examine documents submitted by the Artist, render decisions, and advise the Artist promptly to avoid any unreasonable delay in the progress of the Artist's work.

B. The County shall, at its expense, furnish the Artist with [specifications and drawings for existing custom shelter construction and drawings of King County Metro's standard passenger shelters].

C. The County shall keep a current record of the disposition and condition of the Parts and make that information available to the Artist upon request. The Artist will be notified if, for any reason, the Parts have to altered, removed or moved to a new location, and the Artist shall have the right to advise the County regarding the disposition of the Parts, pursuant to Section 12.

D. The County shall abide by all King County Public Art Commission (KCPAC) policies and procedures.

7. Compensation

A. The County shall reimburse the Artist for satisfactory completion of the work specified in this Agreement in an amount not to exceed $00000.00 payable after the signing of the Terms and Conditions. This lump sum amount is inclusive of all applicable state and federal taxes including any Washington State Sales Tax owed by the

County as a result of this Agreement. It is the responsibility of the Artist to remit the sales taxes to the Washington State Department of Revenue.

B. The County shall have sole responsibility for determining stages of completion. It is understood that the County has no obligation regarding sales commissions or any agreements with galleries or agents with whom the Artist may have contracted.

C. The Artist may invoice the County for progress payments for labor and materials, not to exceed the total compensation.

D. The Artist is entirely responsible for cost control. No extra payments will be allowed as a result of cost overruns.

E. If the Artist fails to comply with any terms or conditions of this Agreement or to provide in any manner the work or services agreed to herein, the County may withhold any payment due to the Artist until the County is satisfied that corrective action, as specified by the County, has been completed.

8. Warranties

A. The Artist warrants that the design or work being commissioned is the original product of his/her own creative efforts.

B. The Artist shall be responsible for a period of one year from the date of installation of the Parts for the integrity of the materials and fabrication techniques of the Parts and the installation. Artist's liability for breach of this warranty shall be limited to the cost of repairs of the Parts and/or the installation. The Artist shall not be responsible for installation, materials or parts that were not fabricated or installed by the Artist as part of this Agreement.

9. Hold Harmless and Indemnification

A. In providing services under this Agreement, the Artist is an independent contractor, and neither his/her agents or employees are employees of the County for any purpose. The Artist shall make no claim of career service or civil service rights which may accrue to a County employee under state or local law.

B. The County assumes no responsibility for the payment of any compensation, wages, benefits, or state and/or federal taxes by, or on behalf of, the Artist. The Artist shall protect, indemnify and save harmless the County and its officers, agents and employees from and against any and all claims, costs, and/or losses whatsoever occurring or resulting from (1) the Artist's failure to pay any compensation, wages, benefits, or taxes; and/or (2) the supplying to the Artist of work, services, materials, or supplies by Artist employees or other suppliers in connection with or support of the performance of this Agreement.

C. The Artist further agrees that he/she is financially responsible for and will repay the County all indicated amounts following an audit exception which occurs due to

the negligence, intentional act and/or failure for any reason to comply with the terms of this Agreement by the Artist, his/her employees, or agents. This duty to repay the County shall not be diminished or extinguished by the prior termination of the Agreement pursuant to the Duration of Agreement, or the Termination section.

D. The Artist shall protect, defend, indemnify, and save harmless the County and its officers, agents and employees from any and all costs, claims, judgments, and/or awards of damages, arising out of or in any way resulting from the negligent acts or omissions of the Artist, his/her employees and/or agents. The Artist agrees that his/her obligations under this subparagraph extend to any claim, demand, and/or cause of action brought by or on behalf of any employees or agents. For this purpose, the Artist, by mutual negotiation, hereby waives, as respects the County only, any immunity that would otherwise be available against such claims under the Industrial Insurance provisions of Title 51 RCW. In the event the County incurs any judgment, award and/or cost arising therefrom including attorney's fees to enforce the provisions of this article, all such fees, expenses, and costs shall be recoverable from the Artist.

E. The County shall protect, defend, indemnify, and save harmless the Artist, his/her officers, employees, and agents from any and all costs, claims, judgments, and/or awards of damages, arising out of or in any way resulting from the negligent acts or omissions of the County, its employees and/or agents. The County agrees that its obligations under this subparagraph extend to any claim, demand, and/or cause of action brought by or on behalf of any employees or agents. For this purpose, the County, by mutual negotiation, hereby waives, as respects the Artist only, any immunity that would otherwise be available against such claims under the Industrial Insurance provisions of Title 51 RCW. In the event the Artist incurs any judgment, award and/or cost arising therefrom including attorney's fees to enforce the provisions of this article, all such fees, expenses, and costs shall be recoverable from the County.

F. Claims shall include, but not be limited to, assertions that use or transfer of software, book, document, report, film, tape, or sound reproduction or material of any kind, delivered hereunder, constitutes an infringement of any copyright, patent, trademark, trade name, and/or otherwise results in unfair trade practice.

10. Insurance

A. Insurance coverage is not required while the Artist is completing work on the project in his/her studio. Prior to the initiation of any on-site installation or fabrication, the Artist and/or his/her subcontractors shall purchase and maintain for the duration of any on-site fabrication and/or installation, insurance against claims for injuries to persons or damages to property which may arise from, or in connection with, the performance of work done by the Artist, his/her agents, representatives, employees, and/or subcontractors.

B. The Artist and/or his/her subcontractors shall pay for the costs of the required insurance.

C. All insurance policies must cover King County, its officers, officials, employees and agents as additional insured as respects: liability arising out of activities performed by or on behalf of the Artist in connection with this Agreement.

D. The Artist and/or his/her subcontractors must furnish certificates of insurance and policy endorsements as evidence of compliance with all insurance requirements of this Agreement. All policies shall be placed with carriers reasonably acceptable to the County.

E. The minimum scope, limits and coverage of insurance required by this Agreement are as follows:

1) COMMERCIAL GENERAL LIABILITY: $1,000,000

Combined single limit per occurrence by bodily injury, personal injury and property damage

2) WORKERS COMPENSATION: Coverage as required by the Industrial Insurance Act of the State of Washington.

3) PROFESSIONAL LIABILITY: $1,000,000. Visual Artists do NOT require professional liability insurance however, in the event that services delivered as a part of this Agreement require professional services, Professional Liability, Errors and Omissions coverage shall be provided. "Professional Services", for the purpose of this Agreement section shall mean any services provided by a licensed professional, such as structural review or engineering.

11. Mainentance

The County, through the Metro King County Transit Division, shall reasonably ensure that the Parts are properly maintained and protected in a manner as to preserve the artistic integrity of the Parts taking into account the recommendations of the Artist as stated in the maintenance criteria provided by the Artist.

12. Alterations, Repairs or Removal of the Parts

A. Except as provided herein, the County will not alter, modify or change the Parts without written authorization from the Artist regarding the proposed alteration, modification or change. Such authorization should not be unreasonably withheld.

B. In the event that the County determines that changes must occur and if the proposed changes affect the Parts designed by the Artist then the County shall notify the Artist immediately of any proposed alterations to the building, structure or the site that would affect the character and appearance of the Parts and shall consult with the Artist in the planning and execution of any such alteration and shall make a reasonable effort to maintain the integrity of the Parts.

C. In the event that the alteration is agreed to in writing by the Artist, the Artist shall be paid for consultation, design and fabrication services necessary to implement the alteration through a written Agreement. The Agreement shall include at a minimum a description of the compensation paid to the Artist, scope of work, payment schedule and schedule for deliverables. If applicable, the Agreement will also include a construction budget and schedule. If the Artist does not want to perform the alteration him or herself, then the County may hire the services of another fabricator or contractor to implement the approved changes.

D. In the event that the Artist and the County disagree on the proposed alteration or removal, or if the County fails to obtain, for any reason, the Artist's written permission as described immediately above, the County in its sole discretion, shall have the right to remove or alter the Parts or a portion of the Parts designed by the Artist providing the following terms and conditions are met:

1) The removal/alteration proposal shall be submitted to and considered by KCPAC or its assigns for a written opinion regarding the proposed removal or alteration.

2) In the event that KCPAC agrees to the removal/alteration proposal, The Artist shall have the right to remove his/her name from the work as well as any identification installed on site that designates that the work is that of the Artist.

13. Proprietary Rights and Rights of Reproduction

A. The parties to this Agreement mutually agree that the Artist shall retain all rights he/she may have under the Copyright Act of 1976, and all other intellectual property rights in and to the designs rendered and Parts fabricated as part of this Agreement.

B. The Artist expressly reserves every right available to him/her at common law or under the Federal Copyright Act to control the making and dissemination of copies or reproductions of the artwork, except as those rights are limited by this Agreement. The Artist authorizes the County and its assigns to photograph, digitally and graphically reproduce by any and all means and media now or hereafter known, the Parts without prior consent of the Artist if for the sole use and benefit of the public, including but not limited to advertising, brochures, and similar material.

C. The County shall assure that all reproductions by the County contain a credit to the Artist and a copyright notice substantially in the following form: "© Copyright, Artist's name, date", in such a manner and location as shall comply with the U.S. Copyright Laws.

14. Entire Agreement/Waiver of Default

This Agreement shall become effective immediately upon its signing. This Agreement constitutes the entire agreement between the parties and may not be verbally amended. All amendments or modifications to this Agreement must be in writing and signed by both parties.

15. Termination

A. This contract may be terminated in whole or in part by either party providing the other party thirty (30) days advance written notice of the termination.

B. Either party may terminate this Agreement, in whole or in part, upon seven (7) days advance written notice in the event: (1) either party materially breaches any duty, obligation, or service required pursuant to this Agreement, or (2) the duties, obligations, or services required herein become impossible, illegal, or not feasible.

C. If the termination results from acts or omissions of the Artist, including but not limited to misappropriation, nonperformance of required services or fiscal mismanagement, the Artist shall return to the County immediately any funds, misappropriated or unexpended, which have been paid to the Artist by the County.

D. If the Contract is terminated as provided in this subsection the County will be liable only for payment in accordance with the terms of this Agreement for services rendered prior to the effective date of termination and the Artist shall be released from any obligation to provide further services pursuant to the Agreement as are affected by the termination, upon written notification by the County to the Artist.

E. Nothing herein shall limit, waive, or extinguish any right or remedy provided by this Agreement or law that either party may have in the event that the obligations, terms and conditions set forth in this Agreement are breached by the other party.

COUNTY: ARTIST:

_____ _____
 Signature

_____ _____
Date Name (Please Print or Type)

 Date

 Federal Taxpayer ID #

AGREEMENT TO PURCHASE ARTISTIC GOODS AND SERVICES FOR ABC COMPANY

City of Seattle

This Agreement is made and entered into by and between ABC Company (hereinafter designated the "CONTRACTOR") and Jane Doe (hereinafter designated the "ARTIST") this 05 day of January, 2004.

In consideration of the promises, covenants and conditions and performances described in this agreement, the parties hereto agree as follows:

I. Scope of Work

ARTIST shall design and produce eight (8) lobby chairs (the "Lobby Chairs") to be attached to the flooring in the Main Lobby of the first floor of the CONTRACTOR's retail store currently under construction at 123 First Avenue North in the City of Seattle.

ARTIST shall work present CONTRACTOR with final design drawings for the eight (8) Lobby Chairs by May 1, 2004. CONTRACTOR agrees to examine the ARTIST's drawings on receipt of drawings and will notify the ARTIST within five (5) days of any proposed changes or revisions. If CONTRACTOR and ARTIST are unable to agree upon the final design of the Lobby Chairs within fifteen (15) days from the date of this Agreement, the CONTRACTOR may terminate this Agreement upon seven (7) days written notice to ARTIST.

The ARTIST shall be available to consult on the placement of the Lobby Chairs, to the extent required to ensure the thematic vision be represented within the Main Lobby of the ABC Company. The ARTIST shall not be responsible for the actual installation of the Lobby Chairs; said installation shall be the responsibility of the CONTRACTOR.

The ARTIST further agrees to perform on-site finishing work as required after the completion of the attachment of the Lobby Chairs to the floor. Finishing work will consist of polishing and sealing the Lobby Chairs, as part of this agreement. However, any cleaning or restoration required due to negligence on the part of the CONTRACTOR or faults in the installation shall be performed by the ARTIST on an hourly basis, at a cost to ABC Company of $50.00 per hour.

II. Period of Performance

The ARTIST agrees to deliver Lobby Chairs on or before November 1, 2004. The ABC Company shall use reasonable efforts to ensure that the area in which the Lobby Chairs are to be installed is ready for installation of the Lobby Chairs on or before November 1, 2004. If construction is delayed and the Main Lobby cannot be ready for installa-

tion by the above date, the ARTIST will be notified by mail and a schedule acceptable to the CONTRACTOR's Project Superintendent and the Artist will be negotiated.

III. Compensation and Payment

A. Amount of Compensation

Total compensation to the ARTIST for satisfactory performance under this agreement shall not exceed $20,000 not including Washington State Sales Tax. This payment covers design, fabrication, shipment and finishing supplies of the Lobby Chairs. This payment does not include installation labor or materials.

B. Progress Payments

The first payment of 1/3 of $20,000 + Washington State Sales Tax will be paid by the CONTRACTOR to the ARTIST upon signing this Agreement.

The second payment of 1/3 of $20,000 + Washington State Sales Tax will be paid by the CONTRACTOR to the ARTIST upon completion of and approval final design drawings.

The final payment of the remaining 1/3 of payment + Washington State Sales Tax is shall be made to ARTIST no later than ten (10) days after the delivery and finishing work of the Lobby Chairs as specified in this Agreement by ARTIST.

IV. Independent Contractor Status

ARTIST shall perform all services as an independent contractor and shall not be considered in any respect an employee of ABC Company. ARTIST shall cooperate with ABC Company and other project contractors with regard to the installation of the Lobby Chairs. ARTIST shall comply with all applicable laws and regulations regarding the work to be performed under this Agreement, including those related to worker safety, and ARTIST shall comply with all workplace safety rules in effect at the site during any time when ARTIST is onsite.

V. Warranties

ARTIST shall be responsible for a period of one year from the date of installation of the Lobby Chairs for the integrity of the materials and fabrication techniques of the Lobby Chairs. ARTIST's liability for breach of this warranty shall be limited to the cost of repairs of the Lobby Chairs.

VI. Identification; Ownership

A. The design of Lobby Chairs including technical and working drawings by the ARTIST will remain the property of the ARTIST.

B. The ARTIST expressly reserves every right available to him/her at common law or under the Federal Copyright Act to control the making and dissemination of copies or reproductions of the artwork, except as those rights are limited by this Agreement.

C. ABC Company shall have irrevocable license to graphically and photographically depict the Lobby Chairs in any non-commercial manner whatsoever. For the purposes of this Subparagraph, the graphic and photographic depiction of the Lobby Chairs in or on materials designed to promote ABC Company, its services or products, or to attract customers to any of its services or products, shall be deemed non-commercial use.

D. ARTIST shall be allowed to photograph the Lobby Chairs for the period of one (1) year from the date of installation and shall retain the right to use such photographs without the prior written approval of ABC Company; provided, however, that such photographs will be used for the ARTIST promotional purposes only.

VII. Termination; Suspension

A. For Cause: Either party may terminate this Agreement in the event of another party fails to perform its obligations as described in this Agreement, and such failures has not been corrected to the reasonable satisfaction of the other in a timely manner after notice of breach has been provided to the other party.

B. For Reasons Beyond Control of Parties: Either party may terminate this Agreement without recourse by the other where performance is rendered impossible or impracticable for reasons beyond such party's reasonable control such as but not limited to acts of nature; war or warlike operations; civil commotion; riot or governmental regulation and control.

C. Notice: Notice of termination pursuant to Subsections A and B shall be given by the party terminating this Agreement to the other not less than seven (7) days prior to the effective date of termination.

D. Suspension: ABC Company may, without cause, require ARTIST in writing to suspend, delay or interrupt their performance of work under this Agreement in part for such a period of time as determined by ABC Company. In the case suspension, delay or interruption, an adjustment may be made to the Agreement price due to any actual increases in ARTIST's cost of performance of the Agreement; provided, however, that no adjustment shall be made to the extent that the performance would have been suspended, delayed or interrupted by another cause for which ARTIST is responsible.

VIII. Identification and Attribution

A. ABC Company agrees to display an identification label provided by ARTIST, from a design approved by ABC Company, in a location near the beginning of the series of artworks.

B. ABC Company has permission and is required to employ the following attribution of the artwork in all forms and media: "Artwork by Jane Doe," or "Jane Doe, ARTIST" or "Lobby Chairs by Jane Doe," or an equivalent designation of attribution.

IX. Indemnification

A. The ARTIST shall defend, protect, indemnify and hold harmless ABC Company, its officers, agents, employees and assigns, from and against any and all damages, claims, suits, and/or actions arising from any negligent acts or omissions of the ARTIST during the performance of the Agreement. ABC Company shall, to the extent permitted by law, indemnify and hold harmless the ARTIST against any and all third party claims or liabilities arising in the connection with the artwork, the site or the project, except claims which may occur as a result or arise in connection with the ARTIST's own negligence or failure to comply with applicable laws, regulations, ordinances and resolutions.

B. Upon completion of the installation of the artwork, the ARTIST does hereby agree to be responsible for a period of one year from the date of installation for the integrity of all materials and fabrication technique contained in the Artwork. This guarantee shall apply only to that artwork which is entirely that of the ARTIST.

X. Entire Agreement

This agreement shall become effective immediately upon its signing. This agreement constitutes the entire agreement between the parties and may not be verbally amended. All amendments or modifications to this contract must be in writing and signed by both parties.

ABC COMPANY ARTIST

_____ _____
Print Name Print Name

_____ _____
Title Title

_____ _____
Signature Signature

_____ _____
Date Date

Public Art Education

Beyond the Ribbon Cutting

Education and Programming Strategies for Public Art Projects and Programs

RENEE PIECHOCKI

It is no secret that public art practitioners work with a diverse cross-section of people to implement public art projects. The typical project involves collaboration among artists, arts administrators, government agencies, funders, designers, contractors, and community organizations—and that's just the beginning. By the time a project is installed, more than thirty individuals may have had some stake in the project's development. It makes for a lovely party when the ribbon is cut at the project's opening. This essay offers ideas, ranging from basic to complex, for educational materials, programs, and outreach strategies that will increase the impact of public art in a community.

In public art administration, the processes of artist selection, design development, and implementation offer excellent examples of how groups of individuals can be brought together to create a lasting impact on civic space. Through the diligence of artists and public art administrators, stakeholders are informed about and kept aware of each milestone in the artwork's progress. Communities are developed each time a public artwork is installed. They don't necessarily share the same neighborhood, but they do share an interest in seeing the artwork succeed. In order to continue the excitement and meaning of a project beyond the ribbon cutting, a similar effort must be made to develop information and programming about public art projects and programs.

In 2001, when the Public Art Network conducted a survey of the nation's public art programs, questions about educational programming, artist outreach, and staff development were included. The resulting report, *Public Art Programs, Fiscal Year 2001*, confirmed that these three essential components of building public art awareness were among the least well funded areas of public art programs. On the average, programs were found to spend 0.4 percent of their budgets on educational programming and artist outreach, and only 0.1 percent on staff development. In general, private nonprofit public art programs outspent programs that were based in government agencies.

This essay focuses on specific educational programming ideas and outreach strategies for building a community that is interested in and informed about public art. The essay concentrates on three areas: the public at large, professional development for artists, and professional development for public art administrators.

The commitment to developing art for installation in nontraditional art spaces comes with the challenge of reaching out to a diverse audience. Millions of people encounter public art as part of an everyday routine. It is certainly valuable to experience a work of art visually or emotionally, without additional layers, but developing materials that provide information and context creates a more meaningful relationship between public art and the public at large.

A key to success in public education and outreach is to develop diverse community connections. Don't make the mistake of communicating only with people who are already in the know. The field of public art inherently involves a wide range of people in project planning and implementation. Capitalizing on that advantage—taking time to consider public art's wide audience and how to communicate with it, and researching existing outlets for information—will result in increased awareness of public art.

In addition, it is important to consider that communities change, and that the people who experience public art in a specific place change as well. The community that participated in the process of selecting the artist and developing the design for a permanent public artwork will not be the same community that lives with the work in ten, thirty, or one hundred years. There has been a trend in public art for at least the past two decades to create community-based or place-specific work, and that is an excellent reason to develop educational materials for public art projects. Consider, for example, a school that serves as the location for a tile mural containing references that were meaningful to the community's once-predominant core Asian population. How can the meaning and value of this work be conveyed to the school's newly predominant Latino and African American students?

Another use of educational materials is in connection with temporary public artworks, which offer artists and programs the ability to work with new or experimental technologies and of-the-moment subject matter. Educational materials place this work in context for viewers and increase understanding and appreciation for the specific project and for contemporary art.

In the long run, the goal is to have increased engagement and understanding of public art on a personal level, leading to increased support for public art and the arts in general—locally, regionally, and nationally.

Signage

As a self-confessed public art tourist, I seek out public art whenever I am in a new place: a city, an airport, a library, and so on. If a public art program does nothing else, it should ensure that every artwork in its collection includes signage. This approach is suggested for permanent and temporary commissions as well as for portable works. Signage is the very first step in adding communication between a viewer and an artwork, beyond the experience of seeing the work. Signage is a way to have an impact

with a small amount of money, especially if the cost of signage is included in the commission allocation.

Signage for a work of art should always include the following elements:

- Name(s) of the artist(s)
- Title of the artwork
- The copyright symbol (©)
- The date of the artwork's creation or installation
- The name of the commissioning organization (this information can help viewers find additional information or contact the commissioning organization if the work is in need of maintenance)
- At least one sentence of interpretive information (perhaps a quote from the artist, a description of the work, or other text that can help develop understanding of the artwork)

It is also common for the signage to include these elements:

- A list of the materials used to create the artwork
- Contact information for the owner and/or commissioning organization (to be included with care, since this kind of information can quickly become dated)
- The artwork's accession number

Press Releases

Developing a press release for a public art project is an essential step in spreading the word about the project to local, regional, and national media outlets. In addition, a press release is a useful tool for sharing information with local government, citizen groups, arts organizations, public art colleagues, educators, and professional organizations in allied fields. Press releases archived on a Web site also become a record of the program's accomplishments.

Public art practitioners often say that there is not enough coverage of public art projects, or that the only projects covered are the few that are controversial. Developing ongoing relationships with media contacts by circulating press releases, tours of projects for the press, and updates can help create a more positive image for public art.

When circulating a press release, consider a wide range of contacts on the local, regional, and national levels. Develop a mailing list of journalists who are interested in art, community development, architecture, landscape architecture, design, tourism, human interest stories, and other areas that fit individual projects (such as those involving technology, libraries, and schools). Include regular contributors as well as freelance writers and producers who specialize in the topics on your list.

In addition to your community's major newspapers and radio and television stations, develop contacts in the following places:

- Local and neighborhood newspapers, including non-English-language newspapers
- Public radio and television programs

• Tourism and cultural development organizations in your region

• Neighborhood organizations and citizen groups that print newsletters or maintain e-mail listservs (for example, if your project is in a park, your local Sierra Club chapter or hiking club might want to inform their members about your project)

• Regional and national organizations that print newsletters or maintain e-mail listservs (for example, your local arts agency or the Public Art Network of Americans for the Arts)

• Trade or professional organizations that publish newsletters or maintain e-mail listservs (for example, if a public art project is made of ceramic tile, consider sending a press release to *Ceramics Monthly*)

If your organization does not have the budget or staff to circulate press releases for each individual project, consider grouping projects (for example, all the projects completed in a six-month period, or all the projects completed for a specific location). At the very least, if funding and staffing are particularly tight, develop short project announcements to be sent out to your contacts via e-mail. Artists also have their own valuable networks—give them this short project announcement to send out to their own mailing lists.

The Web site http://www.press-release-writing.com offers the following ten tips for writing a press release:

1. Make sure the information is newsworthy.
2. Tell readers that the information is intended for them, and tell them why they should go on reading.
3. Start with a brief description of the news and then indicate who announced it, not the other way around.
4. Ask yourself how people are going to relate to the press release and whether they will be able to connect with it.
5. Make sure that the first ten words of the press release are effective, since they are the most important.
6. Avoid fancy language and excessive use of adjectives.
7. Deal with facts.
8. Provide as much contact information as possible (the person to contact, address, phone number, fax number, e-mail address, Web site address).
9. Issue a press release only when you have something of substance to say.
10. Make it as easy as possible for media representatives to do their jobs.

Web Site

It is essential for a public art program to have a presence on the World Wide Web, whether as a section of an umbrella organization's site or as a site specifically dedicated to the public art program. The program's Web site is the first place the public at large will search for information about the program. A Web site can be quickly updated, and the cost of developing and maintaining it is less than the expense of constantly developing and publishing new print materials.

Developing a Web Site

When you develop a new Web site or update an existing one, be sure to visit a wide variety of sites to research the types of features you would like to include. (See the Resources at the back of this book for Web site addresses of public art programs nation-wide.) In addition, visit the Web sites of cultural institutions, policy organizations, professional organizations, and artists to develop a feel for current styles. Doing so will help you outline your goals, establish your aesthetic concerns, and gauge your updating capabilities so that your site's designer can develop a Web site that suits your needs.

Consider the following basic sections for your Web site:

- Your public art program's description and goals
- Administrative documents, such as your ordinance, policies, and guidelines
- Information for artists, including opportunities and slide registry forms
- Current project information and press releases
- An events calendar
- Downloadable project fact sheets and tour brochures

The following sections will further enhance your site:

- A list of public art/artist resources in your region
- Links to public art/arts organizations
- A platform for hosting Web-based art projects
- An archive of completed projects
- An online registry of artists' work

Uses of a Web Site

The City of New York's Department of Cultural Affairs includes an archive of completed percent-for-art projects on its Web site. It is not a separate percent-for-art Web site; rather, it is integrated into the city's site. The archive includes an image of each completed project, a project description, a quote by the artist, the project's location, and a list of the sponsoring agencies. The viewer can specify an archive search based on the artist's name, the work's location, or the sponsoring agency. To view this archive, visit www.nyc.gov.

If your program is interested in the Internet as public space, and in commissioning artists to create Web-based art projects, visit www.rhizome.org. Rhizome is a nonprofit organization founded in 1996 to provide an online platform for the global new-media art community. The organization's programs and services support the creation, presentation, discussion, and preservation of contemporary art that uses new technologies. One of Rhizome's core activities is commissioning artists and presenting work created for the Web.

The Ohio Arts Council has developed on its Web site the On-Line Visual Arts Registry for local and national artists. This registry is intended for use as an outreach

tool by collectors, designers, architects, curators, journalists, selection panels, gallery owners, and art enthusiasts of all kinds. The information for each entry includes the artist's name, the artist's biography, several images of the artist's work, and the artist's contact information. The registry also includes a link to other online registries. To view the registry, visit www.oac.state.oh.us.

Printed Materials

There are several levels of printed materials that can be produced about public art projects to enhance or create a learning experience. In addition, printed materials act as marketing tools that increase a public art program's visibility. The following suggestions for printed materials range from easy to complex and include distribution ideas.

Project Fact Sheet

A fact sheet is a simple one-page document that gives an overview of an individual project. It typically includes the following elements:

- The artist's name
- The project's title, location, completion date, medium or media, and dimensions
- A description of the project
- A statement by the artist about the work
- The artist's biography
- The names of the selection jury's members
- Information about the commissioning organization and the public art program
- An image of the artwork

The fact sheet should be made available at the artwork's location and should also be provided as a downloadable document on the Web sites of the commissioning organization and the public art program.

Postcard

A color postcard of an individual artwork acts as both an educational and a marketing tool for the project and for the public art program. The front of the postcard should feature a professional photograph, with the following elements on the back of the card:

- The artist's name
- The project's title and location
- The name(s) of the commissioning organization(s)
- A Web site address for the public art program
- An e-mail address for the public art program

The postcard can be distributed with a press release, handed out by public art program staff at meetings, or made available at the site of the featured artwork.

Tour Brochure

A tour brochure can encompass a program's entire collection, a neighborhood, or a facility (such as a courthouse) where public art is located. The brochure should include the following elements:

- A good map
- Written directions for walking, driving, parking, and public transportation
- An image of and description for each project

If your budget does not allow you to print a brochure, consider developing a downloadable document, such as a PDF file on your program's Web site, or collaborate on a brochure with another agency or community organization. For example, if you have recently completed a series of public art projects in a downtown location, work with local business organizations or the chamber of commerce to develop a brochure that features all downtown public art, cultural organizations, restaurants, and historic sites.

The tour brochure should be made available at locations that feature public artworks, at key tourist destinations (such as visitors' centers, convention centers, and hotels), and at locations frequented by local residents, such as libraries and cultural organizations. Like a postcard, a tour brochure is a dual educational/marketing tool that can be distributed by public art program staff at meetings.

Program Brochure

Developing a simple brochure about your public art program is a great way to provide an overview of public art and your program's goals and provide information about how to get involved. One of the best ways to get someone to go to your Web site is to offer a piece of paper that includes the site's address. Your brochure is a way to bring people to your Web site for additional information and invite them to download tour brochures, learn about artist opportunities, and so on.

Catalogs, CDs, and DVDs

If a significant budget is available, consider creating a catalog that features your public art collection. A catalog can contain expanded educational information to place your program in the context of contemporary art. In addition to giving an overview of individual projects, the catalog can present and discuss the public art program as a whole and compare it with other contemporary and historic program models. It can include essays by critics and cultural theorists and feature interviews with artists, administrators, designers, and other stakeholders.

Producing a CD or a DVD allows for video and audio to be used as methods of highlighting the collection. Publication and distribution of such material must be carefully considered, of course. Professional advice and consultation from publishers, editors, and distributors should be sought before the project gets under way and funds are committed.

Public Programs

In addition to inviting people come to you for information, you can reach out to new or established public art audiences in several ways.

Receptions

Public art programs often organize opening receptions for new installations. A reception traditionally involves a tour of the artwork and remarks by the artist, funders, and commissioning agencies. Hosting a reception is a great way to invite everyone involved with a project to celebrate its completion. Civic spaces that include public art are dynamic sites for receptions. If the project is sited at a new facility, its reception and the building's opening may be organized as a single event.

But the unveiling of a finished project is not the only reason for hosting a reception. After the people who will be using and working in a new facility have settled in, consider a meet-the-artist event. Having a chance to experience the artwork and then hear the artist speak about it and answer questions will enhance the work for the community. Consider videotaping the event so that the artist's presentation can be viewed again as the location's community changes.

Tours

If agencies or organizations in your community are hosting meetings or other events, consider working with them to organize these events at locations that feature public art, and provide printed materials about the works or opportunities for guided tours in conjunction with such events. Developing a guided tour of public art projects is an excellent way to increase knowledge about and appreciation of public art. In addition to offering the information included in a printed brochure and a fact sheet, an in-person tour can be tailored to suit the needs and interests of the audience. Think about including colleagues from other fields to enhance the tour—invite a curator, a historian, a naturalist, or an architect to complement the public art information. Meeting the artist whose work is featured is recommended.

Most public art programs do not have the staff to offer ongoing tours of public art projects. Consider an annual tour that highlights new commissions or a different neighborhood. An additional option is to partner with another organization, such as the local chapter of the American Institute for Architects, to develop an art-and-architecture tour. Yet another option is to research organizations that provide regularly scheduled tours in your community and supply them with information about public art projects to be incorporated into their own tours.

Slide Presentations

When people are unfamiliar with public art, there is no substitute for showing them examples of it. When it is not possible to bring people to see works of art in person, developing slide presentations is a feasible solution.

If you are establishing a public art program, a slide presentation is an excellent educational tool. In 2000, when the town council of Chapel Hill, North Carolina, authorized the Chapel Hill Public Arts Commission to develop a percent-for-art program, the commission faced the challenge of increasing awareness about public art in a community with little experience of it. The commission hired a consultant to develop a forty-five-minute slide presentation about public art that could be shown to different groups across town. The slide show developed a context for the history of public art and gave examples of a range of contemporary public art projects in all media. In addition to the slide show, the presentation included information about methods of commissioning and implementing a public art program. The presentation was delivered by commission volunteers to town council staff members, elected officials, and citizen groups. The commission also advertised several public meetings where the presentation was given.

If your program is already established, a slide presentation can increase awareness about public art among new audiences in your community. Consider developing slide presentations for groups of several interests and ages. The audience for slide presentations includes city planners, engineers, architects, staff members of city agencies, educators, librarians, elected officials, curators, historians, preservationists, real-estate agents, students, journalists, members of neighborhood development groups, and tourists. The public art program's staff can invite the audience to the program's offices, or they can offer to be guests at meetings organized by host groups.

Another type of slide presentation is a lecture series. Cary Visual Art, Inc., a nonprofit public art program in Cary, North Carolina, has been organizing the Public Art In Focus lecture series since 2001. The series, initiated when the organization identified the need for expanded knowledge about public art in the community, also became a way to build excitement about upcoming public art opportunities in the region. At least four times a year, a public art practitioner—a group that includes artists, administrators, curators, and educators—is invited to present an hour-long lecture. The guest lecturer is paid an honorarium and a travel fee. The lecture is free, open to the public, and widely advertised in the community through printed postcards and listserv announcements. It is a valuable educational opportunity for members of public art commissions as well, who may not attend national conferences, meet with their colleagues, or read journals and articles about public art. The lecture series keeps them informed, right in their own backyard, about what is happening nationally in their field.

Docent Programs

A docent is a volunteer teacher, lecturer, or guide who is trained to give visitors extensive information about a specific topic. Museums and historical sites across the country have trained docents to meet their educational programming needs. For a public art program, whose staffing and budget constraints are similar to those of a museum, developing a docent program can be a way to meet the goal of increasing awareness about public art in the community.

MTA Metro Art, in Los Angeles, has developed an extensive docent program, nominated in 2002 for a Public Art Network award. Maya Emsden, who leads MTA Metro Art, offers the following comments:

In the late 1990s, the MTA Metro Art program was receiving numerous requests for guided tours of the public art in the Metro Rail system. Unfortunately, the department was unable to fulfill the demand for tours because of pressing project-management responsibilities.

During a tour given to staff members of the Los Angeles County Museum of Art, Barbara Lashenick, a docent with eighteen years' experience, asked if there might be an interest in formulating a docent council. Not only was Barbara a strong arts advocate, she also had years of experience in developing and coordinating volunteer programs and was clearly dedicated to bringing an awareness of art to the public outside a museum setting.

Thus was born the Metro Art Docent Council. It began with twelve experienced volunteer docents drawn from museums throughout Los Angeles County. After a three-month training program led by Metro Art staff, the docents debuted their touring skills at the opening of the Metro Rail Hollywood stations, in June 1999.

Today the Docent Council has grown to almost thirty volunteers who have introduced well over ten thousand people to the public art in the Metro Rail system, and the demand continues to rise as word spreads. Multiple tours, all free, are given each month, and the response has been overwhelmingly positive.

As public art administrators, we all acknowledge the importance of informational programs, which bring recognition to the field of public art. Unfortunately, few programs have the staff or the funding to provide such a service. The MTA Metro Art Docent Council not only offers free educational services to the public but also displays a self-sustaining model for success in the field of public art.

The Docent Council is an integral part of the Metro Art program. This commitment continues to improve as the docents expand their understanding of the works through field trips and visits to artists' studios. Through training, docents are able to successfully translate unique insights into the artworks, the artists who created them, and the processes that made the works a reality. Docent tours provide creative enrichment for public transit customers and impart a valuable cultural experience of public art within the growing development of transportation in Los Angeles.

For more information about Metro Art and the docent program, visit www.mta.net.

PROFESSIONAL DEVELOPMENT FOR ARTISTS

The number of public art programs across the country is steadily increasing. The *2003–2004 Public Art Program Directory* listed 350 programs. According to *Public Art Programs, Fiscal Year 2001,* the programs have an average workload of fourteen projects

each. This means that there are nearly 4,900 active public art projects each year in the United States. In order for programs to work with new artists and develop fresh approaches to their projects, it is essential that the programs reach out to artists who are new to the field of public art.

Public art education for artists exists in the form of workshops, continuing education, and degree programs. In addition, an increasing number of universities and colleges are offering individual courses in public art as elements of their B.A., B.F.A., and M.F.A. programs. A list of degree programs in public art can be found in the Public Art Network section of the Web site of Americans for the Arts (www.AmericansForThe Arts.org/PAN).

In 2004, Fort Worth Public Art, in Texas, developed a series of four three-hour workshops for artists interested in learning about the public art process. The series was called On Making Public Art, and the workshops—titled "Getting into the Game," "Putting the PUBLIC in Public Art: Austin Stories," "Teaming with Design Professionals & Other Artists," and "Left Brain Aspects of Public Art"—were offered to artists free of charge. There was no application process, and any artist was eligible to attend.

The series was structured so that a new workshop on a different topic was offered on the last Saturday of each month. The workshops featured experienced public artists and administrators, offered printed resources, and allocated time for questions and answers. An artist could choose to attend any or all of the workshops.

In San Jose, California, the Office of Cultural Affairs developed a series of training workshops for artists that started in 2002. The organization has expanded the impact of its workshops by posting the workshop manual on the agency's Web site (www.sanjoseculture.org). The manual consists of four PDF documents. Although nothing can take place of a hands-on training session, this free, downloadable manual is helpful to artists who want to demystify the public art process by examining concrete materials involving public art funding methods, calls for artists, community interaction, insurance, budget preparation, proposal development, and guidelines for artwork maintenance. Samples of the agency's artist contracts are also posted online for artists to review.

The following professional development activities can also be produced for artists.

Mock Panels

In general, an artist invited to serve on a selection panel has already had some public art experience. What happens on an artist selection panel can be a mystery for artists new to public art. For those who have been invited to an interview with a selection panel, only the interview process itself is revealed. To help educate artists about the selection process, a public art program can develop a mock panel and invite artists to experience the process first hand, from slide review to interviews. Be sure to leave time for questions as well as for suggestions by artists about what could make the selection process more artist-friendly.

Call-for-Proposals Exhibitions

Artists new to public art have voiced the opinion that it is a difficult field to break into. To receive a commission, it is perceived, previous experience is required—but how can such experience be obtained? To answer this need, a public art program might consider sponsoring a call-for-proposals exhibition. The program would circulate a call for proposals, using the same criteria that are used for its other commissioning opportunities, and the works submitted would be exhibited in a gallery setting rather than commissioned. Proposal reviews could be offered by public art program staff and other arts administrators, and awards could be given. In addition to adding an exhibition to their résumés, artists new to public art would have a public art proposal to add to their portfolios.

Student Presentations

If no public art courses are offered at local colleges and universities, a public art program could collaborate with an art professor to develop a slide presentation/workshop about public art as a useful tool in educating new artists about the field. Consider a presentation that includes images of a diverse selection of public art projects, an overview of what is involved in completing a commission, and information about local, regional, and national opportunities.

PROFESSIONAL DEVELOPMENT FOR ARTS ADMINISTRATORS

It is not uncommon for public art administrators to feel as if they are working in a vacuum. According to *Public Art, Fiscal Year 2001,* the average public art program in the United States has about two staff members, and these two may be the only people in their community or region who are familiar with public art practice. In order for individual administrators to develop new ideas, learn from others' mistakes, and not reinvent the wheel, it is essential that they be connected to colleagues in their field. The following suggestions are intended to encourage professional development opportunities for public art administrators.

Know Your Local Colleagues

Public art administrators can become isolated because of geography, or simply because it can be impossible to get a group of busy people together even for coffee. Don't get caught in this trap. It is important to know what's in the works among local and regional public art colleagues. Networking can yield valuable information about positive events (successful installations, good reviews, new service providers) and negative events (controversial projects, abrupt changes in agency administration). This is the kind of information that can save staff time, effort, and heartache.

For the past ten years, the Fairmount Park Art Association, in Philadelphia, has been organizing regular brown-bag lunches for public art administrators. The meet-

ings are open to all and are regularly attended by consultants, curators, and the staff of the city's public art programs. The lunches feature "show and tell" about individual projects, and guest presenters are also invited to speak about a variety of topics.

Jeffrey York, who leads the Public Art and Community Design Program of the North Carolina Arts Council, has developed a series of field trips to public art programs across the state. The host location works with York to lead discussion about a topic, and the discussion is followed by a tour of the program's projects. York has also organized a free public art listserv, available to administrators and artists, as well as seminars where local arts administrators meet with colleagues from across the country.

Florida, which has the second largest number of public art programs in the country, has developed a statewide service program for the field, the Florida Association of Art in Public Places. The group organizes annual meetings in different locations throughout the state and has active committees that focus on various projects and interest areas for the field. For more information, visit www.floridapublicart.org.

Connect with the Field

In addition to getting to know your local colleagues, there are several ways for you to connect with the field on a national level.

Join the Public Art Network

Joining a national service organization is an excellent way for you to network and keep current. The Public Art Network, a program of Americans for the Arts, is designed to provide services to the diverse field of public art and to develop strategies and tools for improving communities through public art. The Public Art Network's key constituents are artists, public art professionals, design professionals, arts organizations, and communities planning public art projects and programs. Among the organization's other services, its members-only listserv functions as a research engine, a platform for critical dialogue, and a newsletter. The organization also sponsors an annual conference and develops products for the field, including the *Call for Artists Resource Guide* included elsewhere in this book. For more information about the Public Art Network, visit www.AmericansForTheArts.org/PAN.

Attend Conferences

Having a presence at conferences, either as presenter or attendee, is another ideal way to meet colleagues and develop insight into new directions in the field. The annual conference organized by the Public Art Network has already been mentioned. Another opportunity is offered by the College Art Association's annual convention, which usually includes several public art-related panels. In addition, look for public art sessions at the annual conferences of the American Institute of Architects and the American Planning Association. Online resources include www.art-public.com, based in France, and the public art conferences and other events listed on the Web site of the Public Art Network.

Subscribe

Subscribing to such publications as *Public Art Review, Art In America, Art Journal,* and *Sculpture Magazine* and making time to read the articles are ways to keep informed. Although not all these publications are focused on public art, they often include articles about individual public art projects and about artists who work in the field. Since public art administrators work with colleagues in allied design fields, reading publications devoted to architecture or landscape architecture will also be very helpful in developing a deeper understanding of what is current in those fields.

See Art

It is important to keep up with the field of public art, but it is also essential for public art administrators to continue participating with the arts in general. Make looking at art and meeting artists a part of your job—the fun part! Seeing art is an essential component of professional development. Visit museums, galleries, and artists' studios, and organize field trips with your staff and colleagues to see art in your region. During other travels, seek out art in public places on your own, or connect with colleagues in the places you are visiting to get lists of projects to see during your stay. Having a bit of a busman's holiday could lead you to experiences off the beaten track.

SAMPLE PRESS RELEASE *Public Art Fund*

For immediate release
 Contact:
 Public Art Fund
 212–980–4575
 E-mail: press@publicartfund.org
 The Museum of Jewish Heritage—A Living Memorial to the Holocaust and Public Art Fund announces . . .

Andy Goldsworthy's *Garden of Stones*

Permanent commission for Memorial Garden completed at Lower Manhattan Museum

Opens September 17, 2003

New York, NY (August 25, 2003)—On September 17, Andy Goldsworthy's first permanent commission in New York City, *Garden of Stones,* will open to the public at the Museum of Jewish Heritage—A Living Memorial to the Holocaust. *Garden of Stones,*

an eloquent garden plan of trees growing from stone, is Goldsworthy's design for the Memorial Garden, an outdoor space that is a central feature of the Museum's new Robert M. Morgenthau Wing. The garden was commissioned by the Museum and organized by the Public Art Fund.

The Memorial Garden is a contemplative space dedicated to the memory of those who perished in the Holocaust and honoring those who survived. For *Garden of Stones,* Goldsworthy worked with nature's most elemental materials—stone, trees, and soil—to create a garden that is the artist's metaphor for the tenacity and fragility of life. Eighteen boulders form a series of narrow pathways in the Memorial Garden's 4,150–square-foot space. A single dwarf oak sapling emerges from the top of each boulder, growing straight from the stone. As the trees mature in the coming years, each will grow to become a part of the stone, its trunk widening and fusing to the base.

A press preview and ceremonial planting with Andy Goldsworthy will be held on September 17 at 11 A.M. To attend, please call 212–980–3942.

Andy Goldsworthy will give a lecture about *Garden of Stones* at 7:30 P.M. on Wednesday, September 17. Admission is $10 for adults, $7 for seniors, and $5 for students. Call 212–945–0039 for tickets.

Garden of Stones reflects the inherent tension between the ephemeral and the timeless, between young and old, and between the unyielding and the pliable. More importantly, it demonstrates how elements of nature can survive in seemingly impossible places. In Jewish tradition, stones are often placed on graves as a sign of remembrance. Here, Goldsworthy brings stone and trees together as a representation of life cycles intertwined. As a living memorial, the garden is a tribute to the hardship, struggle, tenacity, and survival experienced by those who endured the Holocaust. This contemplative space, meant to be revisited and experienced differently over time as the garden matures, is visible from almost every floor of the Museum. The effect of time on humans and nature, a key factor in Goldsworthy's work, is richly present in *Garden of Stones,* as the sculpture will be viewed, as well as cared for, by future generations.

As with his previous permanent works, which are typically site-inspired, Goldsworthy noted that *Garden of Stones* draws inspiration from its local surroundings: "One of the most powerful images I have of New York was staying in a hotel on Broadway. My room was high up in the building, I think on the 17th floor. I looked out of the window of my room and I saw a tree that had seeded itself, growing out of the side of the building opposite. It was for me a potent image of nature's ability to grow, even in the most difficult circumstances."

Garden of Stones: *The Process*

Goldsworthy began working on *Garden of Stones* in late 2002. In the winter and early spring of 2003, he traveled to forests and quarries in the northeastern United States seeking out suitable boulders, which he located in Barre, Vermont. Searching for boulders that were free of flaws, Goldsworthy selected stones which range in size and physical character. He noted that "there is an energy within a group of stones of various sizes. It becomes a family." The smallest stone is three tons, while the largest weighs more than 13 tons.

Most of the boulders he selected had been removed from nearby farmlands hundreds of years ago, something that appealed to Goldsworthy, since there was a tradition of human involvement with the stone. "My working of the stones is a continuation of the journey these stones have made. They have a history of movement, struggle, and change which I hope will resonate with the garden." He chose to include eighteen boulders in part because of the number's symbolic significance: In Hebrew every letter also possesses a number value. *Chai,* whose number value is 18, is the Hebrew word for life, and is known to many in the traditional toast "*L'chaim*"—to life!

In all of Goldsworthy's works, the process of selecting and becoming familiar with the natural materials he uses is a key element of the work itself. For *Garden of Stones,* he researched several different methods of hollowing the stones, including coring, water jet cutting, and burning with a flame torch. "I rarely repeat a work twice, so each work is a step into the unknown," he has said. He chose the flame torch method, in part because it was the most efficient, but also because granite is a fire-formed stone: Goldsworthy saw an affinity between the way the stone came into being and the way in which it became part of *Garden of Stones.* This spectacular technique melted away the interior of the stones, transforming solid granite into molten liquid.

For the trees, Goldsworthy selected a species of dwarf oak, *Quercus prinoides.* The trees will begin as small saplings, and over the course of decades will grow to be around 12 feet tall. "Amidst the mass of stone the trees will appear as fragile, vulnerable flickers of life—an expression of hope for the future. The stones are not mere containers. The partnership between tree and stone will be stronger for having grown from the stone."

Goldsworthy is most known for his fleeting works with nature. "I try whenever possible to make one or two ephemeral works each day," Goldsworthy has said. But his permanent works are "much more thought-out and reasoned. . . . I take seriously the responsibility of leaving behind something that will last a long time." *Garden of Stones,* while using stone, one of nature's more immutable materials, is balanced by the delicacy of the young tree. In no other of Goldsworthy's permanent commissions is there such a marriage of the ephemeral and the timeless.

Goldsworthy was selected for this major commission from a group of more than

60 internationally known artists. The Museum and Public Art Fund collaborated on the Memorial Garden selection process, inviting artists and landscape architects to submit materials for consideration. Five artists were commissioned to make full proposals by a panel that included input from the Trustees of the Museum, Holocaust survivors, and members of the larger community. The artist competition was funded by Museum Trustee Michael Steinhardt.

About Andy Goldsworthy

Andy Goldsworthy is known for his outdoor sculptural interventions and indoor installations that transform nature's most familiar elements into graceful designs. Using color and geometric form to order found materials—such as stone, trees, mud, grass, snow, ice, and leaves—Goldsworthy creates visual displays in which the changing nature of the materials is as much a part of the work as the design itself. With their apparent effortlessness, Goldsworthy's creations impart a sense of wonder, drawing attention to the inherent power, beauty, and mystery of nature. The simplicity of each work belies its labor-intensive origins, the hours spent gathering stones of a certain type, layering colored leaves into a circle, or patiently waiting as a circle of water freezes to ice.

Andy Goldsworthy was born in Cheshire, England, in 1956. Since the 1970s, he has been making sculptures and installations with and about nature. Solo museum exhibitions of his work have been held in the Setagaya Art Museum, Japan (1994); the Barbican Centre, London (2000); Site Santa Fe, New Mexico (2000); the Museum of Contemporary Art, San Diego (2002); and elsewhere around the world. His other major permanent commissions in the United States include *Storm King Wall* (1995–97) at Storm King Art Center; *River* (2000) at Stanford University; and *Three Cairns* (2002) at the Des Moines Art Center. Andy Goldsworthy was the subject of an award-winning documentary by Thomas Riesshleimer, *Rivers and Tides*. In New York he is represented by Galerie Lelong.

Garden of Stones will be open Sunday through Friday during the Museum's regular visiting hours. There is no museum admission charge to visit the garden. The Museum is located at 36 Battery Place across from the Ritz Carlton Hotel. Subways: N, R to Whitehall; 4, 5 to Bowling Green; 1, 9 to South Ferry.

About the Museum of Jewish Heritage—A Living Memorial to the Holocaust

The Museum of Jewish Heritage—A Living Memorial to the Holocaust opened to the public in September 1997. Its mission is to educate people of all ages and backgrounds about the 20th century Jewish experience before, during, and after the Holocaust. With more than 2,000 photographs, 800 artifacts, and 24 original documentary films, the Museum's core exhibition combines archival material with modern media to provide a thoughtful and moving chronicle of history, keeping the memory of the past

alive and offering hope for the future. For more information about the Museum of Jewish Heritage—A Living Memorial to the Holocaust, please visit its Web site at www.mjhnyc.org/index.htm.

About the Museum's Expansion

The Museum's four-story Robert M. Morgenthau Wing, designed by Kevin Roche John Dinkeloo and Associates, architects of the original Museum building, complements the main building and houses a theater, an educational center with classrooms and multimedia capabilities, expanded exhibition space, library and resource center, café and catering hall, offices, as well as the Memorial Garden. The 82,000–square-foot Morgenthau Wing opens in September. Support for the Memorial Garden came from the New York City Council.

About the Public Art Fund

The Public Art Fund is New York's leading presenter of artists' projects, new commissions, installations, and exhibitions in public spaces. With 25 years of experience and an international reputation, the Public Art Fund identifies, coordinates, and realizes a diversity of major projects by both established and emerging artists throughout New York City. By bringing artworks outside the traditional context of museums and galleries, the Public Art Fund provides a unique platform for an unparalleled public encounter with the art of our time.

For this project, the Public Art Fund has partnered with the Museum of Jewish Heritage—A Living Memorial to the Holocaust, overseeing the artist selection process and the creation and installation of the Memorial Garden.

The Public Art Fund is a nonprofit arts organization supported by generous gifts from individuals, foundations, and corporations, and with public funds from the New York State Council on the Arts, a state agency, and the New York City Department of Cultural Affairs.

Public Art Maintenance

Planning for Maintenance RURI YAMPOLSKY

In an ideal world, planning for the maintenance of a public art collection would begin with the inception of the public art program. As soon as the program acquired its first artwork, a method of funding the work's maintenance would be determined, an inventory of the program's collection would be begun, arrangements would be made for each artwork's maintenance information to be made available upon the work's accession, and a roster would be created of contractors able to perform repairs and restoration.

In the real world of public art, most collections do not spring fully formed from the minds of the civically predisposed. Instead, they develop through an agglomeration of gifts, legislation, and other acquisition methods that as often as not are accidental. And just as a city discovers that it actually has a real collection of public art, the realization dawns that one of the historic bronzes bequeathed to the city is developing a bad case of corrosion and is in dire need of a conservator's attentions. Indeed, it is with just this sort of realization that planning for maintenance often begins.

What constitutes planning for maintenance? This kind of planning involves at least three interdependent elements:

1. A tracking system
2. A system for engaging conservators and others to perform routine and major maintenance and restoration
3. A system that provides adequate funding

TRACKING

Planning for maintenance entails keeping tabs on a number of resources. For example, an agency would want to determine whether a particular artwork requires major rather than routine maintenance, and it would want to draw up a schedule to set priorities for which pieces would be restored when.

In all such matters, it is essential to have a way of tracking the collection. One requirement is a database where information can be stored about the physical characteristics of artworks and their maintenance requirements, and where reports can reside about the artworks' condition assessments and treatment histories. These records themselves need to be maintained and kept current, and they must be accessible. An agency might choose to have one staff member venture out into the field to monitor and report on the condition of artworks in the collection, and another staff

member might be assigned to enter this information into the database. Paper records would almost certainly supplement the digital files.

CONSERVATION/RESTORATION

Another indispensable facet of a maintenance plan is a network of individuals or entities to be called on as contractors for major and routine maintenance as well as for assessment and the other specialized types of work that artists, fabricators, and conservation technicians perform. It may also be possible to persuade a city department on whose property a public artwork sits (for example, a department of parks and recreation) to assume some of the routine tasks (such as landscaping) that may be required for the artwork's maintenance; the parameters of this responsibility can be set out in a formal agreement or memorandum of understanding. Citizens in the neighborhood where an artwork is sited can be pressed into service, too. They can be trained to perform routine maintenance tasks, or they can simply volunteer to notify the agency if the artwork is damaged.

FUNDING

Not the least important element of a maintenance plan is adequate funding for the restoration and repairs that the database and the conservators are saying the collection needs. When the newest addition to a collection of site-integrated art sprouts graffiti, the agency will want to be able to pay for removal of the offending tag, and here is where the interdependence of the maintenance plan's elements is most evident: a well-organized, methodically conceived, fully developed plan provides ammunition when it is time to seek budget authority and grants to support the public art program's maintenance activities.

The Nuts and Bolts of a Maintenance Program

PEGGY KENDELLEN AND ROBERT KRUEGER

Whether a public art collection consists of five or five hundred artworks, a plan for maintenance prolongs the life of the works and sustains the collection's quality and integrity. A basic maintenance plan contains the following ingredients:

- Policies and guidelines
- An inventory
- Condition assessments
- A database
- Hard-copy files
- Image files
- The means to get the job done (that is, staff and funds)

When the skills and expertise of administrators, artists, fabricators, conservators, maintenance technicians, and other specialists are blended together, the results can be not only a solid program prepared for maintenance hurdles but also a long-lived, well-cared-for collection.

POLICIES AND GUIDELINES

A framework for a sound maintenance program includes policies and guidelines that establish an overall mission statement as well as processes for acquiring works through commissions, direct purchase, gifts, and donations. If an artwork is a donation, then have the donor provide maintenance funds through an endowment, if such an arrangement is feasible. That should stave off last-minute scrambling for funds for annual maintenance or, in the worst-case scenario, for repairs if severe damage requires immediate attention. It makes sense to determine at the outset who will take care of the artwork and who will pay for that care. In writing policies, it is advisable to become familiar with the Visual Artists Rights Act of 1990.

On the other side of the coin, a de-accessioning policy should be created to take care of removing an artwork from the collection. A work is typically de-accessioned when it has been damaged beyond repair, when its site changes, or when the work endangers public safety. Over time, design pitfalls or flaws in workmanship may rear their ugly heads, and the artwork will need to be replaced, remade, or removed. If there are guidelines to support the difficult process of disposing of an artwork, it will be easier to garner support for such a decision.

Giving artists a heads-up on maintenance concerns by placing a simple sentence in a project's call for artists gets everyone plugged in to maintenance issues from the very start—artists, members of the selection panel, future owners or caretakers, and arts administrators. It's never too late to consider appropriate siting and materials, and the call for artists can address these issues. The selection panel can then be attentive to the project's site, materials, structure, surface finish, and installation as well as to its anticipated maintenance. Beware of claims that a work doesn't require any maintenance. That would be preferable in an ideal world, but that's never the case for the majority of projects.

The artist's contract should include a section related to warranty for loss or damage. A typical warranty period, during which the work is guaranteed to be free from defects related to materials and workmanship, is one year. Many agencies are rethinking the one-year warranty, however, especially with pieces that include resins and/or kinetic, electronic, and computer media. For a small fee, a conservator can review the selected design before fabrication and make appropriate written recommendations. This process can help ensure that all materials used in the project are compatible. Discussion may focus on the site, the materials and design, the foundation and footings, and structural and surface materials.

A conservation record form, completed by the artist, should be required as part of the contract. The information would describe the methods and materials used in the work's fabrication and installation. It helps to have this background if the artist becomes unreachable at any point during the life of the artwork. For an older work without such a record, oral history is often the only option. In this case, information has to be gathered from collection and project managers, from custodial and operational staff at the facility where the work is sited, from the artist (or from the artist's agent, estate, or family), and from fabricators and foundries in order to come up with a complete picture of the work and make an accurate prognosis for the existing problem.

INVENTORY AND CONDITION ASSESSMENTS

As already mentioned, two more elements of the maintenance plan are an inventory of the collection and a condition assessment for each of its works.

An inventory captures the following information about each artwork:

- The name of the artist(s)
- The work's title
- The year the work was completed
- The year the work was acquired and/or installed
- The name of the work's owner

- The location of the work
- The work's medium or media
- The work's dimensions

One example of such activity is the work undertaken by a joint project of Heritage Preservation and the Smithsonian American Art Museum called Save Outdoor Sculpture! This partnership documents monuments and outdoor sculpture in the United States and helps communities preserve their sculptural legacy. In the early 1990s, Save Outdoor Sculpture! conducted a nationwide inventory of outdoor sculpture. The ongoing challenge is to keep that inventory current.

As for condition assessment, a qualified conservator can instruct individuals in gathering objective data about an artwork, but it's in the best interests of the organization to have the conservator do the more subjective condition assessment, since a conservator will see more than can be seen by an untrained eye. An artwork's current condition, in addition to the recommendations and cost estimates for its maintenance and conservation treatments, are included in such an assessment.

RECORDKEEPING

The archive of a collection should be accessible and should contain hard-copy files, an inventory database, an image catalog, and maintenance reports. The records in the archive will contain such information as the artist's intentions for the artwork, instructions for the artwork's maintenance, and a detailed accounting of its maintenance in addition to images of the work. This kind of archive provides a trail of essential data on which future decisions can be given a firm footing.

The project's *hard-copy file* contains the artist's contract, a conservation record form, plans and drawings for the piece, and any other data critical to the understanding of the artist's intentions and to the maintenance of the piece.

The *inventory database* includes the data collected from the inventory, with a few additions: the work's acquisition method (commission, direct purchase, or gift), and any project anecdotes. A secondary database, linked to the inventory, contains detailed *maintenance reports* on the work's structural and surface condition, its maintenance treatment, the names of those who performed maintenance treatments, a list of the equipment and materials used in maintaining the work, recommendations for future treatment, an accounting of maintenance costs, before- and after-treatment images, and pertinent notes.

Finally, a *slide* or *digital image catalog* of the collection is a critical component of any public art collection. Many organizations already have such catalogs in place and can offer their expertise in setting one up. There should be plans for updating digital storage methods as technology changes.

Eyesores that develop from deferred maintenance can be avoided by following a well-thought-out plan. In the long run, it usually costs less to maintain than to restore. The quality of the hands-on maintenance work is not to be taken lightly. If a program is fortunate enough to have permanent staff dedicated to maintenance, it is recommended that those individuals have relevant training and education as well as knowledge in related fields. Helpful fields of knowledge may include sculpture fabrication, construction, electronics, mechanics and facilities, chemistry, and art conservation. These staff members can also benefit from basic training by a professional conservator. People maintaining artworks would benefit by being familiar with the code of ethics for conservators (see aic.stanford.edu/pubs/ethics.html).

In many cases, agencies have only enough resources to contract for this work. The hiring of contracted maintenance technicians should be based on pertinent experience (for example, foundry experience, work with a conservator, knowledge of electrical systems and technology, and many of the skills alluded to at the end of the previous paragraph). Contracted maintenance technicians should have liability insurance or other types of required business insurance (for example, unemployment insurance and property insurance).

Partnerships should be sought out in efforts to solve particular problems. For example, the Portland (Oregon) Water Bureau has partnered with the Regional Arts & Culture Council (RACC) to repair several prominent fountains. The expertise of the Water Bureau and its knowledge of qualified contractors have been indispensable in getting the job done right. In the most recent case, RACC urged the Water Bureau to address an important fountain in downtown Portland. The conservator, the artist, a plumber, an electrician, and a welder worked together to restore the piece completely and solve chronic plumbing problems that had been causing the sculpture's lackluster appearance.

Often the owners of a collection will seek out the original artist to restore his or her own work. In many cases this is the best solution, but it can also can be problematic if the artist's desire or motivation to alter the piece while working on it takes over, or if the artist's technical skills are not a good match for the repair. Regardless of his or her skill level or interest in the project, the artist should be kept informed of potential problems with and needed repairs to the work.

Aside from conservators and artists, there are others who can contribute expertise, planning, and supervision to a project. This group includes engineers, materials scientists, representatives of foundries, muralists, architects, plumbers, electricians, computer and technology experts, neon specialists, and additional fabricators.

DEVELOPING RESOURCES

In working on a specific maintenance crisis, it is important to get the public involved. For example, know who an outdoor sculpture's supporters are: friends and patrons of the artist, neighborhood movers and shakers, leaders in the public and private

sectors. This type of information can be critical in gaining both fiscal and political support for the project. There are many hidden "fans" of public art in the community, and it can help to spread the word through various neighborhood and local newspapers, church bulletins, and neighborhood meetings.

Apart from grassroots fundraising, resources can be obtained through grants, percent-for-art allocations, governmental operating budgets, and private foundations. *Designing Outdoor Sculpture Today for Tomorrow,* a booklet available from Save Outdoor Sculpture! (see the Resources at the back of this book), can help in sorting through the many ways to do fundraising for artwork maintenance.

A public art collection is an important element in the livability and cultural history of a city, as it is in the history of an academic institution or other organization. Establishing a maintenance program comes with the territory of managing a public art program. One good way for an emerging public art program to get in touch with hundreds of administrators coping with common issues is to use the Public Art Network's e-mail listserv.

As a program develops, policies and guidelines also grow and change. Reinventing the wheel will not be necessary, but new spokes will probably have to be added as the field evolves.

CONSERVATION RECORD: TWO-DIMENSIONAL WORK OF ART

Regional Arts & Culture Council

To be completed by artist as addendum to contract when artwork is completed.

Date: _____ Accession #: _____ RACC #: _____
(For office use only.)

Artist:

Title of Work:

Date Work Completed

Dimensions of Work (HxWxD):

(Attach additional sheet if necessary.)

Materials

Describe the materials/media used in the fabrication of the painting, drawing, collage, etc. (Be specific. Include source or manufacturer, brand names, fiber content, paper type, life expectancy of material according to manufacturer, etc.)

1. *Support* (base or foundation, i.e. paper, canvas, cardboard, panel, etc.):

2. *Ground* (material, primer, etc. used to isolate media from support):

 Method of application/tools used:

3. *Materials/media* used in painting, drawing, collage, etc. Also specify palette (brand name of media, color names):

Method of application/tools use. If collage, what glue was used to assemble?

Medium/thinners used:

4. *Varnish or protective coating.* (e.g. natural, paint color and type, glaze, sealer, patina, fire retardant, etc.):

Method of application/tools used:

When applied (i.e. immediately upon completion, after 6 months, etc.):

5. *Describe materials used* in the presentation of the artwork. (e.g., composition of base or backing, framing, type of hanging fixtures, etc.):

6. Under what type of light was work executed?

7. Location of process/completion:

 Date of completion:

 How long was work in process?

Framing

1. Are there any aesthetic preferences in how work should be framed (e.g., mat color, frame color/material)?

2. If work is comprised of more than one piece requiring special assembly, supply documentation on how to install correctly. (Provide photograph or sketch):

Environmental Factors

Describe existing environmental factors which may affect the condition of the artwork and any precautionary measures which should be taken. (e.g., direct sunlight, temperature, air moisture or dryness, flooding , air pollutants, human interaction with artwork — touching, sitting, climbing, vandalism):

Desired Appearance

1. What may be acceptable alteration in form, surface, texture, coloration as related to natural aging of materials?

2. If the work is site-specific, describe in detail the particular relationship of the work to its site, including any significant physical aspects of the site which, if altered, would significantly alter the intended meaning and/or appearance of the work.

Maintenance/Conservation Instructions

Provide detailed instructions regarding the methods and frequency of maintenance for the artwork (e.g., removal of dust/dirt, maintenance of protective surfaces, etc.), or less frequent and more extensive preventive measures, (e.g. disassembly and inspection, reapplication of protective sealers, repainting, etc.):

Conceptual Information

Please provide conceptual information on the work, including subject/source of inspiration:

_____ _____
Artist Signature Date

TO BE COMPLETED BY AGENCY
Condition of artwork upon accession:

_____Excellent _____Good _____Fair _____Poor

_____ _____
Agency Signature Date

CONSERVATION RECORD: THREE-DIMENSIONAL WORK OF ART

Regional Arts & Culture Council

To be completed by artist as addendum to contract when artwork is completed.

Date: _____ Accession #: _____ RACC #: _____
 (For office use only)

Artist:

Title of Work:

Dimensions of Work:

Attach additional sheet if necessary.

Medium and Technique

(Supply brand names of materials used when possible.)

1. Principal materials used in fabrication, describe in detail. (i.e. specific metal, brand name, source, or manufacturer, etc.):

If applicable, describe any electrical components used, their operation and supplier:

2. Other materials used. (such as screws, nails, glue, armatures, etc.):

3. Preliminary work methods. (i.e. drawings, smaller models, etc.):

4. Equipment used in construction:

5. Final work methods, describe in detail. (i.e. cast, welded, carved, modeled, thrown, assembled, etc.):

If the work has been cast, specify how many have been and/or will be produced:

6. Describe how final surface/patina achieved:

7. Protective coating:

Method of application:

8. Where was work completed? (i.e. name of studio, foundry, etc.):

Date work completed:

How long was work in process?

Installation

1. Are there any special installation considerations (i.e. viewing height, measured distance from relative objects. etc.)?

2. If work is comprised of more than one piece requiring special assembly, supply documentation on how to install correctly (provide photograph or sketch):

3. Can the work be exhibited out of doors? Yes _____ No _____

External Factors

Describe existing environmental factors which may affect the condition of the artwork and any precautionary measures which should be taken. (e.g., direct sunlight, extremes of annual rain or snowfall, temperature, air moisture or dryness, acidity of rainfall, flooding, wind, vibrations, air pollutants, vehicular and/or pedestrian traffic; animal interaction with artwork — potential for nesting, droppings, etc.; human interaction with artwork — touching, sitting, climbing, vandalism):

Desired Appearance

1. Describe in specific terms and, if necessary, with drawings or photographs, the physical qualities for which the agency should strive in order to maintain the artist's intent. (e.g. matte rather than glossy luster, color of patina) What may be acceptable alteration in form, surface, texture, coloration as related to natural aging of materials?

2. If the work is site-specific, describe in detail the particular relationship of the work to its site, including any significant physical aspects of the site which, if altered, would significantly alter the intended meaning and/or appearance of the work:

Packing and Shipping Instructions (include diagrams)

Maintenance/Conservation Instructions

Provide detailed instructions regarding the methods and frequency of maintenance for the artwork (with observations regarding permanency/durability of materials and techniques):

1. Routine maintenance (e.g., removal of dust, dirt; maintenance of protective surfaces; tightening, adjusting, oiling; etc.):

2. Cyclical maintenance (less frequent and more extensive preventive measures, e.g., disassembly and inspection; reapplication of protective sealers; repainting; etc.):

Conceptual Information

Provide conceptual information on the work, including subject, source of inspiration:

_____ _____
Artist Signature Date

TO BE COMPLETED BY AGENCY
Condition of artwork upon accession:

_____ Excellent _____Good _____ Fair _____ Poor

_____ _____
Agency Signature Date

CONSERVATION RECORD: PRINTS

Regional Arts & Culture Council

To be completed by artist as addendum to contract when artwork is completed.

Date: _____ Accession #: _____ RACC #: _____
 (For office use only)

Artist: _____

Title of Work: _____

Date completed: _____

Dimensions of Work (H x W x D: _____
(Attach additional sheet if necessary.)

Materials

Describe the materials/media used in the fabrication of the painting, drawing, collage, etc. (Be specific. Include source or manufacturer, brand names, fiber content, paper type, life expectancy of material according to manufacturer, etc.)

1. *Medium* (Brand names, technique and surface — include type of plates, stones, screen, etc. used):

2. *Support* (Include type of paper, brand names, etc.):

3. *Number of runs and colors*:

4. Size of Edition _____ x _____
Artist's Proofs _____ to _____
Studio Proofs _____ to _____
Cancellation Proof _____ Yes _____ No
Retouch Proof _____ Yes _____ No

5. Date work completed: _____

How long was work in progress?

Printing

1. Printer

Name: _____

Address: _____

2. Publisher and City

Name: _____

Address: _____

Edition printed at: _____

Date: _____

3. The plates, stones or screens and all other prints have been destroyed or effaced:
Yes _____ No _____

4. Are there other facsimiles of this work? Yes_____ No_____

External Factors

1. Describe desired physical positioning of the artwork (e.g., measured distances from relative objects or points in the environment; characteristics of physical context relevant to the intent for the work, e.g. wall behind print must be neutral white or off-white, etc.):

2. Describe existing environmental factors which may affect the condition of the artwork and any precautionary measures which should be taken (e.g., direct sunlight, extremes of temperature, air moisture or dryness, vibrations, air pollutants, etc.):

Desired Appearance

Describe in specific terms and, if necessary, with drawings or photographs, the physical qualities for which the agency should strive in order to maintain the artist's intent. Specifically, what may be acceptable alteration in form, surface, texture, and coloration as related to natural aging of materials?

Packing and Shipping Instructions (and diagram)

Maintenance/Conservation Instructions

Provide detailed instructions regarding the methods and frequency of maintenance for the artwork as follows:

1. *Routine maintenance* (e.g., removal of dust, dirt; maintenance of protective surfaces, etc.):

2. *Cyclical maintenance* (less frequent and more extensive preventive measures, e.g. disassembly and inspection; reapplication of protective sealers, etc.):

Conceptual Information

Please provide conceptual information of the work including subject/source of inspiration:

_____ _____
Artist Signature Date

TO BE COMPLETED BY AGENCY
Condition of artwork upon accession:

____ Excellent ____ Good ____ Fair ____ Poor

_____ _____
Agency Signature Date

PORTLAND PARKS & RECREATION MAINTENANCE AGREEMENT FOR SCULPTURE IN CITY OF PORTLAND PARKS

Regional Arts & Culture Council

The Regional Arts & Culture Council (RACC) and Portland Parks & Recreation (PP&R) recognize the importance of ongoing maintenance of outdoor sculpture found in the City's parks. PP&R's mission acknowledges the importance of preserving and enhancing the parks legacy and promoting appreciation of the natural environment.

Since an adequate funding source for the conservation and maintenance of all City-owned outdoor sculpture is yet to be created, RACC is seeking to establish partnerships with appropriate City Bureaus to share the costs of ongoing maintenance of outdoor sculptures. The intent of this policy is to identify appropriate PP&R participation in the maintenance of City of Portland owned outdoor sculptures located in Portland parks. (See Attachment 1 for list of sculptures and fountains covered by this agreement).

STATEMENT #1: Major conservation and/or routine maintenance of sculptures in Portland parks is necessary in order to prolong the life of the sculptures, improve the aesthetics of individual sculptures and fountains, and preserve and enhance the an individual park's surroundings. Of equal importance is heightening public awareness about the importance of caring for and properly maintaining Portland's heritage of outdoor sculpture. Increased public awareness of services are objectives of both PP&R and RACC.

Application 1: PP&R will notify RACC's Public Art Program of the need for maintenance/repair of outdoor sculpture in Portland parks.

Application 2: All routine maintenance will be performed on-site. Routine maintenance is defined as specified preservation activities outlined in the "maintenance specifications" of the conservation report provided by the conservator after a conservation treatment has occurred. PP&R agrees to provide any necessary equipment for ongoing maintenance that is unavailable to RACC (e.g., ladder, access to water source, water hoses, power washer).

PP&R will provide the maintenance of the stone bases of sculptures in consultation with RACC. It is agreed that neither air abrasive techniques (e.g., sandblast, baking soda blast, walnut shell blast) nor acid-based cleaners will be used to clean stone pedestals unless such a process is approved by a professional art conservator. The maintenance of the metal sculptures is the responsibility of RACC although removal of minor graffiti by PP&R staff can be arranged on a case-by-case basis.

Application 3: RACC, in consultation with PP&R, will determine the need for any major conservation projects for sculptures in the parks. A major conservation project is defined as any project that requires more than washing and/or waxing of a sculpture. A professional conservator will be hired to oversee any such project and will be compensated by RACC.

Application 4: RACC, in partnership with PP&R, will provide press release materials to members of the press for a conservation project, if deemed necessary.

STATEMENT #2: RACC and PP&R recognize that incidents of graffiti have dramatically increased over the past few years and acknowledge the importance of removing graffiti as quickly as possible using effective removal methods that are not damaging to the sculptures or to the stone pedestals.

Application 1: Graffiti must be removed as soon as possible after it has been discovered. In difficult cases, it may be necessary to conduct test trials to determine appropriate removal materials and equipment. These tests will be conducted under the auspices of RACC and written reports will be forwarded to PP&R. PP&R personnel may participate in these test trials with their supervisor's approval.

Health and safety regulations appropriate for the materials/equipment used will be followed in all graffiti removal work. Only materials and methods approved by a conservator may be used. Efforts should be made to remove highly visible and more disagreeable graffiti before less offensive matter. Where graffiti has a high visibility impact, its removal should be given a high priority regardless of its content.

Application 2: PP&R will remove minor graffiti (i.e., isolated incidents of tagging) from stone bases/pedestals in consultation with RACC. RACC will provide PP&R with a list of appropriate graffiti removal products for stone pedestals. If PP&R is unable to successfully remove graffiti, they will contact RACC. RACC will provide on-site training and/or a conservation backup consultant on a case-by-case basis.

Application 3: For major graffiti removal projects, a conservator/conservation technician will be consulted. For the purposes of this agreement, major is defined as heavily graffitied pedestals or graffiti covering more than one side of several pedestals in one location. Major graffiti removal may be turned over to an appropriate professional at the discretion of RACC.

Application 4: It is agreed that neither air abrasive techniques (e.g., sandblast, baking soda blast, walnut shell blast) nor acid-based paint removers will be used to remove graffiti from stone pedestals.

STATEMENT #3: An adequate funding source for the restoration and maintenance of all City-owned outdoor sculpture is needed. If and when a funding source is identified, modifications will be made to this agreement as needed.

This agreement is hereby agreed to by:

_____ _____
Charles Jordan Date
Director
Portland Parks & Recreation

_____ _____
Bill Bulick Date
Executive Director
Regional Arts & Culture Council

Recordkeeping and Public Art

PATRICIA FAVERO

When a new work, whether commissioned or directly purchased, enters a public art program's collection, the program accumulates and retains historical facts about the commissioning or purchasing process. Often the program has had close contact with the artist as well. Thus the program becomes a primary source of basic information about the work and the circumstances of its creation, and there is every reason for the program to augment and update that information as the artwork ages and as the community's environments and opinions evolve.

A program that enhances public areas with works of art must document and keep track of its growing collection. Just as art in public spaces reflects and shapes the cultural atmosphere in which it is set, reliable records help write the cultural history of a city or a region as time passes and public opinions change. Good documentation is also essential to ensuring that a collection is properly cared for and maintained. This essay describes the elements of a good, comprehensive system for keeping records about the works in a public art collection.

THE ACCESSION NUMBER

Each work of art, as it is accepted, or "accessioned," into the permanent collection, should be assigned a unique identifier: its accession number. This number indicates the source of the work (a collection, for instance, or an acquisitions fund), the year in which the work was accessioned, and the order in which it was accessioned with respect to other works acquired in the same year.

Consider a diptych painting, for example, which was purchased from Seattle City Light (the municipal utility company) with percent-for-art funds, and which was the fourteenth artwork accessioned into the City of Seattle's public collection in 1998. It was given the following accession number:

CL98.014a,b

What does this number mean?

CL City Light was the source of the painting.
98 The painting was accessioned in 1998 (the year may also appear as "1998").
.014 The painting was the fourteenth artwork to enter the collection in 1998.
a,b The painting has two parts.

Suppose now that the program's next acquisition in 1998, also from City Light, was a series of five photographs, which might be exhibited either together or individually.

Each photograph was given an accession number identical to that of all the others in the series, with one variation: instead of letters (as in "CL98.014a,b," to indicate the integral components of an artwork that will always be exhibited with all its parts), digits at the end of the accession number indicate that the individual photograph belongs to the series but may also be exhibited on its own:

CL98.015.01
CL98.015.02
CL98.015.03
CL98.015.04
CL98.015.05

OBJECT REFERENCE MATERIAL

Like a library with its card catalog, a public art program needs a format for quickly obtaining information about each of the works in its collection, and about the related project. Two documents serve this purpose: the *catalog sheet* and the *public information fact sheet*.

Catalog Sheet

The catalog sheet records essential information about the physical object:

- The object's artistic classification (painting, sculpture, photograph)
- The object's dimensions and, if relevant, those of its frame or pedestal
- A detailed list of the materials that make up the artwork
- A description of the artwork and its condition, accompanied by a photograph

Public Information Fact Sheet

The public information fact sheet gives an overview of the circumstances surrounding the object's creation and includes the following information:

- The project's name, the amount of the project's funding, and the source or sources of the funding
- Names of those who served on the selection panel
- A brief history of the purchasing process, including a description of the work's relationship to its setting

Both documents should also include the piece's general identifying information:

- The artwork's accession number
- Name(s) of the artist(s)
- Title of the artwork
- Date(s) of the work's completion
- The work's medium or media
- The work's location (if it is permanently sited)

How this information is stored and accessed will depend on the size of the collection and on the program's budgetary and staff limitations. Public art is subject to public information requests of all kinds, however, and so the process of retrieving this information has to be efficient and easy. Therefore, regardless of whether binders or a database are used to catalog the collection, there must be a standard format for data entry as well as a consistent system for recording and cross-referencing data.

Paper Files

Because some kinds of project information cannot be stored in a database, a paper filing system will certainly be needed. In addition to the other information it contains, the paper file should contain a copy of the catalog sheet and a copy of the public information fact sheet, for easy reference. The goals of a paper filing system should be to satisfy the public's reasonable requests for information and to adequately monitor the status of the collection, but without having the filing system occupy too much space or take up too much time in a busy office.

Historical Documentation

The paper file should contain documentation sufficient to prove the program's ownership of a work and to determine or verify the artist's intentions for its presentation and aesthetics. A file containing historical documentation would typically include the following items:

- A copy of the prospectus for the project
- The artist's proposal
- A copy of the purchase agreement, or of the program's formal acceptance of the artwork as a gift
- Correspondence and newspaper clippings related to events that were significant in the project's implementation (for example, difficulties with the project's fabrication or installation, or early public responses to the work)
- A detailed statement by the artist about his or her work

With respect to the artist's statement, having it on file adds to the historical significance of the individual object and to the collection as a whole. A program that commissions or purchases artwork through direct contact with artists has unique access to artists' thoughts and ideas during the creation process. The program also has the best chance of accurately recording artists' intentions for their artworks. Therefore, the artist's statement should be more than just a statement about the work's meaning. It should elaborate on any significance that the materials used in the work may have for the piece's overall meaning. Solicitation of the artist's statement also offers an opportunity for discussion of the artist's preferences for the artwork as it ages, deteriorates, or sustains damage, and this discussion can guide an approach acceptable to the artist for the care of the object.

Object Documentation

A paper file is essential for monitoring the movement and condition of an art object, and for safely and properly approaching its maintenance or conservation. A file containing object documentation would typically include the following items:

 • All structural and installation diagrams for the object
 • Documents related to specific concerns for the object's maintenance
 • Detailed information about materials or products used in the manufacture of the piece or recommended for its maintenance, including varnishes, paint, preservatives, and graffiti-resistant coatings
 • Notes on periodic surveys of the object's condition, and documentation of any regular maintenance or conservation treatment, giving dates and including photographs and descriptions of the treatment undertaken

It is important to remember that each artwork is unique and will have its specific needs. Good records make it possible to organize preservation-related needs into general, perhaps seasonal, categories and thus allow for a maintenance program that is both efficient and able to consider the individual requirements of each object in the collection.

Sited works exposed to the elements obviously require regular monitoring and maintenance. Perhaps less obvious is the fact that a portable collection of various artworks on display in offices, hallways, waiting rooms, and other high-traffic areas also requires regular monitoring, since exhibition environments are rarely ideal. The condition of objects can be recorded regularly on survey cards, which track and illustrate the needs of the collection and are useful in setting priorities for conservation and maintenance.

ADDITIONAL RESOURCES

The unique risks faced by the works of art in a public collection, and the budgetary concerns that frequently come into play in questions of collection management, present challenges that require creative solutions. The goal of recordkeeping, in service of such solutions, is always the same: to protect the integrity of the individual artwork and the safety of all the objects in the collection.

Programs like Save Outdoor Sculpture! (see Peggy Kendellen and Robert Krueger, "The Nuts and Bolts of a Maintenance Program," elsewhere in this book) exemplify the creative use of scarce resources to document and take care of a public art collection. Also helpful in this regard are publications like Buck and Gilmore's *The New Museum Registration Methods*, a guide that the more active public art programs will find useful, since the procedures used with sited and portable public collections are relatively similar to those employed by museums (for more about these programs and publications, see the Resources section at the back of the book).

De-accession

Ideally, artworks that are carefully selected for public display would be able to remain in good repair and in place indefinitely. However, there are many conditions that can precipitate the removal of artwork and the need to formally remove it from a public collection. Artworks can deteriorate beyond repair due to vandalism or environmental factors. Artwork locations can be modified and buildings can be torn down. An artwork can become an attractive nuisance that poses a public hazard. All of these factors can precipitate the need to remove a work from public display. De-accession is the word that is used when an artwork is removed from a collection. The following policy describes the guidelines the City of Seattle established in considering de-accession of works from its collection.

POLICY FOR REVIEW AND DE-ACCESSION OF CITY-OWNED WORKS OF ART *City of Seattle*

Purpose

Provision of procedures for periodic review and evaluation by the Seattle Arts Commission (SAC) [now the Mayor's Office of Arts & Cultural Affairs] of the City's artwork collection in accordance with policies of acquisition and de-accession.

Acquisition Policy

The SAC establishing ordinance (99982), 1% for Art ordinance (102210, 105389) and Gifts ordinance (107578) designate the SAC as the City department responsible for acquisition of works of art which will enrich the urban environment and increase awareness of the visual arts. To this end the SAC seeks to acquire works of art of the highest quality which are representative of the diversity of artistic expression.

Allied with this policy of acquisition is the responsibility of the SAC to evaluate the collection as a whole on a regular basis to determine the current condition of artworks, maintenance needs, and consider the de-accessioning of individual artworks.

De-accession Policy

De-accessioning is a procedure for the withdrawal of an artwork from public exhibition for an indefinite duration through storage or loan, or on a permanent basis through several methods of disposition available. Since artworks are acquired by the City through a thorough review process by impartial peer panels, based on the quality of the artwork and the value of the work to the collection as a whole, de-accessioning should

be considered only after ten years have elapsed from the date of installation of permanent works, and five years after acceptance in the case of portable works. De-accessioning should be cautiously applied only after a careful and impartial evaluation of the artwork to avoid the influence of fluctuations of taste and the premature removal of an artwork from the collection.

Eligible Artworks

Works eligible for consideration for de-accession through this policy include:

- Artworks purchased or commissioned through the 1% for Art ordinance.
- Gifts of artwork accepted by the SAC in accordance with the 1978 Gifts ordinance.
- All other City-owned artworks purchased separately by City departments or received as gifts prior to the passage of the Gifts ordinance. SAC evaluation of an artwork may be requested by the department owning the artwork or initiated as an advisory action by the SAC.

De-accession Procedure:

- At a minimum of once every five years the Public Art Program (PAP) Committee of the SAC, or its designee, will review the City's artwork collection.
- The Committee designates an advisory panel composed of visual art professionals (e.g. artists, museum curators, art historians, conservators) to review specific items proposed for de-accession and make recommendations to the PAP Committee and the SAC about the disposition of these works.

Tenure. By policy of the Public Art Committee, members of the De-accession & Gifts Panel will serve four-year overlapping terms.

The advisory panel may consider the de-accessioning of artwork for one or more of the following reasons:

- A work is not, or is only rarely, on display because of lack of a suitable site.
- The condition or security of the artwork cannot be reasonably guaranteed in its present location.
- The work has been damaged or has deteriorated to the point that it can no longer be represented to be the original work of art.
- The artwork has been damaged and repair is impractical or unfeasible, or the cost of repair or renovation is excessive in relation to the original cost of the work.
- The artwork endangers public safety.
- Significant changes in the use, character or actual design of the site require a re-evaluation of the relationship of artwork to the site.

• The artwork has been determined to be of inferior quality relative to the quality of other works in the collection, or has been determined to be incompatible with the rest of the collection.

• The City wishes to replace the artwork with a work of more significance by the same artist.

• The artwork requires excessive maintenance or has faults of design or workmanship.

Sequence of Action to De-Accession

• The PAP Committee appoints an advisory panel.

• The PAP Committee and/or staff determines that an artwork meets one of the criteria of section 3, above.

• The PAP staff prepares a report which indicates:

1. Any restrictions which may apply to this specific work, based on contract review.
2. An analysis of the reasons for de-accessioning.
3. Options for storage or disposition of the work.
4. Appraised value of the work, if obtainable.

• The advisory panel reviews the report at its next scheduled meeting. The panel may seek additional information regarding the work from the artist, art galleries, curators, appraisers or other professionals prior to making a recommendation to the PAP Committee.

• A recommendation for action is sent to the PAP Committee, and if approved, is referred to the full SAC.

• The SAC considers the recommendation at a regularly scheduled meeting.

• Upon confirmation of its recommendation, the PAP Committee shall consider the following actions (in order of priority):

1. Sale or Trade:

 • Sale through auction, art gallery or dealer resale, or direct bidding by individuals, in compliance with City law and policies governing surplus property.
 • Trade through artist, gallery, museum, or other institutions for one or more other artwork(s) of comparable value by the same artist.

2. Indefinite loan to another governmental entity.

3. Destruction of work deteriorated or damaged beyond repair at a reasonable cost, and deemed to be of no or only a negligible value, in accordance with national standards for conservation and de-accession.

4. Re-donation, sale or other arrangement agreed upon with the donor or artist at the time of the City's acquisition of such artwork.

• No works of art shall be sold or traded to members or staff of the SAC, consistent with SAC conflict of interest policies.

• Proceeds from the sale of a work of art shall be returned to the Municipal Art Fund departmental account from which the original purchase was made if acquired through the 1% for Art program. Funds from the sale of gifts shall go to the Gifts and Trust Fund for future artwork projects. Any pre-existing contractual agreements between the artist and the City regarding resale shall be honored.

Legal Issues

Visual Artists Rights Act (VARA)

The Visual Artists Rights Act of 1990　　　RURI YAMPOLSKY

The Visual Artists Rights Act of 1990 (VARA) is a piece of federal legislation that gives artists certain rights with respect to their artworks.

VARA protects artists and their artworks by allowing artists to claim what are known as the rights of attribution and disassociation. Artists claiming the right of attribution under VARA are acknowledged as the creators of their artworks, whereas artists claiming the right of disassociation can prevent the attachment of their names to artworks that they did not create, or that have been modified by others in ways that could prove prejudicial to the originating artists' reputations or honor.

VARA does not specifically address the forms of integrated creative work that make up much of what is commissioned as public art. Nevertheless, if at the outset there is general awareness of artists' rights as spelled out in VARA, misunderstandings may be prevented and future litigation perhaps avoided. In practical terms, VARA forces a commissioning agency to consider, in a proactive and positive way, the possibility of subsequent changes to the site for which an artwork is being proposed, as well as consequent changes to the artwork itself.

When both the artist and the commissioning agency are aware of VARA and its provisions, a contractual process can be established for dealing with such potential modifications. For example, a contract can spell out the procedure for notifying the artist of impending changes to the site where the artwork is displayed, and for the artist to provide or withhold consent or be involved in the changes. A contract also gives the agency a way of stating its right to manage its buildings and properties in addition to any artwork sited there. A contract can even ask the artist to waive his or her VARA rights.

In Seattle, to cite one example of how VARA fits into the process of commissioning public art, the Office of Arts & Cultural Affairs attempts to balance its role as an advocate for artists with its responsibility to represent the interests of the City of Seattle. In keeping with this desired balance, every effort is made to develop a contract that leaves the artist's VARA rights intact while also creating a mechanism for assessing and handling unexpected disruptions to the artwork.

The Impact of the Visual Artists Rights Act of 1990 on the Use and Redevelopment of City or County Property

GORDON B. DAVIDSON

Can an artist whose work is displayed on developed property frustrate the remodeling, improvement, or demolition of that property? The Visual Artists Rights Act of 1990 (VARA), through enforcement mechanisms available under the Copyright Act, provides protections both to artists and to certain forms of art that may make the redevelopment, improvement, or demolition of a building in which such artwork is installed more difficult than originally anticipated, or even impossible without the artist's consent.

This essay begins by presenting four hypothetical vignettes, or problem statements, related to the provisions of the Visual Artists Rights Act. It goes on to examine VARA, the types of works and rights recognized and protected by the act, the remedies available for violations of VARA, and how VARA specifically protects artworks installed in buildings. Finally, it offers recommendations for ensuring compliance with VARA's provisions[1] and concludes by discussing the four problem statements in view of the likely impacts of the Visual Artists Rights Act.

PROBLEM STATEMENTS

Problem A

A city has purchased a sixty-year-old office building that features a mural painted sometime in 1991 on an exterior wall, next to the building's parking lot, and an Art Deco mosaic on the entrance facade and patio. The building isn't listed on any historic register. The mosaic was done by the state's most famous ceramist, who recently died. The mural was the first major work painted by a group of young artists who just won a national competition to create a mural in the state capitol. The city's facilities manager has an appropriation to install a canopy at the building's entrance, and to build an addition that will extend out onto a portion of the parking lot. In order for the canopy to be supported by the necessary columns and beams, the mosaic will have to be pierced. The plans for this addition also call for a doorway to be cut through the center of the mural, and for a lower corner of the mural to be covered by a wall. Can all this remodeling be undertaken?

Problem B

In 1999, an art gallery that was leasing a surplus garage from the county remodeled most of the space into an exhibition area. Decorations on a "recycling" theme were installed up the walls and across the ceiling and include scrap auto parts and televi-

sion sets, some of which are wired for illumination. A neon snake now winds its way from the entrance throughout the gallery space, and recycled bits of mirror follow its track in a mosaic pattern on the floor. The gallery's lease, which expired several months ago, provided that all improvements to the garage would be subject to the county's prior approval and, upon being affixed, would become the county's property. The county's building department did issue a permit for the remodeling that took place, but no one in the facilities department now recalls having seen the plans for the installation. Another entity is now interested in leasing the space but wants "that junk" removed. Can the installation be removed?

Problem C

In 1992, the city arts commission undertook a competitive selection process for the improvement of a community center's conference room. It subsequently approved the design, fabrication, and installation of six wall-sconce lamps, a display case, and several watercolors, all by well-known local artists. Because the roof of the community center had been improperly repaired before the lamps, display cases, and paintings were installed, a leak has caused repeated water staining of the display case's top, as well as intermittent problems with the operation of the lamps. The city's facilities manager has known about the leak for several years, but because the conference room is not heavily used, the maintenance needs of other city buildings have seemed more important. Now, after an unusually wet winter, major water damage has occurred. The display case's surfaces are severely warped, and the watercolors are badly stained. The facilities manager thinks the room should be stripped of all its furnishings and converted into a storeroom. Can that be done?

Problem D

A few years ago, a sculpture was installed in the lobby of a city parks department's recreational facility. When it became the target of children's pranks and minor vandalism, the facility's staff proposed to relocate the sculpture. A letter was sent to the sculptor at the address set forth in the acquisition contract for the artwork, requesting the artist's comments on this idea. When four months passed without a reply from her, the head of the parks department had the sculpture remounted in the middle of a fountain, in an outdoor courtyard at the parks department's headquarters. The sculpture appears to have rapidly and dramatically changed since its relocation, for its surface details are now much harder to see, and its color is much lighter than when the sculpture was indoors. The head of the parks department has just received a letter from the attorney who represents the sculptor. The letter demands the immediate relocation of the artwork, its restoration, and damages for violation of the artist's rights. What should be the response to this letter?

THE VISUAL ARTISTS RIGHTS ACT OF 1990

The Visual Artists Rights Act of 1990 was enacted as Public Law 101–650. This amendment to the federal Copyright Act is designed to protect the honor and reputation of artists who create certain types of visual art, and to protect such art from certain forms of distortion, mutilation, or destruction. Because VARA preempts equivalent provisions in state laws that provide similar rights to artists, it purports to create a uniform, national basis for the enforcement of such rights.

VARA is this country's first federal-level acknowledgment that an artist retains some personal "moral rights" (as distinct from economic rights) in his or her artwork after its sale.[2] As such, however, VARA is only a distillation of more established European concepts associated with moral rights.

TYPES OF ARTWORKS PROTECTED BY VARA

VARA protects only works of "visual art," a term defined in 17 U.S.C. §101 as follows:

1. A painting, drawing, or print that has been signed by the artist and exists either in a single copy or in a limited edition of two hundred or fewer copies consecutively numbered by the artist[3]

2. A sculpture that bears the signature or identifying mark of the artist and exists either as a single work or in a limited edition of two hundred or fewer copies consecutively numbered by the artist[4]

3. A still photographic image[5] that has been signed by the artist, has been produced for exhibition purposes only,[6] and exists either in a single copy or in a limited edition of two hundred or fewer copies consecutively numbered by the artist

The definition of "work of visual art" in 17 U.S.C. §101 specifically excludes (and thereby places outside VARA protection) the following items:

• Any poster, map, globe, chart, technical drawing, diagram, model, motion picture or other audiovisual work, book, magazine, newspaper, periodical, database, electronic information service, electronic publication, or similar publication

• Applied art (defined as "two- or three-dimensional ornamentation or decoration affixed to otherwise utilitarian objects,"[7] such as building directory signs, ceiling or wall lighting fixtures, and the like)

• Any merchandising item or advertising, promotional, descriptive, covering, or packaging material or container

• Any portion or part of any item described in the three bulleted points immediately preceding this one

• Any work made for hire[8]

• Any work not subject to copyright protection under Title 17 of the United States Code (the federal copyright legislation)

VARA also does not apply to any work of art installed in or on a building before June 1, 1991.

VARA recognizes and protects three rights.

First, the artist can claim the right of "attribution," that is, the right to be recognized by name as the creator of a work of visual art and to prevent any other artist from claiming to have created that work. Only an artwork's creator may assert this right, which is not affected by the artist's retention or disposition of rights associated with the copyright to the artwork, or by the artist's retention or disposition of other rights associated with the artwork itself, including its copyright. Where there are multiple creators of a single artwork, all may claim this right.[9]

Second, the artist can claim the right of "disassociation" (a corollary of the right of attribution), that is, the right to prevent the use of the artist's name in connection with a work of visual art that the artist did not create, or in connection with a work of visual art that the artist did create but that has been distorted, mutilated, or otherwise modified in such a way as to become prejudicial to the artist's honor or reputation.[10]

Third, the artist can claim the right to the "integrity" of the physical condition of a work of visual art, that is, the right to prevent any intentional distortion, mutilation, or other modification of the work that would be prejudicial to the artist's honor or reputation. VARA further protects the integrity of a "work of recognized stature" by enabling the creator of such a work of visual art to prevent its destruction.[11]

VARA does not provide protection against any modification of an artwork that results from the passage of time or the nature of its inherent materials (an example of such modification would be the weathering of soft stone designed to have water pouring over it). Moreover, modification of a work of visual art that results from the work's public presentation, including placement and lighting, or from the work's conservation does not constitute a destruction, distortion, mutilation, or other modification that is prejudicial to an artist's honor or reputation as long as the actions taken do not constitute gross negligence.[12]

The rights of attribution and integrity recognized by 17 U.S.C. §106A(a)(1) and (2) do not apply to any reproduction, depiction, portrayal, or other use of the artwork in, upon, or in any connection with any works made for hire or in connection with any of the specific items excluded by 17 U.S.C. §101 from the definition of "work of visual art."[13] The reproduction, depiction, portrayal, or other use of such a work does not constitute the destruction, distortion, mutilation, or other modification against which protection may be sought pursuant to 17 U.S.C. §106A(a)(1).[14] Finally, VARA does not apply to any artwork's destruction, distortion, mutilation, or other modification prior to June 1, 1991.[15]

DURATION OF ARTISTS' RIGHTS PROTECTED BY VARA

The duration of an artist's VARA-recognized rights of attribution and integrity varies according to when the work of visual art was created and when its title was transferred

from the artist to another party (if the artist has not waived those rights in the manner discussed under "Waiver of VARA-Protected Artists' Rights," below):

• *For a work of visual art created before June 1, 1991,* no VARA protections are available if (a) ownership interests were transferred from the artist to another party before that date or (b) the artist consented to the installation of the artwork in a building before June 1, 1991. If, however, title to a work of visual art created before June 1, 1991, was not transferred until after that date, then VARA rights and protections will apply for the lifetime of the artist and may continue for as long as fifty years after the artist's death.[16]

• *For a work of visual art created on or after June 1, 1991,* the artist's rights of attribution and integrity last until the end of the year in which the artist dies.[17]

• *For any work of visual art created by more than one artist,* the rights exist until December 31 of the year in which the last surviving artist dies.[18]

REMEDIES AVAILABLE FOR VIOLATIONS OF VARA

When VARA has been violated, the injured artist may seek the same legal remedies as are available for any other civil violation of the copyright law, including injunctive relief, impounding, damages, profits or statutory damages, court costs, and reasonable attorneys' fees.[19] Statutory damages are generally in the range of $500 to $20,000 but may be increased to $100,000 for willful violations and decreased to $200 for innocent infringements. In contrast to situations involving violations of other Copyright Act provisions, no criminal penalties are available under VARA. An artist does not have to have his or her name and address on file with the Register of Copyrights at the U.S. Copyright Office in Washington, D.C., in order to bring an action for violation of VARA. Because an artist's "moral rights" under VARA are distinct from economic or property rights, an action for money damages may be brought by the artist even if he or she no longer holds title to the artwork or its copyright.

WAIVER OF VARA-PROTECTED ARTISTS' RIGHTS

VARA specifically distinguishes the rights of attribution and integrity from the right of ownership of any copy of the work of visual art (that is, title to the piece). An artist's VARA rights are also distinguishable from any copyright associated with the artwork, and from any exclusive right granted with respect to such copyright (such as a license to reproduce its image for one or more purposes).[20] VARA makes the artist's personal rights of attribution and integrity nontransferable to another person. Thus, while the artist's copyright (an economic right) may be sold or given away or subdivided into segments, as in the case of limited licenses to exploit the image in various ways, the artist retains the personal rights of attribution and integrity with respect to his or her artworks until those rights are waived. If the right of attribution is waived, then the artwork presumably becomes an anonymous creation—it cannot be attributed to anyone.

Any waiver of these rights must be granted in a written document that is signed by the artist and that specifically identifies the work and the uses of that work to which the waiver applies.[21] The waiver applies only to the work and to the uses so identified. The artist can specify the exact extent to which his or her VARA rights are waived and need not grant a blanket waiver. In granting a waiver, the artist may specify the conditions in which the waiver will and will not be effective.

If a work is a collaboration between or among two or more artists, a waiver by any of the artists waives such rights for all the artists.[22]

Transfer of ownership of a one-of-a-kind artwork, or of any copy of a multiple-image work of visual art (such as a print), or of the copyright or any exclusive right under the copyright does not constitute a waiver of the rights conferred by 17 U.S.C. §106A(a).[23]

HOW VARA PROTECTS ARTWORKS INSTALLED IN BUILDINGS

VARA provides different protections to artists, and imposes different obligations on building owners or managers, according to whether a work of visual art that is attached to or incorporated into a building is or is not removable without consequent change.[24]

If a work of visual art can be removed from a building without the artwork's destruction, distortion, mutilation, or other modification in a way that would be prejudicial to the artist's honor or reputation, then 17 U.S.C. §113(d)(2) governs the procedure under which such removal can occur. Under that provision, the building owner must make a diligent, good-faith attempt to give the work's creator written notice of the owner's desire to have the art removed from the building prior to commencement of any removal action by or for the owner.[25] If the effort to notify the artist is unsuccessful, or if within ninety days after receipt of such notice the artist fails to pay for the artwork's removal or to actually remove it, then the artist loses his or her right of "disassociation" granted under 17 U.S.C. 106A(a)(2), as well as the right to protect the artwork's "integrity" granted under 17 U.S.C. 106A(a)(3) (the rights to prevent any intentional distortion, mutilation, or other modification of the artwork that would be prejudicial to the artist's honor or reputation, and, if the artwork is deemed to be "a work of recognized stature," to prevent its destruction).[26] Within that ninety-day period, however, if the artist does remove or pay for removal of the artwork, then the artist's VARA rights remain in effect, and ownership of the artwork reverts to the artist.[27]

By contrast, if a work of visual art that has been integrated into or otherwise made part of a building cannot be removed without such distortion, mutilation, or other modification as would be prejudicial to the artist's honor or reputation, then the building owner's removal of such art will violate VARA unless a "consent agreement" of the sort contemplated in 17 U.S.C. §113(d)(1) has been executed. In the absence of such an agreement, a similar violation will occur if a work of visual art that is "of recognized stature" is destroyed when it is removed from a building. A consent agreement is not the same as the waiver authorized by 17 U.S.C. §106A(e), discussed under "Waiver of VARA-Protected Artists' Rights," above. A consent agreement is one in which

the . . . [artist] consented to the installation of the work in the building either before . . . [June 1, 1991], or in a written instrument executed on or after such effective date that is signed by the owner of the building and the . . . [artist] and that specifies that installation of the work may subject the work to destruction, distortion, mutilation, or other modification, by reason of its removal. . . . [28]

Without such an agreement, the artist can bar the building owner from remodeling or altering the building in a way that destroys, damages, or changes the art in a way that is prejudicial to the artist's honor or reputation. This restrictive power lasts for the lifetime of the artist or longer.[29]

If a building is conveyed to another owner after an artwork has been integrated into it, then the VARA obligations of the building owner who conveys the building become the obligation of the person or entity that acquires the building.[30]

Neither the special "consent agreement" procedure described in 17 U.S.C. §113(d)(1), with respect to nonremovable works of visual art, nor the special notice procedure described in 17 U.S.C. §113(d)(2), with respect to removable works of visual art, applies where an artwork is integrated into or installed in something other than a building, such as a sidewalk, a pathway, a trail, a plaza, a park, a pond, a streetlight, and so on. Where this latter type of installation or integration occurs, a waiver of the sort contemplated in 17 U.S.C. §106A(e) may clarify the respective rights of the artist and the municipal purchaser.

RECOMMENDATIONS

• Have your arts commission staff or building-management office inventory all artworks located in or on every building owned by your city or county, to determine whether the artworks are owned by your city or county and which, if any, constitute "a work of visual art" that is affected by VARA.

• If your city or county owns any work of visual art that was acquired on or after June 1, 1991, and that has been installed on or in any building, insert some sort of code on the identifying label affixed to or adjacent to the artwork, and in the inventory and other files maintained about artwork on city or county property, to indicate that the artwork is VARA-protected.

• Review all lease forms commonly employed to allow one or more other parties to use city or county property, and determine what limits exist on the tenant's right to make improvements, which party owns the improvements, and when (if ever) ownership of improvements is to shift to the other party.

• If there is no lease provision that specifically addresses artwork installation, consider including one that prohibits a tenant from installing removable or nonremovable artwork in a city or county building without first having provided to some designated city or county official detailed plans describing the proposed artwork and how it will be attached to or incorporated into the leased space, and having secured the building owner's express permission for the installation.

• Unless your city or county has an interest in owning the artwork that any such tenant might install, consider including a provision in your lease form that permits the installation only of artwork that can be removed from the leased premises without the artwork's becoming destroyed, distorted, mutilated, or otherwise modified. Also consider including a provision that requires the tenant to execute with the landlord, and with every artist who is permitted to install artwork in or on the leased premises, a consent agreement containing the acknowledgment, cited earlier, specifying that "installation of the work may subject the work to destruction, distortion, mutilation, or other modification, by reason of its removal."

• You may also want to include a provision obligating the tenant to indemnify the city or county from and against any artist's VARA-based claim arising out of the installation of such artwork, or arising out of the destruction, distortion, mutilation, or other modification of the artwork in a manner that would be prejudicial to the artist's honor or reputation, and from any act or omission other than one committed solely by the city or county or any of its employees or agents. Back up this indemnification obligation with a requirement that the tenant provide insurance protection for the benefit of the landlord against such risks.

• When a new public facility, whether a building or something else, is being designed, ensure that city or county staff communicate with the facility's architect about whether and how artwork can be integrated into it in a way that neither unreasonably burdens the city or county and any successive facility owners nor victimizes the artists who may be engaged to create art to be integrated into the facility.

• When the purchase of a building is being contemplated, be sure to obtain, as part of the due-diligence process, a description of all the artwork that has been installed in the building and an explanation of the means by which it has been hung, erected, mounted, and so on; that way, you can determine the extent to which it can possibly be removed without damage or other adverse modification. You should require the seller to provide you with all available information about ownership of any artwork (for example, the date when the title was transferred from the artist, and the dates when the artwork was created and installed in the building) and about other circumstances of the artwork's installation so that you can evaluate whether the artwork is VARA-protected. You should also review any leases of space in the building, to determine whether existing tenants under those leases may create VARA-related problems for you in the future. If some or all of the artwork in the building is to be removed before or as part of the conveyance, you should clarify which party (the seller, the buyer, or the tenant) is responsible for providing notice to the artist(s) affected, and how the timing of the artwork's removal will affect closing and your use of the building after closing. (Remember that under VARA, an artist has ninety days after receipt of notice of the intended removal of an artwork from a building to pay for the removal or to actually remove the artwork and thereby reacquire title to it.)

• The details of the artwork installed in a building may also be of considerable interest to the lenders of any financing used to acquire improved property, since the redevelopment of a building on improved property can be tied up for a potentially

significant period by an artist whose work was installed in the building without the artist's having signed a consent agreement or any waiver of his or her VARA rights.

DISCUSSION OF PROBLEM STATEMENTS

Problem A

The sixty-year-old building that the city owns was obviously built before VARA became effective. Although the initial facts don't indicate that the mosaic was created as part of the original construction, or before June 1, 1991 (the date VARA became effective), the fact that it was done in an Art Deco design for a building erected in 1936 suggests that the mosaic is an element of the original project.

There are several dates to be considered in evaluating whether a work of visual art is protected by VARA: the date of the artwork's completion, the date of its installation, the date the building's construction was completed, and the date the building and any incorporated artwork were accepted by the owner, with a resulting transfer of title of the same to the building owner. (Many governmental entities require an official act, such as an ordinance, or a board resolution to accept a gift of art or acknowledge the completion of a public work that includes integrated artwork. In the absence of such action, a title transfer may not be effective.) It is just as important to know whether the artist transferred title to the artwork to any other person or entity before title to the artwork was acquired by the city; whether the artist consented to the installation of the artwork in the building; and whether the artist signed an agreement that constitutes a "consent agreement" under 17 U.S.C. §113(d)(1)(B), as discussed under "How VARA Protects Artworks Installed in Buildings," above, together with the date each such action occurred. One or more of these dates may constitute grounds for including an artwork under VARA or for excluding it from VARA protections. Accordingly, the dates the mosaic and the building were completed will have to be verified, as will the city's actual ownership of the artwork. Is there any documentation that title to the artwork was transferred to the city upon the artwork's completion, or that title was officially accepted? Is there any documentation that the artist consented to the installation of the artwork in the building, and of when such consent was given? (Such documentation might include evidence that the artist himself was commissioned to create the work in place, or at least that he worked on such an installation.) Conversely, is there any possibility that the artist somehow retained title to the artwork? The building administrator or city historian may be able to assist the search for this information. The answers to these questions need to be found because they can have a major impact on the ultimate conclusions about what can be done to the artwork.

It can be presumed that the piercing of the mosaic to support the new canopy will have an adverse effect on the artwork. If the mosaic was installed in the building before June 1, 1991, *or* if the artist either transferred title to the artwork to any other person or entity or consented to installation of the artwork in the building before that date, then the artist has no VARA rights, even though he is the state's most famous

ceramist. Under those circumstances, his mosaic is not protected from distortion, mutilation, or other modification, regardless of whether such changes would or would not be prejudicial to his honor or reputation. If the artist has no VARA rights, then he also has no right to disassociate his name from the artwork after the new canopy columns have modified its appearance. If, however, before June 1, 1991, title to the artwork was not transferred by the artist to some other person or entity, or if the artist did not consent to installation of the artwork in any building, then the artist may well have acquired VARA rights and protections both for himself and for his artwork.

Because the artist is the state's most famous ceramist, it could be argued that his mosaic is a "work of recognized stature," the sort of artwork for which VARA provides the most protection. Regardless of whether or not it is such a work, if its installation in the building occurred before June 1, 1991, or if the artist transferred title to the artwork before that date, then the mosaic isn't entitled to VARA protection, despite its apparent importance.

The same factual questions need to be asked with respect to the mural in order to determine whether or not it is affected by VARA.

If VARA applies to the mural, then because it is the first major work of several young artists who have since won a national competition, they may be able to claim that the mural they created for the city building is a "work of recognized stature." In that case, the artists can legally prevent the city's destruction of the mural. Theoretically, it could be argued that cutting a doorway into the center of the mural and erecting a new wall that covers a corner of the mural is not equivalent to the artwork's "destruction," but it's probably pointless to make that argument: the artists could assert that the city's intentional distortion, mutilation, or other modification of their artwork—an assertion unlikely to be deniable—would be prejudicial to their honor or reputation, a situation that in itself constitutes a violation of VARA.

Might the city have some defense against a claim by the mural artists that the city's building addition constitutes an intentional distortion, mutilation, or modification of the artwork? The city should review all the material it has in its files about the mural, beginning with the agreement under which the artists created the artwork, to see if *any* of the artists involved in the project executed a waiver of any VARA right. (Remember that any *one* artist's waiver will have the effect of waiving *all* the artists' VARA rights to the extent expressed in that waiver.) If what looks like the language of a waiver is discovered, there may still be questions about its effectiveness. For example, under both VARA itself and applicable state law there may be established principles regarding the nature and effectiveness of waivers, including but not limited to the requirement that a waiver be clear and unequivocal, be in writing, and specifically identify the artwork with respect to which the waiver has been given. A concurrent search should be made for a VARA consent agreement, which will be either a written document signed by one or more of the artists *before* June 1, 1991, in which the artist(s) acknowledge(s) consent to the installation of the mural in the building, or a document signed by one or more of the artists *after* June 1, 1991, that states "that installation of the artwork may subject the work to destruction, distortion, mutilation, or other

modification, by reason of its removal." (The quoted words are crucial, for they come straight out of VARA and provide the basis for the consent-agreement exception to VARA's normal provisions.) It will be necessary to consult with legal counsel about whether any document that appears to constitute a waiver or a consent agreement actually has that character and is likely to be enforceable.

If no signed waiver of the artists' rights or no consent agreement is found, then the city's relationship with the artists goes back to the beginning point: the need to negotiate with them about what the city can do in order to erect the desired building addition. Perhaps merely disassociating the artists from the modified artwork (that is, removing their names from any public display adjacent to the artwork) will be sufficient to satisfy their VARA-based concerns. Perhaps the artwork can be removed from the building and located elsewhere without being destroyed, distorted, mutilated, or otherwise modified in a way that would be prejudicial to the artists' honor or reputation. VARA notice procedures will have to be followed if it is found that after June 1, 1991, the mural was completed and accepted by the city, or that its title (ownership) was transferred to a person or entity other than the artists, or that any of the artists consented to the mural's installation in the city's building after that date. Another option might be to compensate the artists for the right to make modifications to their artwork or for their execution of a consent agreement. Payment of compensation can be rationalized on the grounds that if the artwork is protected by VARA, then the artists are likely to be entitled to damages, court costs, and attorneys' fees in any VARA enforcement action that they might bring to stop the impact on the mural that would result from the city's building addition.

Problem B

The decoration of the county's surplus garage on a "recycling" theme by the former tenant of that space, and the legal issues raised by the desire to remove "that junk," appear to have created a situation almost identical to that described in the 1996 case of Carter v. Helmsley-Spear, Inc.[31] The artists in the Carter case sued under VARA for protection of their sculpture after the tenant's lease was terminated, the former tenant filed for bankruptcy, the building owner prohibited the artists from entering the building to continue work on their sculpture, and the building owner's representative indicated that the artwork was going to be removed. The federal district judge in that case found that the component parts of a walk-through sculpture installed in a New York City mixed-use commercial building's lobby had coordinated thematic elements, and that for this reason the entire lobby should be treated as a single work of visual art. Although the judge found that the lobby artwork was not equivalent to a piece by, say, Picasso, it was still a "work of recognized stature" because it was meritorious and was recognized as such by members of the artistic community. The court ruled that even though the artwork had been commissioned by a building tenant, and not by the owner, and even though the tenant's lease had expired, a permanent order should be issued to restrain the building owner from removing the artists' sculpture from the building for the lifetime of the artists, and from otherwise violating the artists' VARA

rights. The judge's order also required the building owner to allow the artists and their guests to enter the building between specified daylight hours to view, photograph, and videotape the artwork.

Because the artwork in the county's garage was installed in 1999, and, like the sculpture in the Carter case, appears to be an intentionally integrated work, it is likely that the artwork falls within the protections of VARA. It will be useful to search for any information that could suggest otherwise, such as information that the artwork was created much earlier and was merely relocated to the garage in 1999, or that title to the artwork was transferred from the artist(s) before June 1, 1991. It will also be a good idea to investigate whether the artist(s) who created the artwork executed any form of waiver or consent agreement that could affect what can be done with the artwork at this point or in the future.

It may be necessary to find out more about how the various components of the installation were incorporated into the building. In considering this aspect, it will be useful to examine whether any of the elements can reasonably be removed from the building without becoming damaged and thus damaging the artwork as a whole.

A question can be raised about whether the installation as a whole is protected by VARA. That act protects only "works of visual art" and excludes from its scope "applied art," which the district court judge in the Carter case noted is defined as "two- and three-dimensional ornamentation or decoration that is affixed to otherwise utilitarian objects."[32] The characterization of the mirrored elements of the floor design will be important if any modification of the floor is anticipated. It should be recalled, however, that when the Carter case was considered on appeal, the appellate court concluded that the affixation of "some of the sculptural elements . . . to the floor, walls and ceiling[,] all utilitarian objects," did not make those elements "applied art," noting that such an interpretation "would render meaningless VARA's protection for works of visual art installed in buildings."[33]

The now-expired lease signed by the former tenant (the art gallery) may provide some relief from the impact of the artwork's having been installed. That agreement may have included an indemnification clause that obligated the art gallery, even after the lease's expiration, to protect and defend the county against the gallery's acts and omissions in connection with its use and occupancy of the space. (Did the former tenant install the artwork without securing the landlord's prior approval and thereby violate the tenant's obligations under the lease? If the county's building department issued a permit for such an installation, did that action arguably constitute the county's approval, or did the lease form make a distinction between acts that the county might take in its governmental capacity and those it might take in its proprietary role as building owner/landlord, and did the lease form provide that the county's actions in its governmental capacity had no effect on the tenant's obligations under the lease? Did the lease administrator in the county's facilities department have knowledge of the art gallery's installation and say or do nothing to protest the planned installation when reviewing plans for remodeling of the space?) If the former tenant has a continuing indemnification obligation, that may be sufficient to make the former tenant liable

for payment of any damages that might be claimed by the artist(s) who created the installation. Of course, the former tenant's ability to pay such damages is another factor that must be considered: the potential relief available from an indemnification clause can turn into no relief at all if the indemnifying party—in this case, the art gallery—no longer exists, hasn't any resources, or wasn't required to back up the indemnification obligation with an appropriate insurance policy protecting the landlord's interests.

Because the county appears to have another tenant interested in the space, time is a major consideration, but resolving VARA questions will require the passage of time, for if the artwork is VARA-protected, the county is obligated to give notice to the artist(s), advising of the county's intention to have the artwork removed from the building and of the fact that the artist(s) will have only ninety days after receipt of such notice to provide for its removal.[34] If the artist should fail to remove the artwork or to pay for its removal within that ninety-day period, then the artwork's VARA protections evaporate, and the building owner is allowed not only to remove the artwork but even to destroy it.

Problem C

Each of the watercolors created for the community center's conference room is clearly a "work of visual art," and thus protected by VARA, because each was commissioned for creation after VARA's effective date of June 1, 1991. Is any of six wall-sconce lamps such a work? Is the display case? Or are all these objects "applied art"—that is, two- or three-dimensional ornaments or decorations affixed to otherwise utilitarian objects?

It will probably be hard for the artists who created the lamps and the display case to argue successfully that their creations are not "applied art," for lamps and display cases are clearly utilitarian objects. A review of the artists' agreements for the creation of the lamps and the display case may clarify whether the artists acknowledged that they were creating "applied art" or whether they executed consent agreements in connection with having been commissioned to create these furnishings.

The water damage to the lamps and the display case is unfortunate, but the damage to the watercolors is more troublesome because the watercolors are undeniably "works of visual art" and therefore have VARA protection. Moreover, since the watercolorist is a well-known artist, these paintings may be works "of recognized stature," a characterization meaning that if the works cannot be restored, the city's failure to repair a repeatedly leaking roof has resulted in these artworks' destruction. What is the effect of the facilities manager's having had prior knowledge of the leaking roof, and of the leak's having repeatedly damaged the artwork in the conference room, with no arrangements made to repair the roof before the artwork was destroyed? The facilities manager is likely to be deemed to have been negligent in the matter of dealing with the leaking roof and providing adequate protection for VARA-protected artworks. Whether that official's acts and omissions constitute "gross negligence" under applicable state law[35] is a question that will probably require a judge's decision.

The city's agreement(s) with the watercolorist will certainly need to be reviewed, and it will be necessary to search for any applicable form of waiver or consent agree-

ment signed by the artist with respect to his watercolors. If no waiver or consent agreement is found, then the city is likely to be exposed to the artist's claim for damages for violation of his VARA rights.

Aside from those problems, issues related to the artworks' relocation may be raised by the facilities manager's desire to strip the conference room of its furnishings and convert it into a storage room. Would the watercolors be removed from the building in which they are currently displayed, or would they simply be relocated within the current building? If the relocation is just within the building, then there is no express obligation under VARA to notify the artist of the relocation, but if the watercolors are to be removed from the building entirely, a literal reading of VARA points to the conclusion that the artist will have to be notified of such intended action. If the city does not intend to dispose of the badly stained and possibly destroyed artworks, then the city's notice obligation under VARA may be limited to the fact of the intended relocation, although an argument can be made that the city also has a moral obligation to give notice to the artist of the damage or destruction suffered by the watercolors. If the city intends to make no effort to restore the watercolors, then its VARA obligation could be met by notice to the artist that both expresses the city's intention to remove the watercolors from the building and invites the artist either to perform the removal or pay for it. If the watercolorist, within ninety days of receiving such notice and invitation, responds by accomplishing the invited removal or paying for that action, then the facilities manager's desire to have the conference room stripped of its furnishings will be satisfied, but that will not absolve the city from its liability to the artist for the damage or destruction suffered by the artworks.

Problem D

In this case, much more information definitely will be needed before the city's parks department can respond to the demand letter from the artist's attorney. Facts to be discovered include but are not limited to the dates of the sculpture's creation, its conveyance by the artist, and its acceptance by the city; the existence of any waiver or consent agreement signed by the artist; and the details of any particular maintenance and care directions or instructions that may have been given by the artist in connection with the artwork.

Information will also be needed about the sculpture itself and about the circumstances of its past and current display. It may also be helpful to consult artwork conservators about the proper care of the material that makes up the sculpture. For example, it is already known that the sculpture is now in an exterior courtyard and has been placed in the middle of a fountain, but is the sculpture also illuminated by direct sunlight? Does water from the fountain drip, splash, spray, or wash over it? Is the sculpture receiving treatment consistent with whatever instructions the artist may have provided for its care and maintenance, or with established conservation standards for the type of material used in its construction? What are the reasons why the color of the sculpture has changed and why its surface details are now harder to see?

It will also be necessary to learn more about prior efforts to communicate with

the artist. For example, although the address set forth in the artist's contract was used in the attempt to notify the artist of the sculpture's intended relocation, was that the appropriate address? Does any city employee know of a different address used more recently by the artist? Did anyone make contact with the U.S. Copyright Office to find out the last address filed there for the artist and verify that it is the same as the address used for the city's attempted notice? If the most recent address on file for the artist with the Register of Copyrights is not the address in the artist's contract, then the city may be subject to a claim by the artist that his or her VARA rights were violated by the city's failure to give prior notice of its intent to relocate the sculpture.[36] In response to any such claim, it may be possible to argue that VARA does not explicitly require that the artist be given prior notice of an artwork owner's intention to remove the artwork from a building if the owner does not also intend to dispose of the artwork, and if disposal was not the city's intention when the artwork was relocated.

Four months passed between the date when the city's notice was sent and the date when the artwork was relocated, but that says nothing about the timeliness of the artist's response after her receipt of the city's notice. It is necessary to find out whether she actually received the city's notice soliciting her comments about relocating the sculpture. (For this reason, any such notice should be sent by certified mail, return receipt requested, or by a courier service that secures acknowledgment of receipt by the addressee.)

If the artist did receive the city's letter but did not respond to it until more than ninety days after receiving it, then that failure may provide a good argument that the artist has waived her VARA right to complain about the artwork's relocation and about any subsequent damage that has resulted. (Recall that if the city's good-faith effort to notify the artist is unsuccessful, or if within ninety days after receipt of such notice the artist fails to pay for the artwork's removal or to actually remove it, then the artist is deemed to have forfeited her VARA rights to disassociate her name from the artwork and to claim damages or other relief from the prejudicial alteration or intentional destruction of the artwork.)

Under VARA, if changes to an artwork result from its public presentation, those changes do not constitute destruction, distortion, mutilation, or other modification that violates the artist's right to the integrity of the artwork unless the changes resulting from such presentation are caused by "gross negligence."[37] Moreover, changes to an artwork that result from the passage of time alone do not constitute distortion, mutilation, or other modification for which VARA provides protection and relief. If information can be gathered about the nature of the materials used in creating the sculpture, and about the decision-making process that caused the sculpture to be installed in a damp or wet environment, it may be possible to gain a better sense of the city's exposure to liability for the artist's claims and for restoration of the artwork. If the sculpture would have faded and worn away even in its original location inside the recreation facility, then the changes that have occurred in its surface definition may not form the basis for any legitimate claim on behalf of the artist. Conversely, if the parks department staff had knowledge of the nature of the materials used in the sculpture's cre-

ation, and if, despite pranks and vandalism, the sculpture's surface did not show appreciable wear during the period of the artwork's display inside the recreation facility, and if the head of the parks department was advised by the staff that the sculpture's relocation to the middle of the outdoor fountain was likely to result in damage to the artwork, then the city's primary tasks will probably be to try to minimize the amount of damages that will have to be paid to the artist and to minimize the cost of the artwork's restoration and of its relocation to a more protective environment.

VARA does not appear to impose on the owners of an artwork the obligation to restore it or have it restored if it has been damaged, or to have it re-created if it has been destroyed. It may be possible to satisfy an artwork owner's VARA responsibilities simply by providing to the artist whose artwork has been damaged or destroyed the opportunity to disassociate himself or herself from the artistic remains. If, however, damage to or destruction of an artwork is the result of an intentional act or omission of a city or county or of any city or county employee or agent, then disassociation may not be deemed sufficient relief inasmuch as the creator of a "work of recognized stature" is entitled by law to prevent its destruction.

NOTES

1. The recommendations outlined here are those of the author, not those of the City Attorney or the Law Department of the City of Seattle.

2. For a more detailed discussion of "moral rights," see Thomas Hayton, "Applying Federal Copyright Law to Public Art," elsewhere in this book.

3. According to the legislative history of the act (House Report No. 101–514), whether a particular work falls within the definition is not governed by the medium or media used in its creation. Therefore, the term "painting" includes murals and works created on canvas or other materials, and the term "print" includes lithographs, serigraphs, and etchings.

4. House Report No. 101–514 indicates that the term "sculpture" includes castings, carvings, modelings, and constructions.

5. House Report No. 101–514 indicates that the term "still photographic image" should be interpreted to include positive images (prints, contact sheets, and transparencies such as slides) and negative photographic images and transparent materials used for printing positive images, but not moving images such as those in motion pictures or videotapes (which are specifically excluded from the statutory definition).

6. In a determination of whether a photograph has been produced "for exhibition purposes," the nature or location of the exhibition is irrelevant; the initial purpose for creating the photograph is what controls whether the photograph is entitled to VARA protection.

7. See Kieselstein-Cord v. Accessories by Pearl, Inc., 632 F.2d 989, 997 (2d Cir. 1980).

8. Under 17 U.S.C. §101, a work made for hire can be created through two means that are mutually exclusive. It can be

(1) prepared by an employee within the scope of his or her employment; or
(2) specially ordered or commissioned for use as a contribution to a collective work, as a part of a motion picture or other audiovisual work, as a translation, as a supplementary work, as a compilation, as an instructional text, as a test, as answer mate-

rial for a test, or as an atlas, if the parties expressly agree in a written instrument signed by them that the work shall be considered a work made for hire. . . .

Whether an artist is or is not an "employee" is determined through traditional, definitional tests of a conventional employer-employee or master-servant relationship. This determination is factual in nature and is based on an application of common-law agency principles and an examination of, among other matters, the scope and duration of the association between (for example) a building owner and an artist commissioned to create an artwork to be installed in the building, the extent of control or decision making exercised by the building owner, the level of skill required of the artist, the origin of and source of payment for the artist's tools and raw materials, and the extent to which usual employee benefits are provided and federal income taxes are withheld from compensation payable to the artist. If the creator of a copyrightable work is an independent contractor rather than an employee, the copyright to the work initially will be vested in the entity commissioning the work *only* if the work falls within one of the nine specific types of works identified in 17 U.S.C. §101(2), and if the parties have executed, before the work's creation, a written agreement that the work will be a work made for hire. See Community for Creative Non-Violence *v.* Reid, 490 U.S. 730, 104 L.Ed.2d 811, 109 S.Ct. 2166 (1989); and Schiller & Schmidt, Inc. *v.* Nordisco Corp., 969 F.2d 410 (7th Cir. 1992).

9. 17 U.S.C. §106A(b).

10. 17 U.S.C. §106A(a)(1) and (2).

11. 17 U.S.C. §106A(a)(3)(A) and (B). Under this provision, any intentional distortion, mutilation, or modification, or any intentional or grossly negligent destruction, of a VARA-protected artwork is a violation of that right. VARA does not define the terms "prejudicial," "honor," "reputation," or "recognized stature," and so these terms have to be interpreted by the courts. House Report No. 101–514 notes congressional recognition that artists who are less well known or appreciated do have honor and reputations worthy of protection, but also congressional intent to provide protection against the destruction only of works of "recognized stature," to prevent unknown artists from being able to gain publicity through petty suits and frivolous claims.

12. 17 U.S.C. §106A(c)(2). The term "gross negligence" is not defined in VARA, and so its meaning is likely to be determined according to applicable state law. For example, under Brewer *v.* Copeland, 86 Wn.2d 58, 71, 542 P.2d 445 (1975), it means

negligence substantially and appreciably greater than ordinary negligence . . . ,

citing Nist *v.* Tudor, 67 Wn.2d 322 at 331, 407 P.2d 798 (1965).

13. Materials excluded from the definition of "work of visual art" are listed in "Types of Artworks Protected by VARA," *supra.*

14. 17 U.S.C. §106A(a)(3).

15. 17 U.S.C. §106A (note). Moreover, the continued, ongoing display after June 1, 1991, of a work of art that was distorted, mutilated, or otherwise modified prior to that date in a way that is prejudicial to the artist's honor or reputation does not give rise to a cause of action under VARA. See Pavia *v.* 1120 Avenue of the Americas Ass'n, 901 F. Supp. 620 (S.D. N.Y., 1995), which involved a large bronze sculpture that in 1963 was installed in the lobby of the New York Hilton Hotel and in 1988 was disassembled, removed from the hotel lobby, and only partially reassembled for public display in a commercial warehouse.

16. 17 U.S.C. §106A(d)(2) and (4); 17 U.S.C. §302. The exact duration of the rights depends upon the date the artwork was created and the Copyright Act provisions in effect at that time. See Pavia, *supra,* which involved an artist who had not transferred title to his artwork to the owners of the hotel in which it had been installed.

17. 17 U.S.C. §106A(d)(1) and (4).

18. 17 U.S.C. §106A(d)(3) and (4).

19. For an illustration of the relief granted to artists under VARA and an analysis of its applicability to a work commissioned by a tenant, see Carter *v.* Helmsley-Spear, Inc., 861 F. Supp. 303 (S.D. N.Y. 1994), *affirmed in part, vacated in part, and reversed in part,* 71 F.3d 77 (2d Cir. 1995), *cert. denied,* 517 U.S. 1208, 116 S. Ct. 1824, 134 L. Ed. 2d 930 (1996).

20. 17 U.S.C. §106A(e)(2).

21. 17 U.S.C. §106A(e).

22. 17 U.S.C. §106A(e)(1). House Report 101–514 notes congressional intent to treat joint artists like joint authors with respect to the exploitation of their personal and economic rights: where one joint author exploits the economic rights in a jointly produced work, that author has the duty to account to other joint authors for any profits earned from such exploitation.

23. 17 U.S.C. §106A(e)(2).

24. Whether an artwork that has been integrated into a building is or is not removable is less a technological question for artwork conservators than an economic one for building owners and artists. Because means now exist to remove almost all forms of art from a building, the determinative issue is likely to be whether the removal is worth the cost. As technology advances, the cost of removing artwork is likely to lessen, and more works are thereby likely to be made removable.

25. A building owner is deemed to have made a diligent, good-faith attempt under 17 U.S.C. §113(d)(2) to give notice of the owner's intentions if the notice to the artist is in writing and is sent by registered mail to the address that the artist most recently filed with the Register of Copyrights.

26. 17 U.S.C. §113(d)(2). The effect of this provision is anomalous: even though the basis for giving notice to the artist is the intent to remove the artwork without damaging it, if the artist is nonresponsive to the notice, or if the artist is unable either to pay for the work's removal or actually to remove it, then the artist can lose the right to complain even about subsequent intentional or grossly negligent destruction of a work of recognized stature, or about intentional distortion, mutilation, or modification of the work in such a way as to be prejudicial to the artist's honor or reputation.

27. 17 U.S.C. §113(d)(2). One curiosity of VARA is its failure to address the possibility that a building owner may want to have a work of visual art simply relocated from one of the owner's buildings to another. The provisions of 17 U.S.C. §113(d)(2) read as if the building owner may not avoid either the obligation of giving the artist ninety days' prior notice of intention to remove the artwork from its most recent location or of giving the artist the opportunity to remove or pay for the removal of the artwork, which would result in transfer of ownership of the artwork—a result perhaps not intended by the building owner.

28. 17 U.S.C. §113(d)(1).

29. 17 U.S.C. §113(d)(1). See "Duration of Artists' Rights Protected by VARA," *supra,* for situations in which VARA rights extend beyond the lifetime of the artist.

30. House Report 101–514 notes that whether the rights granted by 17 U.S.C. §106A(a)(2) and (3) to protection of an artwork from damage or destruction apply in a given case is governed not by who owns the building at any given time but rather by the fact of integration and the circumstances surrounding the installation.

31. See n. 19.

32. See Carter, *supra,* in 861 F. Supp. at 315.

33. See *id.,* in 71 F.2d at 85.

34. In connection with a building owner's obligation to give an artist ninety days' prior

notice of the owner's intent to remove an artwork from a building, see Martin *v.* City of Indianapolis, 982 F. Supp. 625 (S.D. Ind. 1997). In that case, the City of Indianapolis was ordered to pay the plaintiff artist the full amount of statutory damages ($20,000) and the artist's attorneys' fees because when the city acquired the land on which the artist's sculpture had been installed, and then contracted for the clearing of the land and the destruction of the sculpture, the city failed to give the artist ninety days' prior notice of the city's desire to have the sculpture removed or of its intent to have the sculpture destroyed.

35. See n. 12.
36. See Martin, *supra.*
37. See n. 12, where this type of behavior is characterized.

VARA CONSENT FORM

AGREEMENT
by and between

[Insert name of building owner]
and

[Insert name of building tenant, if any]
and

_____(ARTIST)

Regarding the Installation of the Artist's Work of Visual Art at/in Certain Premises

Through this Agreement, the [insert name of appropriate building manager or owner/public official] gives consent (receipt of which is hereby acknowledged by the Artist and [insert name of building tenant, if any]), for the installation at or in the Premises leased by [insert name of building tenant, if any] from [insert name of building owner] under the Lease Agreement executed on or about [date], pursuant to [insert citation to any special legal authority, such as a municipal ordinance or state statute required to authorize execution of the lease], of the following work of visual art by the Artist:

Title:_____

Size:_____

Medium:_____

Other description:_____

Authorized location:_____

in consideration of which consent the Artist acknowledges, for the benefit of [insert name of building tenant, if any] and [insert name of building owner], the Artist's understanding and agreement that such installation may subject such work to destruction, distortion, mutilation, or other modification by reason of the removal of such artwork from such Leased Premises.

By: _____
Artist

By: _____
[Insert name of person authorized to execute agreement for Building Owner]

By: _____
[Insert name of person authorized to execute agreement for Building Tenant]

STATE OF _____)

) ss. (Acknowledgment by Artist)

COUNTY OF _____)

On this _____ day of _____, _____, before me, the undersigned, a Notary Public in and for the State of _____, duly commissioned and sworn, personally appeared _____ to me known to be the Artist identified in the document set forth above, who executed the same, and acknowledged the same to be his/her free and voluntary act and deed for the uses and purposes therein mentioned, and on oath stated that he/she was authorized to execute such document.

WITNESS my hand and official seal hereto affixed the day and year in this certificate above written.

_____ _____
(Signature) (Printed or typed name of Notary Public)

Notary Public in and for the State of_____,

residing at _____

My appointment expires _____

STATE OF _____)

) ss. (Acknowledgment for Building Owner)

COUNTY OF_____)

On this _____ day of _____, _____, before me, the undersigned, a Notary Public in and for the State of _____, duly commissioned and sworn, personally appeared _____ to me known to be the Building Owner identified in the document set forth above, who executed the same, and acknowledged

the same to be his/her free and voluntary act and deed for the uses and purposes therein mentioned, and on oath stated that he/she was authorized to execute such document.

WITNESS my hand and official seal hereto affixed the day and year in this certificate above written.

_____ _____
(Signature) (Printed or typed name of Notary Public)

Notary Public in and for the State of_____ _____

residing at _____

My appointment expires _____

On this _____ day of _____, _____, before me, the undersigned, a Notary Public in and for the State of _____, duly commissioned and sworn, personally appeared _____ to me known to be the representative of the Building Tenant identified in the document set forth above, who executed the same, and acknowledged the same to be his/her free and voluntary act and deed for the uses and purposes therein mentioned, and on oath stated that he/she was authorized to execute such document.

WITNESS my hand and official seal hereto affixed the day and year in this certificate above written.

_____ _____
(Signature) (Printed or typed name of Notary Public)

Notary Public in and for the State of_____,

residing at _____

My appointment expires _____

STATE OF _____)
) ss. (Acknowledgment for Building Tenant)
COUNTY OF _____)

Copyright

Applying Federal Copyright Law to Public Art THOMAS HAYTON

This essay is about (federal) copyright protection of publicly owned artworks. The question of copyright has to do with the replication of images of such works and, to a lesser extent, the curating of the physical works themselves.

Portions of the copyright statutes dealing with the care of physical works resulted largely from amendments to the code passed in 1990 under the name Visual Artists Rights Act (VARA). Related rights, such as the right of privacy, are different and answer to different rules.[1] Parties can also change copyright rules by contract.

BASIC ELEMENTS

Copyright

Protections against copyright "infringement" involve the unauthorized copying of "original works of authorship" that are "fixed in a tangible medium."[2] This definition begs three questions:

1. What work is qualified for protection?
2. Who owns the copyright?
3. What sort of use of the work constitutes "copying"?

VARA

Some artists, apart from their right to control the replication of images, have a say in the preservation of physical works of art.

WHAT WORK IS PROTECTED?

Copyright in General

To be protected by the copyright statutes, the thing must be an "original work of authorship" and be fixed in a "tangible medium."[3] The phrase "tangible medium" refers to something that is perceptible by the senses, but not necessarily by the sense of touch, which means that readings and staged presentations are protected.[4] Mere ideas are not protected by copyright statutes, although they may be protected under other laws, such as those that concern patents,[5] trade secrets, and publicity.

Although a copyright cannot exist until there is a tangible manifestation, it is important to recognize the distinction between the copyright and the tangible manifestation: ownership of the work does not translate into ownership of the copyright.[6] (This rule is commonly appreciated more for works that are not considered to be public

art—when, say, the issue involves ownership of a book or of a Picasso original—but the rule is equally applicable to public art).

Categories of Copyrightable Works

The federal statutes set out categories of qualified works and then say that the categories are illustrative only.[7] The category that covers public art is "pictorial/graphic/sculptural works." The whole list is "literature, composition and songs, drama, choreography, pictorial/graphic/sculptural works, movies, sound recordings, and architectural works."

Irrelevance of Taste to Copyright Protection

A work's entitlement to copyright protection does not depend on its seriousness or "goodness."[8] Note, however, that critical acclaim for a work is a factor in determining whether the work is of sufficient stature for certain protections as a piece of "visual art"; see "Artists' and VARA Rights After Sale of Works," below. The quality or notoriety of a work also has a bearing on the amount of the damages that can be awarded for copyright infringement; see "Sanctions," below.

VARA

Additional protections apply to "visual art," which means

> a painting, drawing, print, or sculpture, existing in a single copy [or] . . . a limited edition of 200 copies or fewer that are signed and consecutively numbered by the author.[9]

WHO OWNS THE RIGHT?

Author as Owner

The owner of the copyright is usually the person who makes the work in the first place, since the copyright initially is owned by the work's author, not by the entity that either commissions it or later buys it. "Author" is merely the term used to denote the artist who creates the work; for a public statue, the "author" is the sculptor.[10] An author can sell ("transfer") the copyright. Because there is a difference between the tangible work and the right to duplicate it, the sale of the work does not include the sale of the copyright unless the sale agreement explicitly says so.

Irrelevance of Ownership of Work to Ownership of Copyright

The question of who owns the tangible work, even if the owner is a public entity, is not important for issues of copyright. The author's protections are not affected by whether the owner of the work is a public or a private entity.[11] There is an exception for federal government works, but only for works created by federal employees in the course of doing their jobs.[12]

Infringement

Anyone can be an infringer. The law expressly applies to infringements by states and their instrumentalities.[13]

Authorship as a Function of the Situation

The question of who is the author depends on the specific situation. Many different arrangements are used in the creation of works, of course, ranging from that of a novelist slaving away on a manuscript in obscurity (the easiest example) to that of numerous people in an architectural firm designing a large building in consultation with engineers. For all creative arrangements, there seem to be two tests for determining who the author is.

Vertical Paradigm

The vertical paradigm defines authorship in a situation where the work has been created by someone who was hired by the tangible work's owner. Here, the distinction is between work by employees ("work made for hire") and work by independent contractors. The basic rule is that an independent contractor and an employee's employer are authors.[14] Of course, this rule places great importance on the decision of whether the work's creator was an employee or an independent contractor at the time of the work's creation. That decision is determined primarily by the amount of control over artistic discretion that resides with the work's owner. The owner may retain power to review progress on the work and to consult on or even veto the work's design, but that power alone does not constitute enough control over artistic discretion to justify a claim of authorship; otherwise, the exception would overcome the rule.[15]

A commissioning agreement (that is, an agreement for the creation of a new work) probably cannot shift the mantle of "author" to the commissioning entity, but an employment agreement can make an employee the author.

Horizontal Paradigm

This paradigm defines authorship in the case of a work where there is participation by a number of people on roughly the same level. It includes "joint works" (that is, works whose parts are integrated in such a way that the parts cannot stand on their own) and "collective works" (that is, works, such as anthologies, whose individual parts can stand on their own).[16]

For a joint work, the copyright is held by each author equally, unless the agreement between joint authors states otherwise.[17] This means that all the authors have the right to use the image of the work, but each must account to the others for their pro rata share of the profits.[18] By contrast, each of the contributors to a collective work retains the copyright to his or her original piece, and the editor or collector gets only the copyright in the collection.

Unauthorized Identical Copies and Derivatives

Copyright protects against unauthorized identical copies and derivatives. An original work cannot be used to create another work, whether the second work is perfectly or imperfectly identical. A "derivative" copy is such an imperfect replica. It is a new work created from the original, and in which the original is still recognizable. The term "derivative work" commonly refers to a translation of a work into a different medium (for example, a screenplay made from a book or a play), but it can also refer to a slightly changed work in the same medium (for example, a print of an original painting).[19] One proves that a work is a derivative, as opposed to an original work that happens to resemble another work, by looking at the degree of similarity between the two and determining whether the second artist had access to the original.[20] At least in theory, the junior work's resemblance to the senior work is not enough to prove that the junior work is a derivative, since spontaneous replication is possible. Again, copyright protects the work but not the design per se; it does not create a monopoly in the same way as does, say, a patent.

Exception for Fair Use

A copier may escape liability by claiming "fair use," a term invoked in cases of scholarly review, news reporting, or commentary (including parody) concerning the work. To ascertain whether this defense of copying applies, one has to consider four factors: whether the copying was done for commercial gain, how creative the original work was, how substantial the copying was, and how damaging the copying was to the value of the original work.[21]

Need to Distinguish Licenses

The copyright owner may enter into contracts to permit third parties to use the image of an artwork. The resulting rights ("licenses") are dependent on such agreements. Options include whether a license is exclusive and the degree of limitation on how and how long the image is used.

A written statement, signed by the owner, is necessary for the transmission of exclusive rights.[22] By contrast, a limited right to use an image may be implied from a commissioning agreement whereby an artist creates an image in exchange for payment, and in circumstances that make clear the buyer's intention to use the image in a certain way, as when architectural plans are used to build a house or when organizers of an event hang multiple copies of a poster originally created for the event organizers by an artist.

Limitation by the "Merger" Doctrine

Where an idea can be expressed in only one way, the idea and its expression are considered to be the same ("merged"), and there is no copyright.[23] Similarly, where the man-

ner of expression is severely limited (as in commercial display of a product), any copyright is considered "thin," which means that it protects only against identical reproductions.[24]

Artists' and VARA Rights After Sale of Works

What rights, if any, do artists have with respect to how tangible original works are preserved or changed after being sold? For "visual art,"[25] there are rights that are intermediate between ownership of a physical work and control over its reproduction. These rights serve to "attribute" the original work to the right artist and protect the "integrity" of the original work against changes.[26] Together, these rights are called "moral rights." By contrast, other copyright protections are more focused on commercial applications, such as royalties.

VARA rights are unavailable where a work has been made by an employee. Employee artists create no moral rights for themselves or their employers.

Attribution

Attribution entails the right to claim authorship of a work, to stop others from claiming authorship of the work, and to disassociate the author's name from the work if the work has been "distorted, mutilated or modified in a way prejudicial to his or her honor or reputation." Neither "honor" nor "reputation" is defined in the statute, and the terms have come to have a rather circuitous meaning, such that the honor or reputation of the artist will be damaged if and when the particular work is damaged.[27]

Integrity

Integrity entails the right to stop the modification of a work if such modification would be prejudicial to the artist's honor or reputation, and the right to stop destruction of a work of "recognized stature." The latter phrase is no more defined than are "honor" and "reputation," but the statute does exclude natural deterioration and curatorial decisions about how to present the work, provided that such decisions are not grossly negligent.[28] The Carter case (see n. 27, above) involved steel contraptions welded to the lobby walls of an office building; the plaintiffs' expert successfully defined this work to have sufficient stature because the lawsuit itself had created that stature. Better proof would be testimony directly on the merits of the work, independent of its connection to the suit.[29]

Damage to, destruction of, or (if the work was created for a specific site) possibly even movement of a work of visual art that has become incorporated into a building may violate the right of "integrity" even if that change to the work is needed to conduct changes or repairs to the building.

A 9th Circuit Court opinion[30] shows that integrity is a two-edged sword. Although VARA provides special protections for art that has been incorporated into buildings, it also imbues the resulting assembly with the characteristics of an "architectural work," and architectural works largely enjoy no protection from photographic reproduction.[31]

In the case, the artist complained about the use in one of the *Batman* movies of his art pieces, which had been installed on the face of an office building in Los Angeles. The court held that the work, since it assumed the mantle of architectural work, was no longer protected from unauthorized photography.

VOLUNTARY TRANSFERS OR LICENSING

Transfer of Exclusive Copyright

Transfer of any exclusive copyright requires a written document signed by the work's author or by the current owner of the copyright.[32] The document should include an explicit statement that the copyright is being transferred, as opposed to a more indirect statement, such as that the artist agrees to recognize himself or herself as an employee while creating some specific work of art—an agreement that probably could not be enforced.[33] The document can be conditioned on, say, the occurrence of certain events, such as payment, although there will always be a question about whether such terms are considered to be a condition to the transfer or merely a bilateral promise on the part of the recipient of the copyright.[34]

"Moral Rights" and Waivers

There can be no transfer of "moral rights," but there can be waivers.[35] Moral rights exist only in the original artist. The artist retains moral rights notwithstanding sale of the tangible work and even of the copyright. Where the artist has sold the right to copy the work, he or she will still have some say in how the copies are made and/or presented.

With some exceptions for older works, waivers of moral rights must be in writing, must be signed by the artist, and must specifically identify the way in which the work can be used.[36] Further, a written statement that the removal of a work, once it has been installed in a building, could damage or destroy the work will constitute a waiver of "moral rights" to that extent, provided that the statement is signed by both the artist and the building owner.[37]

INADVERTENT LOSS OF COPYRIGHT

Expiration

Copyright can be inadvertently lost through its expiration. Copyright typically lasts for the lifetime of the author (or, in the case of a joint work, for the lifetime of the last surviving author) plus seventy years. The copyright of a work made for hire lasts either ninety-five years from the year of its first publication or one hundred twenty years from the year of its creation.[38]

Waiver and Waiting Too Long to Enforce Rights

A second way to lose copyright protections inadvertently is to wait too long to complain about a particular infringement. Normally, the work's mere exposure to the pub-

lic does not create this type of problem. (Indeed, the work's exposure to the public is normally the objective of the work's very creation, and so copyright protection would be less than useful if it were to expire upon the work's distribution or exposure to the public.)

There is an exception where architectural work is concerned: photographs of a building and of the artworks incorporated into it, even photographs used thereafter for commercial purposes (as in the publication and sale of postcards), are not prohibited so long as the building is "ordinarily visible" from a public place.[39]

FORMALITIES

Notice or Equivalent Warning for Nonpublished Works

"Notice" is the term used for the ubiquitous copyright warning that we see on published works. Copyright notices are useful but, since 1989, unnecessary.

A proper copyright notice is plainly visible and contains the name(s) of the author(s), the date of the work's publication, and some indication that copyright is claimed (for example, the word "copyright" or the typical symbol ©). The copyright notice should be placed on the work itself (and, of course, on copies as well), not merely somewhere in the work's vicinity.[40]

The term "publication" means distribution of copies of a work to the public, not merely public display of the work.[41] Accordingly, much public art has not technically been "published," even though it has been placed in highly visible and public spots. For a unique example of public art that has been published, consider *Hammering Man*, one copy of which is adjacent to the Seattle Art Museum; there are other authorized copies in other locations around the world.

Although copyright notice is not germane to unpublished works, the best practical course would be to place on an unpublished work a notice stating the claim to copyright, the name(s) of the artist(s), the date of the work's creation, and a statement that there has been as yet no "publication" of the work.

Registration

A copyright holder may register the copyright with the Library of Congress. As with notice, registration is important but not essential for basic protection of the copyright. Registration is not needed for the copyright itself, but it is needed before an infringement case can come to trial.[42] It is also important for recovery of damages (see the discussion in "Sanctions," below).

Registration of the copyright is not needed in order to enforce the artist's moral rights.

SANCTIONS

There is a wide range of recovery options, including even criminal prosecution.[43] There can be civil injunctions,[44] orders to impound and destroy offending works,[45]

and awards of monetary damages (including recovery of ill-gotten gains) for infringement or violation of VARA rights.[46]

Registration of the work must at least be started before litigation for its infringement can start. Registration also enhances the plaintiff's recovery options: it allows for the recovery of court costs and attorneys' fees,[47] and it allows use of a statutory schedule to compute actual damages,[48] thus avoiding the sometimes difficult job (notwithstanding statutory provisions favorable to victims[49]) of computing actual damages and the allocable amount of the infringer's profits associated with the infringement.[50]

Because an infringement victim's greatest leverage is the ability to disrupt an ongoing program that has already incorporated his or her art, the main weapon is an injunction, even if monetary relief is the principal objective.

NOTES

1. See Downing v. Abercrombie & Fitch, 205 F. 3d 994 (9th Cir. 2001).

2. 17 U.S.C. 102(a).

3. Rogers v. Koons, 960 F. 2d 301 (2nd Cir 1992) (posed photo of puppies and owners is sufficiently creative).

4. The phrase "tangible medium" means that a work's embodiment, by or under the authority of the author, is permanent enough to permit the work to be perceived for a duration that is more than transitory. 17 U.S.C. 101.

5. 17 U.S.C. 102(b). Other things not protected by copyright are procedures, processes, and mere lists of data. See id.; Baker v. Selden, 101 U.S. 99 (1879) (accounting system not copyrightable, but book describing new system is). Mr. Selden's accounting system—a special application of double-entry accounting—could be protected only through patent. Slogans and symbols are not protected by copyright but may be protected under federal and state trademark laws. See Taco Cabana v. Two Pesos, 932 F. 2d 1113 (5th Cir 1991) (protection of unique appearance of restaurant chain's facilities under the trademark concept of trade dress); Rock and Roll Hall of Fame v. Gentile Productions, 1998 Fed. App. 0020P (6th Cir. 1997) (I.M. Pei's design of new museum is not protectable as trademark because there is insufficient proof of any identification of the unique image of the building and any product or service of its owner).

6. 17 U.S.C. 202. See MacLean v. Mercer-Meidinger-Hansen, 952 F. 2d 769 (3rd Cir 1991) (license to use a computer program cannot be implied merely from its transfer, but the fact of the transfer is a factor in determining whether the transferor intended to provide a license to use).

7. 17 U.S.C. 102(a).

8. Bleistein v. Donaldson Lithographic Co., 188 U.S. 239, 251 (1903) ("It would be a dangerous undertaking for persons trained only to the law to constitute themselves final judges of the worth of pictorial illustrations, outside of the narrowest and most obvious limits").

9. 17 U.S.C. 101. The definition goes on to include the category "still photographic image produced for exhibition," with a similar limitation on signed copies. It then excludes, by name, the categories of poster, advertisement, promotion, technical drawing, model, periodical, and other items. Courts are supposed to use common sense in determining whether the category of work involved in the case qualifies for copyright protection. See

Pollara *v.* Seymour, 344 F. 3d 265 (2nd Cir. 2003) (Banner promoting nonprofit corporation's lobbying work not "fine art"). Nevertheless, the courts are not supposed to critique the artistic merit of the work in making that classification. See *id.* For a much more detailed discussion of the Visual Artists Rights Act, see Gordon B. Davidson, "The Impact of the Visual Artists Rights Act Of 1990 on the Use and Redevelopment of City or County Property," elsewhere in this section of the present volume.

10. Hart *v.* Sampley, 1992 U.S.Dist. Lexis 21478 (DDC 1992) (sculptor has legitimate interest in copyright in *Three Servicemen* statue on Washington Mall).

11. Hart *v.* Sampley, 1992 U.S. Dist. Lexis 1154 (DDC 1992), 1992 U.S.Dist. Lexis 21478 (DDC 1992).

12. 17 U.S.C. 105. See Schnapper *v.* Foley, 667 F. 2d 102 (CA DC 1981) (film *commissioned* by federal government from an independent contractor is protected by copyright); Hart *v.* Sampley, 1992 U.S. Dist. Lexis 21478 (DDC 1992) (the same is true for sculpture).

13. 17 U.S.C. 511.

14. 17 U.S.C. 201(b).

15. See CCNV *v.* Reid, 490 U.S. 730 (1989) (nonprofit organization, as owner of a publicly exposed sculpture, had only a normal commissioning agreement with the sculptor, and so the owner has no copyright unless the owner can also prove that it was a joint author). Accord Meltzer *v.* Zoller, 520 F. Supp. 847 (DC NJ 1981) and MGB Homes *v.* Ameron Homes, 903 F. 2d 1486 (11th Cir 1990) (architect retains copyright even though owner or contractor retains the right to review).

16. 17 U.S.C. 201 (c).

17. Sweet Music *v.* Melrose Music, 189 F. Supp. 655 (D.C. Cal 1960).

18. Edward B. Marks Music *v.* Jerry Vogel Music, 42 F. Supp. 859 (S.D.N.Y. 1942). See 17 U.S.C. 201 (a) note.

19. Rogers *v.* Koons, 960 F. 2d 301 (2nd Cir. 1992) (sculpture is a derivative work of a photograph).

20. This idea of a reciprocating scale reached what appears to be a pinnacle in Sid and Marty Krofft *v.* McDonald's Corp., 562 F.2d 1157 (9th Cir 1977), where it was suggested that a very high degree of similarity between the original and the alleged infringing work permits the court to dispense altogether with proof of the infringer's access to the original.

21. 17 U.S.C. 107; Brewer *v.* Hustler Magazine, 749 F. 2d 527 (9th Cir. 1984) (magazine's use of funny image that appeared on photographer/plaintiff's business cards not protected by fair use but employed merely to boost sales of the magazine); Ringgold *v.* Black Entertainment Television, 126 F. 3d 70 (2nd Cir. 1997)(TV show's use on set of copyrighted quilt not fair use); Sandoval *v.* New Line Cinema, 147 F. 3d 215 (2nd Cir. 1998)(brief, non-detailed use of copyrighted photos in movie is fair use).

22. 17 U.S.C. 204. See also 101 (definition of "transfer of copyright ownership").

23. Ets-Hokin *v.* Skyy Spirits Inc., 323 F. 3d 763 (9th Cir 2003).

24. Ets-Hoken, *supra.*

25. See text at n. 9 for definition.

26. These are the results of the Visual Artists Rights Act, codified in 17 U.S.C. 101, 106A, and 113. Congress expects courts to use common sense and generally accepted standards in determining whether any particular work qualifies for this treatment.

27. See Carter *v.* Helmsley-Spear, 861 F. Supp. 303 (SD NY 1994) rev'd on other grounds, 71 F. 3d 77 (2nd Cir 1995).

28. 17 U.S.C. 106A (c)(2). This provision says that conservation and presentation methods can be "modifications" but are immune from claims of infringement in the absence of gross negligence or worse.

29. See Martin *v.* City of Indianapolis, 982 F. Supp. 625 (DC Ind. 1997).

30. Leicester *v.* Warner Bros., 232 F.3d 12(2) (9th Cir. 2000).

31. See text associated with n. 39.

32. 17 U.S.C. 204(a).

33. MGB Homes *v.* Ameron Homes, 903 F. 2d 1486 (11th Cir 1990); 18 Am. Jur. 2d Copyright etc. 64.

34. Effects Associates, Inc. *v.* Cohen, 908 F. 2d 555 (9th Cir 1990) (defendant failed to pay agreed price for film footage produced by plaintiff, but the court held that plaintiff did not intend to condition the right to use the film on payment, and so the case was one of contract breach rather than copyright infringement).

35. 17 U.S.C. 106A (b) and (e)(2). For a good description of the automatic, unalterable waiver of copyright that used to vex authors who published works without sufficient notice, see Letter Edged in Black, Inc. *v.* Public Bld. Comm., 320 F. Supp. 1303 (DC Ill, 1970).

36. 17 U.S.C. 106A(e).

37. 17 U.S.C. 113(d)(1).

38. 17 U.S.C. 302(a)-(c).

39. Compare 17 U.S.C. 106(2) with 120(a).

40. 17 U.S.C. 401(c); Letter Edged In Black, Inc. *v.* Public Bld. Comm., 320 F. Supp. 1303 (DC Ill. 1970) ("Chicago Picasso" notice insufficient in part because it was merely in the room where the maquette of the eventual full-size sculpture was displayed to the public).

41. 17 U.S.C. 101. Hart *v.* Sampley, 1992 U.S. Dist. Lexis 21478 (DDC 1992). Note, however, that publication has also been held to have occurred when owners displayed and permitted photographs of a maquette of a sculpture, in part to increase publicity for the owner's fundraising campaign for the money needed to build the sculpture. See Letter Edged in Black, Inc. *v.* Public Bld. Comm., 320 F. Supp. 1303 (DC Ill. 1970).

42. 17 U.S.C. 411.

43. 17 U.S.C. 506.

44. 17 U.S.C. 502.

45. 17 U.S.C. 503.

46. 17 U.S.C. 504.

47. 17 USC 412, 505.

48. 17 U.S.C. 412, 504(c).

49. See 17 USC 504(b), which provides that it is the infringer's burden to prove its costs and other causes of its income when recovery of the infringer's profits is sought.

50. In Mackie *v.* Rieser, 296 F. 3d 909 (9th Cir. 2002), which concerned a print advertisement's unauthorized use of the image of a public sculpture, the court rejected the artist's proof of the amount of profits associated with the advertisement, even though the artist was armed with the advertiser's internal business-planning data showing the number of purchases associated with the ad. What evidently was missing was proof of the portion of sales caused by the specific part of the ad that constituted the infringement. Compare Andreas *v.* Volkswagen of Am., 336 F. 3d 789 (8th Cir. 2003).

Part 7

Resources

Guide to Public Art Resources

Americans for the Arts, Washington Office
1000 Vermont Avenue NW, 6th Floor
Washington, DC 20005
(202) 371–2830; (202) 371–0424 (fax)
www.AmericansForTheArts.org.

The nation's leading nonprofit organization for advancing the arts in America, dedicated to representing and serving local communities and creating opportunities for every American to participate in and appreciate all forms of the arts. Visit the Web site for up-to-the-minute research and information, the Online Field Directory, links to Americans for the Arts programs (including the Public Art Network), the online bookstore, and tips and tools for advocating for support of the arts and arts education.

Center for Art and Culture
819 Seventh Street, NW, Suite 505
Washington, DC 20001–3772
(202) 783–5277
www.culturalpolicy.org

Founded in 1994 in Washington, D.C., to inform and improve policy decisions that affect cultural life. The guiding principles of its mission include freedom of imagination, inquiry, and expression as well as freedom of opportunity for all to participate in a vital and diverse culture. The center commissions research, holds public roundtables, and publishes new voices and perspectives on the arts and culture. Through its Art, Culture & the National Agenda project, the Center has identified seven areas where policies intersect with cultural issues: law, globalization, access, preservation, community, investment, and education. The organization's Web site is a source of research and information on these topics, and the center hosts a public listserv with the latest news on arts and culture.

Cultural Policy and the Arts
www.cpanda.org

An interactive, Web-accessible digital archive of policy-relevant data on culture and the arts. The initiative is designed to help policymakers, journalist, scholars, and others gain easy access both to current research findings and to previously hard-to-find data on the arts, including public opinion on the arts, city-specific data, and recently released statistics. CPANDA comprises four major components: the data archive, quick facts about the arts, research guides, and a free e-mail listserv.

The National Endowment for the Arts
1100 Pennsylvania Avenue, NW
Washington, DC 20506
(202) 682–5400
www.arts.gov

Exists to foster, preserve, and promote excellence in the arts, to bring art to all Americans, and to provide leadership in arts education. Established by Congress in 1965 as an independent agency of the federal government, the NEA is the nation's largest annual funder of the arts, bringing great art to all fifty states, including rural areas, inner cities, and military bases. The NEA offers several grants programs whose guidelines are appropriate for public art projects and initiatives.

New York Foundation for the Arts
155 Avenue of the Americas, 14th floor
New York, NY 10013–1507
(212) 366–6900; (212) 366–1778 (fax)
http://www.nyfa.org

Offers an extensive database called NYFA Source as well as NYFA Current, a free weekly national e-newsletter.

The Urban Institute
2100 M Street, NW
Washington, DC 20037
(202) 833–7200
www.urban.org

A nonprofit, nonpartisan policy research and educational organization established to examine the social, economic, and governance problems facing the nation. The Urban Institute provides information and analysis to public and private decision makers to help them address these challenges and strives to raise citizens' awareness of the issues and trade-offs in policymaking.

PROFESSIONAL AND ADVOCACY ORGANIZATIONS

American Association of Museums
1575 Eye Street, NW, Suite 400
Washington, DC 20005
(202) 289–1818; (202) 289–6578 (fax)
http://www.aam-us.org

Founded in 1906 and dedicated to promoting excellence within the museum community. Through advocacy, professional education, information exchange, accreditation, and guidance on current professional standards of performance, AAM assists museum staff, boards, and volunteers across the country to better serve the public. AAM is the only organization representing the entire scope of museums and the professionals and nonpaid staff who work for and with museums.

American Institute of Architects
1735 New York Avenue, NW
Washington, DC 20006–5292
(800) AIA-3837
www.aia.org

The voice of the architecture profession. The AIA empowers its members and inspires the creation of a better built environment.

American Planning Association
122 S. Michigan Avenue, Suite 1600
Chicago, IL 60603
(312) 431–9100
www.planning.org

A nonprofit public interest and research organization committed to urban, suburban, regional, and rural planning. APA, with its professional institute, the American Institute of Certified Planners, advances the art and science of planning to meet the needs of people and society.

American Society of Landscape Architects
636 Eye Street, NW
Washington, DC 20001–3736
(202) 898–2444
www.asla.org

The national professional association representing landscape architects. Founded in 1899, ASLA promotes the landscape architecture profession and advances its practice through advocacy, education, communication, and fellowship.

International Association of Professional Art Advisors
433 Third Street, Suite 3
Brooklyn, NY 11215
(718) 788–1425
info@iapaa.org

Founded to serve as a forum for developing excellence and innovation in the philosophy and practices appropriate to the concerns of the professional art advisor.

National Assembly of State Arts Agencies
1029 Vermont Avenue, NW, 2nd Floor
Washington, DC 20005
(202) 347–6352; (202) 737–0526 (fax)
http://www.nasaa-arts.org

A membership organization that unites, represents, and serves the nation's state and jurisdictional arts agencies. NASAA's mission is to advance and promote a meaningful role for the arts in the lives of individuals, families, and communities throughout the United States. The organization empowers state arts agencies through strategic assistance that fosters leadership, enhances planning and decision making, and increases resources.

Art in the Public Interest/Community Arts Network
P.O. Box 68
Saxapahaw, NC 27340
(336) 376–8404
www.communityarts.net

Collaborates with Virginia Tech on the Community Arts Network to gather and disseminate information about community arts activities and all that intersects with the public interest. APInews is the network's free monthly newsletter.

Art-Public
www.art-public.com

Contains information on international events, artists, and their works as well as other Web links. Art-Public presents numerous cities and regions active in the field of public art.

Arts Resource Network
Mayor's Office of Arts & Cultural Affairs
700 Fifth Avenue, Suite 1766
Seattle, WA 98104
www.artsresourcenetwork.org

A service provided by the Office of Arts & Cultural Affairs. In addition to listing artist opportunities and resources, the Web site includes case studies and resources for public art, community arts, and professional growth.

Public Art Network
www.AmericansForTheArts.org/PAN

A program of Americans for the Arts designed to provide services to the diverse field of public art and to develop strategies and tools to improve communities through public art. PAN's Web site is a clearinghouse for public art information. Services include a listserv, an annual conference, and development of publications and information directly related to the field of public art.

Public Art on the Net
www.zpub.com/public

Consists of a free listserv and an international public art Web-link list hosted by Sheffield Hallam University.

Art on File
1837 E. Shelby
Seattle, WA 98112
(206) 322–2638
http://www.artonfile.com

Offers slides and digital images of art and architecture for lectures, reports, and presentations. Individual images and sets are available.

Designing Outdoor Sculpture Today for Tomorrow, by Save Outdoor Sculpture!
http://www.heritagepreservation.org/pubs/pubsindex.htm

Sixteen-page booklet, available as a free download, offering strategies to incorporate conservation and maintenance of outdoor artworks into the planning process. The guide identifies elements that, if used in the design process of outdoor sculpture, can lead to less costly and more effective programs of care after installation. Save Outdoor Sculpture! is an initiative of Heritage Preservation and the Smithsonian American Art Museum.

Lessons Learned: A Planning Toolsite
http://arts.endow.gov/resources/Lessons/index.html

A free online resource from the National Endowment for the Arts. This excellent resource is a compendium of planning advice from a variety of professional arts consultants, many of whom were associated with the NEA Advancement Program of 1980–1996. It can be consulted for any planning project.

Light Impressions Archival Supplies
P.O. Box 787
Brea, CA 92822–0787
(800) 828–6216; (800) 828–5539 (fax)
http://www.lightimpressionsdirect.com

Offers a wide variety of archival supplies, including image boxes, slide and negative storage and presentation supplies, and framing systems.

Public Art Bibliography
www.AmericansForTheArts.org/PAN

A resource maintained by Americans for the Arts. This comprehensive public art bibliography is downloadable for free.

Public Art Program Directory
www.AmericansForTheArts.org

This essential resource is the most comprehensive directory of public art programs in the United States. It is a great tool for artists and administrators who want to learn about programs and opportunities nationwide. To order it, visit the bookstore at www.AmericansForTheArts.org or call (800) 321–4510.

University Products—The Archival Company
(800) 336–4847; (800) 532–9281 (fax)
http://www.universityproducts.com

A family of companies supplying archival products internationally.

Willoughby Associates, Limited
266 Linden Street
Winnetka, IL 60093
(847) 332–1200; (847) 332–1272
http://www.willo.com

Offers collection-management software and services.

"Year in Review" Slide Sets, by Americans for the Arts

Developed by the Public Art Network of Americans for the Arts as an extension of the annual "Year in Review" conference session. These slide sets highlight innovative and exciting examples of American public art. Preview images and order a set online at www.AmericansForTheArts.org/PAN, or call (800) 321–4510.

CONSERVATION AND PRESERVATION ORGANIZATIONS AND RESOURCES

American Institute for Conservation and Preservation of Historic and Artistic Works
1717 K Street, Suite 200
Washington DC 20006
(202) 452–9545; (202) 452–9328 (fax)
http://aic.stanford.edu

A national membership organization of conservation professionals. The organization's Web site includes free brochures for the care of a variety of items, including ceramics, glass, paintings, metal objects, books, architecture, and videotape. The site also contains information on choosing a conservation professional.

Association for Preservation Technology International
4513 Lincoln Ave., Suite 213
Lisle, IL 60532–1290
(630) 968–6400; (888) 723–4242 (fax)
http://www.apti.org

A cross-disciplinary organization dedicated to promoting the best technology for conserving historic structures and their settings.

Archetype Publications, London
6 Fitzroy Square
London W1T 5HJ
England
+44–207–380–0800; +44–207–380–0500
http://archetype.co.uk

Publishes and sells books on the conservation of artworks and antiquities.

Campbell Center for Historic Preservation Studies
203 E. Seminary,
Mount Carroll, IL 61053
(815) 244–1173; (815) 244–1619 (fax)
http://www.campbellcenter.org

Offers training courses in the preservation of artifacts. On-site training is available.

Conservation Online
http://palimpsest.stanford.edu

A project of the Preservation Department of Stanford University Libraries. CoOL is a full-text library of conservation information, covering a wide spectrum of topics of interest to those involved with the conservation of archives and of library and museum materials.

Heritage Preservation/Save Outdoor Sculpture!
1625 K Street, NW
Suite 700, Washington, DC 20006–3836
(202) 634–1422 or (888) 388–6789; (202) 634–1435 (fax)
http://www.heritagepreservation.org *and* www.heritagepreservation.org/
PROGRAMS/SOS

A membership organization that works to ensure the preservation of America's collective heritage. Heritage Preservation's programs and publications provide advice and guidance on the proper care and maintenance of monuments, works of art, architecture, books and archives, historic documents and objects, photographs, natural science specimens, and anthropological artifacts. Save Outdoor Sculpture! is an initiative of Heritage Preservation and the Smithsonian American Art Museum to document all monuments and outdoor sculpture in the United States and to help communities and diverse local groups preserve their sculptural legacy for the next century.

National Center for Preservation Technology and Training
Northwestern State University
645 College Avenue
Natchitoches, LA 71457
(318) 356–7444; (318) 356–9119 (fax)
http://www.ncptt.nps.gov

Promotes and enhances the preservation and conservation of prehistoric and historic resources in the United States for present and future generations through the advancement and dissemination of preservation technology and training. NCPTT is an interdisciplinary program of the National Park Service to advance the art, craft, and science of historic preservation in the fields of archeology, historic architecture, historic landscapes, objects and materials conservation, and interpretation. NCPTT serves public and private practitioners through research, education, and information management.

National Preservation Institute
P.O. Box 1702
Alexandria, VA 22313
(703) 765–0100
http://www.npi.org

A nonprofit organization offering specialized information, continuing education, and professional training for the management, development, and preservation of historic, cultural, and environmental resources. NPI provides seminars in historic preservation and cultural resource management, serving a broad spectrum of professionals from the public and private sectors.

PUBLIC ART STUDY PROGRAMS

At California State University, Monterey Bay, the Institute for Visual and Public Arts, in the College of Arts, Humanities, and Social Sciences, focuses on the artist's relationship to audience and community and on the creation of art as a social act. The program is for undergraduate artists and art educators seeking to earn a B.A. degree. Course descriptions, an extensive list of FAQs, and information about the program's educational approach can be viewed at http://csumb.edu/academic/descriptions/vpa.html. For more information, contact Amalia Mesa-Bains, (831)-582–3005, or send e-mail to the program: vpa@csumb.edu.

The University of Southern California, Los Angeles, offers graduate study in public art. This two-year professional degree program, the only one of its kind in the United States, is designed to meet the training needs of those seeking a career in public art. The program is geared to arts administrators, public art consultants, cultural policymakers, grantwriters, nonprofit directors, and public artists. A list of courses offered, a course schedule, a faculty list, and information about the program's educational approach are available at http://www.usc.edu/publicart. For more information, contact Jay Willis, director; Caryl Levy, associate director; or Debby Crooks, program coordinator: (213) 743–4562 or pasprog@usc.edu.

The University of Washington, Seattle, offers a series of courses in public art for artists. A fusion of art, design architecture, and landscape architecture, the interdisciplinary coursework includes theoretical investigation, design studio, and community design/build projects. See http://www.studypublicart.org for a course list, a faculty list, and information about the program's educational approach. For more information, contact Professor John T. Young, (206) 543–0997 or jtyoung@u.washington.edu.

RESOURCES FOR ARTIST OPPORTUNITIES

Public Art Network Listserv
www.AmericansForTheArts.org/PAN

Available to all members of Americans for the Arts. Listserv participants frequently post artist opportunities. In addition, opportunities are posted in the PAN weekly e-newsletter. To join Americans for the Arts and learn more about the listserv, visit the membership section of the Web site or send e-mail to membership@artsusa.org. To submit an opportunity for posting, send e-mail to pan@artsusa.org.

Public Art Review
FORECAST Public Artworks
2324 University Avenue W., Suite 102
Saint Paul, MN 55114
(651) 641–1128; (651) 641–0028 (fax)
www.publicartreview.org
forecast@visi.com

The only national journal dedicated to public art. Publishes quarterly by FORECAST, this publication includes articles, project reviews, book reviews, job listings, and other information of value to the field. Opportunities for artists and some articles are posted online.

Milestones
Phoenix Arts Commission
200 W. Washington, 10th Floor
Phoenix, AZ 85003
(602) 262–4637; (602) 262–6914 (fax)
milestones@phoenix.gov
www.ci.phoenix.az.us/ARTS/artscomm.html

A monthly public art newsletter produced by the Phoenix Arts Commission and featuring listings of artist opportunities, information about projects in Arizona, public art job listings, and general information of interest to the field. Online, hardcopy, and listserv versions are available.

NYFA Source and *NYFA Current*
New York Foundation for the Arts
155 Avenue of the Americas, 14th Floor
New York, NY 10013–1507
(212) 366–6900; (212) 366–1778 (fax)
http://www.nyfa.org

An extensive database (NYFA Source) of nationwide awards, services, and publications for artists of all disciplines, and a free weekly national e-newsletter (NYFA Current). The database offers artists, arts organizations, and the general public information on more than 2,900 arts organizations and 900 publications for individual artists nationwide in addition to information about 2,800 award programs and 2,400 service programs, with more programs added every day.

ArtistsRegister.com
WESTAF
1543 Champa Street, Suite 200
Denver, CO 80202
(303) 629–1166
www.artistsregister.com.

An online slide registry and resource center, a service of WESTAF (Western States Artist Federation). The slide registry is well organized and easy to use. Services include postings of artist opportunities, a monthly listserv bulletin, community discussion bulletin boards, and the sale of artist mailing lists.

ArtsOpportunities.org
www.artsopportunities.org

A free online classifieds bank for the arts, offering information about artist, employment, and internship opportunities. This service uses a search engine to connect arts-related organizations with artists, interns, volunteers, and potential employees. It is an initiative of the Southern Arts Federation and the Center for Arts Management and Technology at Carnegie Mellon University.

Index to Public Art Progams

This index lists public and nonprofit public art programs in the United States and U.S. territories. Please visit each program's Web site, or write for program information. For detailed information about these programs, you can also consult the public art program directory maintained by Americans for the Arts (see the previous section, "Guide to Public Art Resources")

ALASKA

Alaska State Council on the Arts
www.aksca.org
411 W. 4th Ave., Suite 1E
Anchorage, AK 99501

Municipality of Anchorage
Anchorage Museum of History and Art
121 W. 7th Ave.
Anchorage, AK 99501

Homer Council on the Arts
www.homerart.org
355 W. Pioneer Ave., Suite 100
Homer, AK 99603

ARIZONA

Arts and Humanities Commission
www.ci.casa-grande.az.us
1% for the Arts Program
510 E. Florence Blvd.
Casa Grande, AZ 85222

Chandler Art Commission
80 S. San Marcos Place
Chandler, AZ 85225

Public Art Advisory Committee
Community Development Department
City of Flagstaff
211 W. Aspen Ave.
Flagstaff, AZ 86001

Gilbert Public Art Program
www.ci.gilbert.az.us
50 East Civic Center Drive
Gilbert, AZ 85296

Glendale Arts Commission
www.glendaleaz.com/publicart
5959 W. Brown St.
Glendale, AZ 85302

City of Mesa Public Art Program
200 South Center St., Bldg. 3
P.O. Box 1466
Mesa, AZ 85211-1466

Peoria Arts Commission
www.peoriaaz.com
8401 W. Monroe St.
Peoria, AZ 85345

Arizona Commission on the Arts
www.ArizonaArts.org
417 W. Roosevelt
Phoenix, AZ 85003

Central Phoenix/East Valley Light Rail Project
www.valleyconnections.com
Public Art Program
411 N. Central Ave., Suite 200
Phoenix, AZ 85004

Phoenix Office of Arts and Culture
www.phoenix.gov/arts
200 W. Washington St., 10th Floor
Phoenix, AZ 85003-1611

ProgramSky Harbor Arts Program
www.phxskyharbor.com
T3, L3, West
3400 Sky Harbor Blvd.
Phoenix, AZ 85034

Scottsdale Public Art Program
www.scottsdalearts.org/publicart
Scottsdale Museum of Contemporary Art
7380 E. 2nd St.
Scottsdale, AZ 85251

Sedona Division of Arts and Culture
www.sedonaAZ.gov
Art in Public Places Program
City Manager's Office
102 Roadrunner Dr.
Sedona, AZ 86336

Sierra Vista Parks & Leisure
www.ci.sierra-vista.az.us
Art in Public Places Program
1011 N. Coronado Dr.
Sierra Vista, AZ 85635

Arizona State University,
 Office of Public Art
www.herbergercollege.asu.edu/public
 _art/index.html
Herberger College of Fine Arts
P.O. Box 872102
Arizona State University
Tempe, AZ 85287-2102

City of Tempe Public Art/Art in Private
 Development
www.tempe.gov/arts
City of Tempe Cultural Services
3340 S. Rural Rd.
Tempe, AZ 85282

Tucson Airport Authority
www.tucsonairport.org
7005 S. Plumer
Tucson, AZ 85706

Tucson /Pima Arts Council
www.tucsonpimaartscouncil.org
10 E. Broadway, Ste. 106
Tucson, AZ 85701-1212

University of Arizona Public Art Advisory
Committee
Percent for Art Program
P.O. Box 21002
Tucson, AZ 85721-10002

City of Yuma
Arts and Culture Division
Yuma Art Center
254 South Main Street
Yuma, AZ 85366-3012

ARKANSAS

Arkansas Arts Council
www.arkansasarts.com
323 Center St.
1500 Tower Building
Little Rock, AR 72201

City of Little Rock
www.accesslittlerock.org
Office of Cultural Affairs
City Hall, Room 203
500 W. Markham St.
Little Rock, AR 72201

Modoc County Mural Project
Modoc County Arts Council, Inc.
212 W. Third St.
Alturas, CA 96101

City of Antioch
www.acfantioch.com
Public Art Program,
Arts & Cultural Foundation of Antioch
P.O. Box 613
Antioch, CA 94509

City of Berkeley
www.ci.berkeley.ca.us
Civic Arts Program Office
2118 Milvia St., Suite 200
Berkeley, CA 94704

City of Beverly Hills
www.ci.beverly-hills.ca.us
444 N. Rexford Dr.
Beverly Hills, CA 90210

City of Brea
www.cityofbrea.net
One Civic Center Circle
Brea, CA 92821

City of Burbank
www.ci.burbank.ca.us
Art in Public Places Program
Parks, Recreation, and Community Services
 Department
275 E. Olive Ave.
Burbank, CA 91502

Carlsbad Arts Office
www.ci.carlsbad.ca.us
1200 Carlsbad Village Dr.
Carlsbad, CA 92008

City of Cathedral City
www.cathedralcity.gov
68700 Ave. Lalo Guerrero
Cathedral City, CA 92234

City of Chico
www.ci.chico.ca.us
Arts Commission
P.O. Box 3420
Chico, CA 95927-3420

City of Chula Vista
Cultural Arts Office
365 F St.
Chula Vista, CA 91910

City of Claremont
www.ci.claremont.ca.us
207 Harvard Ave.
P.O. Box 880
Claremont, CA 91711

Del Norte Association for Cultural
 Awareness
P.O. Box 1480
Crescent City, CA 95531

Art in Public Places
www.culvercity.org
Cultural Affairs
9770 Culver Blvd.
Culver City, CA 902320

City of Cupertino
www.cupertino.org/city_government/
 commissions/fine_arts_commission/
 index.asp
Fine Arts Commission
10300 Torre Ave.
Cupertino, CA 95014-3255

City of Davis
www.cityofdavis.org
Planning and Building Community
 Development Department
23 Russell Blvd.
Davis, CA 95616

Sierra County Arts Council
www.sierracounty.org
Art in Public Places Program
P.O. Box 546
Downieville, CA 95936

Art In Public Places
www.ci.emeryville.ca.us/guide/
 arts_culture.html
City of Emeryville
1333 Park Ave.
Emeryville, CA 94608

City of Escondido
201 N. Broadway
Escondido, CA 92025

Humboldt Arts Council
www.humboldtarts.org
636 F St.
Eureka, CA 95501

City of Fairfield Arts & Community Events
www.ci.fairfiled.ca.us
City of Fairfield
1000 Webster St.
Fairfield, CA 94533

City of Fremont
www.fremont.gov
Art in Public Places
Recreation Services
3300 Capitol Ave., Bldg. B
Fremont, CA 94538

Fresno Arts Council
www.fresnoarts.org
1245 Van Ness
Fresno, CA 93721

City of Glendale Arts and Culture
 Commission
www.ci.glendale.ca.us
Public Art Program
613 E. Broadway, Room 120
Glendale, CA 91206

Nevada County Arts Council
Public Art Program
P.O. Box 307
Grass Valley, CA 95945

City of Laguna Beach
www.lagunabeachcity.org
505 Forest Ave.
Laguna Beach, CA 92651

Community Art Project
P.O. Box 4066
Laguna Beach, CA 92651

University of California at San Diego
www.stuartcollection.ucsd.edu
The Stuart Collection
9500 Gilman Dr.
UCSD Department 0010
La Jolla, CA 92093-0010

Lake County Arts Council
www.lakecountyartscouncil.com
325 Main St.
Lakeport, CA 95453

Lodi Arts Commission
www.lodiarts.org
125 S. Hutchins St.
Lodi, CA 95240

Public Corporation for the Arts
www.artspca.org
Public Art Program
110 West Ocean Blvd, Ste. 204
Long Beach, CA 90802

City of Los Angeles
www.culturela.org
Cultural Affairs Division
433 S. Spring St., 10th Floor
Los Angeles, CA 90013

The Community Redevelopment Agency of
 the City of Los Angeles
www.crala.org (See "art program")
354 Spring St., Suite 700
Los Angeles, CA 90013-1258

LA Metro Art
www.mta.net
One Gateway Plaza, 19th Floor
Los Angeles, CA 900012-2932

Madera County Arts Council
www.maderaarts.org
315 W. Olive Ave.
Madera, CA 93637

City of Manhattan Beach
www.ci.manhattan-beach.ca.us
 or
www.citymb.info
1400 Highland Ave.
Manhattan Beach, CA 90266

Yuba–Sutter Regional Arts Council
www.yubasutterarts.org
624 E St.
P.O. Box 468
Marysville, CA 95901

City of Moorpark
www.ci.moorpark.ca.us
Art in Public Places Program
Community Services Department
799 Moorpark Ave.
Moorpark, CA 93021

City of Mountain View
www.ci.mtnview.ca.us
500 Castro St.
Mountain View, CA 94041

Alameda County Art Commission
www.acgov.org/arts
Public Art Program
P.O. Box 29004
Oakland, CA 94604-9004

Art at BART Program
Bay Area Rapid Transit District
www.bart.gov
Mail Stop LKS-16
800 Madison St.
P.O. Box 12688
Oakland, CA 94604-2688

City of Oakland Public Art Program
www.oaklandculturalarts.org
One Frank H. Ogawa Plaza, 9th Floor
Oakland, CA 94612

City of Oxnard
www.ci.oxnard.ca.us
Planning Department
305 W. 3rd St., 2nd Floor
Oxnard, CA 93030

City of Palm Desert
www.palmdesertart.org
73-503 Fred Waring Dr.
Palm Desert, CA 92260

City of Palm Springs
www.ci.palm-springs.ca.us
P.O. Box 2743
Palm Springs, CA 92263-2743

City of Palo Alto
www.ci.palo-alto.ca.us/artsculture/artinpub-
lic.htm
Public Art Commission
1313 Newell Rd.
Palo Alto, CA 94303

City of Paramount
www.paramountcity.com/docs/art.php
Art in Public Places Program
Administrative Services Development
16400 Colorado Ave.
Paramount, CA 90723

City of Pasadena
www.ci.pasadena.ca.us/plannings/arts/
 homecult.asp
Cultural Affairs Division
175 N. Garfield Ave.
Pasadena, CA 91109

City of Pico Rivera
www.ci.pico-rivera.ca.us
Department of Recreation and Community
 Services
P.O. Box 1016
Pico Rivera, CA 90660-1016

City of Pleasanton
www.ci.pleasanton.ca.us
Public Art Program
200 Old Bernal Ave.
Pleasanton, CA 94566

City of Richmond
www.ci.richmond.ca.us/~arts/
Arts and Culture Commission & Arts and
 Culture Division
3230 Macdonald Ave.
Richmond, CA 94804

California Arts Council
www.cac.ca.gov
1300 I St.
Suite 930
Sacramento, CA 95814

Sacramento Metro Arts Commission
www.sacculture.com
Art in Public Places
2030 Del Paso Blvd.
Sacramento, CA 95815

Calaveras County Arts Council
www.calaverasarts.org
Art in Public Places Program
P.O. Box 250
San Andreas, CA 95249

City of San Diego
www.sandiego.gov/arts-culture/
 publicart.shtml
Commission for Arts and Culture
1010 Second Ave.,Suite 555
San Diego, CA 92101-4904

Port of San Diego
www.portofsandiego.org
Public Art Program
Tidelands Collection
P.O. Box 120488
San Diego, CA 92112-0488

San Francisco Arts Commission
www.sfgov.org/sfac/pubart
25 Van Ness Ave., Suite 240
San Francisco, CA 94102

San Francisco Redevelopment Agency
Percent for Art Program
770 Golden Gate Ave.
San Francisco, CA 94102

City of San Jose
www.sanjoseculture.org
Office of Cultural Affairs
365 Market St., Suite 450
San Jose, CA 95113

City of San Luis Obispo
www.slocity.org
990 Palm St.
San Luis Obispo, CA 93401

San Luis Obispo County Arts Council
www.sloartscouncil.org
Art in Public Places Committee
P.O. Box 1710
San Luis Obispo, CA 93406

Santa Barbara County Arts Commission
www.sbartscommission.org
P.O. Box 2369
Santa Barbara, CA 93120

City of Santa Clarita Public Art
www.santa-clarita.com/arts
23920 Valencia Blvd., Suite 120
Santa Clarita, CA 91355

Santa Cruz City Public Art Committee
www.ci.santa-cruz.ca.us/pr/pac/pac.html
323 Church St.
Santa Cruz, CA 95060

Santa Cruz County Arts Commission
www.scparks.com
Percent for Art Program
Parks Department
979 17th Ave.
Santa Cruz, CA 95062

City of Santa Monica
www.arts.santa-monica.org
Percent for Art Program
Cultural Affairs Division
1685 Main St., Room 106
Santa Monica, CA 90401

Mural Conservancy of Los Angeles
www.lamurals.org
P.O. Box 50440
Sherman Oaks, CA 91413

City of Stockton
www.stocktongov.com
6 E. Lindsay St.
Stockton, CA 95202

City of Sunnyvale
http://sunnyvale.ca.gov/Departments/Parks
 and+Recreation/Recreation
 Department of Parks and Recreation
P.O. Box 3707
Sunnyvale, CA 94088-3707

City of Thousand Oaks
www.toaks.org
Art Commission
2100 Thousand Oaks Blvd.
Thousand Oaks, CA 91362

Social and Public Art Resource Center
www.sparcmurals.org
685 Venice Blvd.
Venice, CA 90291

City of Ventura
www.ci.ventura.ca.us
Office of Cultural Affairs
P.O. Box 99
Ventura, CA 93002-0099

City of Walnut Creek Public Art Program
www.ci-walnut-creek.ca.us

Dean Lesher Regional Center for the Arts
1601 Civic Dr.
Walnut Creek, CA 94596

City of West Hollywood
www.weho.org
8300 Santa Monica Blvd.
West Hollywood, CA 90069-4314

Yolo County Arts Council
www.yoloarts.org
P.O. Box 8250
120 West Main Street, Suite E
Woodland, CA 95695

COLORADO

City of Aurora
www.auroragov.org
Art in Public Places
14949 E. Alameda Dr.
Aurora, CO 80012

City of Broomfield
www.ci.broomfield.co.us/cultural
Public Art Program
1 DesCombes Dr.
Broomfield, CO 80020

Boulder Arts Commission
www.artresource.org
P.O. Drawer H
Boulder, CO 80306

Public Arts Committee
www.deltaco.org/publicartcommittee.
 htm
City of Delta
360 Main St.
Delta, CO 81416

City of Denver
www.denvergov.org/public_art_program
Office of Art, Culture and Film
1380 Lawrence St., Suite 790
Denver, CO 80204

Colorado Council on the Arts
www.coloradopublicart.org
www.coloarts.state.co.us
Art in Public Places Program
1380 Lawrence St., Suite 1200
Denver, CO 80204

Denver International Airport Art Program
www.flydenver.com/art
8500 Pena Blvd., Room 9870 AOB
Denver, CO 80249-6340

Denver Urban Renewal Authority
1555 California St., Suite 200
Denver, CO 80202

Fort Collins Art In Public Places Program
www.fcgov.com/artspublic
City of Fort Collins
Lincoln Center
417 W. Magnolia St.
Fort Collins, CO 80521

Summit County Arts Exhibit Committee
www.co.summit.co.us
P.O. Box 1855
Frisco, CO 80443

Grand Junction Commission on Arts and
 Culture
www.gjarts.org or www.gjcity.org
1340 Gunnison
Grand Junction, CO 81501

Greeley Public Art Program
www.ci.greeley.co.us
City of Greeley
651 10th Ave.
Greeley, CO 80631

Fine Arts Committee
www.littletongov.org
c/o Littleton Historical Museum
6028 S. Gallup St.
Littleton, CO 80120

Longmont Art in Public Places Program
www.ci.longmont.co.us
375 Kimbark St.
Longmont, CO 80501

City of Loveland
www.ci.loveland.co.us
Art in Public Places Program
Loveland Museum and Gallery
Fifth and Lincoln
Loveland, CO 80537

Town of Vail
www.vailgov.com
Art in Public Places Program
1309 Elkhorn Dr.
Vail, CO 81657

CONNECTICUT

Connecticut Commission on Culture and
 Tourism
www.ctarts.org/artpublic.htm
One Financial Plazaa
755 Main St.
Hartford, CT 06103

Greater Hartford Arts Council
www.connectthedots.org
Public Art Program
P.O. Box 231436
Hartford, CT 06123-1436

City of Middletown
Commission on the Arts
P.O. Box 1300
Middletown, CT 06457

One Percent for Art Program
Department of Cultural Affairs
City of New Haven City Hall
165 Church St.
New Haven, CT 06510

DELAWARE

Wilmington Arts Commission
www.ci.wilmington.de.us
City/County Building
800 N. French St., 9th Floor
Wilmington, DE 19801

DISTRICT OF COLUMBIA

Art in Architecture Program
General Services Administration
1800 F St., NW, Room 3341
Washington, DC 20405

Art in Embassies Program
http://aiep.state.gov
U.S. Department of State
OBO/OM/ART
Washington, DC 20522-0611

Art In Transit Program
Washington Metropolitan Transit Authority
600 Fifth St.
Washington, DC 20001

D.C. Creates Public Art Program
www.dcarts.dc.gov
D.C. Commission on the Arts and
Humanities
410 8th St., NW, 5th Floor
Washington, DC 20004

MetroArts
www.wmata.com/about/intro/index.html
Washington Metropolitan Transit Authority
600 5th St.
Washington, DC 20001

Save Outdoor Sculpture!
www.heritagepreservation.org
1625 K St., NW, Suite 700
Washington, DC 20006

FLORIDA

Florida Atlantic University
Office of the University Architect
FAU Administration Building, Room 392
777 Glades Rd.
Boca Raton, FL 33431

Pinellas County Arts Council
www.pinellasarts.org
14700 Terminal Blvd., Suite 229
Clearwater, FL 33762-2941

Volusia County Manager's Office
www.celebratingculture.com/aipp.htm
Leisure Sevices Division
202 N. Florida Ave.
DeLand, FL 32720

Art-in-the-Downtown
www.ddaftlaud.com
Downtown Development Authority
101 NE Third Ave., Suite 350
Fort Lauderdale, FL 33301

Broward County Cultural Affairs Division
www.browardarts.net
Public Art and Design Program
100 S. Andrews Ave.
Fort Lauderdale, FL 33301

Florida Gulf Coast University
www.dos.state.fl.us/dca/asbpub.html
College of Arts and Sciences
10501 FGCU Blvd. S.
Fort Myers, FL 33965-6565

Lee County Alliance of the Arts
www.artinlee.org
10091 McGregor Blvd.
Fort Myers, FL 33919

Gainesville/Alachua County Art in Public
 Places
www.gvlculturalaffairs.org
Department of Cultural Affairs
Station 30
P.O. Box 490
Gainesville, FL 32602

University Gallery
Art in State Buildings Program
University of Florida
P.O. Box 115803
Gainesville, FL 32611-5803

Jacksonville Art in Public Places Program
www.culturalcouncil.org
300 W. Water St., Suite 201
Jacksonville, FL 32202

City of Key West
www.keywestcity.com
Art In Public Places Program
P.O. Box 1409
Key West, FL 33041

Florida Keys Council of the Arts
www.keysarts.org
1100 Simonton St.
Key West, FL 33040

Fine Arts and Cultural Affairs
www.miami-airport.com
mia Gallery
Miami International Airport
P.O. Box 592075
Miami, FL 38159

Florida International University
www.fiu.edu/~visart
Public Art Program
Art and Art History Department
University Park DM 382
Miami, FL 33199

Miami Beach Art in Public Places
www.miamibeachfl.gov/newcity/depts/
 acre/index.asp
Tourism and Cultural Development
555 17th Street
Miami Beach, FL 33139

Miami–Dade Art in Public Places
www.co.miami-dade.fl.us/publicart
111 NW First St., Suite 610
Miami, FL 33128-1982

City of Orlando Public Art Program
www.cityoforlando.net/arts/index.htm
Department of Arts and Entertainment
400 S. Orange Ave.
Orlando, FL 32802-4990

University of Central Florida
www.fp.ucf.edu
Art in State Buildings Program
Art Department
P.O. Box 161342
VAB 105-C
Orlando, FL 32816-0342

City of Ormond Beach
www.ormondbeach.org
Sculpture Garden Committee
Department of Leisure Services
The Casements
25 Riverside Dr.
Ormond Beach, FL 32176

GardensArt
www.pbgfl.com
Parks and Recreation Department
City of Palm Beach Gardens
4404 Burns Road
Palm Beach Gardens, FL 33410

Arts Council of Northwest Florida
www.artsnwfl.org
17 S. Palafax St., Suite 335
Pensacola, FL 32502

University of West Florida
Public Art Program
University Relations
11000 University Parkway
Pensacola, FL 32514-5750

City of Sarasota
www.sarasotagov.com/Planning/
 public_art_program/main.html
Public Art Program
P.O. Box 1058
Sarasota, FL 34230

Sarasota County
www.scgov.net
Arts in Public Places
1001 Sarasota Center Blvd.
Sarasota, FL 34240

City of St. Petersburg
www.stpete.org
P.O. Box 2842
St. Petersburg, FL 33731

Art in Public Places
www.martinarts.org
c/o Arts Council of Stuart and Martin
 County
80 East Ocean Boulevard
Stuart, FL 34994

Art in State Buildings Program
www.Florida-Arts.org
Florida Department of State
500 South Bronough St., Room 405
Tallahassee, FL 32399-0250

Florida A & M University
Visual Arts Department
Foster Tanner Fine Arts Building,
 Room 100A
Tallahassee, FL 32307

Florida State University
www.fsu.edu
University Relations
216 Westcott Building
Tallahassee, FL 32306-1350

City of Tampa Public Art Program
www.tampagov.net/publicart
306 E. Jackson St., 74N
Tampa, FL 33602

Hillsborough County Public Art Program
www.hillsboroughcounty.org
c/o Real Estate Development, Architecture
 Services
601 East Kennedy Blvd.
Tampa, FL 33602

University of South Florida
www.arts.usf.edu/museum/PublicArt/
 PubArt.html
Contemporary Art Museum
4204 E. Fowler Ave.
CAM 101
Tampa, FL 33620

Public Art Program
www.artsbrevard.org
2725 Judge Jamieson Way, B-104
Viera, FL 32940

City of West Palm Beach
www.cityofwpb.com
Art in Public Places
P.O. Box 3366
West Palm Beach, FL 33402

Palm Beach County Cultural Council
www.pbccc.org
Art in Public Places Program
1555 Palm Beach Lakes Blvd., #300
West Palm Beach, FL 33401

GEORGIA

Athens–Clarke County Public Art Collection
ACC Leisure Services Department
Lyndon House Arts Center
293 Hoyt St.
Athens, GA 30601

City of Atlanta
www.bcaatlanta.com
Bureau of Cultural Affairs
City Hall East, 5th Floor
675 Ponce de Leon Ave. NE
Atlanta, GA 30308

City of Atlanta Department of Aviation Art
 Program
www.atlanta-airport.com
P.O. Box 20509
Atlanta, GA 30320

Fulton County Arts Council
www.fultonarts.org
Public Art Program
141 Pryor St. SW, Suite 2030
Atlanta, GA 30303

Metropolitan Atlanta Rapid Transportation
 Authority
www.itsmarta.com
Percent for Art Program
2424 Piedmont Rd. NE, 4th Floor
Atlanta, GA 30324-3330

Metropolitan Public Art Coalition, Inc.
www.mpacAtlanta.org
c/o 675 Drewry Street, Studio 9
Atlanta, GA 30306

HAWAII

City & County of Honolulu
www.honolulu.gov/MOCA
Mayor's Office of Culture and the Arts
530 S. King St., Room 404
Honolulu, HI 96813

Hawaii State Foundation on Culture and
the Arts
www.state.hi.us/sfca
250 S. Hotel St., 2nd Floor
Honolulu, HI 96813

IDAHO

Boise City Arts Commission
www.cityofboise.org
P.O. Box 500
Boise, ID 83701-0500

Idaho Commission on the Arts
www2.state.id.us/arts
2410 Old Penitentiary Rd.
Boise, ID 83712

ILLINOIS

Aurora Public Art Commission
20 E. Downer Place
Aurora, IL 60507

Chicago Public Art Group
www.cpag.net
1259 S. Wabash Ave.
Chicago, IL 60605

City of Chicago
www.cityofchicago.org
Department of Cultural Affairs
Public Art Program
78 E. Washington St.
Chicago, IL 60602

Evanston Arts Council
www.cityofevanston.org
927 Noyes St.
Evanston, IL 60201

Quad City Arts
www.quadcityarts.com
Public Art Program
1715 Second Ave.
Rock Island, IL 61201

State of Illinois
www.cdb.state.il.us
Illinois Art-In-Architecture Program
Capital Development Board
401 S. Spring St., 3rd Floor
Springfield, IL 62706

INDIANA

City of Bloomington Percent for the Arts
www.city.bloomington.in.us/engineering/
arts_commission/index.html
Bloomington Community Arts Commission
401 N. Morton St.
P.O. Box 100
Bloomington, IN 47402

Indianapolis Public Art Program
www.indyarts.org
Arts Council of Indianapolis
20 N. Meridian St., Suite 500
Indianapolis, IN 46204

IOWA

City of Ames Public Art Commission
www.ci.ames.ia.us
City of Ames
515 Clark Ave.
P.O. Box 811
Ames, IA 50010

Iowa State University
www.museums.iastate.edu
Art on Campus Committee
Brunnier Art Museum
290 Scheman Building
Ames, IA 50011

Cedar Falls Public Art Program
www.hearstartscenter.com/publicart
Hearst Center for the Arts
304 W. Seerley Blvd.
Cedar Falls, IA 50613

University of Northern Iowa
www.uni.edu/chfa/dep_art.html
Art & Architecture Committee
Department of Art
Cedar Falls, IA 50614-0362

City of Cedar Rapids Visual Arts
Commission
www.cedar-rapids.org/development/
 index.asp
50 Second Ave. Bridge, 6th Floor
Cedar Rapids, IA 52401

Greater Des Moines Public Art Foundation
C/o Greater Des Moines Community
 Foundation
1915 Grand Avenue, PO Box 7271
Des Moines, IA 50309

Iowa Arts Council
www.iowaartscouncil.org
600 E. Locust
Des Moines, IA 50319-0290

Art in State Buildings Committee
University of Iowa Museum of Art
150 N. Riverside Dr.
Iowa City, IA 52242

Iowa City Public Art Advisory Committee
www.icgov.org
City of Iowa City
Planning and Community Development
 Department
410 E Washington St.
Iowa City, IA 52240

KANSAS

Lawrence Arts Commission
www.ci.lawrenceks.org/boards.shtml#arts
Percent for Art Program
City Hall
P.O. Box 708
Lawrence, KS 66044

Salina Arts and Humanities Commission
www.salinaarts.com
Community Art & Design Program
Box 2181
Salina, KS 67402-2181

CityArts
www.cityartswichita.com
City of Wichita
344 North Mead
Wichita, KS 67202

LOUISIANA

Art in State Buildings
www.crt.state.la.us/arts
Louisiana Division of the Arts
P.O. Box 44247
Baton Rouge, LA 70804

City of New Orleans Percent for Art
 Program
www.artscouncilofneworleans.org
Arts Council of New Orleans
Public Art Department
725 Howard Avenue
New Orleans, LA 70130

Shreveport Regional Arts Council
www.shrevearts.org
800 Snow St.
Shreveport, LA 71101

MAINE

Maine Arts Commission
www.mainearts.com
193 State Street
State House Station, Suite 25
Augusta, ME 04333-0025

The Portland Public Art Program
www.ci.portland.me.us/planning/
 pubart.htm
Portland Planning Office
389 Congress St.
Portland, ME 04101

MARYLAND

Baltimore Office of Promotion and the Arts
www.promotionandarts.com
7 E. Redwood St., Suite 500
Baltimore, MD 21202

Public Arts Trust
www.ahcmc.org
Arts and Humanities Council of
 Montgomery County
4405 East West Highway, Suite 401
Bethesda, MD 20814

Prince George's County Art in Public Places
 Program
www.goprincegeorgescounty.com
Revenue Authority of Prince George's
County
1300 Mercantile Lane, Suite 108
Largo, MD 20774

City of Rockville
www.rockvillemd.gov
Art in Public Places
Glenview Mansion
603 Edmonston Dr.
Rockville, MD 20851

MASSACHUSETTS

Boston Art Commission
www.cityofboston.com/arts
Boston City Hall, Room 716
Boston, MA 02201

ICA/Vita Brevis
www.icaboston.org/vita
The Institute of Contemporary Art
955 Boylston St.
Boston, MA 02115

New England Foundation for the Arts
www.nefa.org
Visible Republic Fund for the Arts
Art & Community Landscapes
145 Tremont Street, 7th Floor
Boston, MA 02111

UrbanArts Institute
www.urbanartsinstitute.org
Massachusetts College of Art
621 Huntington Ave.
Boston, MA 02115-5801

Cambridge Arts Council Public Art Program
www.cambridgeartscouncil.org
344 Broadway
Cambridge, MA 02139

MINNESOTA

Duluth Public Arts Commission
www.ci.duluth.mn.us/city/artscommission
12 E. 4th St.
Duluth, MN 55805

Art in Public Places
www.ci.minneapolis.mn.us
Minneapolis Planning
350 S. 5th St., Room 210
Minneapolis, MN 55415-1385

Hiawatha Public Art and Design Program
Metro Transit
www.metrotransit.org
560 Sixth Ave. N.
Minneapolis, MN 55411

Public Art on Campus
www.weisman.umn.edu
University of Minnesota
Weisman Art Museum
333 E. River Rd.
Minneapolis, MN 55455

FORECAST Public Artworks
www.forecastart.org and www.publicartreview.org
2324 University Ave. W., Suite 102
Saint Paul, MN 55114

Minnesota Percent for Art in Public Places
www.arts.state.mn.us/other/percent.htm
Minnesota State Arts Board
Park Square Court
400 Sibley St., Suite 200
Saint Paul, MN 55101-1928

Public Art Saint Paul
www.publicartstpaul.org
253 East 4th Street, Suite 201
Saint Paul, MN 55101

City of Blue Springs Public Art Commission
www.bluespringsgov.com
903 W. Main St.
Blue Springs, MO 64015

City of Columbia
www.GoColumbiaMo.com
Office of Cultural Affairs
P.O. Box 6015
Columbia, MO 65205

Kansas City Municipal Art Commission
www.kcmo.org/pubworks.nsf/web/
 art?opendocument
City Hall, 17th Floor
414 E. 12th St.
Kansas City, MO 64106-2743

Arts in Transit
www.artsintransit.org
Metro
707 N. First St.
St. Louis, MO 63102

Regional Arts Commission
www.art-stl.com
Public Art Program
6128 Delmar Boulevard
Saint Louis, MO 63112

MONTANA

Montana Arts Council
www.art.state.mt.us
Percent-for-Art Program
316 N. Park Ave., Suite 252
P.O. Box 202201
Helena, MT 59620-2201

Missoula Public Art Committee
Public Art Program
City Hall
435 Ryman
Missoula, MT 59802

NEBRASKA

Lincoln Arts Council
www.artscene.org
920 O St.
Lincoln, NE 68508

Nebraska Arts Council
www.nebraskaartscouncil.org
3838 Davenport
Omaha, NE 68131-2329

NEVADA

Nevada Arts Council
www.nevadaculture.org
Art in Public Places Program
716 N. Carson St., #A
Carson City, NV 89701-4079

City of Las Vegas Arts Commission
www.lasvegasnevada.gov

Public Art Program
749 Veterans Memorial Dr.
Las Vegas, NV 89101

Clark County Public Art Program
2601 East Sunset Road
Las Vegas, NV 89120

NEW HAMPSHIRE

New Hampshire Percent for Art Program
www.nh.gov/nharts
2 Beacon St.
Concord, NH 03301

NEW JERSEY

Office of Cultural and Heritage Affairs
www.aclink.org/culturalaffairs
Atlantic County Percent for Art Program
40 Farragut Ave.
Mays Landing, NJ 8330

New Jersey State Council on the Arts
www.njartscouncil.org
Arts Inclusion Program
P.O. Box 306
225 West State Street
Trenton, NJ 08625-0306

NEW MEXICO

Bernalillo County
www.bernco.gov
1% for Public Art Program
One Civic Plaza NW, 10th Floor
Albuquerque, NM 87102

Art in Public Places Board
http://hermay.org/app.html
Art Public Promotion
4667 Ridgeway
Los Alamos, NM 87544

City of Albuquerque
www.cabq.gov/airport/arts.html
Aviation Department
Albuquerque International Sunport
P.O. Box 9948
Albuquerque, NM 87119

New Mexico Art in Public Places
www.nmarts.org
228 E. Palace Ave.
P.O. Box 1450
Santa Fe, NM 87504-1450

City of Albuquerque
www.cabq.gov/publicart
Public Art Program
DFAS/CIP
P.O. Box 1293
Albuquerque, NM 87103

Santa Fe Arts Commission
P.O. Box 909
Santa Fe, NM 87504-0909

Dormitory Authority of the State of
 New York
DASNY/CUNY Percent for Art Program
515 Broadway
Albany, NY 12207

Buffalo Arts Commission
www.ci.buffalo.ny.us
Art in Public Places Program
222 City Hall
Buffalo, NY 14202

Town of Huntington Public Art Initiative
http://town.huntington.ny.us
Division of Cultural Affairs
Town of Huntington
100 Main St.
Huntington, NY 11743-6991

Public Art for Public Schools
School Construction Authority
30-30 Thomson Ave.
Long Island City, NY 11101

CITYarts, Inc.
www.cityarts.org
525 Broadway, Suite 700
New York, NY 10012

Creative Time, Inc.
www.creativetime.org
307 Seventh Ave., Suite 1904
New York, NY 10001

Minetta Brook
www.minettabrook.org
105 Hudson St., Room 411
New York, NY 10013

MTA Arts for Transit
www.mta.info
347 Madison Ave.
New York, NY 10017

NYC Health and Hospital Corporation's Art
 Collection
NYC Health and Hospital Corporation
346 Broadway, Room 506
New York, NY 10013

New York City Percent for Art Program
www.nyc.gov/culture
Department of Cultural Affairs
330 W. 42nd St., 14th Floor
New York, NY 10036

Port Authority of New York and New Jersey
Art Program
115 Broadway, 7th Floor
New York, NY 10006

Public Art Fund, Inc.
www.publicartfund.org
One E. 53rd St.
New York, NY 10022

Art in Public Places of Rockland County,
 New York
www.rocklandartcenter.org
Rockland Center for the Arts
27 S. Greenbush Rd.
West Nyack, NY 10994

North Carolina Zoological Park
www.nczoo.org
4401 Zoo Parkway
Asheboro, NC 27205

Public Art Board
www.ci.asheville.nc.us
Department of Parks and Recreation
P.O. Box 7148
Asheville, NC 28802-7148

Cary Visual Art, Inc.
www.caryvisualart.org
P.O. Box 4322
Cary, NC 27519-4322

Town of Cary Public Art Program
www.townofcary.org
Department of Parks, Recreation and
 Cultural Resources
111 James Jackson Avenue, Suite 201
Cary, NC 27513

Chapel Hill Public Arts Commission
www.chapelhillarts.org
306 N. Columbia St.
Chapel Hill, NC 27516

Arts and Science Council of
 Charlotte–Mecklenburg
www.artsandscience.org
Public Art Program
227 W. Trade St., Suite 250
Charlotte, NC 28202

Charlotte Area Transit System
www.ridetransit.org
Art-in-Transit
600 E. Fourth St.
Charlotte, NC 28205

Greensboro Library Arts Commission
www.greensborolibrary.org
219 N. Church St.
Greensboro, NC 27401

City of Hickory Public Art Program
www.ci.hickory.nc.us
P.O. Box 398
Hickory, NC 28603

City of Raleigh Art Commission
http://www.raleigh-nc.org/arts/index.htm
P.O. Box 590
Raleigh, NC 27602

Contemporary Art Museum
www.camnc.org
P.O. Box 66
Raleigh, NC 27602-0066

North Carolina Arts Council
www.ncarts.org/services_programs.cfm
Department of Cultural Resources
MSC 4632
Raleigh, NC 27699-4632

Raleigh–Durham International Airport
www.rdu.com
P.O. Box 8001
RDU Airport, NC 27623-0001

OHIO

Art in Transit
www.sorta.com
Metro
1014 Vine St., Suite 2000
Cincinnati, OH 45202

Cleveland Public Art
www.clevelandpublicart.org
1951 W. 26th St., Suite 101
Cleveland, OH 44113

Ohio Arts Council
www.oac.state.oh.us
Percent for Arts Program
727 E. Main St.
Columbus, OH 43205

City of Dayton
www.daytongov.org
Public Art Commission
P.O. Box 22
Dayton, OH 45401

Dublin Arts Council
www.dublinarts.org
7125 Riverside Dr.
Dublin, OH 43016

Fitton Center for Creative Arts
www.fittoncenter.org
101 S. Monument Ave.
Hamilton, OH 45011

Art Commission of Greater Toledo
www.acgt.org
1838 Parkwood Ave., Suite 120
Toledo, OH 43624

OKLAHOMA

Oklahoma City Arts Commission
Oklahoma City Parks and Recreation
 Department
420 Main St., Suite 210
Oklahoma City, OK 73102

Arts Commission for the City of Tulsa
2210 S. Main
Tulsa, OK 74114-1190

State of Oklahoma Art in Public Places Act
www.state.ok.us/~arts/
Oklahoma Arts Council
P.O. Box 52001-2001
Oklahoma City, OK 73152-2001

Arts Commission for the City of Tulsa
2210 South Main
Tulsa, OK 74114-1190

OREGON

Beaverton Arts Commission
www.ci.beaverton.or.us/departments/arts
Percent for Art Program
P.O. Box 4755
Beaverton, OR 97076-4755

Percent for Art Program
www.lanearts.org
Lane Arts Council
99 W. 10th Ave., Suite 100
Eugene, OR 97401

Regional Arts & Culture Council
www.racc.org
108 NW 9th Street, Suite 300
Portland, OR 97209-3318

TRI MET
www.tri-met.org
710 NE Holladay St.
Portland, OR 97232-2168

Oregon Arts Commission
www.oregonartscommission.org
775 Summer St. NE, Suite 200350
Salem, OR 97301-1284

PENNSYLVANIA

City of Philadelphia
www.phila.gov
Office of Art and Culture
Percent for Art Program
1515 Arch St., 12th Floor
Philadelphia, PA 19102

Exhibitions Programs at Philadelphia
 International Airport
www.phl.org
Terminal E
Philadelphia, PA 19153

Fairmount Park Art Association
www.fpaa.org
1616 Walnut St., Suite 2012
Philadelphia, PA 19103

Redevelopment Authority of Philadelphia
Fine Arts Program
1234 Market St., 16th Floor
Philadelphia, PA 19107

City of Pittsburgh
www.city.pittsburgh.pa.us/artcomm
Department of City Planning
200 Ross St., 4th Floor
Pittsburgh, PA 15219

Sprout Public Art
www.publicart.sproutfund.org
4920 Penn Avenue
Pittsburgh, PA 15224

RHODE ISLAND

Rhode Island State Council on the Arts
www.risca.state.ri.us
1 Capitol Hill, 3rd Floor
Providence, RI 02908

SOUTH CAROLINA

South Carolina Arts Commission
www.state.sc.us/arts
Percent for Art Program
1800 Gervais St.
Columbia, SC 29201

SOUTH DAKOTA

South Dakota Arts Council
www.sdarts.org
800 Governors Dr.
Pierre, SD 57501

Chattanooga Public Art Program
www.AlliedArtsChattanooga.org
406 Frazier Avenue
Chattanooga, TN 374053

The Arts & Culture Alliance of Greater
 Knoxville
www.knoxalliance.com
P.O. Box 2506
Knoxville, TN 37901

UrbanArt Commission
www.urbanartcommission.org
8 South 3rd Street, Suite 100
Memphis, TN 38103

Arts in the Airport
www.flynashville.com
One Terminal Dr., Suite 501
Nashville, TN 37214

Metropolitan Nashville Arts Commission
www.artsnashville.org
209 Tenth Ave. S., Suite 416
Nashville, TN 37203-0772

Tennessee Arts Commission
www.arts.state.tn.us
401 Charlotte Ave.
Nashville, TN 37243-0780

TEXAS

City of Austin Art in Public Places
www.cityofaustin.org/aipp
P.O. Box 1088
Austin, TX 78767

City of Corpus Christi
Public Art Program
P.O. Box 9277
Corpus Christi, TX 78469-9277

City of Dallas Public Art Program
www.dallasculture.org
Office of Cultural Affairs
1925 Elm St., Suite 400500
Dallas, TX 75201

Fort Worth Public Art
www.fw.orgfwpublicart.org
Arts Council of Fort Worth & Tarrant
 County
1300 Gendy St.
Fort Worth, TX 76107

Civic Art and Design
www.cachh.org/civic
Cultural Arts Council of Houston/Harris
 County
3201 Allen Parkway, Suite 250
Houston, TX 77019

Houston Municipal Art Commission
www.ci.houston.tx.us/municipalart
Building Services Department
900 Bagby, 2nd Floor
Houston, TX 77002

Texas Tech University Public Art Program
Texas Tech University
P.O. Box 42014
Lubbock, TX 79409-2014

City of Plano
Creative Arts Division
www.planotx.org
Public Art Program
P.O. Box 860358
Plano, TX 75086-0356

City of San Antonio
www.sanantonio.gov/publicworks/pubart
Public Art & Design Enhancement Program
P.O. Box 839966
San Antonio, TX 78283

University of Texas at San Antonio
www.utsa.edu
Public Art Program
Department of Art and Art History
6900 North Loop, 1604 West
San Antonio, TX 78249

Texarkana Regional Arts and Humanities
Council
www.trahc.org
Community Programs
P.O. Box 1171
321 W. 4th
Texarkana, TX 75503

UTAH

Ogden City Arts
www.ogdencity.com
1875 Monroe Blvd.
Ogden, UT 84401-0647

Salt Lake City Public Art Program
www.slcgov.com/arts
Salt Lake City Art Arts Council
54 Finch Lane
Salt Lake City, UT 84102

Salt Lake County Public Art Program
www.co.slc.ut.us/fi/slcoart/collection.html
Salt Lake County Art Collection
2001 South State Street, Suite S3200
Salt Lake City, UT 84190

Utah Public Art Program
www.arts.utah.gov/publicart
Utah Arts Council
617 East South. Temple
Salt Lake City, UT 84102

VERMONT

Art in State Buildings
www.vermontartscouncil.org
Vermont Arts Council
136 State St., Drawer 33
Montpelier, VT 05633-6001

VIRGINIA

Alexandria Commission for the Arts
www.ci.alexandria.va.us
Alexandria Department of Recreation
Parks & Cultural Activities
1108 Jefferson St.
Alexandria, VA 22314-3999

Arlington County Cultural Affairs Division
www.arlingtonarts.com
Department of Parks, Recreation, and
 Community Resources
2100 Clarendon Blvd., Suite 414
Arlington, VA 22201

City of Chesapeake Fine Arts Commission
www.chesapeake.va.us
Public Art Committee
112 Mann Dr.
Chesapeake, VA 23322

City of Richmond Public Art Program
Department of Community Development
900 E. Broad St.
Richmond, VA 23219

Auburn Arts Commission
www.ci.auburn.wa.us
Public Art Program
25 W. Main St.
Auburn, WA 98001

Bainbridge Island Public Art Program
www.artshum.org
Bainbridge Island Arts and Humanities
 Council
221 Winslow Way W., Suite 201
Bainbridge Island, WA 98110

City of Bellevue
www.cityofbellevue.org/planning.asp
Bellevue Arts Commission
P.O. Box 90012
Bellevue, WA 98009

Whatcom Museum of History & Art
www.watcommuseum.org
Public Art Program
121 Prospect St.
Bellingham, WA 98225

Edmonds Arts Commission
www.ci.edmonds.wa.us
700 Main St.
Edmonds, WA 98020

Everett Cultural Commission
www.everettwa.org
802 Mukilteo Boulevard
Everett, WA 98203

City of Issaquah Arts Commission
www.ci.issaquah.wa.us
Public Art Program
City Hall
P.O. Box 1307
Issaquah, WA 98027

City of Kent Arts Commission
www.ci.kent.wa.us/artsr
220 4th Ave. S.
Kent, WA 98035-5895

Pierce County Arts + Cultural Services
 Division
Percent for Art Program
8815 S. Tacoma Way, Suite 202
Lakewood, WA 98499

City of Lynnwood
www.ci.lynnwood.wa.us
Arts Commission
P.O. Box 5008
Lynnwood, WA 98046-5008

Mercer Island Arts Council
www.ci.mercer-island.wa.us
Art in Public Places Program
2040 84th Avenue SE
Mercer Island, WA 98040

City of Olympia Arts Program
www.ci.olympia.wa.us/par
222 N. Columbia
Olympia, WA 98501

Washington State Arts Commission
www.arts.wa.gov
711 Capitol Way South
P.O. Box 42675
Olympia, WA 98504-2675

Renton Municipal Arts Commission
www.ci.renton.wa.us
Percent for Art Program
City Hall
1055 S. Grady Way
Renton, WA 98055

4Culture
www.4culture.org
506 2nd Avenue, Room 200
Seattle, WA 98104-2307

Mayor's Office of Arts & Cultural Affairs
www.cityofseattle.net/arts
700 Fifth Ave., Suite 1766
PO Box 96748
Seattle, WA 98124-4748

Seattle–Tacoma International Airport
www.portseattle.org
Exhibitions and Acquisitions Program
Port of Seattle
Aviation Marketing Office
P.O. Box 68727, Room 301
Seattle, WA 98168

Sound Transit
www.soundtransit.org
401 S. Jackson
Seattle, WA 98104

City of Spokane Arts Commission
www.spokanearts.org
Percent for Art Program
Department of Arts and Cultural Services
W. 808 Spokane Falls Blvd.
Spokane, WA 99201-3333

Municipal Art Program
www.cityoftacoma.org
Tacoma Arts Commission
747 Market St., Suite 1036
Tacoma, WA 98402

Wenatchee Arts Commission
www.cityofwenatchee.com
Percent for Art Program
Wenatchee City Hall
P.O. Box 519
Wenatchee, WA 98807

WEST VIRGINIA

West Virginia State Arts Agency's Grants
 & Services
www.wvculture.org/arts/index.html
Art Section, Department of Education and
 the Arts
Cultural Center, Capitol Complex
Division of Culture and History
1900 Kanawha Blvd. E.
Charleston, WV 25305-0300

WISCONSIN

Madison CitiARTS
www.ci.madison.wi.us
Madison Municipal Building, Suite 200
215 Martin Luther King Jr., Boulevard
Madison, WI 53710-2985

Wisconsin Arts Board
www.arts.state.wi.us
101 E. Wilson St., First Floor
Madison, WI 53702

Milwaukee Arts Board
www.mkedcd.org/artsboard
809 N. Broadway
Milwaukee, WI 53202

Milwaukee County Public Art Program
Department of Public Works
2711 W. Wells St.
Milwaukee, WI 53208

Wyoming Arts Council
www.wyomingartscouncil.org
Art in Public Buildings
2320 Capitol Ave.
Cheyenne, WY 82002

Sheridan Public Arts Committee
P.O. Box 848
Sheridan, WY 82801

U.S. TERRITORIES

Commonwealth Council for Arts and
 Culture
www.pixi.com/~cpac/ccac.htm
Public Art Program
P.O. Box 5553 CHRB
Saipan, MP 96950

Guam Council on the Arts and Humanities
 Agency
www.guam.net/gov/kaha
Art In Public Places Program
Guam CAHA
P.O. Box 2950
Hagatna, GU 93932

Neighborhood Matching-Fund Grant Programs

In the last few years, many cities and counties have developed neighborhood matching-fund grant programs. If your region is not listed, contact your local government's neighborhood or planning department for more information on funding opportunities.

ARIZONA

Mesa

Neighborhood and Community Assistance
Office
64 E. 1st St., Suite 203
Mesa, AZ 85211

Phoenix

Neighborhood Services Department
Grants Division
200 W. Washington St., 4th Floor
Phoenix, AZ 85003

CALIFORNIA

Riverside

City of Riverside Development Department
3900 Main St., 5th Floor
Riverside, CA 92522
(909) 782–5649
Jeff McLaughlin, Redevelopment
Coordinator

Santa Ana

Housing Department
P.O. Box 1988
Santa Ana, CA 92702
(714) 667–2225

COLORADO

Boulder

Neighborhood Minigrants
P.O. Box 791
Boulder, CO 80306
(303) 441–4478
Administrator

Fort Collins

Neighborhood Resources Office
405 Canyon Avenue
P.O. Box 580
Fort Collins, Colorado 80522–0580
(970) 224–6145
Dan MacArthur, Neighborhood

FLORIDA

Jacksonville

Neighborhoods Department
117 W. Duval St., Suite 310
Jacksonville, FL 32202
(904) 630–4963
Roslyn M. Phillips, Director
 of Neighborhoods

Jupiter

Neighborhood Enhancement Program
(561) 746–5134
Jody Rivers, Neighborhood
Coordinator
jodyr@jupiter.fl.us

Orlando

Neighborhood Services
129 E. Gore St.
Orlando, FL 32806
(407) 246–2169
(407) 246–3508 (fax)

MINNESOTA

Duluth

Pam Kramer
(218) 723–3357

NORTH CAROLINA

Asheville

Public and Community Information
Office
Neighborhood Matching Grant
 Program
P.O. Box 7148
Asheville, NC 28002
Robin Nix (828) 259–5484

NEVADA

Las Vegas

Neighborhood Partners Fund
Department of Neighborhood Services
(702) 229–6269
(702) 382–3045 (fax)

Charlotte/Mecklenburg County

Neighborhood Development
Department
 (704) 336–3301
Stanley Watkins, Director

OHIO

Cleveland

Division of Neighborhood Services
 City Works Neighborhood
 Matching Grants Program
601 Lakeside Ave., Room 302
(216) 664 4074
(216) 420–7964 (fax)

OREGON

Eugene

Beth Bridges
 (541) 682–5272
beth.b.bridges@ci.eugene.or.us

TEXAS

Houston

Neighbohood Programs
(713) 837–7834
Benneth Okpala
Benneth.Okpala@cityofhouston.net

Pasadena

Neighborhood Network
Karen Hollon
(713) 475–7221

Plano

Keep Plano Beautiful Commission
Homeowners Matching Grant
Meredith Shapiro, Solid Waste Public
Information Coordinator
meredith@gwmail.plano.gov

UTAH

Salt Lake City

(801) 535–6150
Sherrie Hansen
Sherrie.hansen@ci.slc.ut.us

WASHINGTON

Bellevue

Neighborhood Enhancement Program
(425) 452–4075

Kirkland

Neighborhood Association Matching
Grants Program
123 Fifth Ave.
Kirkland, WA 98033
(425) 828–1100

Redmond

Planning Department
P.O. Box 97010
Redmond, WA 98073

Renton

Economic Development,
 Neighborhoods and Strategic
 Planning
(425) 430–6595
Norma McQuiller
nmcquiller@ci.renton.wa.us

Seattle

Department of Neighborhoods
Neighborhood Matching Fund
(206) 684–0464
Bernie Matsuno
bernie.matsuno@ci.seattle.wa.us

Vancouver

Vancouver Office of Neighborhoods
Community Services Department
Neighborhood Consolidated Grant
 Request
210 E. 13th Street
P.O. Box 1995
Vancouver, WA 98668–1995
(360) 696–8222 or vanneib@ci.
 vancouver.wa.us

Print and Video Resources

PRINT RESOURCES

Periodicals/Serial Volumes

Fabric Architecture. Bimonthly. Saint Paul, Minn.: Industrial Fabrics Association.

Grey Room. Quarterly. Cambridge, Mass.: MIT Press.

Milestones. Monthly. Phoenix, Ariz.: Phoenix Arts Commission.

Places. Serial. Published in association with the College of Environmental Design, University of California, Berkeley, and the School of Architecture and Planning, Massachusetts Institute of Technology. Cambridge, Mass.: MIT Press.

Public Art Review. Semiannual. Saint Paul, Minn.: FORECAST Public Artworks.

Sculpture. Monthly. Washington, D.C.: International Sculpture Center.

Sculpture Matters. Biannual. Edinburgh: Scottish Sculpture Forum. (Previously published by the defunct Scottish Sculpture Trust.)

Terra Nova. Quarterly. Cambridge, Mass.: MIT Press.

Catalogs/Annual Directories

The Guild: The Architect's Source of Artists and Artisans. Madison, Wisc.: Krause Sikes.

Hirsch Farm Project catalog. Chicago: Hirsch Farm Project.

Public Art Affairs catalog. Saint Paul, Minn.: FORECAST Public Artworks.

Public art program directory, 2003–2004. Washington, D.C.: Public Art Network of Americans for the Arts, 2002.

Books/Articles

Adams, Eileen. *Public Art: People, Projects, Process.* London: London Arts Board, 1997.

Alanen, Arnold R., and Robert Z. Melnick, eds. *Preserving Cultural Landscapes in America.* Baltimore: Johns Hopkins University Press, 2000.

Alberro, Alexander, ed. *Two-Way Mirror Power: Selected Writings by Dan Graham on his Art.* Cambridge, Mass.: MIT Press, 1999.

———, and Blake Stimson, eds. *Conceptual Art: A Critical Anthology.* Cambridge, Mass.: MIT Press, 1999.

Alexander, Garvin, et al. *Urban Parks and Open Space.* Washington, D.C.: Urban Land Institute, 1997.

Altshuler, Bruce. *The Avant-Garde in Exhibition: New Art in the Twentieth Century.* Berkeley: University of California Press, 1998.

Amidon, Jane. *Radical Landscapes.* New York: Thames & Hudson, 2001.

Austin, Joe. *Taking the Train: How Graffiti Art Became an Urban Crisis in New York City.* New York: Columbia University Press, 2001.

Bach, Penny Balkin, ed. *New*Land*Marks: Public Art, Community, and the Meaning of Place.* Washington, D.C.: Grayson Publishing, 2001.

Baeder, John. *Sign Language: Street Signs as Folk Art.* New York: Harry N. Abrams, 1996.

Balzer, Richard. *Peepshows: A Visual History.* New York: Harry N. Abrams, 1998.

Banyas, Rebecca, and Mary Preister. *Westside Light Rail Public Art Guide.* Portland, Oregon: Tri-Met, 1998.

Barrie, Brooke. *Contemporary Outdoor Sculpture.* Gloucester, Mass.: Rockport Publishers, 1999.

Bayley, Stephen, ed. *Imagination.* London: Phaidon, 2003.

Beardsley, John. *Art and Landscape in Charleston and the Low Country.* A project of the Spoleto Festival USA. Washington, D.C.: Spacemaker Press, 1998.

———. *Earthworks and Beyond.* 3rd ed. New York: Abbeville Press, 1998.

Becker, Carol, ed. *The Subversive Imagination: Artists, Society, and Responsibility.* New York: Routledge, 1994.

———, and Ann Wiens, eds. *The Artist in Society: Rights, Roles, and Responsibilities.* Chicago: Chicago New Art Association/New Art Examiner Press, 1995.

Beebe, Mary Livingston. *Landmarks: Sculpture Commission for the Stuart Collection, University of California, San Diego.* New York: Rizzoli, 2000.

Benezra, Neal, and Olga M. Viso. *Distemper: Dissonant Themes in the Art of the 1990s.* Washington, D.C.: Hirshhorn Museum and Sculpture Garden, Smithsonian Institution, 1996.

Benjamin, Andrew, ed. *Installation Art.* London: Academy Editions, 1993.

Berleant, Arnold, ed. *Environment and the Arts: Perspectives on Environmental Aesthetics.* London: Ashgate, 2002.

Bogart, Michele H. *Public Sculpture and the Civic Ideal in New York City, 1890–1930.* Washington, D.C.: Smithsonian Institution Press, 1997.

Bois, Yve-Alain, and Rosalind E. Krauss. *Formless: A User's Guide.* Cambridge, Mass.: MIT Press, 1997.

Bourdon, David. *Designing the Earth: The Human Impulse to Shape Nature.* New York: Harry N. Abrams, 1995.

Brenson, Michael. *Visionaries and Outcasts: The NEA and the Place of the Visual Arts in America.* New York: New Press, 2001.

Buck, R., and J. Gilmore. *The New Museum Registration Methods.* Washington, D.C.: American Association of Museums, 1998.

Buhle, Paul, and Mike Alewitz. *Insurgent Images: The Labor Murals of Mike Alewitz.* New York: Monthly Review Press, 2002.

Burnham, Jack. "System Esthetics." *Artforum,* Sept. 1968, 30–35.

Burnham, Linda Frye, and Steven Durland, eds. *The Citizen Artist: 20 Years of Art in the Public Arena. An Anthology from* High Performance *magazine, 1978–1998.* Gardiner, N.Y.: Critical Press, 1998.

Carlson, Allen. *Aesthetics and the Environment: The Appreciation of Nature, Art, and Architecture.* London and New York: Routledge, 2000.

Casey, Edward S. *The Fate of Place: A Philosophical History.* Berkeley: University of California Press, 1997.

Cavanagh, Terry. *Public Sculpture of Liverpool.* Liverpool, England: Liverpool University Press, 1997.

Cheng, Carl. "Public Art: More Than a Pretty Distraction." *Los Angeles Times,* July 31, 2000.

Christy, Jim. *Strange Sites: Uncommon Homes & Gardens of the Pacific Northwest.* Maderia Park, British Columbia: Harbour Publishing, 1996.

Cochran, William. *Community Bridge.* Frederick, Md.: Shared Vision, 1996.

Collins, Glenn. "Design Selected for a Memorial at Ground Zero." *New York Times,* Jan. 7, 2004.

———, and David W. Dunlap. "The 9/11 Memorial: How Pluribus Became Unum." *New York Times,* Jan. 19, 2004.

Crabtree, Amanda. *Public Art, Art and Design Profile,* no. 46. London: Academy Group, 1996.

Danto, Arthur C. *After the End of Art: Contemporary Art and The Pale of History.* Princeton, N.J.: Princeton University Press, 1997.

———. *Embodied Meanings: Critical Essays and Aesthetic Meditations.* New York: Farrar, Straus and Giroux, 1994.

Deutsche, Rosalyn. *Evictions: Art and Spatial Politics.* Chicago/Cambridge, Mass.: Graham Foundation for Advanced Studies in the Fine Arts/MIT Press, 1996.

Dixon, John Morris, ed. *The Design of Public Places. Urban Spaces,* no. 2. Washington, D.C.: Visual Reference Publications, Urban Land Institute, 2001.

Doss, Erika Lee. *Spirit Poles and Flying Pigs: Public Art and Cultural Democracy in American Communities.* Washington, D.C.: Smithsonian Institution Press, 1995.

Dunitz, Robin J. *Painting the Towns: Murals of California.* Los Angeles: RJD Enterprises, 1997.

Dunlop, Beth. *The City Is My Canvas: Richard Haas.* New York: Prestel, 2000.

Easterling, Keller. *Organization Space: Landscapes, Highways, and Houses in America.* Cambridge, Mass.: MIT Press, 2001.

English, Ron, and Maggie Balistreri, eds. *Propaganda: The Art and Subversion of Ron English.* New York: Soft Skull Press, 2001.

Fabos, Julius Gy, and Jack Ahern, eds. *Greenways: The Beginning of an International Movement.* Amsterdam and New York: Elsevier, 1996.

Ferrell, Jeff. *Tearing Down the Streets: Adventures in Urban Anarchy.* New York: Palgrave, 2001.

Ferrier, Jean-Louis. *Outsider Art.* Paris: Terrail, 1998.

Feuer, Wendy. *Art in Transit: Making It Happen.* Washington, D.C.: Federal Transit Administration, 1996.

Fineberg, Jonathan, ed. *Discovering Child Art: Essays on Childhood, Primitivism, and Modernism.* Princeton, N.J.: Princeton University Press, 1998.

Finkelpearl, Tom. *Dialogues in Public Art.* Cambridge, Mass.: MIT Press, 2000.

Flam, Jack, ed. *Robert Smithson: The Collected Writings.* Berkeley: University of California Press, 1996.

Fleming, Ronald Lee. *Placemakers: Creating Public Art That Tells You Where You Are, with an Essay on Planning and Policy.* Boston: Harcourt Brace Jovanovich, 1987.

Flink, Charles A., and Robert M. Searns. *Greenways: A Guide to Planning, Design, and Development.* Washington, D.C.: Island Press, 1993.

Foster, Kathleen A. *Thomas Hart Benton and the Indiana Murals.* Bloomington: Indiana University Press, 2001.

Francis, Mark, and Randolph T. Hester, eds. *The Meaning of Gardens: Idea, Place, Action.* Cambridge, Mass.: MIT Press, 1990.

Freeland, Cynthia. *But Is It Art?* New York: Oxford University Press, 2001.

Freeman, Phyllis, Mark Greenberg, Eric Himmel, Andreas Landshoff, and Charles Miers, eds. *New Art.* New York: Harry N. Abrams, 1990.

Fuller, Patricia. *Five Artists at NOAA: A Casebook on Art in Public Places.* Seattle: Western Regional Center, National Oceanic and Atmospheric Administration/Real Comet Press, 1985.

Gayle, Margot, and Michele Cohen. *The Art Commission and the Municipal Art Society Guide to Manhattan's Outdoor Sculpture.* New York: Prentice Hall, 1988.

Garten, Cliff, ed. *Saint Paul Cultural Garden.* Saint Paul, Minn.: Place Placo Press, 1996.

Gellburd, Gail. *Creative Solutions to Ecological Issues.* New York/Philadelphia: Council for Creative Projects/University of Pennsylvania Press, 1993.

Gerz, Jochen. *Jochen Gerz,* Res Publica: *The Public Works.* Ostfildern, Germany: Hatje Cantz, 2000.

Getz-Preziosi, Pat. *Sculptors of the Cyclades: Individual Tradition in the Third Millennium B.C.* Ann Arbor: University of Michigan Press, 1987.

Godfrey, Tony. *Conceptual Art.* London: 1998.

Goldman, Shifra M. *Dimension of the Americas: Art and Social Change in Latin America and the United States.* Chicago: University of Chicago Press, 1995.

Goldstone, Bud, and Arloa Paquin Goldstone. *The Los Angeles Watts Tower.* Los Angeles: Getty Conservation Institute and J. Paul Getty Museum, 1997.

Grande, John. *Playing With Fire: Armand Vaillancourt, Social Sculptor.* Montreal: Zeit & Geist, 1999.

Grant, Daniel. "The Maintenance of Public Artworks." *Sculpture* 19:7 (2000), 36–41.

Groth, Paul, and Todd W. Bressi, eds. *Understanding Ordinary Landscapes.* New Haven: Yale University Press, 1997.

Harris, Craig, ed. *Art and Innovation: The Xerox PARC Artist-in-Residence Program.* Cambridge, Mass.: MIT Press, 1999.

Harrison, Marina, and Lucy Rosenfeld. *Art on Site: Country Artwalks from Maine to Maryland.* New York: Michael Kesend Publishing, 1993.

Hayden, Dolores. *The Power of Place: Urban Landscapes as Public History.* Cambridge, Mass.: MIT Press, 1995.

Hedgecoe, John. *A Monumental Vision: The Sculpture of Henry Moore.* London: Collins and Brown, 1998.

Herman, Judy, with essays by Julie Courtney, Janet Greenstein Potter, and Harriet F. Senie. *Points of Departure: Art on the Line.* Philadelphia: Main Line Art Center, 2001.

Hiss, Tony. *The Experience of Place.* New York: Knopf, 1990.

Huebner, Jeff. *Murals: The Great Walls of Joliet.* Joliet, Ill.: Friends of Community Public Art, 2001.

Huie, Wing Young. *Lake Street U.S.A.* Saint Paul, Minn.: Ruminator Books, 2002.

Hunt, Marjorie. *The Stone Carvers: Master Craftsmen of Washington National Cathedral.* Washington, D.C.: Smithsonian Institution Press, 1999.

Iovine, Julie V. "The Memorial Roads Not Taken." *New York Times,* Feb. 1, 2004.

Jackson, John Brinckerhoff. *Discovering the Vernacular Landscape.* New Haven, Conn.: Yale University Press, 1984.

———. *Landscape in Sight: Looking at America.* New Haven, Conn.: Yale University Press, 1997.

———. *The Necessity of Ruins, and Other Topics.* Amherst: University of Massachusetts Press, 1980.

———. *A Sense of Place, A Sense of Time.* New Haven, Conn.: Yale University Press, 1994.

Jacobs, Mary Jane. *Conversations at the Castle: Changing Audiences and Contemporary Art.* Cambridge, Mass.: MIT Press, 1998.

———. *Culture in Action: A Public Art Program of Sculpture Chicago.* Seattle: Bay Press, 1995.

Jellicoe, Geoffrey, and Susan Jellicoe. *The Landscape of Man: Shaping the Environment from Prehistory to the Present Day.* New York: Thames & Hudson, 1987.

Johnson, Paul-Alan. *The Theory of Architecture: Concepts, Themes, and Practices.* New York: Wiley, 1994.

Jordan, Sherrill, ed. *Public Art, Public Controversy: The Tilted Arc on Trial.* New York: American Council of the Arts, 1987.

Joselit, David, Joan Simon, and Renata Saleci. *Jenny Holzer.* London: Phaidon, 1998.

Julier, Guy. *Watermark.* Lancaster, England: Cardiff Bay Art Trust, 1996.

Kahn, Douglas. *Noise, Water, Meat: A History of Sound in the Arts.* Cambridge, Mass.: MIT Press, 1999.

Kaprow, Allan. *Essays on the Blurring of Art and Life.* Berkeley: University of California Press, 1993.

Kastner, Jeffrey, and Brian Wallis. *Land and Environmental Art.* London: Phaidon, 1998.

Keens, William, Anne Watson, and Barbara Hoffman. *A Visual Artists' Guide to Estate Planning.* Colorado Springs, Colo. Marie Walsh Sharpe Art Foundation, 1998.

Keldermans, Karel, and Linda Keldermans. *Carillon: The Evolution of a Concert Instrument.* Springfield, Ill.: Phillips Press, 1996.

Kern, Hermann. *Through the Labyrinth: Designs and Meaning Over 5000 Years.* New York: Prestel, 2000.

Kester, Grant H., ed. *Art, Activism, and Oppositionality.* Durham, N.C.: Duke University Press, 1997.

Kimmelman, Michael. "Ground Zero's Only Hope: Elitism." *New York Times,* Dec. 7, 2003.

Kwon, Miwon. *One Place After Another: Site-Specific Art and Locational Identity.* Cambridge, Mass.: MIT Press, 1999.

Lacy, Suzanne, ed. *Mapping the Terrain: New Genre Public Art.* Seattle: Bay Press, 1995.

Lee, Pamela M. *Object to Be Destroyed: The Work of Gordon Matta-Clark.* Cambridge, Mass.: MIT Press, 2000.

Lewellan, Constance M. *The Dream of the Audience: Theresa Hak Kyung Cha (1951–1982).* Berkeley: University of California Art Museum/University of California Press, 2001.

Levi Strauss, David, et al. *Daniel J. Martinez: The Things You See When You Don't Have A Grenade!* Santa Monica, Calif.: Small Art Press, 1996.

Levinson, Sanford. *Written in Stone: Public Monuments in Changing Societies.* Durham, N.C.: Duke University Press, 1997.

Lin, Maya. *Boundaries.* New York: Simon & Schuster, 2000.

Lingwood, James. *House/Rachael Whiteread.* London: Phaidon, 1995.

Lippard, Lucy. *Lure of the Local: Senses of Place in a Multicentered Society.* New York: New Press, 1998.

———. *On the Beaten Track: Tourism, Art, and Place.* New York: New Press, 1999.

———. *Overlay: Contemporary Art and the Art of Prehistory.* New York: New Press, 1995.

Little, Charles E. *Greenways for America.* Baltimore: Johns Hopkins University Press, 1990.

London, Peter. *Step Outside: Community-Based Art Education.* Heinemann, 1994.

Longhauser, Elsa Weiner, Gerald Wertkin, and Harald Szeemann, eds. *Self-Taught Artists of the 20th Century: An American Anthology.* San Francisco: Chronicle Books, 1998.

Longo, Gianni. *A Guide to Great American Public Places: A Journey of Discovery, Learning, and Delight in the Public Realm.* New York: Urban Initiatives, 1996.

Lozano-Hemmer, Rafael, ed. *Alzado Vectorial/Vectorial Elevation. Relational Architecture,* no. 4. Mexico City: Conaculta/Ediciones San Jorge, 2000.

Lynch, Kevin. *What Time Is This Place?* Cambridge, Mass.: MIT Press, 1972.

Margolius, Ivan. *Automobiles by Architects.* New York: Wiley, 2000.

Matilsky, Barbara C. *Fragile Ecologies: Contemporary Artists' Interpretations and Solutions.* New York: Rizzoli, 1992.

McCulloch, Michael, with Ed Carpenter. *Ed Carpenter: Breath of Light.* Milan: L'Arca Edizioni, 2000.

McDonnell, Sharon. "Business Travel: Art Exhibits Help Make Time Fly Between Flights." *New York Times,* Dec. 30, 2003.

McHarg, Ian L. *Design with Nature.* New York: Wiley, 1992.

Meinig, D. W., ed. *The Interpretation of Ordinary Landscapes: Geographical Essays.* New York: Oxford University Press, 1995.

Meyer, Elizabeth. "The Public Park as Avant-Garde (Landscape) Architecture: A Comparative Interpretation of Two Parisian Parks, Parc de la Villette (1983–1990) and Parc des Buttes–Chaumont (1864–1867)." *Landscape Journal,* Spring 1991, 16–26.

Miles, Malcolm. *Art, Space, and the City: Public Art and Urban Futures.* London and New York: Routledge, 1997.

———. *The Uses of Decoration: Essays in the Architectural Everyday.* New York: Wiley, 2000.

———, Iain Borden, and Tim Hall, eds. *The City Culture Reader.* London and New York: Routledge, 2000.

Molyneaux, Brian Leigh. *The Sacred Earth.* Boston: Little, Brown, 1995.

Morphy, Howard. *Aboriginal Art.* London: Phaidon, 1998.

Mugerauer, Robert. *Interpretations on Behalf of Place: Environmental Displacements and Alternative Responses.* Albany: State University of New York Press, 1994.

Muscamp, Herbert, et al. *The Once and Future Park.* New York: Princeton Architectural Press, 1993.

Nichols, Susan. *Tips, Tales and Testimonies to Save Outdoor Sculpture.* Washington, D.C.: Heritage Preservation, 2002.

Norberg-Schulz, Christian. *Architecture: Meaning and Place.* New York: Rizzoli, 1988.

———. *The Concept of Dwelling: On the Way to Figurative Architecture.* Milan/New York: Electa/Rizzoli, 1985.

———. *Genius Loci: Towards a Phenomenology of Architecture.* New York: Rizzoli, 1980.

North Carolina Department of Cultural Resources. *Creating Place: North Carolina's Artworks for State Buildings.* Raleigh, N.C.: North Carolina Arts Council, 2002.

Nou, Jean Louis. *Borobudur.* New York: Abbeville Press, 1996.

Novokov, Anna, ed. *Veiled Histories: The Body, Place, and Public Art.* Gardiner, N.Y.: Critical Press, 1997.

Oakes, Baile, ed. *Sculpting with the Environment: A Natural Dialogue.* New York: Van Nostrand Reinhold, 1995.

Orosz, Istvan, Marta Sylvestrova, and Gale Stokes. *Art as Activist: Revolutionary Posters from Central and Eastern Europe.* New York/Washington, D.C.: Universe Books/Smithsonian Institution Traveling Exhibition Service, 1992.

Parissien, Steven. *Station to Station.* London: Phaidon, 1997.

Peter, Jennifer, and Louis Crosier, eds. *The Cultural Battlefield: Art Censorship and Public Funding.* Gilsum, N.H.: Avocus Publishing, 1995.

Phillips, Patricia C. "Creating Democracy: A Dialogue with Krzysztof Wodiczko." *Art Journal* 62:4 (2003), 32–49.

Platt, Ron. *Borne of Necessity.* Greensboro: Weatherspoon Art Museum/University of North Carolina, 2004.

Purves, Ted. *Shadow Cabinets in a Bright Country.* New York/Kassel: apexart/Kunsthalle Fridericianum, 2002.

Pierre, Arnauld. *Bernar Venet.* Milan: Giampaolo Prearo Editore, 2000.

Potteiger, Matthew. *Landscape Narratives: Design Practices for Telling Stories.* New York: Wiley, 1998.

Powers, Stephen J. *The Art of Getting Over.* New York: St. Martin's Press, 1999.

Prather, Marla, with contributions by Alexander S. C. Rower and Arnauld Pierre. *Alexander Calder: 1898–1976.* New Haven: Yale University Press, 1998.

Prigoff, James, and Robin Dunitz. *Walls of Heritage, Walls of Pride.* Rohnert Park, Calif.: Pomegranate, 2000.

Princenthal, Nancy, and Jennifer Dowley. *A Creative Legacy: A History of the NEA Visual Artists' Fellowship Program, 1966–1995.* New York: Harry N. Abrams, 2001.

Project for Public Spaces. *How to Turn a Place Around: A Handbook for Creating Successful Public Spaces.* New York: Project for Public Spaces, 2000.

Public Art Fund. *Public Art Fund's Urban Paradise: Gardens in the City. Public Art Issues,* no. 3. New York: D.A.P./Distributed Art Publishers, 1994.

Quinn, John R. *Fields of Sun and Grass: An Artist's Journal of the New Jersey Meadowlands.* New Brunswick, N.J.: Rutgers University Press, 1997.

Rajer, Anton, and Christine Style. *Public Sculpture in Wisconsin: An Atlas of Outdoor Monuments, Memorials and Masterpieces in the Badger State.* Madison.: SOS! Wisconsin, 1999.

Relph, E. C. *Place and Placelessness: Research in Planning and Design.* London: Pion, 1976.

Rochfort, Desmond. *Mexican Muralists: Orozco, Rivera, Siqueiros.* San Francisco: Chronicle Books, 1998.

Rogers, Elizabeth Barlow. *Landscape and Design: A Cultural and Architectural History.* New York: Harry N. Abrams, 2001.

Rose, Barbara, and Dale Lanzone. *Chihuly Projects.* New York: Harry N. Abrams, 2000.

Rower, Alexander S. C. *Calder Sculpture*. Washington, D.C./New York: National Gallery of Art/Universe Publishing, 1998.

Rybczynski, Witold. *A Clearing in the Distance: Frederick Law Olmsted and America in the Nineteenth Century*. New York: Scribner, 1999.

Sato, Masaru. *Community Design: Elements of Modern Environmental Landscape and Signage*. Tokyo: Graphic-sha, 1992.

Savage, Kirk. *Standing Soldiers, Kneeling Slaves: Race, War, and Monument in Nineteenth-Century America*. Princeton, N.J.: Princeton University Press, 1997.

Schimmel, Paul, and Russell Ferguson, eds. *Out of Actions: Between Performance and the Object, 1949–1979*. New York: Norton, 1998.

Scully, Vincent Joseph. *American Architecture and Urbanism*. New York: Praeger, 1969.

Seattle Arts Commission. *Public Art 101 Curricular Book*. Seattle: Seattle Arts Commission, 2001.

Senie, Harriet F. *The* Tilted Arc *Controversy: Dangerous Precedent?* Minneapolis: University of Minnesota Press, 2001.

———, Glenn Harper, James Grayson Trulove, et al. *Dancing in the Landscape: The Sculpture of Athena Tacha*. Washington, D.C.: Editions Ariel, 2000.

———, and Sally Webster, eds. *Critical Issues in Public Art: Content, Context, and Controversy*. New York: HarperCollins, 1992.

Serra, Josep Ma. *Elementos urbanos: Mobiliario y microarquitectura/Urban Elements: Furniture and Microarchitecture*. Barcelona: Gustavo Gili, 1996.

Sheehy, Colleen, ed. *Theater of Wonder*. Minneapolis: University of Minnesota Press, 1999.

Shellenbarger, Pat. "Going to the Wall: Community Rallies Around Rare Murals." *Grand Rapids Press,* Feb. 15, 2004.

Sims, Patterson, with Mary Jane Jacob and Arthur Danto. *Howard Ben Tre*. New York: Hudson Hills Press, 1999.

Slifer, Dennis. *Guide to Rock Art of the Utah Region: Sites with Public Access*. Santa Fe: University of New Mexico Press, 2000.

Smith, Roberta. "The Rush-Hour Revelations of an Underground Museum." *New York Times,* Jan. 2, 2004.

Sollins, Susan. *Art: 21*. New York: Harry N. Abrams, 2001.

Solnit, Rebecca. *Wanderlust: A History of Walking*. New York: Viking Press, 2000.

Spaid, Sue. *Ecovention: Current Art to Transform Ecologies*. Cincinnati: Ecoartspace, Contemporary Arts Center, 2002.

Stallabrass, Julian, Pauline van Mourik Broekman, Niru Ratnam, et al. *Locus Solus: Site, Identity, Technology in Contemporary Art*. London: Black Dog Publishing, 2000.

Steward Heon, Laura. *Billboard: Art on the Road*. Cambridge, Mass.: MIT Press, 1999.

Sturken, Marita. *Tangled Memories: The Vietnam War, the AIDS Epidemic, and the Politics of Remembering*. Berkeley: University of California Press, 1997.

Sullivan, Mary Ellen. *Cows on Parade*. Kreuzlingen, Switzerland: Neptun Verlagsauflieferung, 1999.

Sussman, Elisabeth. *Keith Haring*. New York/Boston: Whitney Museum of American Art/Bulfinch Press and Little, Brown, 1997.

Symmes, Marilyn, ed. *Fountains: Splash and Spectacle: Water and Design from the Renaissance to the Present*. New York: Cooper-Hewitt National Design Museum/Rizzoli, 1998.

Tabart, Marielle, et al. *L'Atelier Brancusi: La Collection. Germain Viatte*. Paris: Centre Georges Pompidou, 1997.

Thiis-Evenson, Thomas. *Archetypes and Architecture*. Oslo: Norwegian University Press, 1987.

Thompson, George F., ed. *Landscape in America*. Austin: University of Texas Press, 1995.

Thomson, Mark, ed. *Social Work: Saatchi and Saatchi's Cause Related Ideas*. London: -273 Publishers, 2000.

Thorne, Martha. *Modern Trains and Splendid Stations of Architecture and Design in the 21st Century*. Chicago: Art Institute of Chicago, 2001.

Torres, Ana María. *Isamu Noguchi: A Study of Space*. New York: Monacelli Press, 2000.

Vergine, Lea, ed. *Trash: From Junk to Art*. Milan/Corte Madera, Calif.: Electa/Gingko Press, 1997.

Walls, Brian, ed. *If You Lived Here: The City in Art, Theory, and Social Activism: A Project by Martha Rosler. Discussions in Contemporary Culture*, no. 6. New York: New Press, 1999.

Walter, E. V. *Placeways: A Theory of Human Environment*. Chapel Hill, N.C.: University of North Carolina Press, 1988.

Weber, Laura, ed. *Public Art in Minnesota*. Saint Paul, Minn.: FORECAST Public Artworks, 1996.

Weibel, Peter, ed. *Net-Condition: Art and Global Media*. Cambridge, Mass.: MIT Press, 2001.

Wijers, Louwrien. *Writing as Sculpture: 1978–1987*. London: Academy Editions, 1996.

Wodiczko, Krzysztof. *Critical Vehicles*. Cambridge, Mass.: MIT Press, 1999.

Wrede, Stuart, and William Howard Abrams, eds. *Denatured Visions: Landscape and Culture in the Twentieth Century*. New York: Museum of Modern Art/Harry N. Abrams, 1991.

Wrigley, Lynette. *Trompe L'Oeil: Murals and Decorative Wall Painting*. New York: Rizzoli, 1997.

Yngvason, Hafthor, ed. *Conservation and Maintenance of Contemporary Public Art*. London/Washington, D.C.: Archetype Publications/Americans for the Arts, 2002.

Zube, Ervin H., ed. *Landscapes: Selected Writings of J. B. Jackson*. Amherst: University of Massachusetts Press, 1970.

VIDEO RESOURCES

Art: 21. Produced by Susan Sollins for PBS, 2001.

Expanding Environments: Transforming Metaphors of Identity. Produced by Ingrid Lilligren for the Brunnier Art Museum, Iowa State University, Ames, 2002.

Fresco: A Story of Art, Community, and Excellence. Produced by Deborah Boldt, Riverside, Conn., 1999.

Graffiti Verité: Read the Writing on the Wall and *Graffiti Verité 2: Freedom of ExpreSSion?*. Produced by Bob Bryan, Los Angeles, 1996, 1998.

Joyce Kozloff: Public Art Works. Produced by Hermine Freed, New York, 1996.

Maya Lin: A Strong Clear Vision. Produced by Ocean Releasing, Los Angeles, 1994.

Public Art: Process and Product. Produced by Vincent Ahern for the University of South Florida Contemporary Art Museum, 1998.

Public Interventions. Produced by Branka Bogdanov for the Institute of Contemporary Art, Boston, 1994.

Salmon in the City. DVD produced by the Seattle Arts Commission, 2001. (This agency is now known as the Mayor's Office of Arts & Cultural Affairs.)

The Contributors

PENNY BALKIN BACH, executive director of the Fairmount Park Art Association, Philadelphia, is a curator, educator, and cultural observer. She has served on national and international juries and advisory panels and has presented lectures, workshops, and exhibitions in addition to having written extensively about public art and the environment.

JACK BECKER founded the Twin Cities–based FORECAST and has been the organization's director since 1978. He began his career in 1977 with the CETA arts program in Minneapolis. In 1989 he developed an annual grant program for emerging artists and established the national journal *Public Art Review*. He has lectured extensively and authored several articles as well as a monograph on public art. He currently manages FORECAST's consulting practice.

CATH BRUNNER leads 4Culture's entrepreneurial public art program, which manages the public art collection of King County, Washington, as well as projects for public and private developers in the Puget Sound region. 4Culture is committed to advancing community through a unique integration of public art with heritage, preservation, and the arts in general.

JESSICA CUSICK is president of Cusick Consulting, specializing in civic art and community development. She is also an adjunct professor in the public art studies program at the University of Southern California. She developed the civic art and design program for the Cultural Arts Council of Houston and Harris County and produced the award-winning Houston Framework.

GORDON B. DAVIDSON retired in 2002 as senior assistant city attorney for the City of Seattle. For more than twenty-five years he served as principal attorney for the Seattle Arts Commission (now the Mayor's Office of Arts & Cultural Affairs). He also served two terms as a member of the King County Public Art Commission.

SEAN H. ELWOOD is director of grants and artist services for Creative Capital, New York City. He is the former curator/collection manager for the Seattle Arts Commission (now the Mayor's Office of Arts & Cultural Affairs), where he was responsible for all aspects of Seattle's Portable Works Collection.

PATRICIA FAVERO is the former registrar for the public art program of the Seattle Arts Commission (now the Mayor's Office of Arts & Cultural Affairs). She is currently earning her master's degree in art conservation at the University of Rochester.

TOM FINKELPEARL, director of the Queens Museum of Art, New York City, was previously program director at P.S.1 Contemporary Arts Center, also in New York, and directed New York's percent-for-art program from 1990 to 1996. He is the author of *Dialogues in Public Art* (MIT Press, 2000).

BARBARA GOLDSTEIN is public art director at the San Jose Office of Cultural Affairs. From 1993 to 2004 she served as public art director at the Mayor's Office of Arts & Cultural Affairs, Seattle, and was previously director of design review and cultural planning for the Los Angeles Cultural Affairs Department.

DONNA GRAVES is a public arts administrator, cultural planner, and writer. She was project director for the Rosie the Riveter Memorial, Richmond, California, and is now working with the City of Richmond and the National Park Service to develop a new national park focusing on the broader social history of the World War II home front. She is the author of *Tending the Home Front: Women on the West Coast During World War II*, forthcoming from the University of California Press.

LAURA HADDAD has been working in the field of public art since 1995. Her past projects include *Undercurrents*, in Seattle's Myrtle Edwards Park; *Millennium Plaza*, in Kent, Washington; *Seattle Waterfront Marriott Rooftop*; and *Starchief*, in West Hollywood, California. In the Seattle area, she is working on projects in the neighborhoods of Fremont, White Center, and Shilshole. Her current work also includes projects in Chapel Hill, North Carolina, and in Portland, Maine. Her formal training is in landscape architecture.

THOMAS HAYTON, an attorney working in the fields of intellectual property and general commercial and construction litigation, has prosecuted copyright infringement cases on behalf of architects and artists. He regularly contributes to university classes on architectural and artistic copyright and serves as general counsel for Allied Arts of Seattle. He is affiliated with the Seattle firm Cutler & Nylander.

PEGGY KENDELLEN is a public art manager with the Regional Arts & Culture Council, in Portland, Oregon. She manages artist-in-residence and temporary installation programs along with public and private site-specific projects. She also gives presentations on public art to student and civic groups.

ROBERT KRUEGER, a practicing sculptor and arts administrator, is collection specialist for the Public Art Department of the Regional Arts & Culture Council, Portland, Oregon, where he has worked since 1998. He is an active member of the Western Association for Art Conservation and the American Institute for Conservation. Before embarking on a career in the arts, he worked for many years in the construction and technical trades.

MATTHEW LENNON is the founder of the HorseHead Project, an ongoing exhibition of temporary artworks. He is a practicing artist, an independent curator, and a public arts officer for the city of Newcastle-upon-Tyne, England.

HELEN LESSICK, an artist and activist, has developed and managed public projects with a variety of arts entities. Her temporary and permanent public artworks and site-related projects have been exhibited and experienced on both U.S. coasts as well as in Europe. She currently maintains her studio in Los Angeles.

PATRICIA C. PHILLIPS writes on public art, sculpture, and other areas of contemporary art. She is a professor of art at the State University of New York at New Paltz and serves as editor in chief of *Art Journal*, a quarterly publication of the College Art Association.

RENEE PIECHOCKI is an artist and public art consultant. From 2000 to 2004 she managed the Public Art Network of Americans for the Arts. She is a member of the collaborative team Two Girls Working: Tiffany Ludwig & Renee Piechocki (www.twogirlsworking.com), whose work focuses on creating projects in the public realm.

NORIE SATO, an artist living in Seattle, has nearly twenty-five years' experience in various aspects of public art, with individual and collaborative/design team work involving transit systems, infrastructure, universities, convention centers, laboratories, and airports. Her work can be seen in Seattle; Portland, Oregon; Dallas; Madison, Wisconsin; and Ames, Iowa, among other locations.

SUSAN SCHWARTZENBERG is a visual artist and photographer. Her work, exhibited internationally, ranges from the development of books and installations to curated exhibitions and larger-scale public works. Her themes include biography, memory, and studies of urban life and history. In 1998–99 she was a recipient of the Loeb Fellowship for Advanced Environmental Studies from Harvard University. She lives in San Francisco and holds a senior staff position at the Exploratorium.

SHELLY WILLIS manages the University of Minnesota's public art program, including the development of temporary and permanent public art on campus throughout the University of Minnesota system. She arrived in Minnesota in 1999, after ten years of managing visual arts programming for the City of Fairfield, California, where she founded and directed the city gallery and the city's public art program, with an emphasis on exploring community identity through temporary and permanent public artworks and exhibitions.

RURI YAMPOLSKY is a public art project manager at the Mayor's Office of Arts & Cultural Affairs, Seattle. Trained as an architect, she manages design team projects as well as site-integrated and infrastructure projects, and she coordinates the maintenance of permanently sited artworks. She has also worked extensively on contracts and on issues involving artists' rights.